THE WILD EDGE

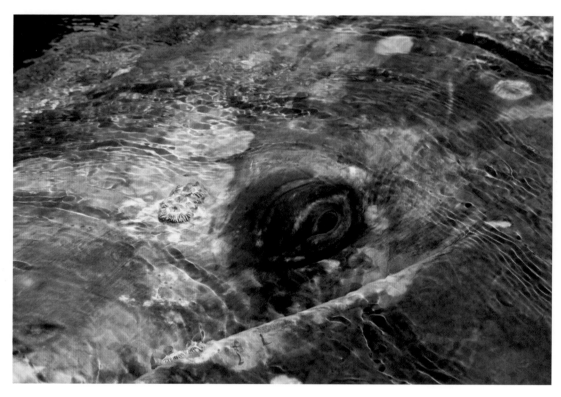

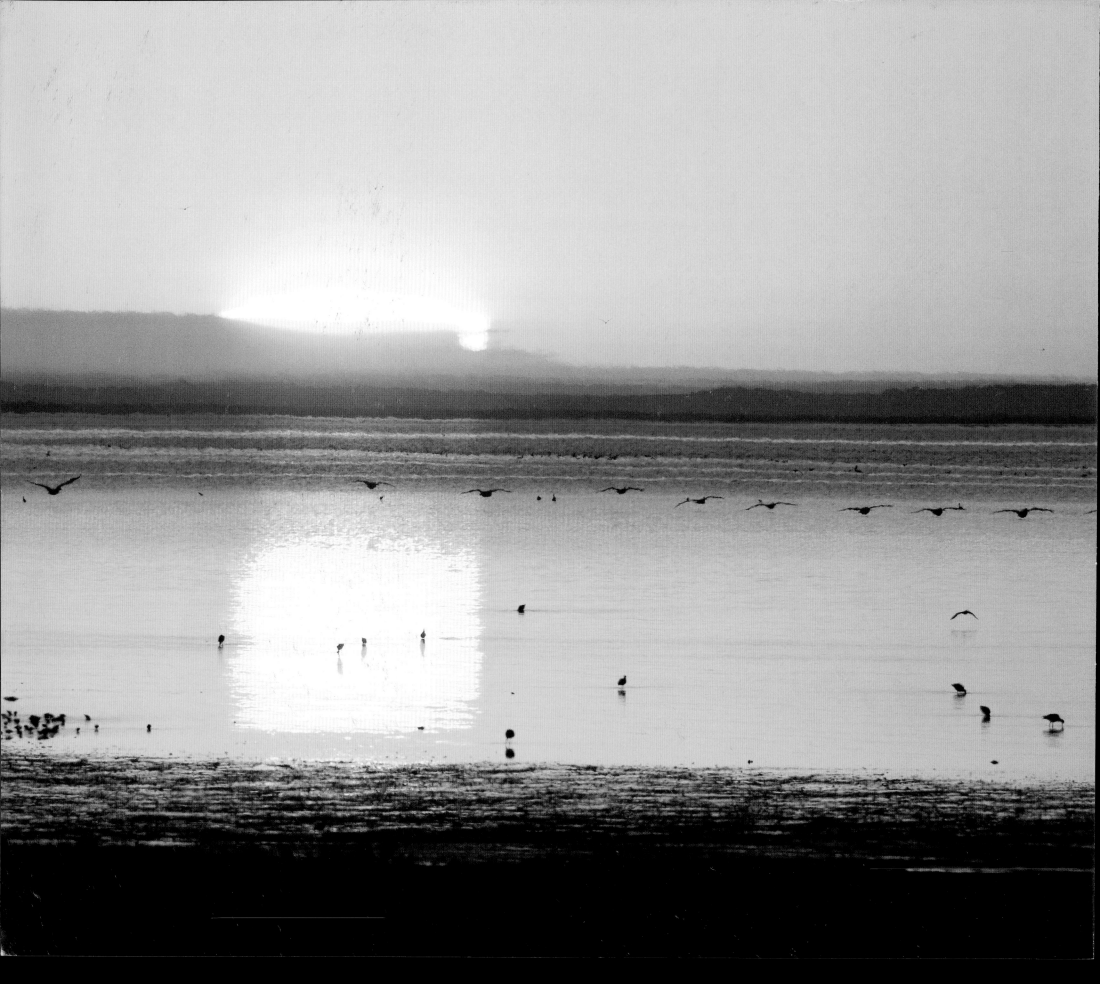

THE WILD EDGE

FREEDOM TO ROAM THE PACIFIC COAST

A PHOTOGRAPHIC JOURNEY BY FLORIAN SCHULZ

INTRODUCTION BY **BRUCE BARCOTT** EPILOGUE BY **PHILIPPE COUSTEAU**

BRAIDED RIVER

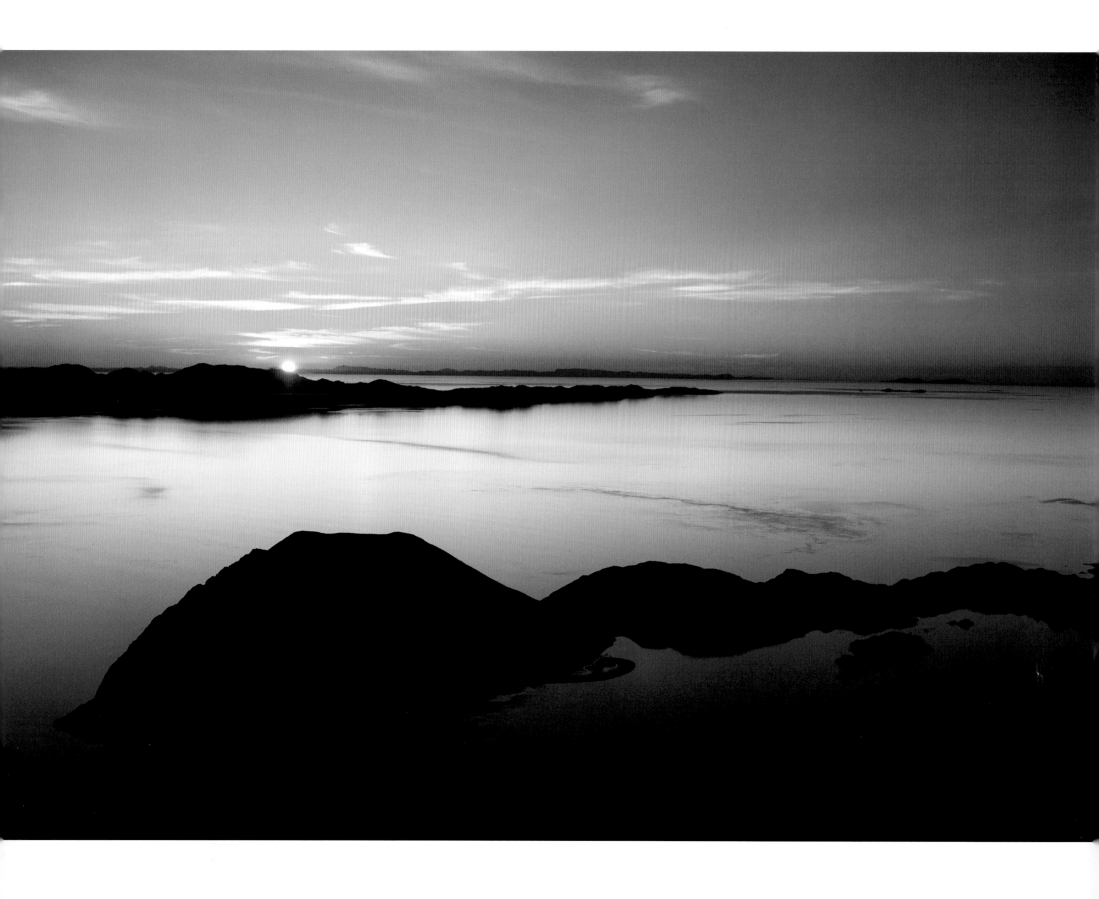

For Margot MacDougall—

in loving memory of our friendship

—F.S.

CONTENTS

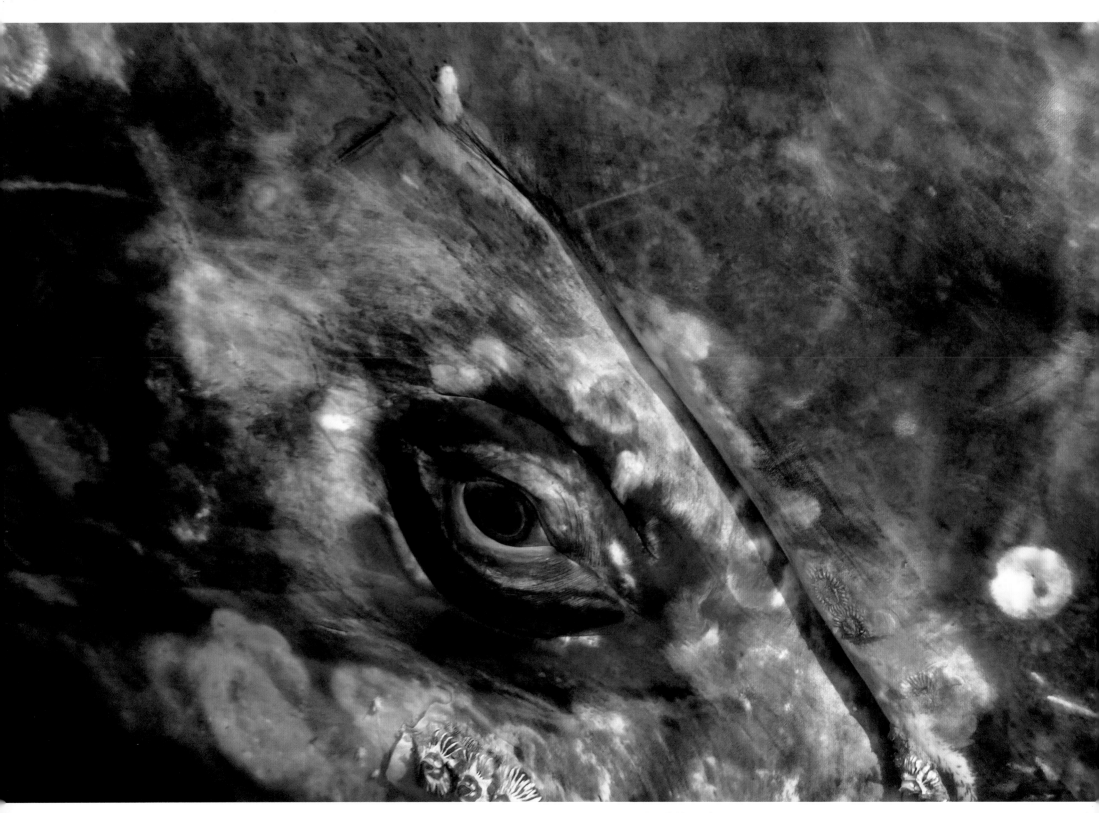

Gray whale in the calving lagoons, where human access is strictly regulated by the Mexican government, Baja California Sur, Mexico

A WILD IDEA

A Protected Wildlife Corridor from Mexico's Baja Peninsula to Alaska's Beaufort Sea

HELEN CHERULLO

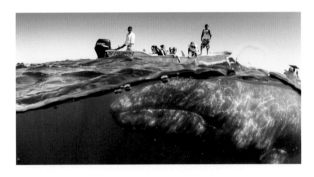

One of the stories from *The Wild Edge* that resonates most strongly with me is from Baja California, of gray whales approaching boats and trusting people to touch their bodies and stroke their newborn calves. These intimate encounters have a profound effect on the people who experience them—a connection of heart and spirit that some describe as among the most stirring moments of their lives. Perhaps this connection also leads to a sense of shared vulnerability, as people recognize the unnatural threats and tolls that human development have taken not only on the whales but on our own lives and our shared planet.

Personal encounters such as these are a powerful initiation to life along the vast and complex Pacific Coast. Of equal importance is the macro view of life orchestrated by changes across millennia of time, weather, and a vast array of sea, land, and sky. The gray whales that you spot off the coast depend on a healthy environment, not only as far as your eye can see, but along the *entire* coastline, from the southern Baja Peninsula to the northern Beaufort Sea of Alaska—from Baja to Beaufort, in shorthand the "B2B."

I think many people who visit "their whales" at urban beaches along the Pacific Coast would admit they don't often think about the epic migration: from remote lagoons in the southern Baja Peninsula of Mexico, where they give birth, to Arctic waters thousands of miles north, abundant with life upon which the whales rely. Further, it

seems inconceivable that a mammal so large depends on tiny krill for food. This is what is so fascinating and critical to understand about the B2B: interconnectivity happens on scales both large and small.

Drilling for oil and dealing with the aftermath of a catastrophic spill along a seemingly remote Alaska coast take on new meaning to California whale watchers when they learn the Beaufort Sea is a "biological hot spot" where the whales migrate. It is this view of key habitat preservation, in addition to a more audacious vision, that we hope to convey in *The Wild Edge*. Together with Florian Schulz and grassroots groups, our goal is to further preserve vast natural and healthy corridors that connect these biological hot spots. Through these unimpeded linkages, life as we know it—life we depend on—will then have the freedom to roam and the greatest chance to adapt and thrive.

The gray whale is just one of many creatures to benefit from more thoughtful consideration and treatment. Among species that migrate along the Pacific Coast are caribou, birds, salmon, and butterflies. Others—including

humans—thrive in place along abundant, healthy coastlines.

As encroachments continue on lands and waters that have historically linked and provided a buffer for parks, preserves, and sanctuaries, establishing protected wildlife corridors could be the salvation for all life—including human communities. To do otherwise is unimaginable: rising levels of oceans destroying coastal communities, annihilation of wild fish for food, ocean acidification killing shellfish and destroying economies while throwing the entire food chain off balance.

We are at a time and in a position when it is possible to make a seismic difference in what kind of life we live now and what we will leave to future generations. We can evolve by choice or by chance. By weaving what we know about the gray whale into a bigger story of profound interdependence, we can find reasons to behave differently for mutual benefit. We have the imagination to explore options, the heart to see beyond our own needs, and the technology and resources to change business as usual.

Our hope with this latest Braided River book and outreach campaign is that the artistry of Florian Schulz's images and the collective voices and stories of this book will set fire to your passion and resolve. We hope you will become another active supporter of protecting the last precious remaining natural wild places of beauty and diversity, helping to provide all life the freedom to roam—not only in your own backyard, but along the entire wild edge of the B2B, and beyond. ■

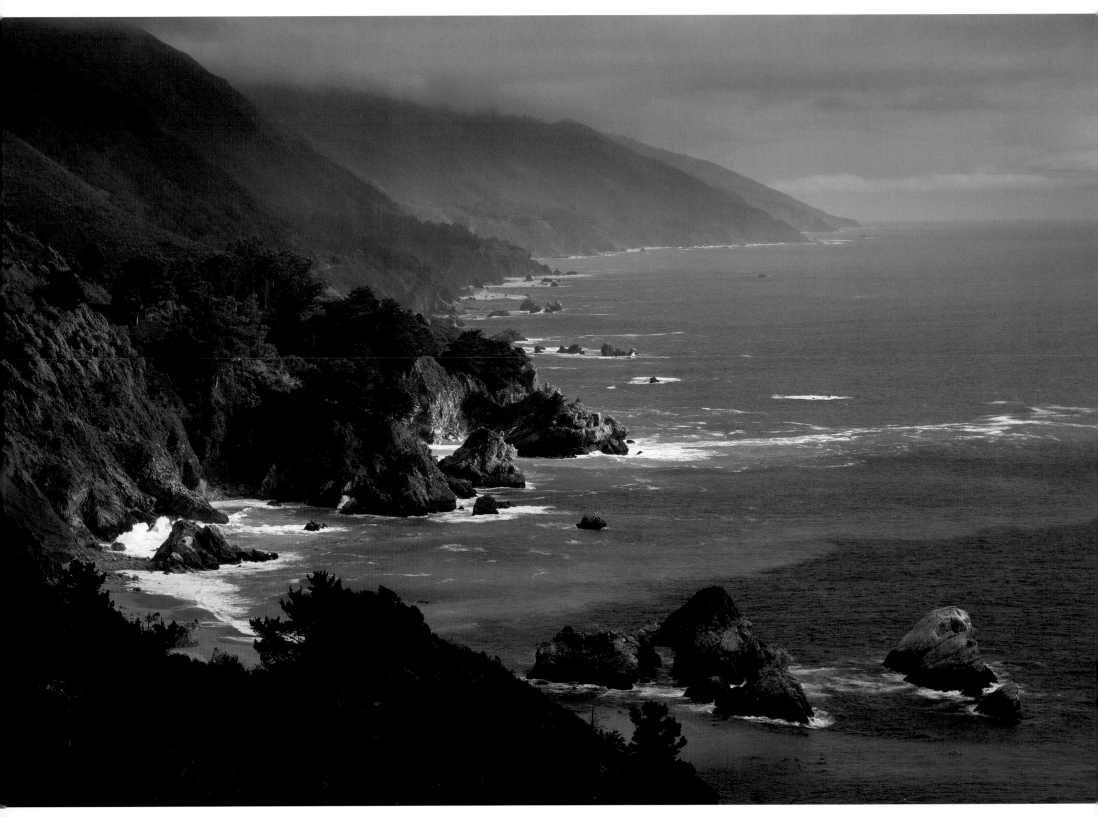

Big Sur, California

CURRENTS OF LIFE

EXEQUIEL EZCURRA

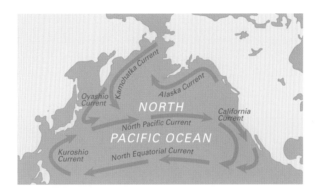

Some natural phenomena are so entrenched in our everyday experiences that we forget how fascinating they truly are. When Jean-Bernard-Léon Foucault hung a pendulum at the Panthéon in Paris and showed that the plane of oscillation shifted with the rotation of the earth, European high society went crazy with excitement. And yet the same forces that tugged Foucault's legendary pendulum affect ocean currents and wind directions every moment, and most of us do not think twice about it. But without these currents and these winds, life would not be what it is along the Pacific coast of North America, from Baja California to the Arctic's Beaufort Sea.

The Wild Edge is about this extraordinary corridor of natural environments that links the Beaufort Sea, in the Arctic Ocean, with the Sea of Cortés in Baja California— a succession of marine and terrestrial ecosystems that support one another, a corridor for some of the most extraordinary migrations on the planet. Led by the breathtaking photographs of Florian Schulz and accompanied by masterful text by Bruce Barcott, Eric Scigliano, and Jon Hoekstra, this book is a celebration of one of the most heterogeneous arrays of environments on Earth that, paradoxically, function as one single life-giving region. From Arctic ecosystems to a cold, wet north and an arid south, from western wet slopes to eastern rain-shadow deserts, from deep ocean trenches

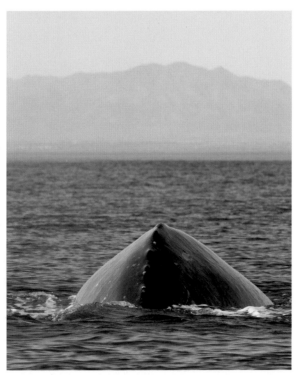

A gray whale dives in the shallow Laguna Ojo de Liebre, Baja California Sur, Mexico.

to high sierras, this region harbors a mosaic of unique habitats, a magnificent diversity of landscapes driven by the interaction between the land and the sea, the living result of a vibrant dialogue between two realms.

In this long coastal corridor, the circulation of winds and currents is the underlying mechanism that drove the evolution of the region's incredible environments, and it is the motor that still maintains their unique existence. In the Northern Hemisphere, the Pacific Ocean has a system of currents that circulate clockwise: Tropical waters move from east to west, from Central America to Asia, and when the northern equatorial current reaches the Asian continent and its islands, it is deflected northeastward, past the Japanese island of Hokkaido, returning toward the western coast of North America. At the coast of British Columbia, a large part of the flow is deflected southward as the California Current, which runs from north to south along the coast, and the rest is deflected northward as the Alaska Current, which sweeps the coasts of the Aleutians and the Bering Sea with its temperate waters. Its large counterclockwise gyre produces the upwelling of fertile deep waters that feed the productivity of the Gulf of Alaska and the Bering Sea.

As it moves south, approaching the tropics, the California Current is deflected westward by the rotational movement of the earth to form again the equatorial current and close the giant gyre of the Pacific, an oceanic

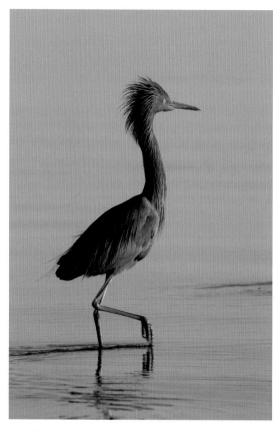

A reddish egret searches for food in a shallow lagoon, Baja California, Mexico.

conveyor belt of energy and nutrients. The westward movement of the surface waters drags deep, cool water from the nutrient-rich layers of the ocean floor, bringing fertility to the ocean surface and maintaining some of the most productive marine ecosystems in the world. Pacific sardine, mackerel, tuna, marlin, and swordfish thrive in the upwelling of these surprisingly cold waters, all the way to the southern cape of the Baja Peninsula.

This simple system of currents, driven by the basic forces of gravitation and the rotation of the earth, maintains some of the most extraordinary ecological contrasts in the planet. The cold, crisp Arctic air feeds the tundra, and the waters of the Alaska Current sustain the northern conifer forests. The moisture-laden westerly winds drench the lush Pacific Northwest forests in rainwater and feed the rich rivers of the region. Along

the coast and mountains of California, the fog and moisture of the coastal currents support the largest living organisms on Earth: the coastal redwoods and the giant sequoias. In the southern latitudes, as the sea grows colder it contributes to the aridity of the land because the moisture-laden oceanic winds heat up and dry as they run into the hot desert coasts. Here, the coastal rain forests are replaced by chaparral, a unique evergreen scrub adapted to winter rains, and farther south chaparral gives way to the great deserts of Baja California.

Surprisingly, almost miraculously, gigantism is here a threading theme: The imposing presence of several species of whales along the marine corridor is matched by the silent presence of 330-foot-tall (100-meter-tall) redwoods along the California coast, massive giant sequoias in the sierras and, farther south, the giant cardón, the largest cactus in the world; the boojum tree, the tallest (and weirdest) desert tree; or the massive contorted trunks of the elephant trees. From tundra and boreal forests to rain forests and redwoods, from rich coastal scrubs to astonishing deserts with enormous plants—all are maintained by the continuum of coastal waters from the Alaskan Arctic to the Baja Pennisula.

But the currents that support life in the sea and on land are not unchanging. During some years, variations in the earth's flow of air weaken the trade winds, slowing down the equatorial and California currents. As a result, the upwelling of nutrient-rich waters decreases, the sea becomes warmer, and marine productivity collapses. Fisheries dwindle, while the land, in contrast, becomes soaked under the abundant rainfall that evaporates from the abnormally warm ocean waters. The deserts bloom and the meadows in California turn golden with millions of flowering poppies. For a brief period, the famine of the sea becomes the feast of the land. Small variations in the oceanic dynamics may trigger times of plenty or of scarcity.

The power of the great Pacific gyre becomes apparent in Isla Rasa, a small seabird island in the Sea of Cortés. When the equatorial currents slow down, the gulf warms up and the normally abundant sardine

This region harbors a mosaic of unique habitats, . . . the living result of a vibrant dialogue between two realms.

population, which relies on colder water, collapses. The nesting seabirds cannot find enough sardines to feed their chicks, which die in the nests, tragically. Like a revelation of the deep, intricate nature of the biosphere, the dynamics of ocean currents 12,000 miles (19,300 kilometers) away may seal the fate of millions of seabird chicks. The nesting seabirds on Isla Rasa clearly show that the complex ecological processes that drive life on our planet are intricately connected, binding all organisms together. In the coastal strip that links Baja to Beaufort, we can fathom the pulse of planetary life.

Reading this book and looking at its beautiful images, we cannot help but wonder about these enigmatic connections between the land and the sea and how these connections might change in the future as a result of the human-driven transformation of our planet. If all things are so interrelated, how can we allow nature to be destroyed bit by bit without recognizing the impact this destruction will have on the continuity of life on Earth?

In the end, this book is a celebration of life and a call to its conservation. As Wallace Stegner brilliantly put it in his "Wilderness Letter," we need that wild country to reassure ourselves of our sanity as creatures. We need to preserve what remains of this amazing wilderness as part of a geography of hope. And hope is what these images offer. Florian Schulz brings them to us with his artistic brilliance and his deep commitment to nature. *The Wild Edge* is a celebration of the continuity of life on Earth and of the uniqueness of this amazing coastal corridor. The B2B corridor is a metaphor for the diversity of our planet: so many different habitats, such immense contrasts, and yet a single entity vibrating in unison with the land and the sea. ∎

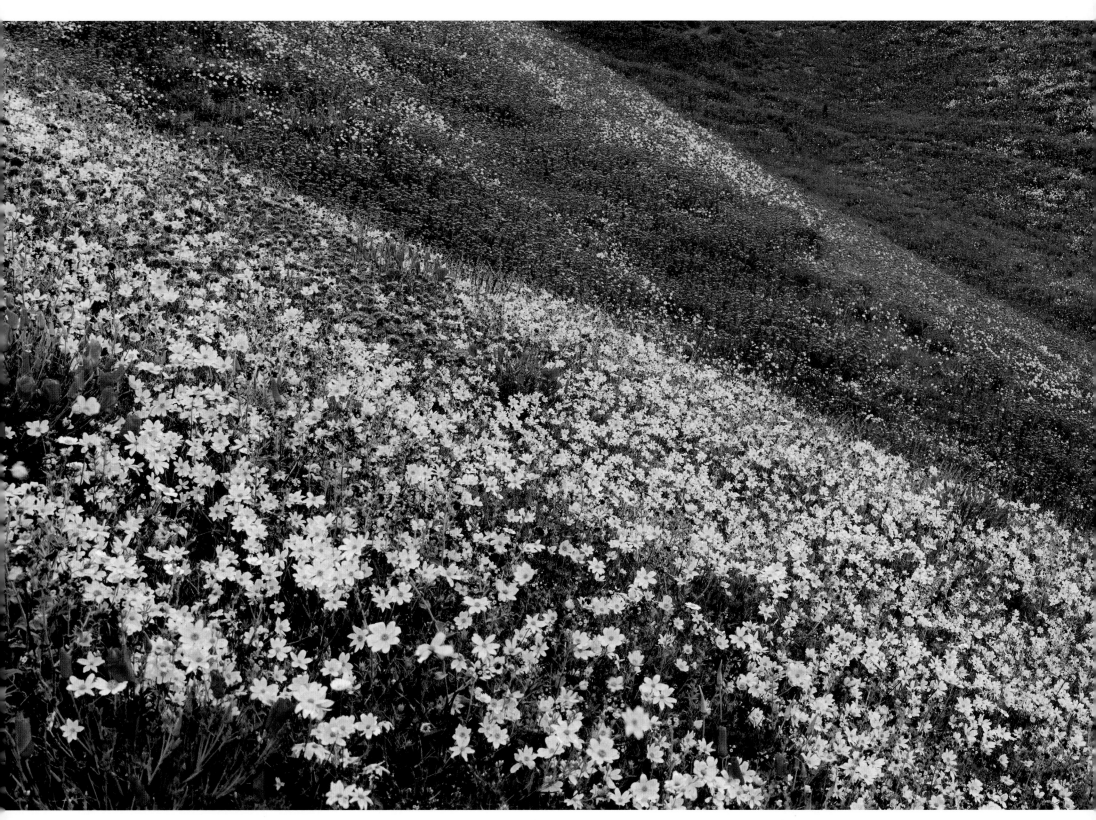

Seasonal rains bring massive wildflower displays in the Tehachapi Mountains, California.

THE WILD PACIFIC EDGE

BRUCE BARCOTT

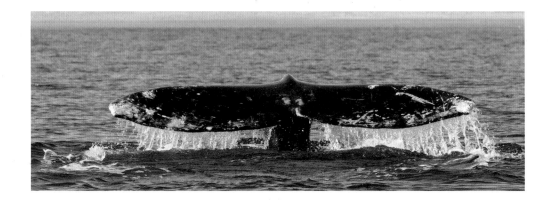

This book is about a new way of looking at the world.

Begin with the familiar: a map of North America. Hold it in your hands. Now turn it 90 degrees to the right. Let the borders of Canada, the United States, and Mexico fade into pinstripes. Allow something ancient to strike your eyes: the wild Pacific edge, Baja California to the Beaufort Sea, a seam of some 6000 miles (9700 kilometers) where land meets sea and creates one of the wildest and most productive corridors of life on Earth.

Right: The last rays of the evening sun illuminate the coastline of Garrapata State Park on California's Big Sur coast.

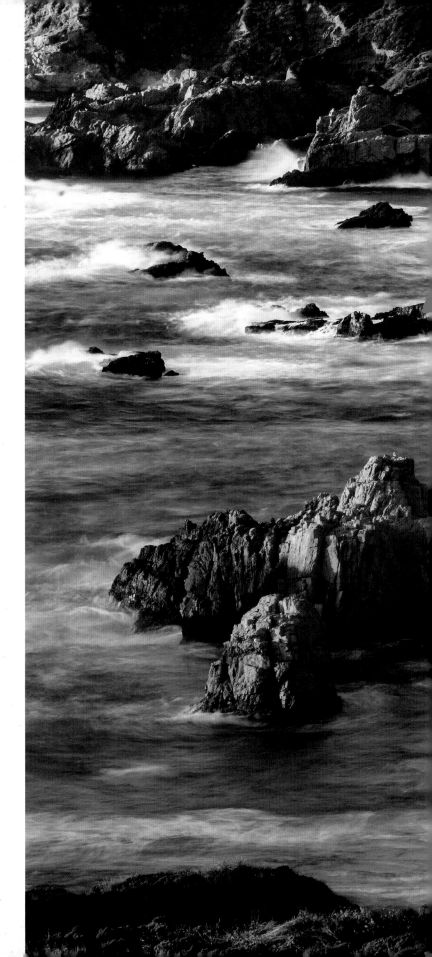

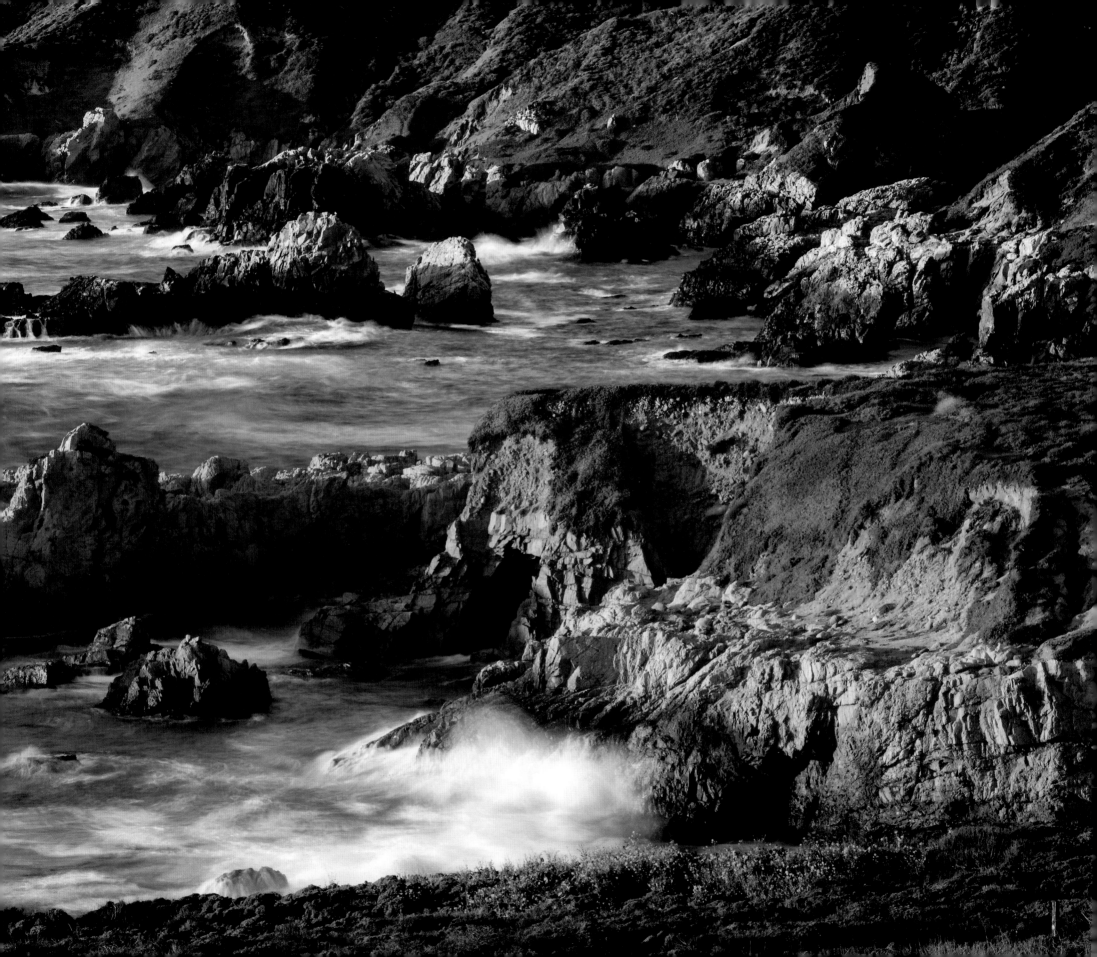

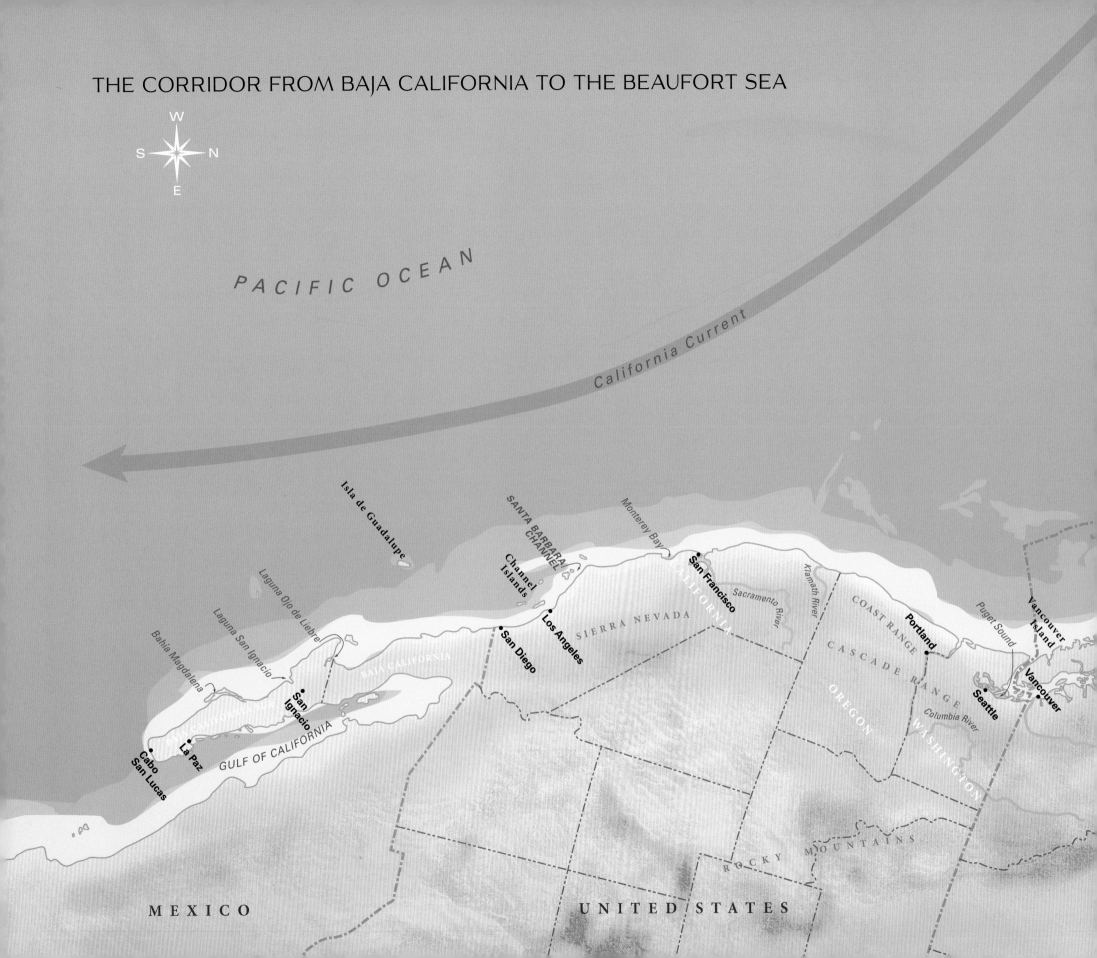

THE CORRIDOR FROM BAJA CALIFORNIA TO THE BEAUFORT SEA

PACIFIC OCEAN

California Current

Isla de Guadalupe

SANTA BARBARA CHANNEL

Monterey Bay

Channel Islands

San Francisco

Sacramento River

Klamath River

COAST RANGE

Puget Sound

Vancouver Island

Los Angeles

SIERRA NEVADA

CALIFORNIA

Portland

CASCADE RANGE

Laguna Ojo de Liebre

San Diego

Vancouver

Laguna San Ignacio

Seattle

Bahía Magdalena

BAJA CALIFORNIA

OREGON

Columbia River

WASHINGTON

BAJA CALIFORNIA SUR

San Ignacio

GULF OF CALIFORNIA

La Paz

Cabo San Lucas

ROCKY MOUNTAINS

MEXICO

UNITED STATES

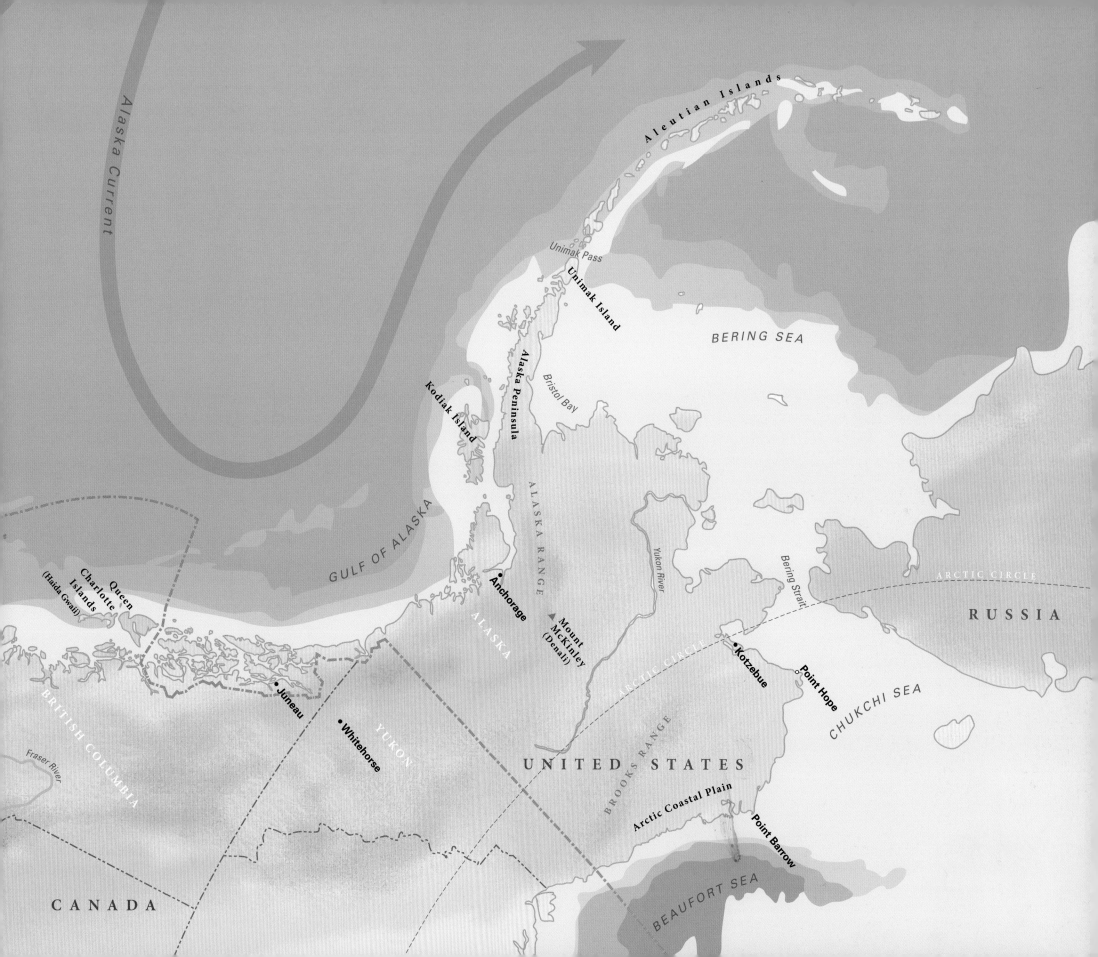

Note the waypoints. Start south at the sunbaked fingertip of Cabo San Lucas, Mexico. Move north to the underwater kelp forests of California's Channel Islands, past the mouth of the mighty Columbia River that separates Oregon and Washington, through the rocky archipelagos of the British Columbia coast, around the spiked horn of Alaska's Aleutian Islands, through the choke point of the Bering Strait, to reach the Beaufort Sea and the Arctic Coastal Plain, that expanse of frozen tundra sliding low and humble into the Arctic Ocean.

Is it a coastline? Not exactly. The B2B—Baja California to the Beaufort Sea—contains a shoreline, but its reach is broader, deeper, more ample: 6000 miles (9700 kilometers) long (roughly the path of the gray whale migration), about 200 miles (320 kilometers) wide. It's an area bigger than India, a nation so double-extralarge they call it a subcontinent. This biological corridor, new in name but ancient in its workings, extends inland to sloping mountains where rivers begin and offshore to seafloor cliffs where the continental shelf drops into the abyssal plain. In between lie deserts, forests, islands, estuaries, fjords, archipelagos, and vast stretches of Arctic tundra. It's a wildlife corridor, a migratory pathway, a trade route, a channel of nutrient flow, a biological hot zone, a corridor of idea exchange and energy transfer. Its constants are energy, movement, and life.

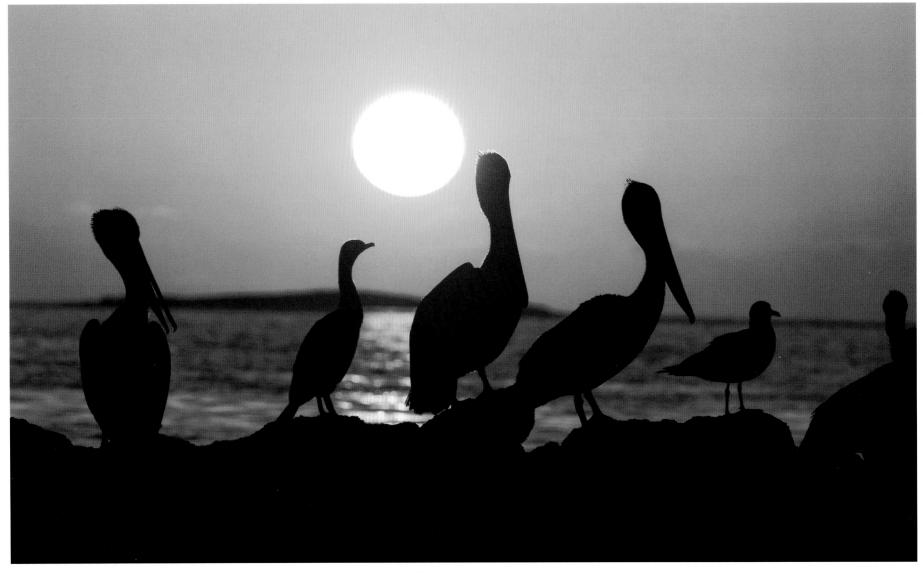

Brown pelicans, a Heermann's gull, and a cormorant at sunrise in the Gulf of California, Baja California Sur, Mexico

For too long we've defined it only in parts: three nations and dozens of First Nations and Native American sovereign lands; two Canadian provinces, four American states, two Mexican states; seven major cities and hundreds of counties, towns, and sleepy backwater burgs. These are products of political borders, puzzle pieces meaningful to *Homo sapiens* but senseless to all the other species that turn the gears of the greater organic machine.

For too long we've remained disconnected from this great corridor by our limited understanding of the biological motion that quickens it. Now is the time to overcome the limitations of human sight. Time for us to see the full range of the B2B as the gray whale, the Pacific salmon, the black bear, and the western sandpiper see it.

Fortunately we have help in that endeavor. For the past ten years, Florian Schulz has roamed this seam with camera in hand. His spectacular photographs, collected here for the first time, offer nothing short of eyesight to the blind. In place of arbitrary borders, he offers us flow-ways and flyways, caribou boulevards and salmon streams. The B2B is defined by flow and movement, by the meeting of disparate species and a give-and-take that can be as gorgeous and subtle as the turn of a wing in flight and as necessary and brutal as the killing of prey. Through Florian's photographs, we gain a new understanding of the real borders, the resource strippers and the movement stoppers: dams, fences, highways, trawl nets, pollution outfalls, land development. Now it's time to see the B2B in its entirety and embrace it whole. It's time for us to acquire fresh eyes.

The idea of a wildlife corridor grew out of a simple realization: movement matters.

Years ago, Wallace Stegner described America's national parks as "the best idea we ever had." Brilliant in conception, breathtaking in realized form, our parks offer every American the opportunity to connect with the wild and primal bones of the nation. The parks and their protective kin—wilderness areas, wildlife refuges, and marine sanctuaries—provide protection against the metastasizing crush of human disturbance. For a long time we thought those safeguards were ample. Then we learned otherwise.

Over the past century, significant species have been disappearing from national parks across the western United States, Canada, and Mexico. In the mid-1980s, ecologist William Newmark discovered that larger national parks like Mount Rainier and Yosemite had lost more than one-quarter of the mammal species extant at each park's creation. In smaller parks, the loss was even greater: as many as 35 to 40 percent of the original mammal species simply disappeared. Bryce Canyon National Park lost its white-tailed jackrabbit and red fox. Woodland caribou disappeared from Glacier National Park. At a certain point, the rangers at Yosemite realized they hadn't seen any mink for many, many years. The gray wolf packs that had thrived in the deep snow of Yellowstone and Grand Teton national parks became a memory.

The parks were doing a fine job of protecting mammals *inside* their boundaries, but the parks weren't enough. The animals also needed room to roam beyond the park boundaries. Development—that warm catchall word for logging, farming, fencing, house building, condominium raising, road grading, and the holy consecration of Safeways and Subways—rubbed up against the parks. Refuges were transformed into biological islands. National parks, writer Jared Diamond noted, had become pieces of natural habitat "isolated in a sea of manmade habitat." Canadian biologist Paul Paquet had a more graphic term for these isolated patches of habitat: wilderness ghettos.

Those ghettos were a problem. The emerging field of island biogeography, pioneered in the late 1960s by Robert MacArthur and Edward O. Wilson, showed us that isolating species on habitat islands greatly increases their chances of extinction. The more circumscribed the habitat, the smaller the population; the smaller

It's a wildlife corridor, a migratory pathway, a trade route, a channel of nutrient flow, a biological hot zone, a corridor of idea exchange and energy transfer. Its constants are energy, movement, and life.

the population, the greater the risk of extinction. Tiny islands usually can't sustain strong and stable gene pools. A limited breeding pool weakens the genetic health of the species, leaving it with a limited ability to survive demographic disasters such as wildfire, flood, drought, volcanic eruption, predation, or the introduction of disease. "The main lesson of island biogeography is this," wildlife biologist Douglas Chadwick once observed, "we cannot tuck species away in little preserves, as if we were storing pieces in a museum, and then come back a century later and expect to find them still there."

That's especially true with large mammals. As a rule, the bigger the body, the smaller the population density and the larger the home range. The territory of a male grizzly can range from 200 to 500 square miles (320 to 800 square kilometers). The annual migration of the gray whale encompasses the entire length of the B2B region, 6000 miles (9700 kilometers) of nearshore ocean and protected lagoons. Across North America, the protected home ranges we offer to our largest and most charismatic mammals are relative shoe boxes.

What would a better conservation scheme look like? It would be big. If the large mammals of North America are to survive, we have to start managing areas outside our national parks, refuges, and marine reserves for wildlife conservation. We have to find a way to expand the room to grow and the freedom to roam.

Enter the idea of the wildlife corridor. Biologist Michael Soulé noticed in 1991 that fragmented habitats bunched close together support more species than

If the large mammals of North America are to survive, we have to start managing areas outside our national parks, refuges, and marine reserves for wildlife conservation. We have to find a way to expand the room to grow and the freedom to roam.

habitat fragments spaced far apart. The closer the habitat islands, the easier it is for species to disperse from one habitat to another. That facilitates the introduction of fresh genes into the mating pool and allows a booming population on one island to disperse and bolster a faltering population on another. The key, said Soulé was the corridors connecting these fragments. Those corridors, he wrote in an article in the *Journal of the American Planning Association,* are "a kind of landscape health insurance policy—they maximize the chances that biological connectivity will persist."

On a microscale, such a corridor could be as simple as a wildlife overpass that allows bears, coyotes, deer, and other mammals to cross a busy highway without becoming roadkill. On a macroscale, it might involve wildlife managers plotting ways to connect a healthy habitat island such as Yellowstone National Park with the national forests, wildlife refuges, and other habitat fragments in the adjacent region.

It fell to a Canadian lawyer to envision a wildlife corridor on a megascale. In 1993 Harvey Locke, a Calgary attorney and lifelong conservationist, wrote the words "Yellowstone to Yukon" on a topographic map while sitting around a campfire in British Columbia. His idea was simple: a cross-border conservation corridor— Yellowstone National Park, in the United States, to Canada's Yukon Territory. Conceived as a protected corridor where wide-ranging mammals could move freely

along the Northern Rockies, the Y2Y quickly gained traction among ecologists and conservation advocates. Locke's idea eventually took as its inspiration the travels of Pluie, a radio-collared gray wolf who, over the course of two years, roamed through three American states and two Canadian provinces. In her own way, Pluie put an exclamation point on the work of Newmark, Soulé, and the other ecologists concerned about the population-limiting size of national parks. In the course of her roamings, Pluie covered 40,000 square miles (64,400 square kilometers)—an area fifteen times larger than Alberta's Banff National Park, the crown jewel of the Canadian Rockies.

Y2Y wasn't a piece of legislation. It remains a never-ending work in progress. It's an ongoing effort to coordinate the conservation efforts of two countries, five American states, two Canadian provinces, and the territory of more than two dozen First Nations and Native American peoples. The Yellowstone to Yukon Conservation Initiative was formally established in 1997, and ten years later Florian Schulz and Braided River produced *Yellowstone to Yukon: Freedom to Roam,* a magnificent chronicle of the landscape and wildlife within the Y2Y.

A decade after Harvey Locke hatched the Yellowstone to Yukon idea, a second megacorridor emerged.

Baja California to the Beaufort Sea, the B2B, had no campfire brainstorm in its creation story. Its prime mover was, oddly enough, the North American Free Trade Agreement. Yes, NAFTA—that still-controversial treaty between Canada, the United States, and Mexico that greased the movement of money, goods, jobs, and people across international borders. One of NAFTA's side agreements created the Commission for Environmental Cooperation (CEC), a trinational group charged with addressing common environmental concerns. Credit the CEC with asking one critical early question. Most global conservation efforts focus on terrestrial habitat and species. CEC officials wondered, What about the oceans?

In the early 2000s, the CEC began identifying high-priority marine conservation areas in the Pacific Ocean from the Baja Pennisula to the Bering Sea. In the spring of 2003, the CEC gathered a coterie of North America's leading scientists and environmental policy makers at British Columbia's Simon Fraser University. They identified twenty-eight marine environments—biological hot spots—essential to the biological diversity of the west coast of North America. Working with biologist Elliott Norse and his Marine Conservation Institute, the CEC published "Baja California to the Bering Sea," a 136-page document that identified priority areas and began talking about ways to protect them and connect them.

The eye-popping ambition and scope of this new B2B corridor was evident even at its birth. Hans Herrmann, head of the CEC's biodiversity program, summed it up well. "Never before have we seen an international, scientific effort map out marine conservation priorities at this scale," he wrote in the CEC document.

What Herrmann didn't know was that a German photographer was about to take that startling scale and expand it. Not long after sending *Yellowstone to Yukon* to the printer in 2007, Florian Schulz embraced the B2B idea and made it his own. For six years, Schulz became one of the roaming mammals within the B2B, sailing and hiking and driving and flying the seam. But he soon realized that the vision of the corridor was too constrained. If Pluie the gray wolf symbolized the Y2Y, the California gray whale fulfilled a similar role for the B2B. And that whale's travels don't end at the Bering Strait; they continue into the far reach of the Beaufort Sea.

Schulz made another crucial expansion. He saw the ineluctable ties between ocean and land, river and sea, forest and fish, how each feed the other in a million different ways. And so his conception of the B2B expanded to include the rivers, estuaries, forests, deserts, and tundra plains that broadly border the sea.

And now it comes alive. Schulz's photographs take us to the outer edges of the B2B and allow us a glimpse of the drama, grace, and beauty of the wild in motion.

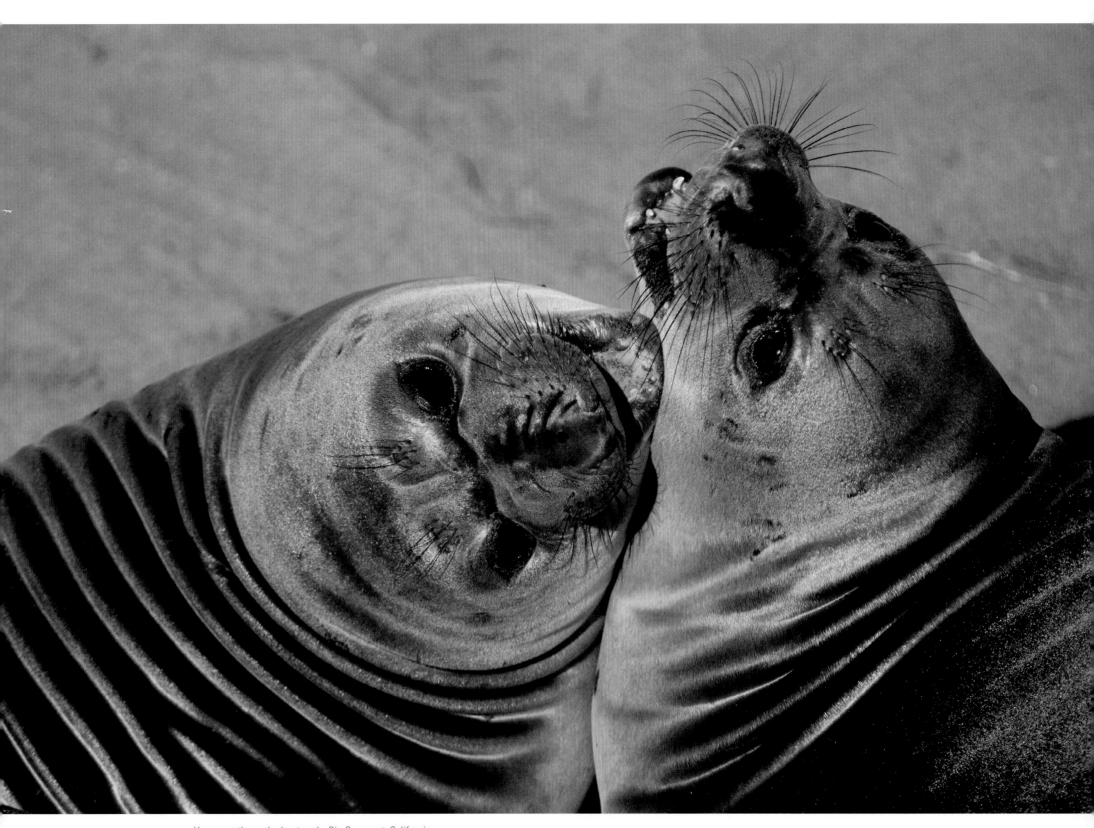

Young northern elephant seals, Big Sur coast, California

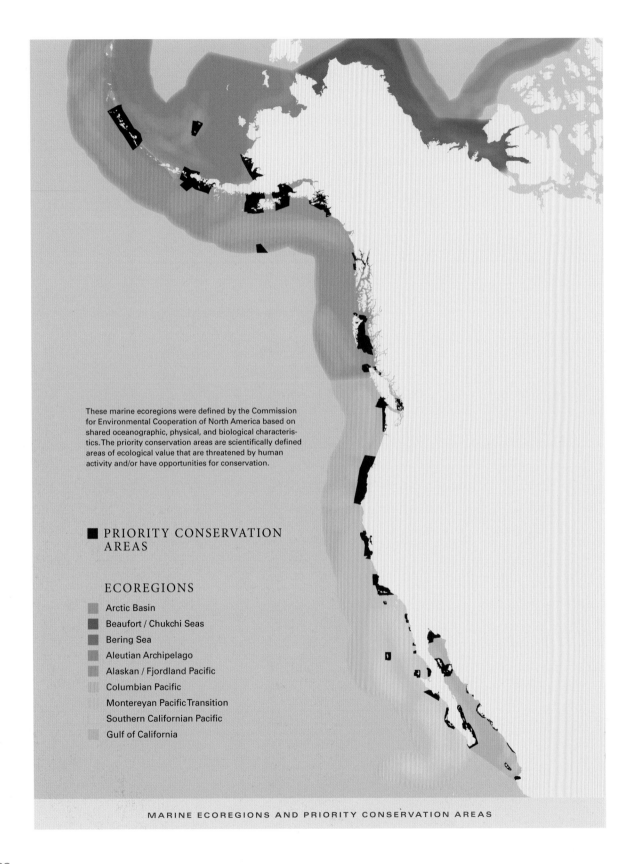

These marine ecoregions were defined by the Commission for Environmental Cooperation of North America based on shared oceanographic, physical, and biological characteristics. The priority conservation areas are scientifically defined areas of ecological value that are threatened by human activity and/or have opportunities for conservation.

■ PRIORITY CONSERVATION AREAS

ECOREGIONS

- Arctic Basin
- Beaufort / Chukchi Seas
- Bering Sea
- Aleutian Archipelago
- Alaskan / Fjordland Pacific
- Columbian Pacific
- Montereyan Pacific Transition
- Southern Californian Pacific
- Gulf of California

MARINE ECOREGIONS AND PRIORITY CONSERVATION AREAS

Through his lens, the invisible connections within this great corridor are made clear: between land and water, north and south, movement and life.

It's been my great fortune to live most of my life within the flow of the wild Pacific edge. A century ago, my ancestors ended their own migrations on the shores of Washington State's Puget Sound, having found here the essentials of life in abundance: safety, food, community, hope. Some were fishermen who raised families on the silver backs of salmon. Others were farmers who worked the rich valley loam laid down by the Skagit and Snohomish rivers. The stenchy pulp-mill town of Everett served as our family's base, a working-class burg chockablock with grandparents and aunts and uncles and cousins.

When I was young, my parents developed an itch to move beyond the reach of the mill's cologne. As the oil boom swept through Alaska in the 1970s, our family struck north for Anchorage. A few years later, we swung south and encamped in Ventura, a sleepy surf town on the Southern California coast. These were our migrations. We were West Coast people, self-defined inhabitants of a north-south corridor. They say that birds and fish can find their way home by using the earth's magnetic field. I can't claim to possess such a finely tuned sense, but I do know that this Pacific-centered childhood imprinted a notion of the geolocational norm onto my brain: ocean west, mountains east, rivers in between.

As a young man struggling to invent myself as a writer, I discovered one of the secrets to a happy life: write about what you love, because your words will pull you into whatever world you create on the page. When I was twenty-two, I worked, miserably, in the World Trade Center in New York City and wrote about Wall Street. That wised me up quick. After a few months I fled the East Coast, returned to Puget Sound, and set up shop as a specialist in wilderness, the outdoors, and the natural world. When duty called, my heart leapt. Out into the wild again!

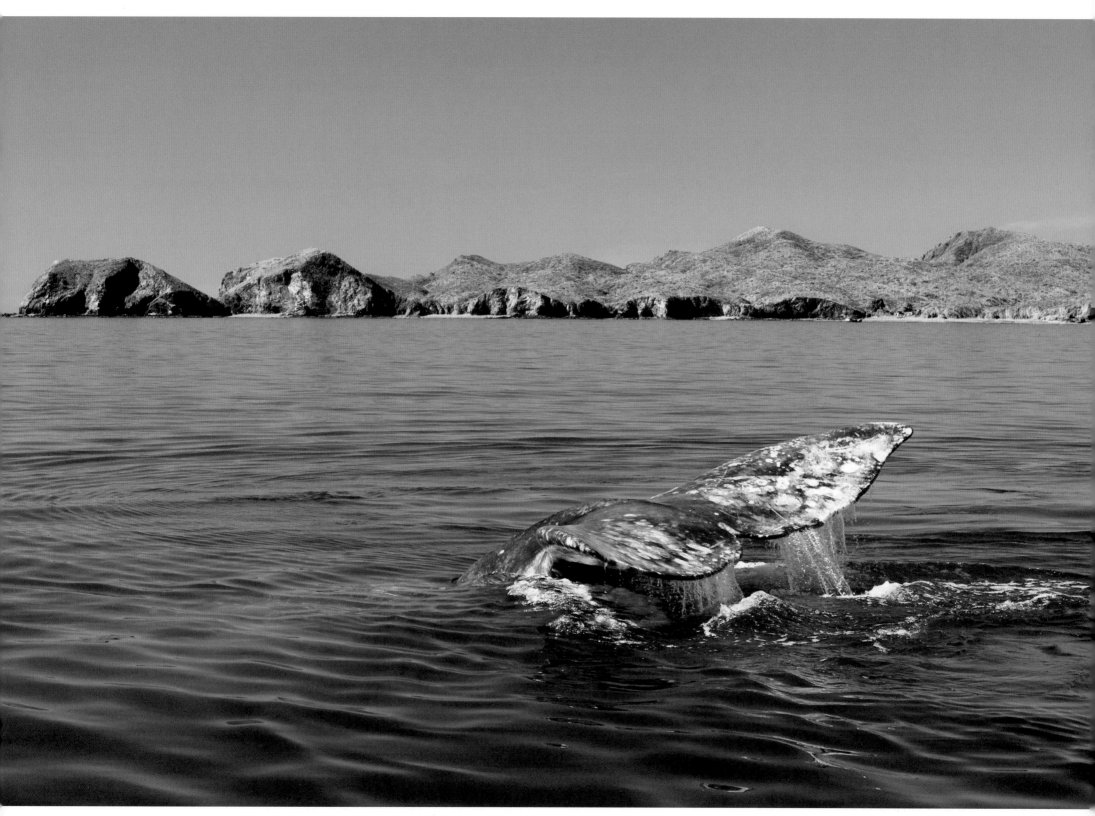

A gray whale's fluke along the coast of Baja California, Mexico

It was on one such expedition that I began to fully understand the B2B ecosystem. Nearly twenty years ago, I was lucky enough to have an extraordinary encounter with a gray whale, one of the world's largest marine mammals and the animal whose migratory range defines the very limits of the B2B—it's a beast designed to teach us about the interconnections that are so rife in this corridor.

On an early April morning, I set out from the sweet little oasis town of San Ignacio, a notch on the waist belt of Baja California Sur, Mexico, toward a sheltered bay some 30 miles (48 kilometers) west. In those years, Laguna San Ignacio had gained some notoriety among adventure travelers for an experience offered nowhere else in the world: for a small fee, a local fisherman would deliver you to a spot where you could touch wild whales. Yes—whale petting.

So it was that I found myself bouncing and jouncing down a Baja freeway—imagine a poorly chosen spur of the Oregon Trail gone to seed—thinking of Joseph Wood Krutch. The old naturalist once described the roads of Mexico's forgotten peninsula as filters meant to separate the meek from the bold. "The rougher the road," he wrote, "the finer the filter."

After two hours on the road's molar-rattling ruts, we were released into a natural salt pan toasted hush-puppy brown. Past the flats I could see a ragtag collection of canvas tents and tin shacks. Beyond them were a half dozen skiffs known as *pangas,* their outboard motors tilted to keep the props clear of the sand. A hand-drawn sign read BEST WHALE WATCHING ASK HERE. I took comfort in the crudeness of the lettering. Corporate money hadn't yet arrived.

Not that it wasn't on its way. The purpose of my trip was to witness Laguna San Ignacio and its magical whales before an international chemical company put it all to ruin by constructing the world's largest industrial saltworks at the water's edge.

As it turned out, the whales would have something to say about that.

The next morning I set out in a *panga* zipped up against a chilly spring breeze that put a light chop on the lagoon. A local fisherman, one of many picking up a little extra cash during the whale season, ferried me and a handful of others out into the deeper water, where we waited. And waited.

Nobody knows how long the gray whales have been coming to Laguna San Ignacio. Perhaps hundreds of years, perhaps tens of thousands. The bay is one of three—the others are Laguna Ojo de Liebre, north of here, and Bahía Magdalena, south—that serve as calving grounds and protected nurseries for one of the world's largest marine mammals. Every fall, as ice begins to form over the whale's summer feeding grounds in the Bering, Chukchi, and Beaufort seas, females and some males journey south along the coast. They move at a slow and steady clip, about 3½ miles per hour (5½ kilometers per hour), in relatively shallow water no farther than about 12 miles (19 kilometers) from shore. The move south takes around forty-nine days, during which they rarely eat, subsisting on the massive tonnage of body fat built up over the previous summer.

Ffffwuhh. We heard her before we saw her. A mother surfaced and sprayed, then rolled away, her softball-size eye checking out the humans bobbing on the surface. The *panga* driver idled the motor so its spinning knives posed no danger. *La máma* boiled the water beneath us. She was well over 40 feet (12 meters) long, three times the size of our boat, and weighed a good 30 tons (27 metric tons).

Then came the baby. Six feet (a couple meters) of infant whale snout rose up and nuzzled the boat. I leaned to starboard and reached out to touch the one-ton newborn. My fingers just barely reached the whale's rostrum. Calves are born thin and have to bulk up quickly, which they do by consuming mother's milk (55 percent fat) to the tune of 80 pounds (36 kilograms) a day. Their blubbery bodies feel as soft and spongy as boiled egg whites.

Why are they here? Scientists have been asking that question for more than 150 years. In the 1850s

Charles Scammon, a commercial whaler, spotted Inupiat whaling implements pincushioned into some gray whales he followed into the calving lagoons of Baja California, thereby registering the first written evidence of their Beaufort-to-Baja migration. Researchers now believe the whales come to the lagoons for the sheltered warm water, which sustains their thin newborns until the calves have a chance to build up that critical layer of insulating blubber. The Baja California *lagunas* also have another advantage: they're just out of range of the gray whale's main predator, the transient orca. Unlike their fish-eating kin—resident orcas, such as those so beloved by the people of Puget Sound—transient orcas subsist on marine mammals including seals and gray whales. Baby grays are one of their delicacies. Orcas prowl in wolflike packs along the Pacific coast from Alaska's Aleutian Islands to Southern California—but no farther. So if the mother gray can make it to Baja California, she's home free.

Or was, until Charles Scammon and his kind arrived in the 1850s. In *The Marine Mammals of the North-western Coast of North America,* Scammon described what would happen when his crew struck a calf first, to lure its mother within killing range. "The parent animal, in her frenzy, will chase the boats, and, overtaking them, will overturn them with her head, or dash them in pieces with a stroke of her ponderous fluke," he wrote in 1874.

So the early years of the human–gray whale relationship along the wild Pacific edge did not contain, shall we say, so much upside for the whales. American and Norwegian whalers slaughtered grays and right whales with cannon-fired harpoons until the adoption of the International Whaling Convention of 1946. Only then did the Baja California lagoons become what they once had been: sanctuaries.

Thirty years after the killing stopped, the whales of Laguna San Ignacio began rubbing up against a local fisherman's *panga.* Maybe they were scratching an itch; perhaps they were just curious. In that moment the old fisherman, Francisco Mayoral, reached out and ran his weathered fingers over their rubbery skin. A new sort of

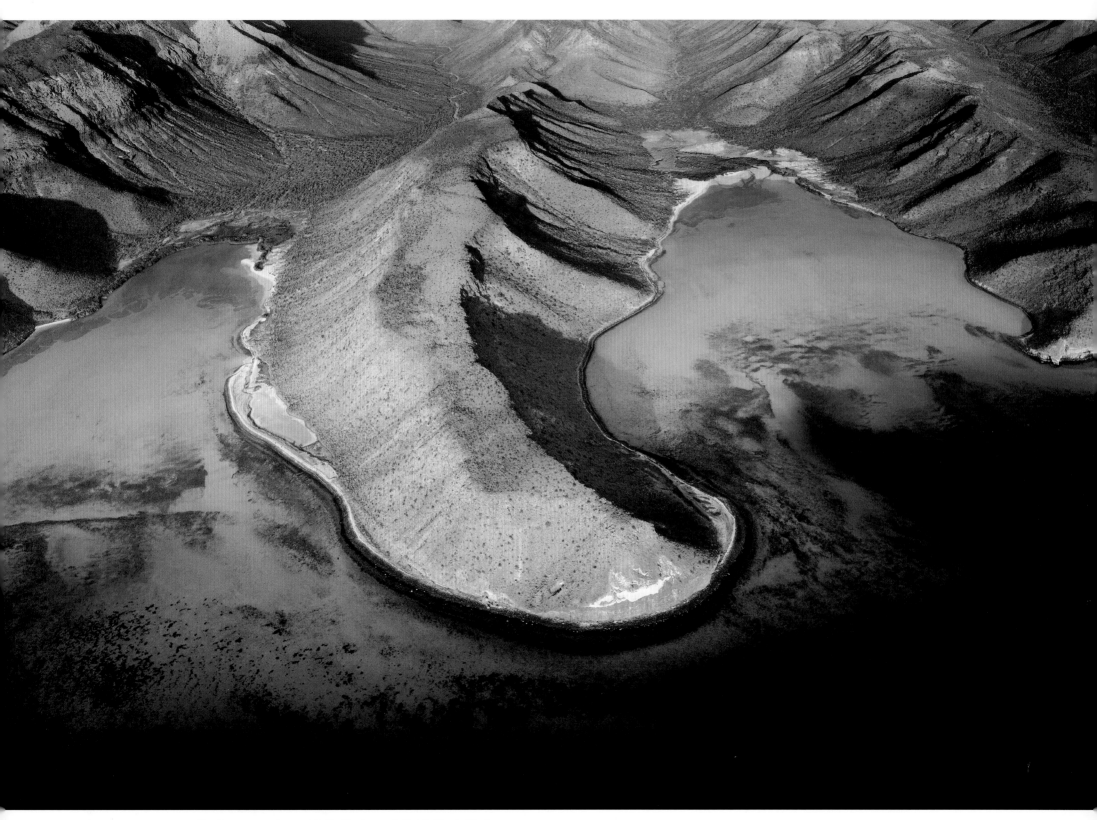

The desert meets the sea, Isla Espíritu Santo, Gulf of California, Mexico.

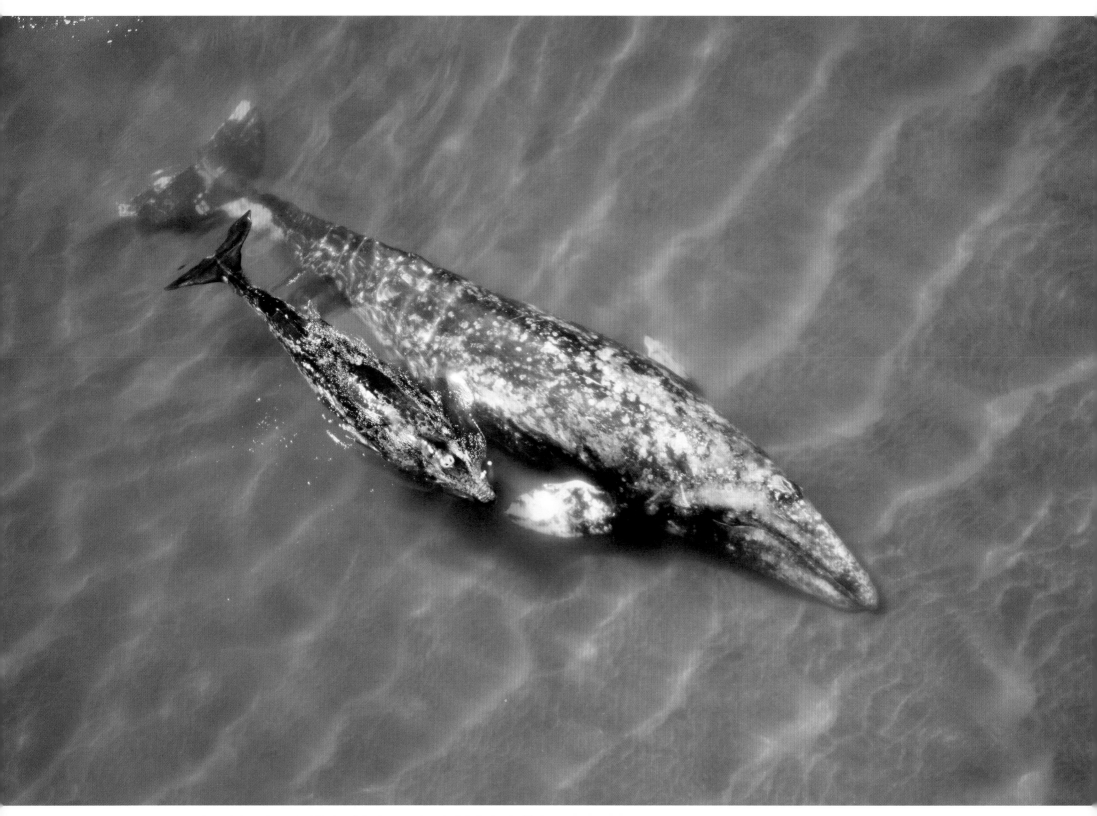

Gray whale mother and calf in the calving lagoons along the Baja Peninsula, Mexico

pact was formed. The whales sensed they no longer had to fear the two-legged mammals in the topside vessels.

By inviting physical contact, the whales inspired an emotional connection too—one that has served both of our species well. By the time the birthing waters of Laguna San Ignacio were threatened by the chemical works in the 1990s, thousands of visitors had reached out to touch the baby whales. We knew how critical the lagoons were to the survival of the grays. The whales had touched our hearts when they touched our hands. And so people rose up on behalf of the whales. Millions of dollars poured into the campaign to defend the lagoon against industrial ruin. In the end, the whale lovers won. Shortly after the turn of the millennium, the chemical company abandoned its saltworks project.

Protecting the gray whales' calving lagoon was a great victory. As we saw with the history of our national parks, though, the protection of a few critical pieces of habitat are necessary but not sufficient if we expect large mammals such as whales, wolves, and bears to survive the century. Our newfound knowledge of island biogeography and the importance of wildlife corridors forces us to consider the entire area encompassed by the whales' life cycle. To do that, we've got to move as they move, go where they go, and take the time to understand the forces acting upon them every mile of their journey.

In early spring, the gray whales and their calves leave the Baja California lagoons and begin the long journey north. They move across the Mexico-US offshore border without stopping to answer the customs man's questions about origins, intentions, and alcohol. They cruise like languid sine waves past the tall kelp forests that fringe the Channel Islands, northwest of Los Angeles, and glide up through the Santa Barbara Channel.

Let me stop for a moment at this channel and linger on a connection. When I was a boy of twelve, I'd spend long afternoons riding waves at Rincon Beach, a thin stretch of sand off the Pacific Coast Highway south of

Santa Barbara. As my friends and I bobbed on our hand-me-down surfboards, waiting for the next wave set, we'd sometimes spot a telltale spout on the horizon, a little plume tiny as a fart. "Whales!" somebody would shout. We'd form cap brims with our hands to shield the glare, point and squint, and see people on the beach doing the same. These were the grays and their newborn calves, traveling north from Baja California, moving into the danger zone where transient orcas lurked.

We didn't know that at the time, of course. How and why they appeared was a mystery. All we knew was: whales!

At the end of those idyllic afternoons, we'd strap our boards to the car roof and dive for the backseat before my mother's inevitable order to halt: "Nobody in the car until I check your feet!" she'd say. Smears of tar stuck to our heels. We were just a few years removed from the 1969 Santa Barbara oil spill, the offshore blowout that pushed a hundred thousand barrels of crude into these waters and onto these beaches. (It remains the third-largest oil spill in American history.) We could literally paddle our boards to Rincon Island, an oil rig operating a half mile offshore. Yet we thought nothing of it. Tar on our feet? I wondered how that got there. As a teenager, I chalked it up to being yet another of life's mysteries. As an adult, I'm irritated at the incuriosity of my younger self. Did the tar bloop out of a natural oil seep, or was it a lingering souvenir of the '69 spill? Effects have causes. String enough of them together, and eventually you'll weave the world.

Pushing on, the gray whales move north up the California coast past the jaws of San Francisco Bay where the scent of the Sacramento River tails into the sea. Until this point, rivers are things of intermittent life; rainstorms flash them into action, but the beds then sit dry for months at a stretch. From this point north, the rivers are strong and alive, knitting the ocean and the land together through the movement of water and the energy of fish.

By late April the whales are passing by Northern California's great redwood forests. Here the B2B seam

In the 1990s, thousands of visitors had reached out to touch the baby whales. We knew how critical the lagoons were to the survival of the grays. The whales had touched our hearts when they touched our hands.

produces one of its most surprising exchanges: fog for forests. The rising air of California's scorching Central Valley pulls moist, cool marine air inland and creates a flowing blanket of fog. During summer, coast redwoods—as well as huckleberries, sword ferns, and tan oaks—can get more than half their water from fog. No ocean, no redwoods.

This is where the influence of salmon starts to be seen. The Klamath and Sacramento rivers represent the southernmost spawning grounds of the Pacific salmon, and even at the outer limits of their range these fish play an indelible role in connecting land and sea. Years ago while driving through the wild mountain forests of Northern California, I came upon a sign by the side of the road. SALMON 4 SALE, it said. Curiosity made me stomp the brake. I knocked on the door and was welcomed in by a Hoopa Indian family. The young man handling the fish pointed across the road to the Trinity River, a tributary of the Klamath (whose headwaters are in Oregon). "These salmon represent life to us here," he told me. "It's dinner, it's lunch, it's breakfast, it's our snack. We freeze it, we dry it, we sell it, we trade it. We give it to the elders who can't fish for themselves." I spread out a map on his kitchen table. We were a good 50 miles (80 kilometers) from the mouth of the Klamath. The Hoopa aren't a coastal people. They live in an inland valley surrounded by mountains and some of the last old-growth forests in California. And yet they're sustained by the salmon and the sea.

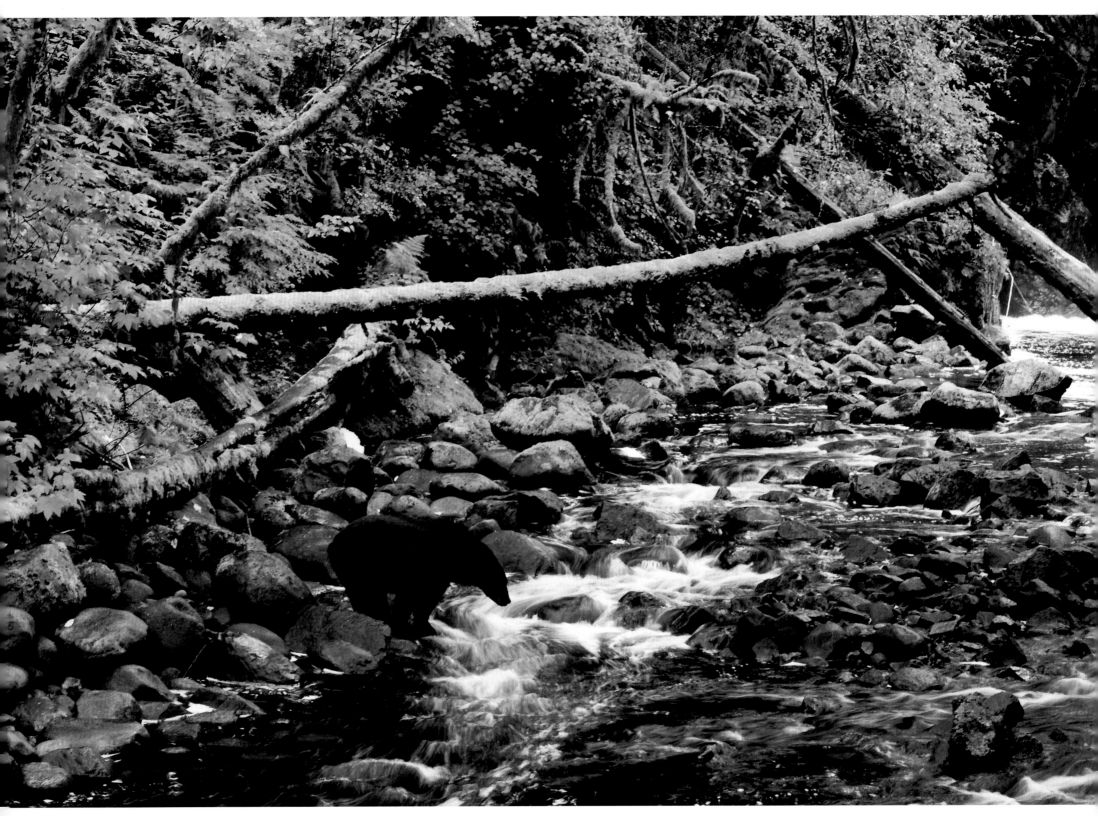

A black bear awaits the arrival of salmon, Vancouver Island, British Columbia, Canada.

The farther north the gray whale travels, the stronger the influence of salmon over the ecosystem. Prior to European contact, the fish acted as the foundation of the region's economy. There were other things to eat and trade, of course, but salmon provided the base unit of protein and coin. One hundred and fifty years of industrial harvest and development very nearly wiped it out, and now we're scrambling double-time to return the salmon to health. That's good news for other species too. The salmon's life cycle takes it from far inland streams to larger rivers to the grand sweep of the Pacific and back again, which means recovering the five species of Pacific salmon bestows benefits upon an uncountable legion of birds, fish, mammals, insects, and humans.

You can see that connection in places like the Nisqually River Delta, tucked deep in the pocket of Puget Sound. The freshwater entry point for historically significant runs of chum, chinook, and steelhead (oceangoing trout), the Nisqually estuary lost nearly half of its salt-marsh habitat in the early 1900s when a local farmer diked and drained it and converted it to row crops. A century later a coalition of tribal, government, and nonprofit groups worked to remove the dike and return the estuary to its natural state.

Salmon habitat was the driving force, but hundreds of species of birds, fish, mammals, and crustaceans also reaped the benefits of the Nisqually restoration. With more than 900 acres (360 hectares) of salt marsh, mudflats, and riparian areas opened up, the estuary has become that much more attractive to migrating birds including the western sandpiper. Another long-distance traveler like the salmon and the gray whale, sandpipers disperse during the winter months to far-flung beaches along the Atlantic coast, the Gulf of Mexico, warmer Pacific coast waters—even all the way to South America. Every spring they make their way to the western coast of Alaska, where they breed in ground nests on dry tundra. Getting to Alaska, though, is a hell of a slog. The sandpipers leapfrog up the coast, stopping at sites

including the Nisqually River estuary to rest and feed for about three days before embarking on the next leg of the journey. The more insects, worms, sand fleas, and tiny crustaceans in the tide flats, the stronger the sandpipers. Once they reach their breeding grounds, most of the birds successfully fledge a brood of chicks. Others end up as food for foxes, weasels, merlins, and peregrine falcons. Connections within the greater B2B corridor: tidal mud in the Nisqually Delta feeds the foxes and falcons of western Alaska.

Eighty to 100 miles (130 to 160 kilometers) a day: that's what the gray whales clock as they move north along the central British Columbia coast. The North American continent shatters along its western edge here, breaking into hundreds of rocky coastal islands where the tide can drop 20 feet (6 meters) in a morning and barnacles grow as big as a lumberjack's thumb. To a person from the depleted zone of Puget Sound, where the bounty of life has been steadily withered by 150 years of overfishing, overcutting, overdamming, and overdevelopment, the biodiversity and abundance here can seem overwhelming.

This is the land of the Great Bear Rainforest, one of the wildest and most abundant forests in North America, on the British Columbia mainland from Vancouver to Southeast Alaska. Deep green mosses beard the tall pillars of western red cedar, hemlock, and spruce. The waters churn with 15-pound (7-kilogram) chum salmon, massing by the thousands at the mouths of clear-running streams. Salmon are so plentiful here that even the wolves eat them. A rare strain of white-furred black bear, known as spirit bears, can be seen trundling down to the salmon streams to fatten up every fall. Schools of porpoises and pods of orcas leap and crash in cold saltwater sprays. Once, while bunking aboard a sailboat with Ian McAllister (one of the environmental leaders profiled by Bonnie Henderson in this book), not far from Princess Royal Island, I woke in the middle of the night to the sound of humpback whales singing. Their eerie clicks, creaks, and whines bounced off the rocks and

Connections within the greater B2B corridor: tidal mud in the Nisqually Delta feeds the foxes and falcons of western Alaska.

echoed through the hull. The next morning we drank coffee and watched a black bear graze through the low-tide wrack. "Beautiful songs," Ian said. "Sometimes you'll hear them two or three nights straight."

During the 1980s and 1990s, the Great Bear region suffered some of the most intensive industrial logging in North America. Years of effort by conservationists finally secured the forest protection it deserves. Sadly, the champagne hadn't even gone flat before another threat appeared on the horizon: tar sands oil.

A Canadian company announced plans to build a massive crude-oil pipeline from the Alberta tar sands region to a seaport at Kitimat, British Columbia. From there oil tankers, five per week, would thread through the tight channels between the islands and set a course for China. The pipeline promised to make a few people very rich and put many people and pristine habitats in peril. During a journey I made there a few years ago, Doug Neasloss, a Kitasoo-Xai'xais wildlife guide and marine planner, confided his worries to me as we sat in the drizzle watching a spirit bear tuck into an egg-heavy salmon. "You can see how special this place is," he said. "We don't want another *Exxon Valdez* on our shores."

By late May the gray whales are tracing the shoreline arc of the Gulf of Alaska. They skirt the edge of Kodiak Island, then make a right turn through Unimak Pass. For the grays, this is their journey's deadliest crux point. Ten miles (16 kilometers) wide at its entrance, Unimak Pass separates the Alaska Peninsula from the Aleutian Islands as the archipelago swoons southwest toward Russia. More important, that narrow gap offers passage between the Gulf of Alaska and the bountiful Bering Sea. As the adult whales approach the pass, they

Meanwhile, on that same day, the gray whales were already lumbering south out of Unimak Pass, headed for the warm, safe waters of the Baja lagoons, repeating their migration, forever moving.

are depleted. They've eaten sparsely or not at all since departing the Baja lagoons months earlier. On the Bering Sea side of Unimak Pass, there is an all-you-can-eat krill buffet. But to get there the gray whales have got to run a gauntlet of orcas.

The transient orcas aggregate around Unimak Island and the pass every spring. They know the whale calves are coming. Canadian biologist Lance Barrett-Lennard, who studied the action around Unimak, has recorded upward of 150 orcas prowling the waters. They attack in packs of three to four, working together to separate and drown the weakest: the gray whale calves. "The grays tried to move into shallow water along the shoreline when attacked," Barrett-Lennard once observed. If the calf could beach itself in less than 10 feet (3 meters) of water, the orcas abandoned their attack. (This may be one reason the grays migrate relatively close to shore.)

An orca kill functions much like a wolf kill. Both apex predators feed on the carcass for a while before abandoning it, which in turn spreads the protein throughout the local food web. Bits of whale meat float to shore, where they're eaten by brown bears and birds. Other parts fall to the seafloor, where sleeper sharks and a host of scavengers converge to feed. More movement, more transfer, more connections: the warm waters of Baja California's Laguna San Ignacio help feed the brown bears of Alaska's Unimak Island.

By early June the grays and their calves are back home in the Bering Sea. "Home" is a fluid concept: the whales will remain here only for the summer and early

fall. But for gray whales and so many other creatures in the B2B region, the Bering Sea acts as one of the primary sources of life. Nutrient-rich water from the North Pacific upwells over the shallow Bering Sea Shelf and combines with high-latitude sunlight to trigger enormous phytoplankton (plant plankton) blooms, which in turn spark zooplankton (animal plankton) blooms, which feed a diverse and abundant variety of biota: more than 450 species of fish, mollusks, and crustaceans; around 50 species of seabirds; more than 25 species of marine mammals. Salmon spawned in rivers thousands of miles away make their way to the Bering Sea to fatten up on small crustaceans, squid, and juvenile pollock. Gray whales and their calves feed on zooplankton in the seafloor sediment, suction-feeding in shallow areas and filtering the tiny packets of protein through their baleen plates. When they're done, it looks like the whales have taken a chomp out of the muddy bottom.

Most grays stay within the Bering Sea, but a few continue north through the Bering Strait and the Chukchi Sea and on east around the north of Alaska to the icy waters of the Beaufort Sea. Here again the specter of oil creeps into the picture. Global oil companies have been fighting for years to drill in the rough, ice-choked waters of the Chukchi and the Beaufort. The American government has, for the most part, allowed them to proceed despite a glaring lack of spill plans and preparedness.

Oil intrudes here in more subtle ways, too. Our century-long habit of hydrocarbon burning is forcing the retreat of the Arctic ice pack and acidifying the oceans, which could prevent some species of zooplankton—that is, food—from forming shells. This form of oil is more menacing because the people and wildlife who feel its effects can't attack the problem directly. There's no insidious presence, only a sensed absence. In the small coastal town of Kotzebue, Alaska, where subsistence hunting and fishing feed the town, I once waited out a disturbing November warm front in a coffee shop on Front Street. Day after day, as the rain fell and the sea ice melted, old men shuffled in, grabbed a cup of coffee, and

looked out at the ice, now too thin to travel or hunt on. "Too warm," one of them said to the other. "Too much rain." Their freezers were going empty, but all they could do was curse the air and the rain.

Meanwhile, on that same day, the gray whales were already lumbering south out of Unimak Pass, headed for the warm, safe waters of the Baja lagoons, repeating their migration, forever moving.

The B2B project challenges each of us to expand—expand our thinking, our conception of ecosystems, our understanding of movement and migrations and corridors of life. Don't stop at Laguna San Ignacio. Start there. And go farther than you'd ever thought possible.

If Florian Schulz's photographs have a special resonance for me, it's because they so often capture places I've been lucky enough to see with my own eyes. Gazing at his images sparks a firework show of sense-memories: greeting the sun on the summit of Washington's Mount Rainier; seining for sockeye at the Fraser River mouth in British Columbia; spying on grizzlies in BC's Great Bear Rainforest; watching flying fish zing across a light chop off the coast of Baja California; waking to the songs of humpback whales along British Columbia's Inside Passage (hugging the mainland from Queen Charlotte Strait to Prince Rupert); riding the swells of the Bering Sea in a pollock trawler; glassing a bald eagle building its nest atop a snag on a San Juan Island bluff; kneeling next to a spawned-out salmon as the light fades from its eyes on the banks of the Nisqually River.

It's in our human nature to seek out and establish connections. As children we watch our parents disappear, alarmingly, behind two enormous hands and then magically reappear: peekaboo. We figure that one out pretty quickly. Other relationships are more hidden and complex, and they take more time to recognize. It's taken humankind centuries of curiosity and painstaking research to fully understand the connections between sun, wind,

and ocean current; between ice and plankton; between river and ocean; between salmon and eagle; between forest and fish; between human and environment.

That last one may be the most important. Across the long span of human history, we've spent most of our time carving civilization out of the wilderness, designing ever-greater machines to subdue the forces of nature. It's as if we've imagined ourselves engaged in a duel to the death: western civilization or the wild—one must die. Only in the past century—a tick of time—have we come to realize that the duel is in fact a dance. The health of our selves and our society depends upon the health of the natural world. It starts with the basic physical elements—the air we breathe and the water we drink—and expands to include the complex workings of the mind and the achievement of those nebulous states we call happiness, contentment, harmony, and grace. The connections are clear for those who wish to find them. It's our duty to recognize and act upon them.

Those acts take all forms. I once rode a fishing trawler on the Bering Sea. It was February and cold. The crew of the *Pacific Prince*—an assortment of fishermen from Oregon, Washington, California, and Alaska—were there to harvest pollock, a white fish known for its delicious taste and great abundance. Most people think of the Bering Sea as an empty and unforgiving place. Unforgiving it may be, but empty it most certainly is not. There was life everywhere: fish and whales and crab underwater, a squawking of seabirds in the air, other trawlers within eyesight and radio distance.

It occurred to me that the Bering Sea drew all kinds of migrants: Whales. Salmon. Birds. People. The men

The health of our selves and our society depends upon the health of the natural world. The connections are clear for those who wish to find them.

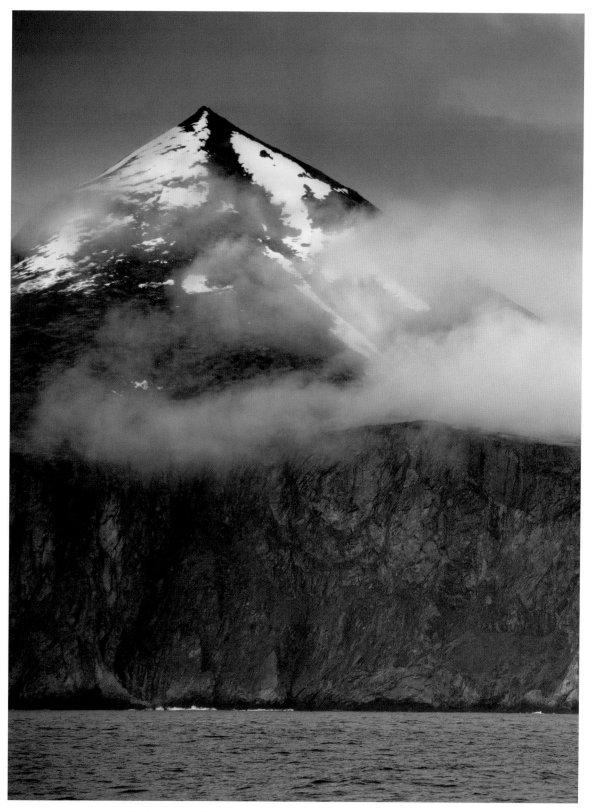

A dramatic shoreline in the Aleutian Islands, Alaska

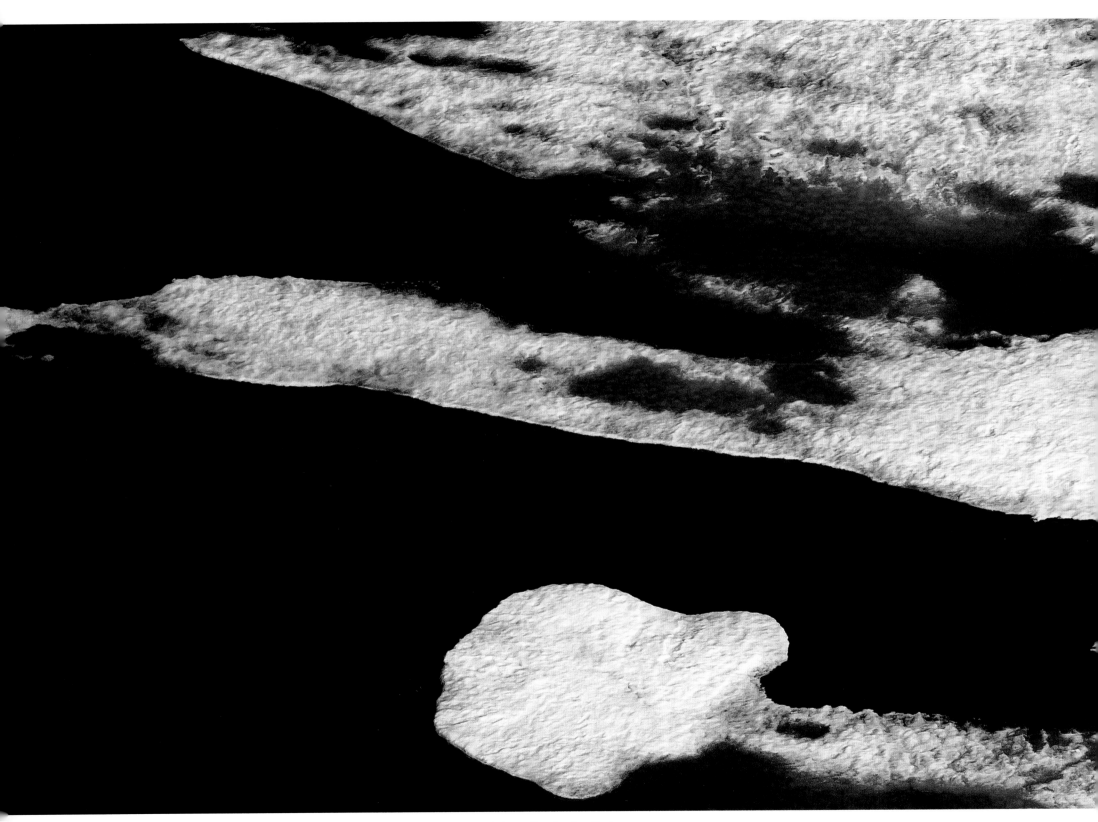

Polar bears are in constant search of food across the ice of the Arctic Ocean, Beaufort Sea, Alaska.

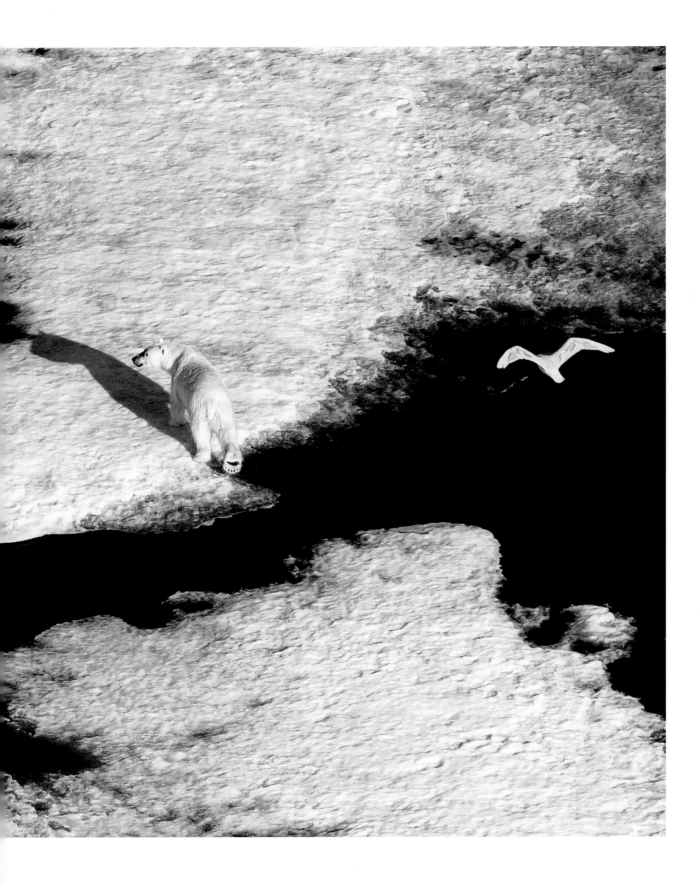

aboard the *Pacific Prince* migrated seasonally from the Lower 48 to the winter pollock grounds near Alaska's Pribilof Islands. The boat itself homeported in Seattle. It, too, crossed into the Bering Sea via Unimak Pass. Later that summer, the crew would return south to fish for Pacific whiting off the coast of Oregon and Washington. Wherever the profitable protein was, that's where they would go.

Unlike most of us, the pollock crew had a finely developed sense of their own place in the food chain and in the B2B corridor. The *Pacific Prince*'s owner had installed a special trapdoor in his trawl net that allowed salmon to escape unharmed. The pollock fleet's salmon bycatch was, and remains, a contentious issue in Alaska, and the innovative net was part of a larger effort to solve the roblem. I watched the captain take special care to maximize his catch of mature pollock and minimize his bycatch of other species.

One afternoon, the ship's engineer burst through the deck hatch. He'd been out on the stern with an ax handle, busting up the ice that had coated the ship's rails. He held a ball of ice in his hands.

"Want to rescue a bird?" he said.

I noted a head popping out of the ice ball. It was the gray-feathered noggin of a fork-tailed storm petrel. "So cold out there, they land and freeze to the deck, then the spray coats 'em in ice," said the engineer.

I gently thawed the bird in my hands. Amazingly, it survived.

I think about that bird now and then. Storm petrels aren't long-distance migrants. They breed around the coast of Alaska and northern British Columbia and then spend most of their lives at sea. There was something about the act of rescuing the bird that stayed with me. For the fishermen aboard the *Pacific Prince* it was a gesture that said, We don't have to take care of other species out here on these unforgiving waters—but we do.

When I set the bird back down on the deck, it paused for a moment and then flew away. It needed to move. ∎

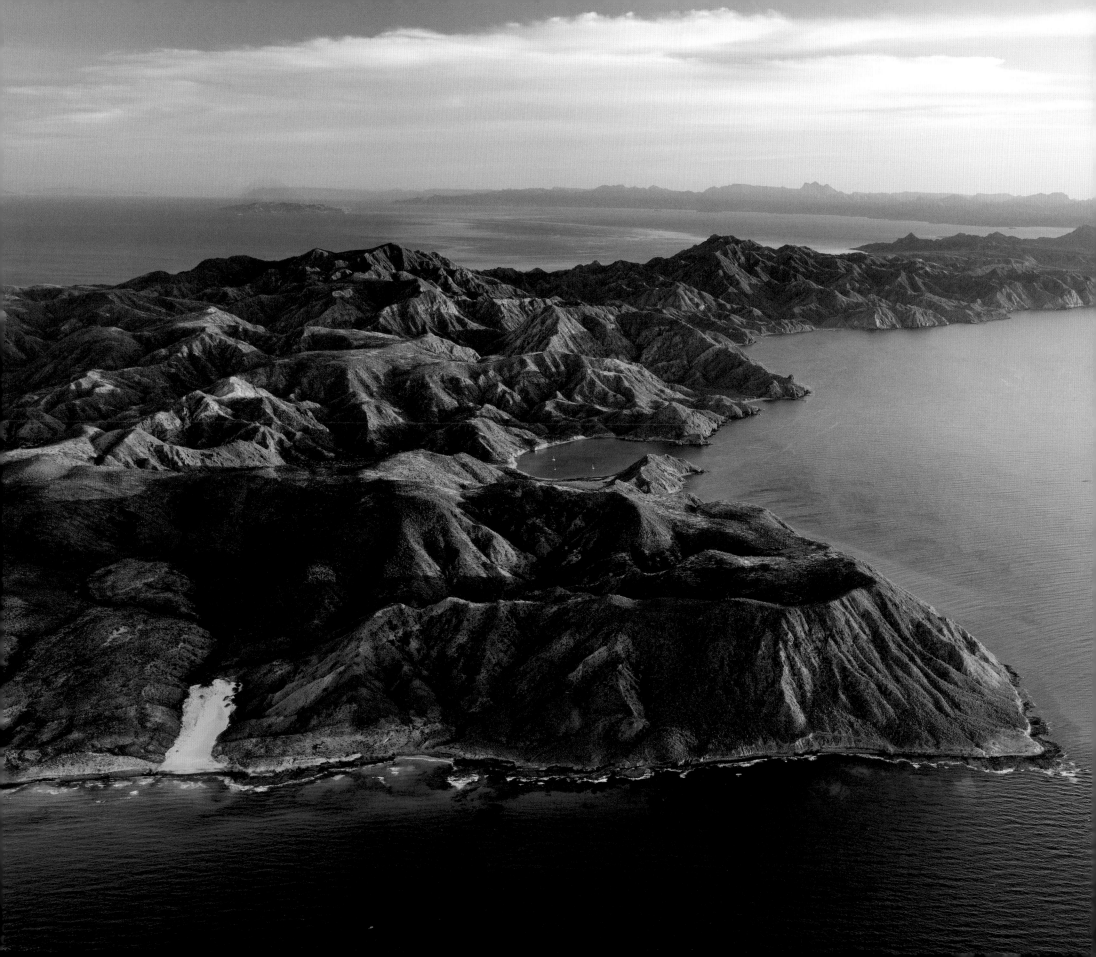

BAJA TO BEAUFORT

A COASTAL JOURNEY

ERIC SCIGLIANO

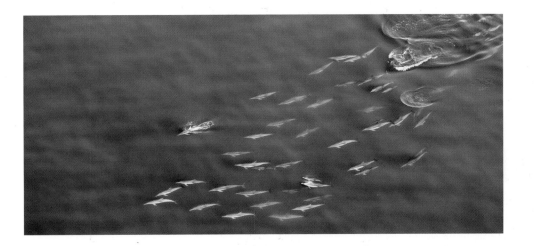

Midway down the 770-mile (1240-kilometer) spine of rock, sand, and fog known as Baja California, the desert curves out into the Pacific Ocean like a scythe. The hook's sharp tip, Punta Eugenia, guards the southernmost passage to a sheltered lagoon and a vast barren beach that have both received some extraordinary visitors from the far north. Laguna Ojo de Liebre is one of four embayments along Baja California's Pacific coast where most of the planet's surviving gray whales gather to breed and give birth each winter. It used to be

Left: Isla Carmen in the Gulf of California, Baja California Sur, Mexico

Our own journey begins and approaches its end in what may be the two richest fishing grounds on Earth: the Gulf of California and the Bering Sea

called Scammon's Lagoon, after the Yankee whaler who came upon the whales' secret breeding grounds in 1857, a discovery that nearly led to their extinction.

The beach is less widely known, though it receives its own abundant cargo on the same currents that the whales ride from their summer feeding grounds. This is Playa Malarrimo, a desert beach that stretches between Punta Eugenia and Ojo de Liebre. Only intrepid beachcombers venture here, seeking treasures and interesting trash. Usually they find the latter, everything from sand-worn beach glass to lost refrigerators. Occasionally they find dugout canoes up to two hundred years old washed down from the coastal forests that stretch from Northern California to Alaska. The dry sands have preserved them, messengers from another age but totems of the same Pacific shore.

Like the gray whales, the canoes and other flotsam that wash into Malarrimo's sandy net are continental surf riders—telltales of the great oceanic, climatic, and geological forces that have shaped North America's western shores, from Baja California to Arctic Alaska, and that tie these forces together still, despite humankind's best efforts to divide and conquer them. Foremost among these forces is the great oceanic river called the California Current, which pushes south along the Pacific coast from the foggy reaches off the Northwest Coast to sunbaked Cabo San Lucas at the southern tip of Baja California. It brings flotsam to Malarrimo, whales to the Baja Peninsula's calving lagoons, and an extraordinary continuity of climate and habitats to this entire stretch of coast and the lands that border it.

In the South and Central chapters, we will travel with this current back to the fork in the oceanic road where it begins, off the Canadian coast. Then, like whales returning to the Arctic, we will trace the California Current's northbound twin, the Alaska Current, on its long arc north and west up the Alaska coast, where it plays the same climate-moderating, habitat-shaping role as the southerly current. And in the third chapter, the North region of the B2B, we will head north into the Bering Sea, through the gateway of Unimak Pass, and on to the Chukchi and Beaufort seas, where the gray whales' journey starts and ends.

In those high-latitude waters the whales, like so many other migratory sojourners, fatten on the lavish larder generated by the high Arctic summer's round-the-clock daylight, which produces an enormous crop of photosynthesizing phytoplankton, or single-celled algae. Krill and other zooplankton, forage fish and predatory fish, seabirds and seals, narwhals and belugas, giant gray whales and bowhead whales—all converge seasonally on this nutritional bounty in the Arctic food web.

The gray whales store enough fat reserves from this feast to see them through the winter, when they birth and nurse their calves in the warm, protected, but less productive waters of the Mexican lagoons, safe from the orcas that stalk them in open waters. By contrast, terns, sandpipers, geese, and other birds of the sea and shore need a steady supply of fresh food for their fast-growing young. So they migrate north as soon as the ice recedes, to lay, hatch, feed, and fledge their eggs and chicks before it returns. Then these snowbirds return to milder climes—from British Columbia to the fertile tide flats and mangrove swamps of the Gulf of California—to recharge for another round of parental labors. Some fly all the way to Central and South America.

One sojourner, the ultimate seasonal migrant, doesn't stop there. The arctic tern breeds along a northern circumpolar belt with the avian multitudes. Come autumn, it flies as far south as it can, to the seashores around Antarctica, to enjoy a second abundant summer. Because arctic terns zig and zag to take advantage of prevailing winds—such journeys are not made on wing power alone—they may fly about 50,000 miles (80,000 kilometers) in a year.

As we read along, we will follow the migration paths of creatures as small as tiny songbirds and as big as 170-ton (154-metric-ton) blue whales, the largest animals known to have inhabited the earth. Our own journey begins and approaches its end in what may be the two richest fishing grounds on Earth: the Gulf of California and the Bering Sea—land-ringed seas that, though they lie a continent apart, share the same need for connected conservation areas if the abundant but heavily exploited life below their surfaces is to recover and endure.

The California and Alaska currents are actually offshoots of an even bigger oceanic river, the North Pacific Drift, which loops across the ocean from Japan and splits into the two currents west of Vancouver Island. They, together with the topography of the undersea continental shelf along their paths, are responsible for the other factor that defines life along the Pacific Coast: the upwellings that bring cool, nutrient-loaded waters up from the depths beyond the shelf. These upwellings nourish massive blooms of phytoplankton, which feed little critters such as krill and copepods, free-swimming crustaceans the size of pencil erasers, and fluttering, translucent swimming snails called pteropods. These in turn feed everything from anchovies to salmon to giant baleen whales. The result: some of the richest marine resources and most diverse marine ecosystems on Earth. The former are both a blessing and a curse for the latter.

On a straight line, Cabo San Lucas, Mexico, and Point Barrow, Alaska—the southernmost and northernmost points on the Baja-to-Beaufort journey—lie 3811 miles (6132 kilometers) apart. If you hug the coastline the entire way, the distance is more than 59,000 miles (94,000 kilometers). Life happens most at the margins, where forest meets meadow, shore meets sea, and continental shelf meets the ocean deep. This twisting, creased, fjord-cut, island-flecked coast has a lot of margin. ■

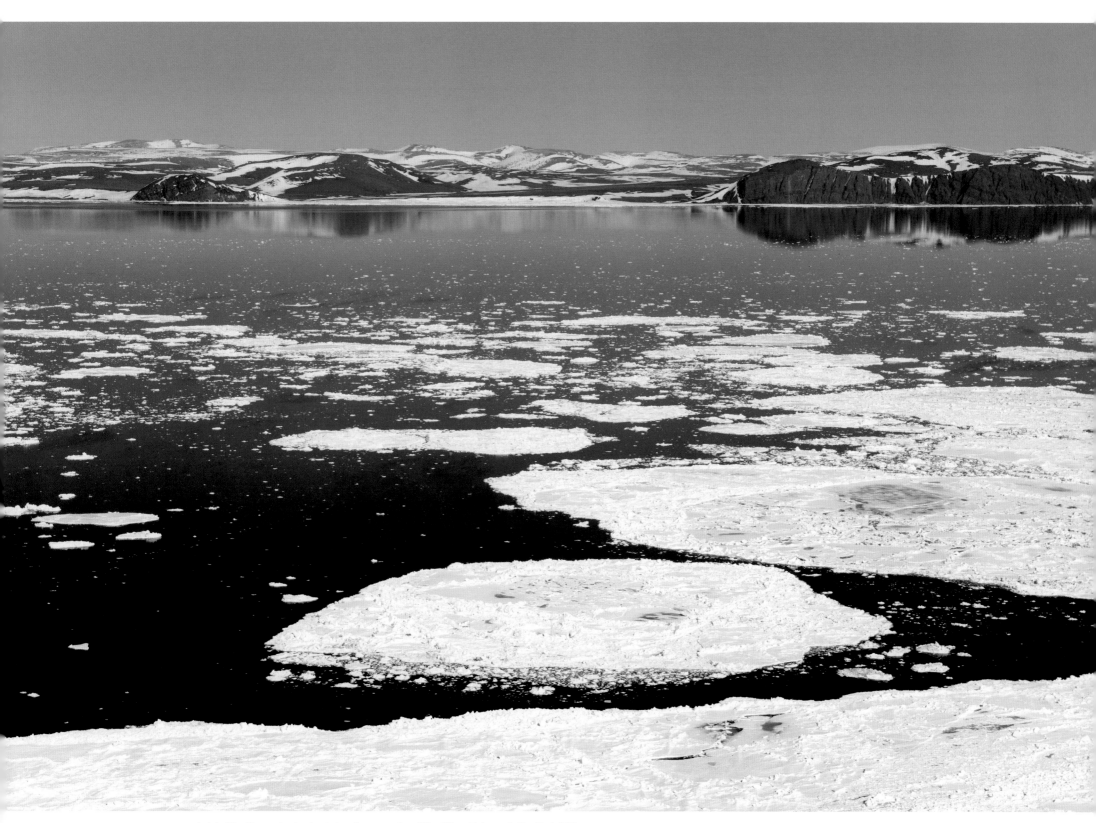

In late May the sea ice begins to break up near the cliffs of Cape Lisburne in the Chukchi Sea.

SOUTH

BAJA CALIFORNIA SUR, MEXICO, TO NORTHERN CALIFORNIA

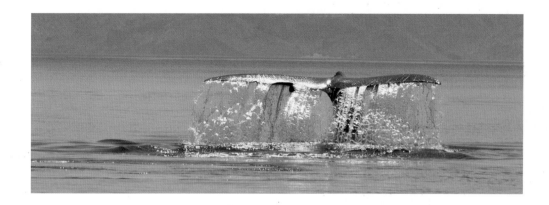

Our journey from Baja California to the far north begins not at Cabo San Lucas but about 700 miles (1100 kilometers) to the north, at the head of the Gulf of California. There, the Colorado River meets the gulf, also known today as the Sea of Cortés. Before dams, pipelines, and irrigation ditches siphoned the river off to water the farms of "America's fruit basket" and the cities of the Southwest Sunbelt, the Colorado River poured more than 700 billion cubic feet (20 billion cubic meters) of water into the gulf. Today only about 280 million cubic feet

Left: Cabo Pulmo National Marine Park, Baja California Sur, Mexico

39

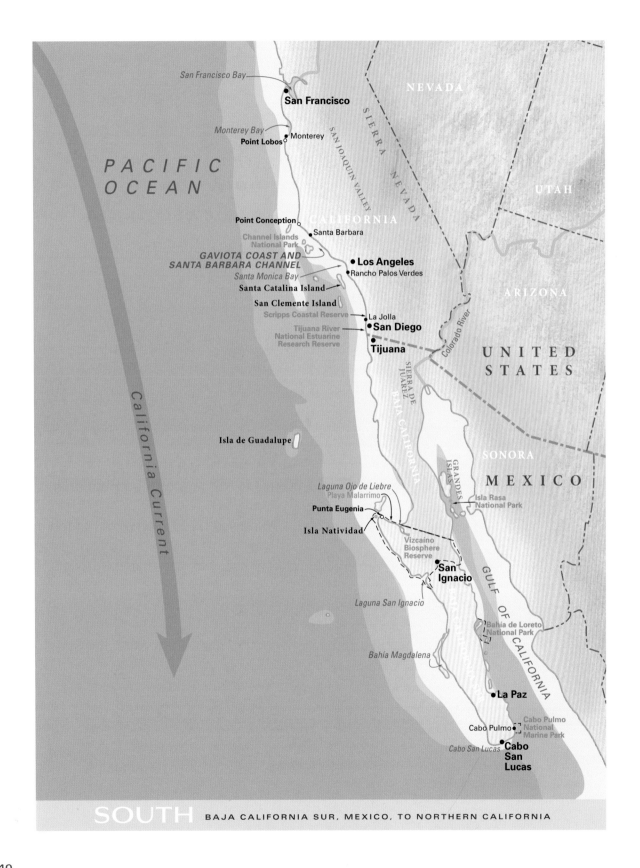

(8 million cubic meters) escape. With drought threatening harvests and climate change threatening worse things to come, the pressure is growing to abandon river restoration efforts and divert even the last meager water available.

Draining the river is a century-old game; blaming someone else for it is nearly as old. "People in Mexico and the United States will blame each other," says Exequiel Ezcurra, director of the University of California–Riverside's Institute for Mexico and the United States and formerly a top environmental official in the administration of Mexico's recent president, Vicente Fox (see Ezcurra's foreword to this book). "But if you look at original documents, as I have, you see what it was—a collaboration to destroy an ecosystem."

Draining the Colorado River has altered not only its own habitats but those of the Gulf of California. Denied that freshwater infusion, the wide, shallow shelf of the northern gulf grows ever more saline—hypersaline, where evaporation is greatest: at the delta.

That so much nevertheless survives is a testament to these waters' extraordinary original abundance. The salt water here is whipped, swirled, shaken, and stirred by famously persistent winds and some of the most extreme tides on Earth. (I can testify to the winds, having spent most of a week huddling on the far shore of Bahia Concepción, midway down the peninsula's inside coast, waiting for the winds to abate enough to paddle back across, finally setting out before dawn to brave them anyway.)

These winds push aside coastal waters, drawing upwellings from deep canyons to the south and east that serve up a nutrient feast. As a result, the northern gulf's murky waters still teem with life, though they're hammered by salination, pesticide runoff, overfishing, and wasted bycatch. They shelter twenty-two endemic fish species and, tenuously, the world's smallest cetacean, a dolphin found nowhere else: the goggle-eyed, smiley-faced, critically endangered *vaquita*.

The shores and small islands that line the northern Gulf of California are major stops on the Pacific Flyway, the avian superhighway that follows the seasonal winds

EXEQUIEL EZCURRA

When, as a young graduate student, Exequiel Ezcurra first visited Mexico's Gran Desierto de Altar—a patch of Sonoran Desert arrayed at the head of the Gulf of California—he said, "I fell instantly in love with the place. I thought it was like heaven: a desert by the sea, a sea by the desert." The Gran Desierto is a vast expanse of sand dunes and salt flats, mesquite and cactus, and El Pinacate, the largest shield volcano in North America.

Ezcurra, now a professor of plant ecology and director of the Institute for Mexico and the United States at the University of California–Riverside, grew up on a ranch in arid central Argentina. His Basque grandfather had been a sailor before he turned to raising sheep and goats, and young Ezcurra was himself a sailor as well as horseman: "The sea and desert were my bearings, my north and my south." When the governor of the Mexican state of Sonora was looking for a botanist to survey the vegetation and other natural resources in the Gran Desierto, Ezcurra took one look and thought to himself, "Yeah, I want to work in this place."

Forty years later, his research interests are still focused on Baja California's deserts and the seas that surround them; his fondness for what he characterizes as a small-scale continent, with its rich biological diversity, has only grown. Baja California's coastline remains relatively undeveloped, compared with the Mexican Riviera (including Mazatlán and Acapulco) and the Yucatan Peninsula (especially Cancún). There, mangrove swamps, and the water filtering and fish habitat they provide, have given way to golf courses; fertilizers used on those golf courses and sewage seeping into the sea have in many cases destroyed the very reefs tourists flock to see. But not in Baja California, Ezcurra says—at least not yet, thanks in large part to the residents' own fierce protectiveness of their home.

Take Laguna San Ignacio, on Baja California's Pacific Coast, where the economy now revolves around winter whale-watching; it all began, unlikely as it sounds, with a single fisherman and a whale befriending one another back in 1972. The lagoon is now a protected natural area, with no hotels on its perimeter, and local tour operators' respectful, unobtrusive style has become a model for ecotourism worldwide.

Or Cabo Pulmo, just northeast of the tip of Baja California Sur, where fishermen themselves, alarmed at the decline of their local fishery, promoted establishment of a national marine park where no fish can

"The people of Baja have become very aware of the value of their place and will often react strongly to attempts to damage their environment."

be caught. That preserve, according to a study Ezcurra led, has become the most successful marine preserve recovery story in the entire Pacific Ocean. "The people of Baja California have become very aware of the value of their place and will often react strongly to attempts to damage their environment," Ezcurra said. Those fishermen now make their living leading scuba tours and, so far, have resisted outside pressure to build hotels on the shoreline overlooking that reef.

"On the one hand," Ezcurra said, "Baja California is a battleground, because there are so many economic interests that want to go in and pillage the landscape": mining and dune-buggy racing, which leave lasting scars on the desert, and large-scale resort development, for instance. "On the other hand," he continued, "so many people are empowered around the conservation of their home that it gives you hope."

And that patch of seaside desert Ezcurra first explored as a graduate student in 1976? He and other scientists documented a wealth of flora and fauna, from Gila

monsters and bighorn sheep to some 540 species of plants. Today 2759 square miles (4439 square kilometers)—an expanse nearly as large as Yellowstone National Park—is protected as a UNESCO biosphere preserve and world heritage site. For Ezcurra, Mexico's Gran Desierto de Altar is a lesson in patience—more than thirty years passed between completion of his survey and the land's formal protection—as well as an example of the kind of broad landscape-scale conservation that the B2B region needs.

"If the ocean goes, the desert goes," he said flatly. "We need to look at these things in a much more interconnected fashion if we are going to aspire, in any modest way, to contribute to conservation of life on Earth."

© Octavio Aburto/ILCP

ISLA RASA

THE FIRST MEXICAN BIRD SANCTUARY

Isla Rasa is a tiny island, less than 1 square mile (1.6 square kilometers) of barren rock, in the middle of the sunbaked Grandes Islas. This spot is home to more than 1 million nesting seabirds, including at least 90 percent of the world's elegant terns and royal terns—cousins to the globe-spanning arctic tern—and Heermann's gulls. These species were nearly exterminated in 1964 when, after decades of commercial gathering, marauding eggers took virtually all the eggs on the island. American and Mexican scientists, including ornithologist Roger Tory Peterson, persuaded the Mexican government to establish its first national bird sanctuary here. The terns and gulls recovered magnificently, a turnaround documented and safeguarded for more than thirty years by one dedicated field biologist, Enriqueta Velarde. Today Isla Rasa exemplifies the importance of even very small points in an ecosystem picture, showing how narrowly such gems can be snatched from the brink.

—E.S.

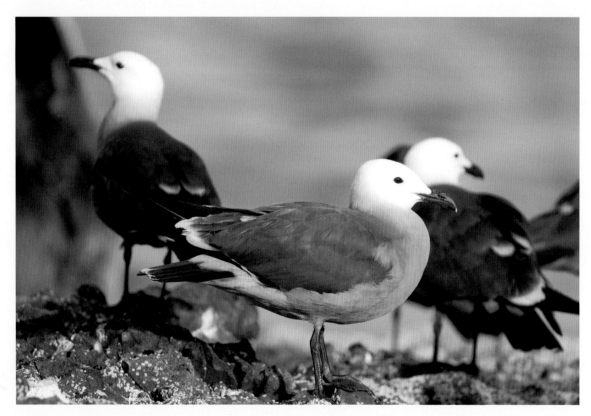

Approximately 90 to 95 percent of Heermann's gulls nest on Isla Rasa in the Gulf of California before migrating north.

from the Arctic to the tropics and back again. Many seabirds, from brown boobies and black skimmers to gleaming, elegant terns with their jaunty swept-back crests, stay to nest here. Even southeastern California's Salton Sea, the landlocked salty residue of a past irrigation disaster, is an important stopover for these migrating aviators.

To the west and south, the gulf's waters descend into precipitous canyons, one nearly 2 miles (3 kilometers) deep—wellsprings for the abundant life near the surface. Along the especially fertile margins between shelves and canyons perch strings and clusters of islands, 922 altogether, ranging from bare rocks to the expansive Grandes Islas that stretch across the gulf a third of the way south from the delta. Some were colonized by life-forms from the mainland, across long-gone land bridges, and many others with creatures from the sea and air, a mixture that makes for a crazy quilt of biodiversity: 877 terrestrial plant and animal species, 60 of them reptiles and 90 of them endemic.

After puttering around the Grandes Islas collecting samples with a biologist buddy, John Steinbeck called them "the Galapagos of Mexico." He was thinking not so much about the islands as the waters around them, but conservation has since taken the opposite tack. The islands themselves are now protected, but only a few isolated patches of water around them—the Bahía de Loreto and Archipelago San Lorenzo national parks and the little San Pedro Mártir Island Biosphere Reserve— as well as the far northern gulf are officially designated as "protected." Together these areas cover less than 10 percent of the gulf.

The life in the gulf's waters is even richer than on its islands. The gulf hosts the most diverse concentration of cetaceans anywhere, 33 species, 40 percent of the world's total, including orcas and blue, fin, humpback, gray, sperm, right, Bryde's, and sei whales. Its waters harbor more than 900 species of fish, nearly a tenth of them endemic, and 4800 identified marine invertebrate species, 740 of them endemic, with perhaps as many waiting to be discovered. The most celebrated endemic

JORGE URBÁN

WIN-WIN SOLUTIONS FOR HUMPBACKS AND HUMANS

BY BONNIE HENDERSON

Jorge Urbán still remembers the first time he saw a whale. He was a student of vertebrate biology at the national university in Mexico City when a cetacean researcher newly arrived from Chile invited Urbán to assist him. Which is how Urbán found himself in the crow's nest of a research vessel cruising the Pacific Ocean northwest of Puerto Vallarta, Mexico, on a fine winter day in 1982. Suddenly, straight ahead of the boat, he saw it: the slow-motion explosion of a 50-foot-long (15-meter-long) humpback whale breaching, shattering the boundary between ocean and sky with its bumpy snout, its mottled ventral pleats, its long flippers, hovering for one timeless moment before crashing back into the sea.

It's possible, even likely, that Urbán has seen that same whale since, perhaps many times. Humpback whales can live for fifty years or more, and they tend to follow the same migratory patterns, the North Pacific population wintering off Mexico or Hawaii and spending summers in the krill-rich waters of the Gulf of Alaska. Urbán has dedicated the last thirty years of his life to studying whales of all kinds in the waters around La Paz, Mexico, where he works as a marine mammal researcher at the Autonomous University of Baja California

Sur. "Twenty-five years ago, some children didn't know the name of Isla Espíritu Santo, the island you can see from La Paz," Urbán said. "Now we have local students who are finishing marine biology studies at the university." And he has a special interest in humpback whales, whose population in the North Pacific has rebounded to more than 22,000 animals—about the same as before whaling slashed their numbers.

Urbán also studies whale-watching itself. As chairman of the International Whaling Commission's Whale-Watching Subcommittee, he has had an opportunity to scrutinize ecotourism worldwide and has used that knowledge to craft whale-watching guidelines in his own country. Proper training for tour operators is helpful, he said, but it's not the most important piece. "Without protected areas, anybody can do anything," he cautioned: untrained outfitters can approach whales too closely, for example, or too many boats can crowd a whale. "When the area is under some kind of formal protection," he said, "you are better able to regulate this kind of activity."

Urbán has been applying that wisdom in the waters around the Revillagigedo Islands, a remote archipelago and UNESCO biosphere reserve a few hundred miles south

of Baja California known as Mexico's "little Galapagos" for the diversity of plants and animals found on the land and in the sea, including the hundreds of humpback whales that winter here. More recently Urbán has focused his research on the whale breeding grounds off Los Cabos, at the southern tip of Baja California Sur, where he has drawn up a detailed proposal for a whale sanctuary, similar to the Hawaiian Islands Humpback Whale National Marine Sanctuary, for consideration by the Mexican government. Whale-watching in these areas isn't a bad thing, Urbán said, as long as boats keep their speeds low and avoid using the same routes

the whales use, and as long as fishermen keep their nets out of the areas whales use in the winter. Personal watercraft such as jet skis must also be regulated (their noise can be harmful to whales).

"From my point of view, the whales are a natural resource," Urbán said—not a resource to harvest, but one to protect. "Because whale-watching is a business activity, it's good for the local people who live where the whales are," he continued. "We want to preserve this activity, and to do that, the whales need to be healthy and happy in the environment. This is the way everybody wins."

© JUAN C. SALINAS

Impacts such as acidification, hypoxia, and, for migratory and other mobile species, overfishing know no boundaries.

fish, a big bream called the *totoaba* has the misfortune of possessing a swim bladder accorded curative powers in Chinese popular medicine; it hovers in isolated pockets, on the edge of extinction.

"Only connect!" the novelist E. M. Forster famously urged. But the efforts in the Gulf of California, as on so many other conservation front lines, have focused on saving particular precious sites rather than forging links between them—on jewels rather than entire coronas. The most celebrated victory in that battle is the national marine park that the Mexican government established in 1995 at Cabo Pulmo, at the Baja Peninsula's southeast tip (though it's now threatened, for the second time, by an attempt to build a megaresort there). Cabo Pulmo is certainly a gem, and a stirring example of the value of marine protected areas (MPAs)—underwater areas, including but not limited to national parks, that are set aside to various degrees for conservation. The currents of the gulf and the open Pacific Ocean clash at Cabo Pulmo like watery armies; I felt like an underwater surfer there, tugged along on a drift dive as wonders flashed by. These currents nurture the peninsula's only full-scale coral reef; sharks, rays, and groupers grow to sizes that are only fond memories in most of the gulf.

Nevertheless, Greg Helms, who represented the Ocean Conservancy in Santa Barbara in the long struggle to establish a network of MPAs in California, USA, wonders about all the effort expended on Cabo Pulmo, while more extensive, complex, and in some cases overfished habitats up the Baja Peninsula's gulf coast have been neglected. "The corollary is," he says, "you've got to spread the love to Bahía de los Ángeles, Bahía de Loreto, the Grandes Islas."

Across the gulf, along Mexico's mainland shore, a very different but complementary habitat is slowly eroding: the *humedales* (wetlands) that line the coasts of the states of Nayarit, Sinaloa, and southern Sonora. Their marshes and mangroves—the northernmost on the Pacific Coast—protect the waters from the land, capturing runoff and pollutants. They protect the land from the waters, buffering storms and preventing erosion. And they provide nurseries for a wide array of fishes and invertebrates, as well as waterfowl and seabirds. Thirty percent or more of the shorebirds riding the Pacific Flyway down from Alaska, Canada, and the western United States overwinter on Sinaloa's coast alone.

But the *humedales* and gulf coastal waters are caught in a vise, between Mexico's most productive fisheries and its most intensive agriculture. The Gulf of California produces three-quarters of the country's fish catch; Sonora, Sinaloa, and Nayarit grow 40 percent of its crops. The two industries, with their conventional production nearly maxed out, are converging, in the form of shrimp farming and other coastal aquaculture. This, together with surging population growth and tourism development, displaces and degrades the mangrove forests. In 2005 Mexico's Instituto Nacional de Ecología estimated that the region's mangroves were disappearing at an alarming 2.5 percent annual clip.

The passage up Baja California's Pacific coast traces a shift in climate, from subtropical to temperate, and in vegetation, from near desert to fog-shrouded grasslands, and the chaparral, rimmed by pine-forested mountains, that runs all the way north to San Francisco. A similar transition unfolds offshore with the beginning of the great kelp forests, the coast's definitive nearshore habitat, stretching all the way to the Aleutian Islands.

Baja California's outer coast is punctuated by four sheltered desert lagoons where the gray whales come to breed and calf each winter. All but one lie in the Vizcaíno Biosphere Reserve, a vast swath of dunes, mountains,

shores, and shallows that straddles the peninsula from Playa Malarrimo to the gulf. But only one lagoon is still undisturbed by human development, and only thanks to a long battle by citizens and conservation groups to repel a huge salt plant proposed there. (Two others already had saltworks.)

In Mexico as elsewhere, not all protected areas are created equal; the activities allowed in them vary greatly and, in some areas, even include commercial fishing. Mere designation—what Greg Helms calls "drive-by conservation"—counts for little if monitoring and enforcement don't follow. Serge Dedina, the executive director of Wildcoast/Costasalvaje, which conserves coastal wildlands on both sides of the US-Mexico border (see his profile in this book), notes that "protection can be weak" for the unusual "desert mangroves" and marshes that line much of the southern half of the Baja Peninsula's west coast, even when the adjacent waters are well secured. "So," he says, "we've been working to extend that protection to the mangroves, and to 60 meters [197 feet] above the mean high-tide line."

Certainly, well-structured and -secured protected areas can shelter target species as well as their habitats from direct, local threats. But what can they do against systemic perils such as hypoxia (low oxygen) and ocean acidification—the corrosive drop in relative alkalinity and in the calcium carbonate that marine organisms need to build their shells—caused by humankind's runaway carbon dioxide emissions? These kill not with hooks and nets but through deadly changes in seawater chemistry.

Protected areas can do a lot, it seems, at least to help species and habitats devastated by these ills recover. In 2012 Stanford University researchers reported that they'd found striking evidence for a truism long taken on faith and anecdotal observation: marine protected areas work. And they had found that proof 4 miles (6 kilometers) off Punta Eugenia, at a little island called Isla Natividad. In 2009, three years after the scientists began monitoring Natividad's pink abalones, and again in 2010, hypoxic "events" caused massive

Mangroves along Isla San José in the Gulf of Mexico, Baja California Sur, Mexico

ISLA GUADALUPE, MEXICO

TWO MIRACULOUS SEAL RECOVERIES

sla Guadalupe, a steep volcanic island 150 miles (240 kilometers) west of the central Baja Peninsula, is an inspiring example of the value of biological reserves (even accidental ones), habitat restoration, and international cooperation. It was the prime breeding and killing ground for the graceful Guadalupe fur seal and enormous northern elephant seal, which were relentlessly hunted through the nineteenth century for, respectively, their luxurious pelts and thick blubber. Elephant seals were already believed to be extinct in 1892, when a Smithsonian expedition happened on eight and killed seven for its collections.

Finding no more seals to kill, the hunters left, and Guadalupe's shores languished in benign neglect. But its uplands were nearly denuded by a hundred thousand descendants of goats released a century earlier by Russian whalers and sealers. The goats almost eradicated the trees that had captured water from the marine fog that washes over the island in lieu of rain. Lush slopes turned arid.

The northern elephant seal's recovery is even more miraculous: The hundred thousand seals living today appear to have descended from a single male ancestor that escaped the slaughter.

Recently, after many delays, the goats were eradicated, and Guadalupe's forests are recovering.

The island's elephant seals and fur seals likewise survived and recovered. The government granted them protection in 1922, and in 1928 Isla Guadalupe became one of Mexico's first conservancies. Today Guadalupe fur seals number about ten thousand and range north to the Channel Islands, just west of Santa Barbara, and eastward into the Gulf of California. The northern elephant seal's recovery is even more miraculous: The hundred thousand seals living today appear to have descended from a single male ancestor that escaped the slaughter. This represents a potential genetic bottleneck but also an extraordinary natural experiment in rediversification. These elephant seals forage as far as Alaska, Hawaii, even Japan, diving nearly a mile deep to feast on squid. They also breed on California's Channel, Farallon, and Año Nuevo islands and as far north as British Columbia's Race Rocks.

Guadalupe's recovery offers a model for other islands in both Mexico and the United States that are likewise afflicted by goats and other destructive invaders—perhaps even for a transnational biosphere reserve over the islands of both Californias, a longtime dream of scientists and conservationists who see the challenges shared by habitats on both sides of *la frontera*. —E.S.

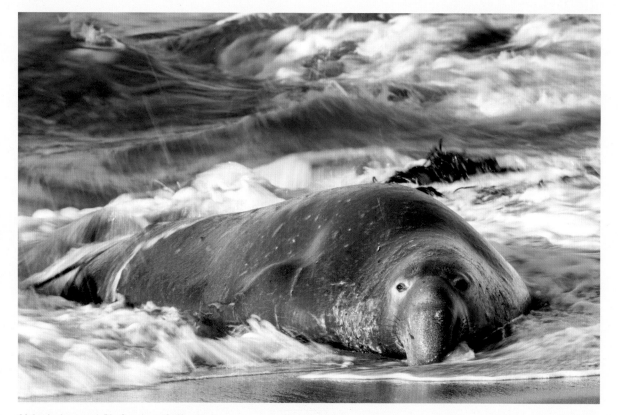

Male elephant seal, Big Sur coast, California

die-offs. But the loss, by weight, was only two-thirds as severe in no-take reserves established by local fishermen as in areas where abalone had been harvested. After the die-offs, the production of abalone eggs declined by half in the unprotected areas but rose by 40 percent in the reserves; the mature abalone that survived there quickly repopulated them.

Impacts such as acidification, hypoxia, and, for migratory and other mobile species, overfishing know no boundaries. Even humbler ecological threats such as urban waste cross borders. The frontier zone between Tijuana, Mexico, and San Diego, California, provides vivid illustration. It is the estuary of the Tijuana River, which drains 1750 border-straddling square miles (2800 square kilometers), two-thirds of them on the Mexican side. The river's headwaters in the Juárez Mountains are, in the words of the US Environmental Protection Agency, "a world biodiversity hot spot." On the US side, the Tijuana River National Estuarine Research Reserve and Tijuana Slough National Wildlife Refuge enclose the largest unfragmented salt marsh in Southern California— one of twenty-one deemed internationally significant by the Ramsar International Convention on Wetlands. The American Bird Conservancy also considers the Tijuana reserves globally important. More than 370 bird species, several of them endangered, have been sighted there, along with endangered plants and crustaceans. A California state marine protected area extends this protection into the nearby waters.

But these are tenuous refuges. The Tijuana River bisects a fast-growing binational metropolis of 5 million. It has been drained for irrigation, loaded with raw sewage and pesticide runoff, and, in Tijuana, channeled through a concrete ditch. It carries effluent and chemicals, trash and old tires into the reserves.

Federal government funds guaranteed under the North American Free Trade Agreement (NAFTA) have helped upgrade water and sewage infrastructure in Tijuana and elsewhere along the border. But cross-border cooperation is still a fraught history and oft-stifled dream.

Nearly eighty years ago, the Franklin D. Roosevelt administration sought to establish border-spanning transnational reserves. But Mexico's government, anxious for its sovereignty after a long and painful history, declined. "We had a brief spring in 1993 when Mexico opened up to binational conservation corridors because of NAFTA," Exequiel Ezcurra recalls. "But it didn't last long."

"Everything broke down after 9/11," sighs Mike McCoy, president of the Southwest Wetlands Interpretive Association, a longtime campaigner for

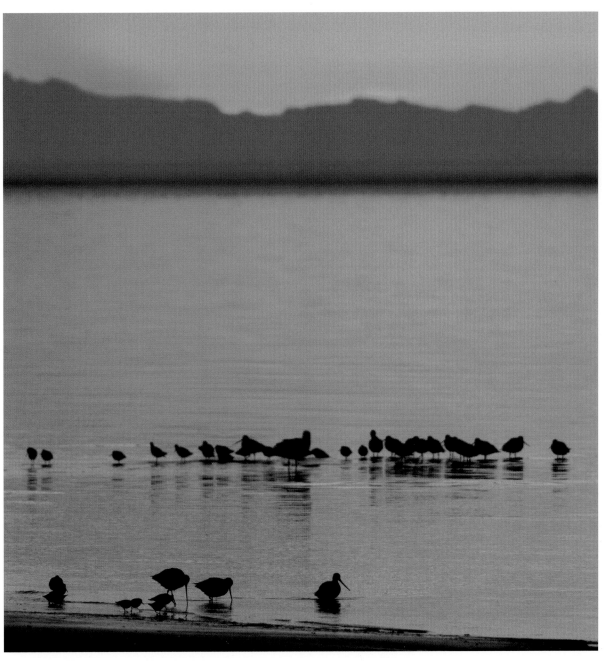

Morning light silhouettes migratory birds in the Laguna Ojo de Liebre, Baja California Sur, Mexico.

SERGE DEDINA

Serge Dedina became a conservation activist almost before he learned to surf. As a boy growing up in Imperial Beach, California, just miles from the Mexican border, he and his family used to picnic and ride bikes along what they called the Sloughs, where the Tijuana River, flowing north out of Mexico, breaks out of its concrete canal walls and makes its last lazy, unfettered turns before emptying into the Pacific Ocean. When an upscale marina was proposed for the site in the mid-1960s, the community organized a grassroots effort to save the Sloughs, prompting seven-year-old Serge to write his first letter to the editor.

Today the Tijuana estuary is protected as a national wildlife refuge and estuarine research reserve, and Serge Dedina, PhD, executive director of Wildcoast/Costasalvaje, a bilingual, binational conservation organization with offices in Imperial Beach and Ensenada, Mexico, is active on both sides of the US-Mexico border. Wildcoast has partnered with celebrities in media campaigns to discourage consumption of sea turtles, works with policy makers and politicians, and partners with the California Department of Fish and Wildlife to help manage that state's southernmost marine protected areas. But at its heart, Wildcoast functions as a land trust: acquiring property,

establishing conservation easements with private landowners, and working with government agencies to designate land and marine areas for conservation. Though it has projects as far south as the state of Oaxaca's mainland Mexican coast on the Pacific, Wildcoast focuses much of its attention on what Dedina characterizes as landscapes of scale—broad stretches of wild coastline—on either side of Mexico's Baja Peninsula.

"There are these amazing integrated ecosystems," Dedina said, listing the elements: mangrove swamps, estuaries and freshwater wetlands, islands, marine upwellings that draw diverse species of fish, birds, and marine mammals. "It's very similar to what you see in Alaska and areas like western Australia and the coast of Africa, where you have this incredible coastal and terrestrial biodiversity all mingled in."

In Mexico, designating an expanse of land as a national protected area doesn't mean it will remain undeveloped, its wildlife protected, and its resources unexploited, as does national park designation in the United States. Within protected areas in Mexico may be tracts of privately owned and virtually unregulated property along with what is called unassigned federal

"We have to be very strategic and focused. Someone's always going to have a reason to destroy a wild area."

territory. All of it is vulnerable to what Dedina considers prime threats to Baja's wildness: mining interests and Americans seeking vacation properties. "We have to be very strategic and focused," Dedina said. "Someone's always going to have a reason to destroy a wild area."

So Wildcoast works with the Comisión Nacional de Áreas Naturales Protegidas, the Mexican equivalent of the United States' National Park Service, to establish federal "conservation concessions" preventing development in some of the most ecologically significant places within and adjacent to these protected areas. One example is Valle de los Cirios: a federally protected area of rocky headlands, estuaries, sand dunes, and cactus-studded uplands stretching from the Pacific to the Gulf Coast of central Baja. Wildcoast has conserved more than 30,000 acres (12,000 hectares) within Valle de los Cirios and more than 33 miles (53 kilometers) of coastline.

"For me the highlight of what we do is making sure these areas remain intact ecosystems," Dedina explained. "There

is inherent value in preserving these huge landscapes, value beyond their biodiversity value or their ecosystem services value.

"We believe in the power of wild places and wildlife to make the world a better place."

© Jeff Wallis

cross-border cooperation, who saw what cooperation there had been wither as the United States rushed to arm and armor its border. "September 11 gave us a blank check to do things along that border that never would have been done."

Then Mexico's drug war succeeded terrorism as a fearsome specter. "For a while," says Ezcurra, "it was more difficult for a member of the National Park Service in California or Arizona to get permission to have coffee with his counterparts in Sonora than to go to Yemen or any country in Africa."

Even before the construction of the immigrant-blocking Border Fence along the southern frontiers of California, Arizona, New Mexico, and part of Texas, bright lights and helicopters formed a forbidding barrier to migrating animals, scaring shy creatures such as black bears, bighorn sheep, and ocelots off their traditional migration and foraging routes. Pronghorns make the longest migrations of any land mammals in the contiguous forty-eight states, and the endangered Sonoran pronghorn especially needs to forage widely in its sparse, arid habitat. But the fence has blocked its critical migration corridor into western Arizona.

McCoy hopes the joint effort to protect the Tijuana River will open the door to cooperation along the rest of the border. Ezcurra sees relations starting to thaw: "The Park Service is talking to its Mexican counterpart again, and there are governmental officers who really want to do things. But the Park Service doesn't have the budget—Congress won't authorize anything for international collaboration. While that spirit is maintained, I think the thaw will proceed very slowly, if at all."

That's doubly sad, he adds, because the opportunities are so rich. A comparative study could draw lessons from Mexico's newly goat-free Guadalupe Island for California's Channel Islands where managers are still laboring to eradicate goats, pigs, and other imported pests. Better yet, he suggests, would be to establish "one protected entity" over all the islands from Punta Eugenia, midway along Baja California's west coast, to

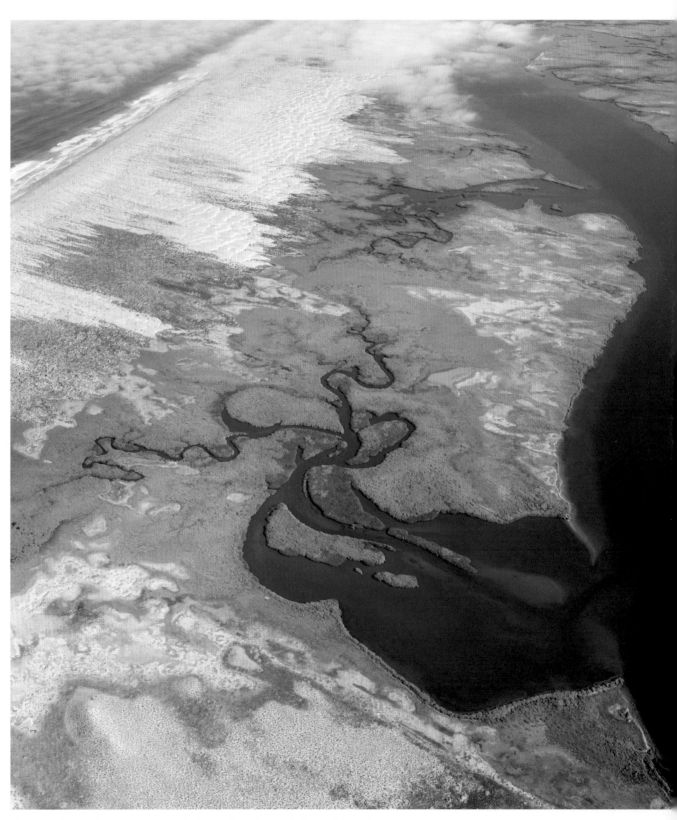

Mangroves line the Pacific coast just north of Bahía Magdalena, Baja California Sur, Mexico.

THE CHANNEL ISLANDS AND GAVIOTA COAST

PRISTINE SHORES, PROTECTED AND UNPROTECTED

California's Channel Islands are enshrined in television nature shows and the popular imagination as the realm of the great white shark. But the waters around them host many more sharks—twenty-five or more species—and much more than sharks: twenty-seven whale and dolphin species, sixty species of rockfish, scores of seabirds. The islands' rich biodiversity and importance in the Baja-to-Beaufort fabric of migration reflect their strategic location at the upper end of the coastline called the Southern California Bight, which arcs westward from San Diego to Point Conception, west of Santa Barbara.

Point Conception pushes the cool California Current offshore, letting a warm southern countercurrent tuck up inshore. Northern and southern species meet and mix here. Both Mexico's Guadalupe fur seal and the Bering Sea's northern fur seal have established (or, in the case of formerly extirpated northern seals, reestablished) rookeries on the islands, joining the sea lions, harbor seals, and northern elephant seals that also breed there. And among migrating seabirds, the islands mark the southern limit for northern fulmars, which breed in the Bering Sea, and the northernmost breeding outpost of the lately endangered brown pelican. They are the black petrel's only US breeding ground. The uplands are similarly endowed: 2000 terrestrial plant and animal species, 130 of them unique, from endemic lizards and salamanders to fox and skunk.

The northern Channel Islands and Santa Barbara Islands to the south, which comprise Channel Islands National Park, are well protected. Likewise the waters around them, which lie in a marine sanctuary extending 6 miles (9.7 kilometers) out from shore, with more restrictive state marine reserves closer in. Not so the more developed islands to the south, Santa Catalina and San Clemente, outside the park: Their network of MPAs is much patchier. Nor the Gaviota Coast across the Santa Barbara Channel, west of Santa Barbara at the end of the bight.

The Gaviota Coast is scenically breathtaking, as only California coastline can be, as well as biologically rich and remarkably pristine; it contains half the state's undeveloped shoreline. Thank accidents of ownership, not intent; it lies largely in Vandenberg Air Base and a few large ranches that haven't yet been subdivided. The coast's friends have long plumped for a Gaviota Coast National Park. The National Park Service under President George W. Bush concluded that yes, it amply deserved to be a park, and no, it wouldn't become one. Some landowners didn't like the idea, and the Park Service couldn't afford to manage it, so somebody else would have to. Who, and how, is what local agencies and conservationists are trying to figure out. —E.S.

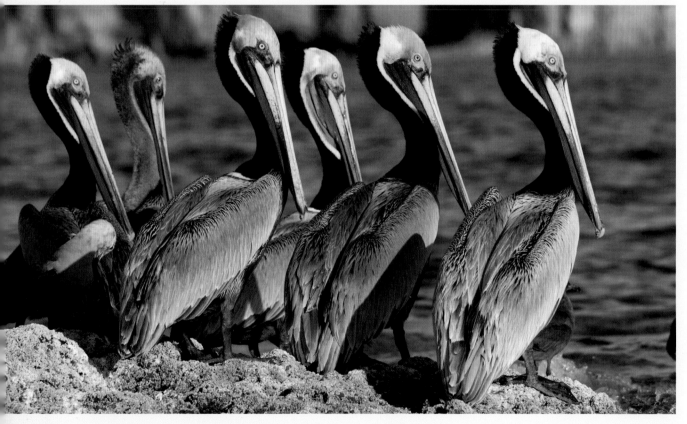

Brown pelicans, Baja California Sur, Mexico

Point Conception west of Santa Barbara. After all, the same California Current surges around these islands and their neighboring mainland coasts. The same seabirds, sharks, whales, and seals journey by them. And the same thick kelp forests grow around them. These algal gardens are the temperate-zone equivalent of tropical coral reefs in the profusion of life they support. Nowhere on Earth does kelp grow so abundantly as along the US and Mexican California coasts.

California, USA, has a badly tarnished environmental record, starting with the gold rush that began in 1848 and jump-started the soon-to-be state's development. The half million would-be miners who flocked to the Sierra Nevada foothills hosed away the hillsides, razed forests for timber and fuel, smothered salmon streams with sluice spoils, and poisoned them with mercury. Pell-mell ocean fishing nearly wiped out seemingly endless sardine stocks and treasured delicacies such as abalone.

But as the twentieth century turned to the twenty-first, the Golden State took the lead in marine conservation. It might not have done so if not for an architect named Alexander Allan, who arrived from Illinois more than a century earlier.

Allan made his bundle building California's first racetracks, then put it to work building a very different legacy. Hired to develop a thousand-lot "Carmelito" subdivision at Point Lobos, the spectacular headland where Monterey Bay and the Big Sur coast meet, he instead bought the unsold lots, and then spent the next three decades buying up and preserving the rest. In 1933 his family sold and gave nearly 400 acres (160 hectares) to the state, which continued to protect them. In 1960 the state designated 750 acres (300 hectares) underwater below the point as what California State Parks calls "the first marine reserve in the United States."

Early pockets of marine protection, such as Point Lobos and the Scripps Coastal Reserve at La Jolla, showed what could be accomplished when developers

and trawlers were kept away. "It's where you have the most persistent kelp, that you have the giant sea bass recovering, where the lobsters and sheepheads come mug you instead of swimming away," rhapsodizes the Ocean Conservancy's Greg Helms.

The state designated fifty-odd marine protected areas along the coast over the course of the twentieth century. But valuable and inspiring though they might be, these were scattered piecemeal, largely without coherent strategy or interconnection. Activists and forward-looking officials set out to do something different. Their break came in 1999, when California's legislature passed the Marine Life Protection Act. It ordered an Imperial Beach–to–Crescent City examination of the waters along the state's 1100-mile (1770-kilometer) coastline, broken into five regions for manageability. Various assemblages of scientists, policy makers, and local stakeholders hashed over and over again, often heatedly, which areas should be protected and how much protection they should receive.

The process of designating them took thirteen sometimes-excruciating years. The highest hurdle, once proponents settled on a more inclusive, less contentious approach, was overcoming the resistance of fishing interests. Many commercial fishermen came to see that setting aside reserves might be the only way to restore the depleted fisheries around them. Sport fishermen held out and even sued, unsuccessfully, to try to block the protection act's implementation.

Finally, in 2012 California designated the last of more than a hundred new marine reserves, parks, and conservation areas along its ocean coast. San Francisco Bay, with the most severely impacted waters, is still pending.

Despite exhaustive scientific review, politics and special interests still entered in, as they do in any broad stakeholder process. Helms, who labored for years on Southern California's protected areas, speaks for many when he describes the sort of trade-offs involved: "We were able to do a B-plus job of putting conservation values in place on Point Dume," the Malibu headland that

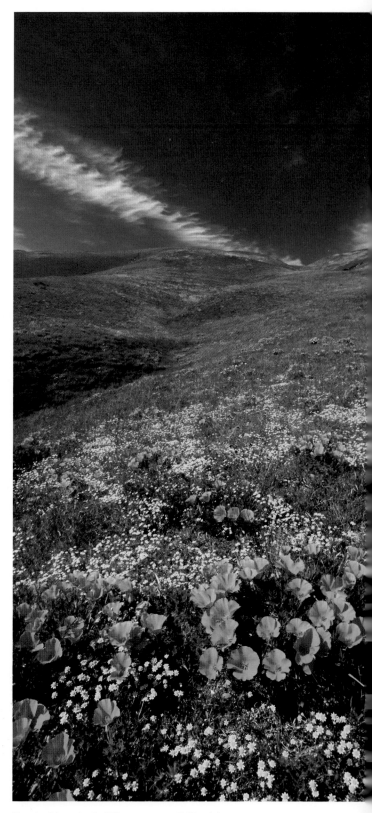

Poppies bloom in the hill country near California's coast.

bookends Santa Monica Bay on the north. "But we didn't do a good job at Palos Verdes," the headland at the bay's south end, whose kelp forests, fish communities, and limpid waters are "even richer than Point Dume's."

At Point Dume, a full range of nearshore and deeper-water habitat is locked in a marine reserve—the highest grade of protection, with no fish take or other intrusive activity allowed—that is as wide at the beach as it is offshore. Palos Verdes received a pie-shaped (wide offshore, tapering to a narrow point at the beach) conservation area, a lower grade of protection under which some take may be allowed.

Why? More people live at Palos Verdes, and its fishing interests were stronger. They balked at losing precious inshore turf. Still, Helms notes, these protected brackets—biologically richer than the bay between, as headlands usually are—are doing their job as refuges and seedbeds. "The fishermen go to the MPAs' edges," he says, wryly. "They know where the abundance is." Still, the reserves and conservation areas add up. The Marine Life Protection Act covers 16 percent of California's state waters, with no fishing or harvesting allowed in 7 percent.

The Baja-to-Beaufort connection holds even inland, in the sprawling Sacramento and San Joaquin river valleys, where gold miners' spoils once washed down from the hills and farmers now grow more than half the United States' fruits, vegetables, and nuts. The claims upon the waters are incessant: fewer than 5 percent of the San Joaquin Valley's original wetlands, and 10 percent of California's as a whole, remain. But those survivors are still indispensable to migrating seabirds and shorebirds. More than 2 million ducks and geese, plus herons, falcons, egrets, grebes, tundra swans, sandhill cranes, and other fellow travelers, touch down or winter over in the Sacramento Valley's flooded rice fields and seasonal marshes. Sixty percent of the sojourners along the Pacific Flyway en route to and from Alaska find rest and sustenance in the San Joaquin Valley. Relinquish more waters, restore more of this avian superhighway, and even more might come. ■

MONTEREY BAY AND BIG SUR

SEAMOUNTS AND DEEP CANYONS

The ocean depths and surface meet in Monterey Bay. North America's biggest offshore submarine canyon—as extensive as the Grand Canyon—cuts a mile-deep gash from Moss Landing at the bay's center shore out to the edge of the continental shelf. It funnels nutrient-rich deepwater upwellings right up the shore, producing an explosion of phytoplankton and all the larger life-forms that feed upon it.

Blue and humpback whales glide into the bay to gorge. Gray whales face a harder choice as they shepherd their new calves north from their Baja California nurseries in spring. They can hug the bay's shore, sheltering in the shallows and kelp thickets but wasting precious time and energy. Or they can make a dash across the bay's mouth, over the gaping canyon—exposing themselves to the orcas that lurk there. Like lions harrying elephants, the orcas fight to tear the calves from their mothers, then pummel them and drag them down until they drown.

Another unforgettable spectacle lies much closer to shore: sea otters cavorting along the rocks, often visible from Monterey's beachfront promenade. The shoreline from Monterey south to Point Conception is the realm of the sea otter. In the early twentieth century, after hunting had exterminated sea otters everywhere else south of Alaska, a tiny remnant population survived unnoticed at Big Sur, around Point Lobos from Monterey. They've since recolonized the Central and Southern California coasts and have begun straying into Baja California's waters. In the process, they've played a key role in restoring the kelp forests by devouring sea urchins, abalone, and other grazers, to the ire of many shellfish harvesters.

The waters off Big Sur also lie in the Monterey Bay National Marine Sanctuary, the largest federal marine sanctuary on the continent, and they are as flush with life as the cliffs and sea stacks of the Big Sur coast are with scenic spectacle. Seventy-five miles (120 kilometers) offshore, the Davidson Seamount, one of a series of extinct underwater volcanoes, rises more than 3000 feet (900 meters) from the bottom, providing a base for forests of sponges and cold-water corals, some of them more than a hundred years old, and the rare deepwater species that thrive in them.

To the north, off San Francisco's Golden Gate, another clutch of underwater promontories breaks the surface. They form the Farallon Islands, a breeding mecca for northern elephant seals and puffins, murres, kittiwakes, and other seabirds, as well as a valuable stopover for many other species as they migrate between Arctic summers and southern winters. Waterfowl and songbirds from the north find refuge along Elkhorn Slough, which empties into Monterey Bay, contains California's largest salt marsh after San Francisco Bay, and hosts some 340 bird species.

This is a coast with something for everyone.

—E.S.

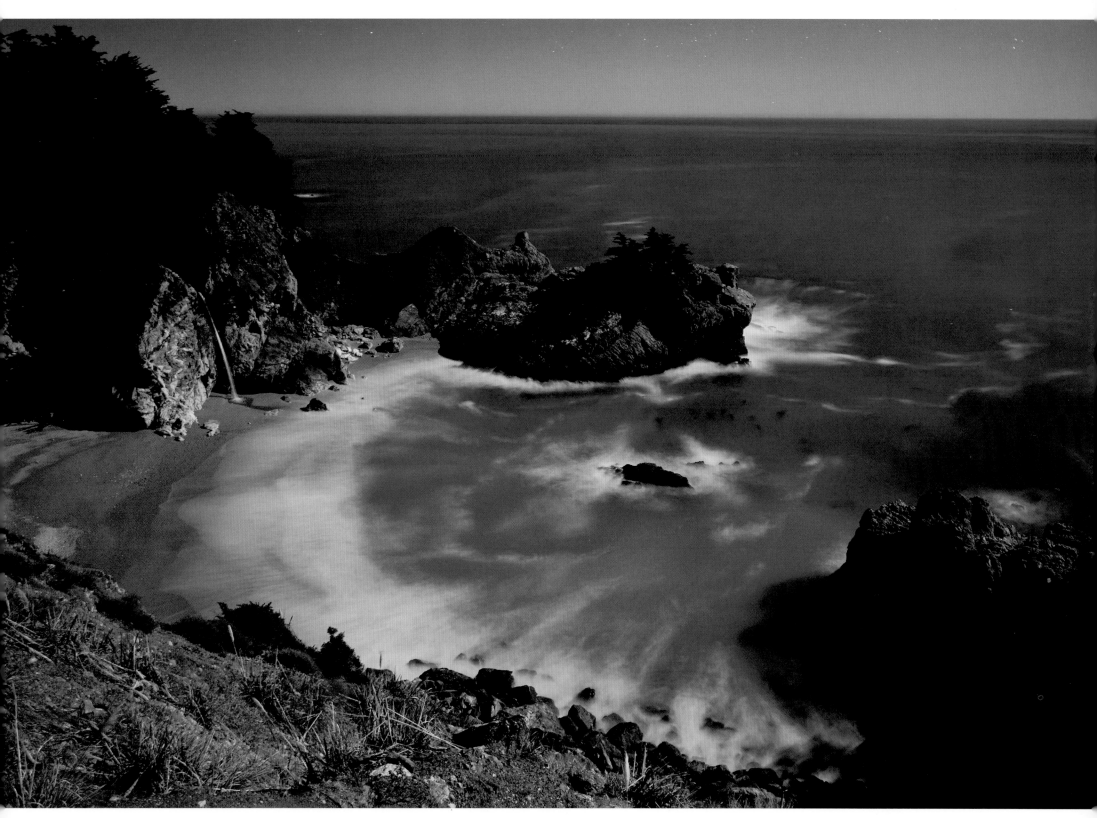

McWay Cove under the moonlit sky in Julia Pfeiffer Burns State Park, Big Sur, California

Sea otters are a common sight along California's Big Sur coast.

JULIE PACKARD

The opening of California's Monterey Bay Aquarium in 1984 was no mean feat. Few large aquariums around the world had ever attempted to display such a wide variety of marine life—from algae to otters—living in a single region. Here, that region was iconic Monterey Bay, with its abalone and kelp and giant Pacific octopuses. Cofounder and Executive Director Julie Packard had the chops—master's degree in marine biology, experience helping govern her family's foundation—to pull it off, but still she worried about the details: how to find all the fish species needed for the exhibits, how to keep a kelp forest alive.

The day the aquarium opened, however, Packard realized that what was inside the tanks wasn't her biggest concern. She said, "I realized the most challenging species in the aquarium was us: the human species."

Humans: We flush our toilets and wash our cars and use water in manufacturing, and ultimately all that water runs downhill to the ocean. Much of our garbage, including plastic that never goes away, ends up in the ocean. We fish, and fish, and fish. Yet few humans have had direct experience with the open sea, which covers the vast majority of the planet, Packard related.

"The oceans are our pantry, our play-ground, our highway," she said. "They provide primary protein for something like a billion people in the world and produce half of the oxygen we breathe." But for too long, Packard continued, "We've taken the oceans for granted. Just in the past few decades, we've started to realize that they not only make it possible for life to exist on Earth, but they also provide a huge amount of services that enable economies to thrive and people to stay healthy. Keeping the oceans healthy is absolutely essential for all life."

That conservation message, Packard came to believe, was far more important than labels on fish tanks. The real challenge for the aquarium, she realized, was "getting into hearts and minds": educating visitors about threats to the ocean and encouraging them to act on its behalf. "We have people who grew up here and are now coming back with their own young children," Packard said. "I love to see that: we've impacted a generation of kids and families."

And so Monterey Bay Aquarium has become much more than an aquarium, despite its breathtaking exhibits such as a huge backlit jellyfish tank in a darkened room. It conducts original research and collaborates with researchers at leading

"We have people who grew up here and are now coming back with their own young children . . . we've impacted a generation of kids and families."

marine labs. It is also an important voice for ocean stewardship, affecting people across the country with such innovative programs as Seafood Watch, which educates consumers and businesses about sustainably harvested seafood to help them make thoughtful decisions about the fish and shellfish they purchase.

All of it aligns with the aquarium's current mission—to inspire conservation of the ocean—which is simpler and yet far more ambitious than its original Monterey Bay–centric vision.

As recently as a quarter century ago, "We thought the oceans were endless," Packard said, "that they can take whatever amount of waste we want to dump in them, and we can fish like there's no tomorrow.

"There are many things that humanity needs to attend to, in terms of quality of life and human health and economic success," Packard continued. "But taking care of nature, which enables us all to be here, needs to be first and foremost, because without that, we have nothing else."

© COREY ARNOLD/COREYFISHES.COM

NOTES FROM THE PHOTOGRAPHER

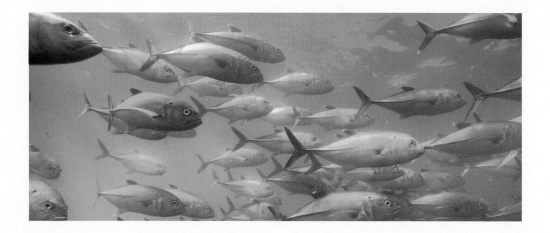

CABO PULMO: A SYMBOL OF HOPE

I am walking along a narrow, sandy path above the edge of the bay of Cabo Pulmo. It is still dark. The half moon illuminates the landscape just enough so I can see a rough outline of the land on this early spring night. I make my way with the help of my headlamp, stepping carefully because the trail runs close to the edge of the cliff. Below me, gentle early-morning waves break on the rocks. With my equipment loaded in my backpack, I am heading to a rocky outcrop at the southern tip of Cabo Pulmo National Marine Park to photograph the sunrise. The day

Right: Aerial view of a coral reef in Cabo Pulmo National Marine Park, Baja California Sur, Mexico

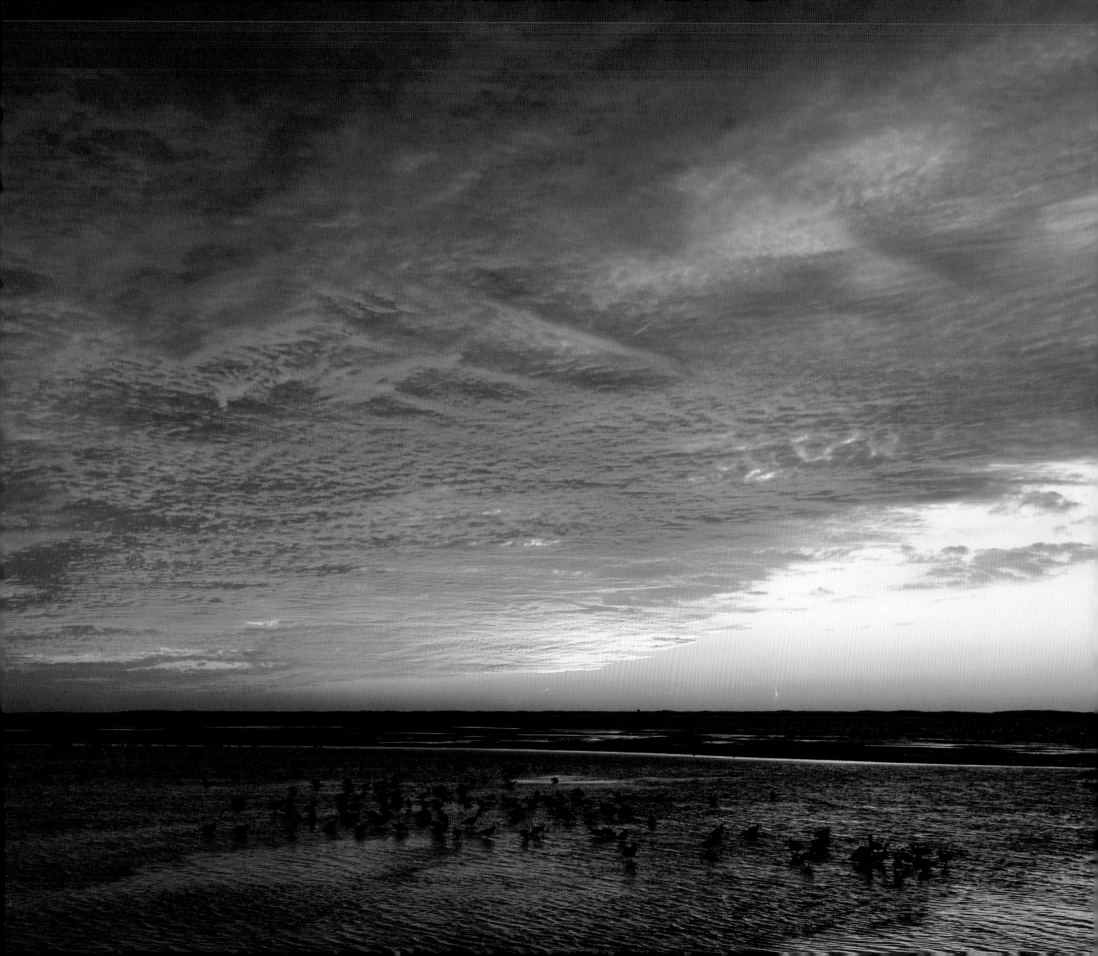

The area of the Cabo Pulmo reserve is just a tiny speck on the map of Baja California's southeastern coast, only 60 miles (96 kilometers) north of busy Los Cabos. But it has become a significant conservation hot spot and a symbol of hope.

before, I had scouted the location and found fantastic formations of soft, sculptured rock that will become a mysterious landscape scene in the morning light.

I make it to the point and sit down to await the sunrise. All is quiet except for the water softly lapping at the shore. The coastline is dark, except for a few little lights at the far end of the bay. The area of the Cabo Pulmo reserve is just a tiny speck on the map of Baja California's southeastern coast, only 60 miles (96 kilometers) north of busy Los Cabos. But it has become a significant conservation hot spot and a symbol of hope.

Only two decades ago, the spectacular Cabo Pulmo coral reef was completely overfished. The Cabo Pulmo village community rallied, and the Mexican government designated the offshore waters of this pristine spot a marine reserve in 1995. The largest coral reef in the Gulf of California has come back from the brink and is now one of the most celebrated ocean conservation success stories between Mexico and Alaska. Ecotourism has become a new opportunity.

But the celebration was almost over when, not long ago, a group of Spanish investors cast their eyes on this beautiful bit of coastline. They saw the potential of creating a tourist development on the edge of the reserve that would rival nearby Los Cabos in scale. Conservationists and locals were alarmed. This development could mean the destruction of the now-flourishing reef.

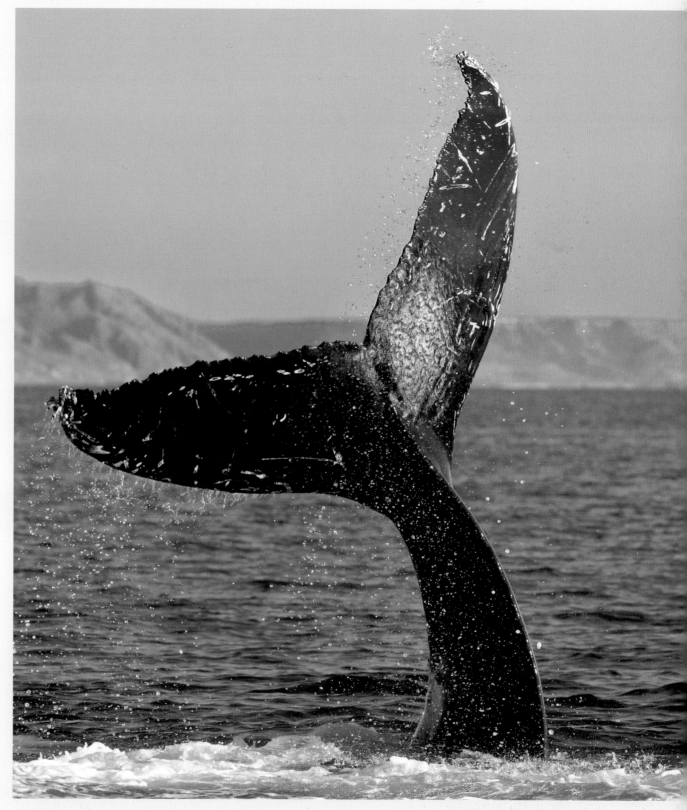

Facing page: Laguna Ojo de Liebre, Baja California Sur, Mexico *Above: Humpback whale, Gulf of California, Baja California Sur, Mexico*

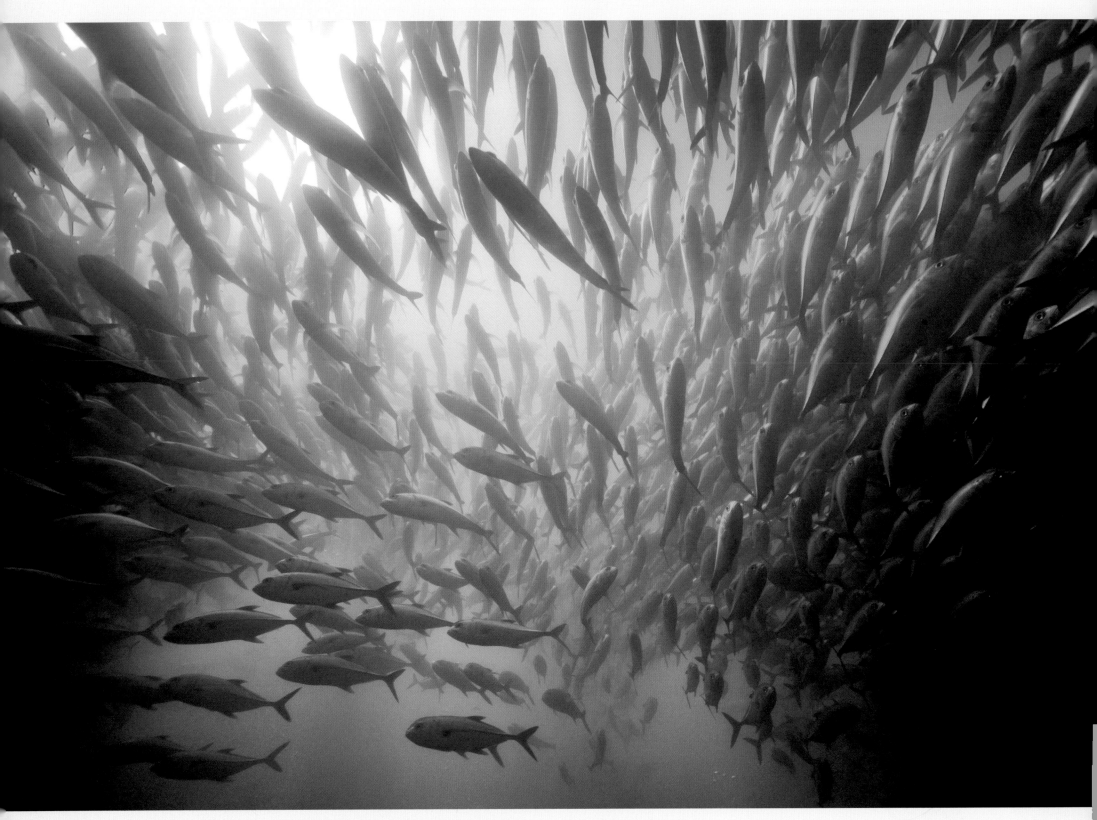

Bigeye jacks in Cabo Pulmo National Marine Park, Baja California Sur, Mexico

The desperate situation drove people together, and alliances were formed to fight this huge tourist project. Signatures poured in from all around the world to urge the Mexican president to halt the project, which had already received the green light. And the battle was won! For now. The coastline is still dark. No high-rise hotels, no nightclubs, parking lots, or golf courses are in sight. Slowly the sun pushes over the horizon and pours its soft, warm light over the beautifully formed rocks as I take a series of images of this coastal gem.

Some of Cabo Pulmos's greatest treasures, however, are not visible from land. They are hidden below the surface of the sea.

Three hours later, I sit on the edge of a *panga* above the Cabo Pulmo reef. I drop backward into the water for a dive. As I sink, the current carries me over the reef. I enter a world beyond imagination. The flourishing centuries-old coral garden teems with life. Groupers, snappers, grunts, and porkfish surround me in large numbers. Suddenly the sunlight penetrating from the surface disappears. An immense group of bigeye jacks swirls above me. Thousands of bright silver bodies with huge eyes swim around me in a magically unified formation. Then, as quickly as they have come, they disappear. I marvel at the vitality and biological diversity of the reef's ecosystem, a true ocean nursery. More than 226 fish species have been observed in the marine reserve, and scientists have calculated that the reef's biomass has grown 463 percent in just a decade. It is no wonder that Cabo Pulmo has become the poster child of designated marine protected areas.

Even though I desire to keep floating among this ocean splendor, my need to breathe forces me to the surface. Back on the *panga*, I am still processing what I just witnessed. I am in complete awe of how quickly this marine ecosystem has recovered after it was declared a protected area and a no-fishing zone. It shows the importance of the creation of marine protected areas. In Cabo Pulmo, this was possible only with the support of the local community, which realized that a healthy reef would benefit them more in the long run.

As we head back to shore, a humpback whale comes up for air near the boat and shows its beautiful tail fluke. Humpback whales gather in the waters in and around Cabo Pulmo during the winter months. The area is their nursery as well. Pregnant females give birth to their calves and nurse them for several months until they are strong enough to follow their mothers north on the annual journey to the nutrient-rich waters of Alaska. During an aerial photography session only days before, I had seen a calf playing with its mother. Now, in the distance, a whale breaches— a gift to remember. Cabo Pulmo is a reminder of the magnificence of nature if we take good care of it or simply let it be.

BAJA CALIFORNIA FROM THE AIR

When you do a lot of aerial photography, you learn what to look for. You develop the ability to judge distance and size from the air. My pilot, Sandy, is an expert at ocean survey work, and in the many hours we have flown together in her small plane, she has taught me a lot about spotting. It's important to be able to differentiate what's happening miles away: is it a gust of wind hitting the surface of the water, a large school of fish, or maybe a huge group of dolphins?

It's April, and the weather is sunny and calm. As we glide along the coast over the southern tip of Baja California, we suddenly see a big disturbance on the water in the distance. Small waves seem to break over a reef just below the water's surface. But as we get closer, we realize that the suspected reef is in motion. It is actually thousands of rays jumping out of the water and creating waves. The ocean looks like it is boiling. I am beside myself with excitement to see such an enormous school of rays. Will I be able to capture it?

I grab my telephoto lens, hoping to photograph their sheer number and unusual jumping behavior. I quickly

Munk's devil rays are believed to be the only species that engage in this repeated jumping, sometimes 10 feet (3 meters) into the air, while traveling in large groups of thousands of rays.

tell Sandy the position I need to be in, and she says, "Here we go," starting to bank and turn. The 10-pound (4.5-kilogram) weight of the lens and camera seems to double with the g-force of the turn. I try to focus and maintain a desirable composition. Then a ray at the edge of the large congregation makes a leap and plunges below the surface, only to leap at a greater velocity a second later. *Click, click, click*—another burst from my camera as the ray soars over the water. Sandy levels the plane, and I quickly review the images on the camera's display. I see Sandy's questioning look out of the corner of my eye.

"Did you get it?" she asks.

I smile and shake my head: "Unbelievable!"

Later I would learn that the rays I photographed had only recently (in the 1980s) been described and named by Italian marine biologist Giuseppe Notarbartolo di Sciara. After my images of the rays were published in various international outlets, he contacted me and told me he had named the species *Mobula munkiana* after his mentor, oceanographer Walter Munk.

Munk's devil ray, with its 3-foot (nearly 1-meter) "wingspan," is much smaller than the other three species of manta rays that live in the Gulf of California. This species is migratory, ranging from Baja California all the way south to Peru. All nine species of devil rays leap out of the water like this, the biologist says, but no one

Overleaf: A school of Munk's devil rays in the Gulf of California, Baja California Sur, Mexico

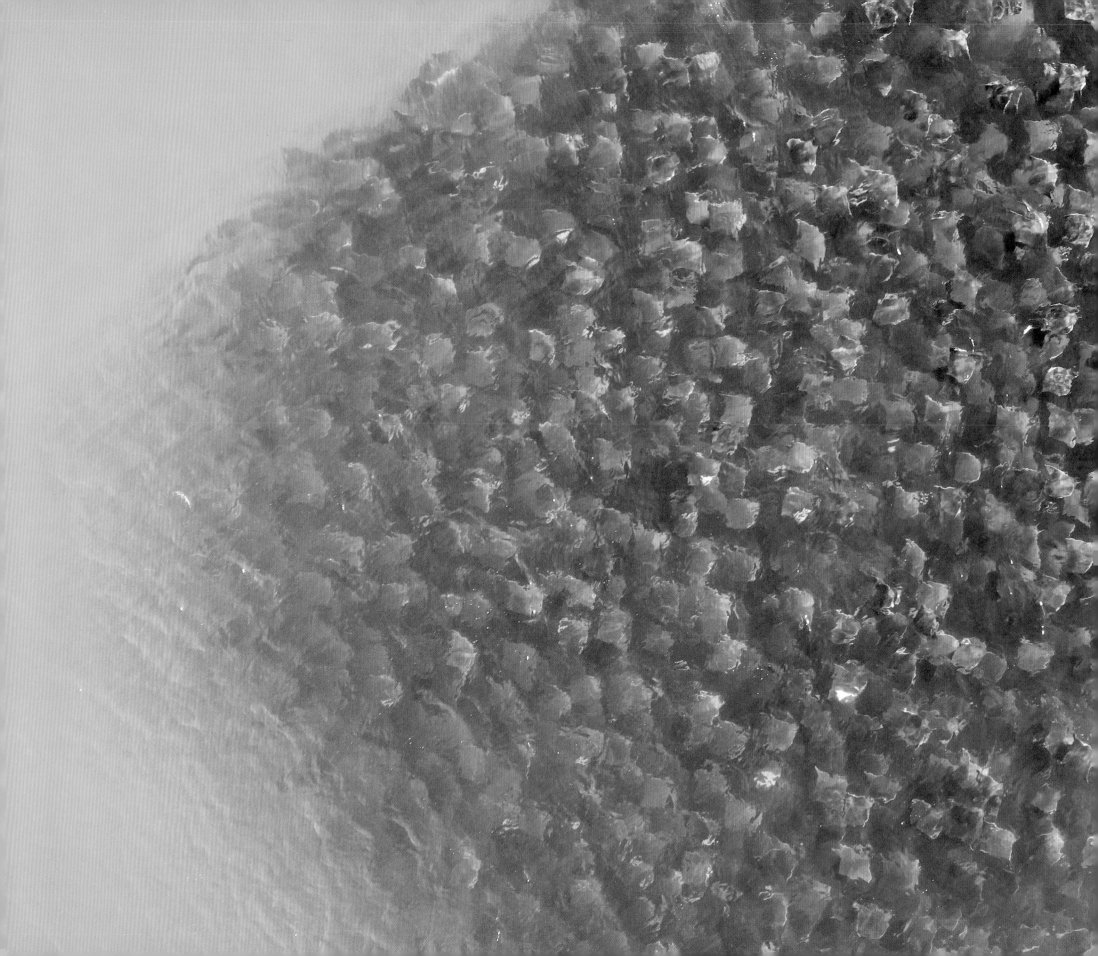

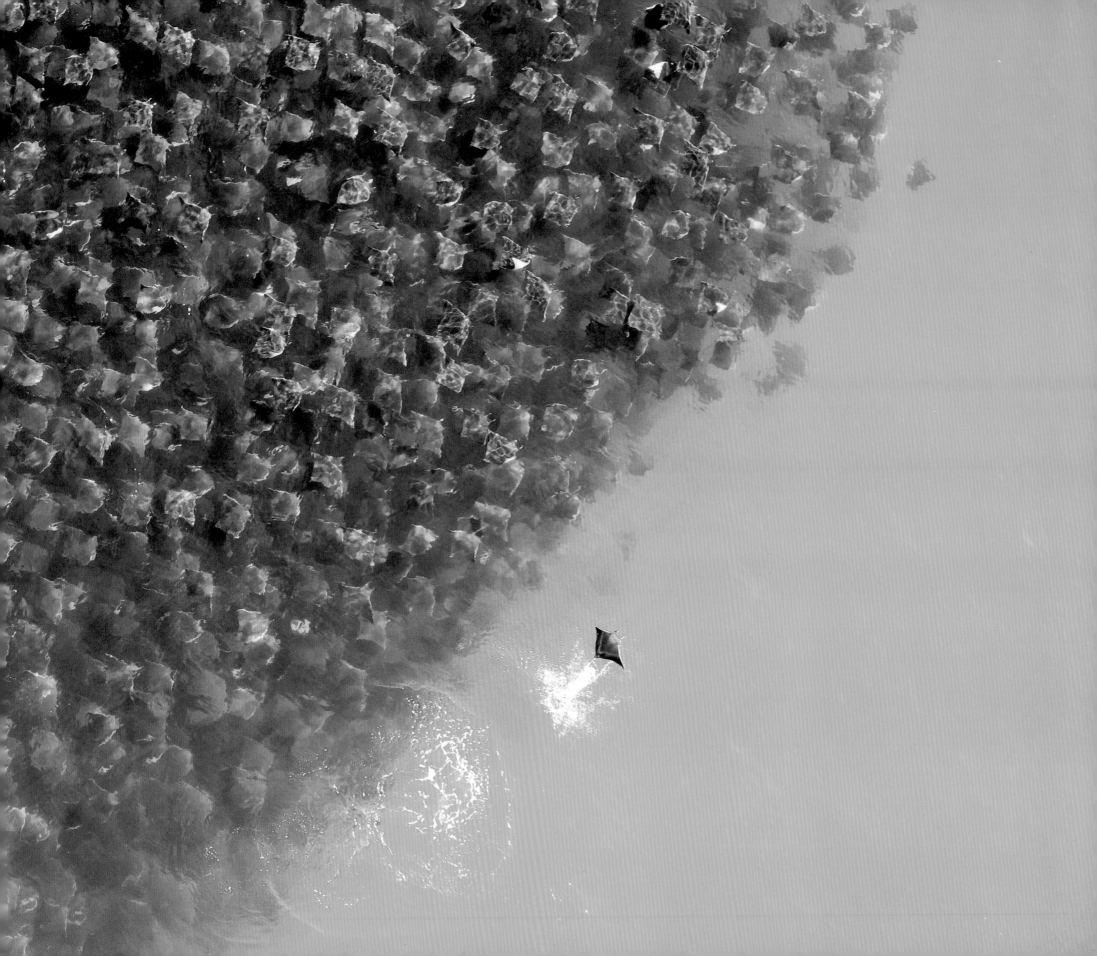

knows why. Munk's devil rays are believed to be the only species that engage in *repeated* jumping, sometimes 10 feet (3 meters) into the air, while often traveling in large groups of thousands of rays.

In my project documenting the immense Baja California region, an aerial perspective is extremely important. I am able to obtain breathtaking images of this lesser-known coastal landscape with its uninhabited islands, inlets, and important ecological zones such as mangrove estuaries. And being above the subject provides a sense of scale. But there is another great advantage to the bird's-eye view. The nutrient-rich waters are often so murky that visibility underwater is not much more than 15 or 20 feet (5 or 6 meters), making it impossible to photograph an entire 50-foot-long (15-meter-long) humpback whale, let alone an 80-foot-long (24-meter-long) blue whale, beneath the ocean's surface. But from the air, I can document mother and calf interactions, feeding behaviors, and even entire groups of whales. I can gain new insights into the many hidden wonders of the Baja Peninsula and the surrounding seas.

For me, this experience with the rays underscores how much there still is to discover in this world. Throughout my aerial work, sitting in the little plane, staring down onto the water and the land, I feel as if I am on a treasure hunt, never knowing what wonder of nature will appear next.

CALVING LAGOONS OF THE GRAY WHALES

Human beings have an affinity for wild creatures. Fascinated and intrigued, people often want to touch them—even a 45-foot-long (14-meter-long) gray whale weighing 35 tons (32 metric tons). And in the calving lagoons of Baja California's west coast, visitors are free to pet these gentle giants on whale-watching tours.

Just before sunrise, I am heading out with my fishermen friend to look for the gray whales that have

entered the lagoons. Every year, the whales travel between 10,000 and 14,000 miles (16,000 and 22,500 kilometers) round-trip between the summer feeding grounds in the Arctic and the warm-water wintering lagoons in Mexico. Now, in February, the highest concentration of whales can be found in the lagoons for their annual ritual of giving birth, nursing their young, and mating.

One particularly friendly whale is swimming our way, skimming the surface of the ocean. It turns its body parallel with the little *panga* and rolls on its side. I am watching the whale with my underwater camera. Its eye seems to study me. The whale comes so close I could reach out and touch its thick, rubbery skin. But I do not move. The whale's eye is looking at me intently. Time stands still and I feel an immense connection. What is going on in the whale's mind? What does it think about being watched by us humans? If this whale could speak, what would it say? There are no words spoken, but I can feel a dialogue between us. It is a conversation that is all the more powerful for being silent.

Animals have no way of speaking up, scolding us when we take their space or their food. They just go on about their lives, trying to survive and raise their young, and if they cannot, they quietly go away. And here I am, face to face with a species that humankind almost wiped out not long ago. I am amazed at the trust this animal gives us.

For centuries, we have slaughtered the whales, almost eradicating some species from the oceans. They were hunted in these very lagoons. The gray whale was once called "devil fish" because of its ferocious fighting behavior. No wonder they fought like the devil, trying to escape from the whalers intent on killing them for their meat and oil. Whale meat was used for food, and blubber was rendered for its oil, which was used for oil lamps and for making soaps and margarine. It seems unbelievable, with today's worldview, that we once killed thousands of these magnificent animals. They were put under complete protection by the International Whaling

Convention of 1946, and today their population has almost recovered.

But are we so different today? Now we hunt on the migration route of the gray whales for a different kind of oil. In some regions, that oil threatens entire ecosystems the whales depend on: in the Great Bear Rainforest of British Columbia, Alaska's Prince William Sound, and the Bering, Chukchi, and Beaufort seas. In today's world, the killing is not as direct. But oil companies are willing to take calculated risks that may destroy not only the habitat of this migratory species but all other animals within that habitat. I hope that in a few years people will look back at this time as the dark old days.

A blow from the whale sprays salt water all over my face and interrupts my thoughts. The whale lifts its nose and touches the side of the boat. "Scratch its nose!" my friend yells at me. "She loves it." I dig in with my fingers, scratching the whale. Suddenly I feel a stinging and pull back. Some sea lice have come loose and are trying to grab on to my hand. I laugh, flick them off, and keep scratching. The whale sends another blow up, and it sounds like a gratified sigh. ■

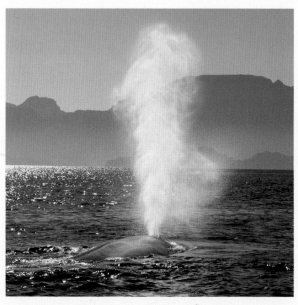

A blue whale spouts in the Gulf of California with the coastline of Baja California Sur, Mexico, in the background.

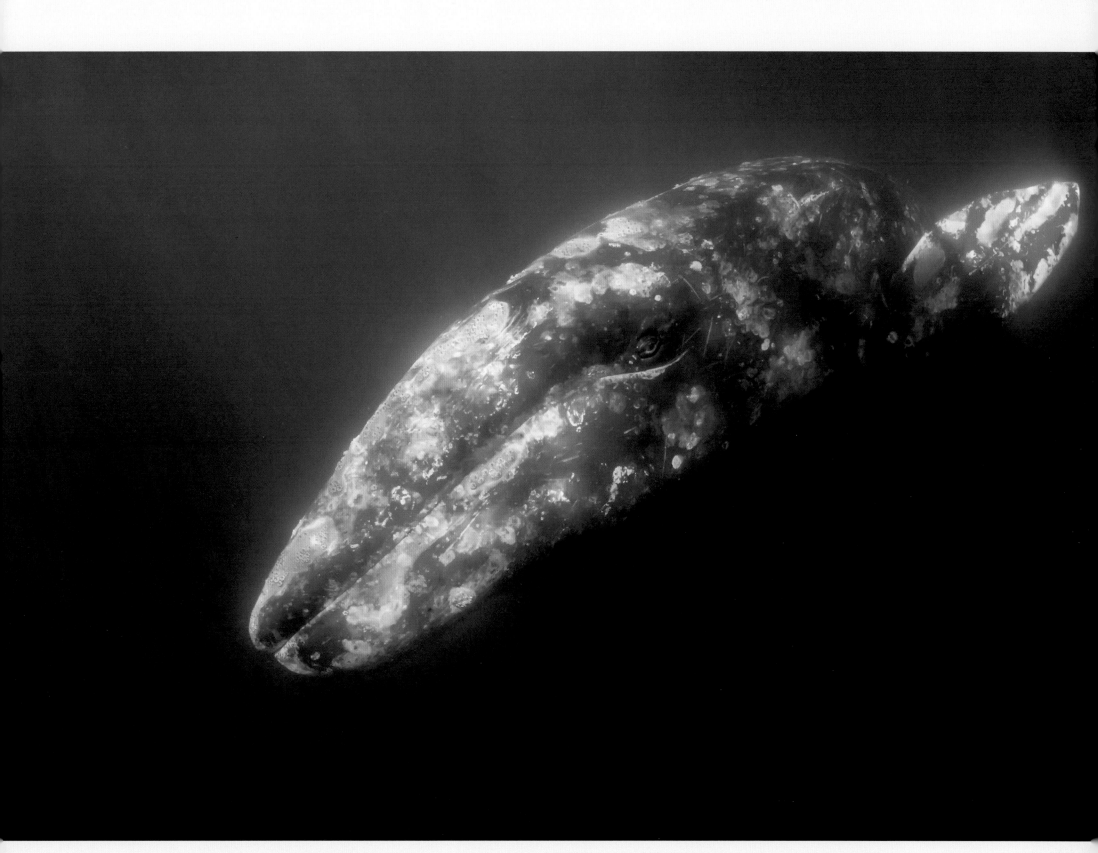

Protection of the gray whale has allowed numbers to rise during recent decades, Gulf of California, Baja California Sur, Mexico.

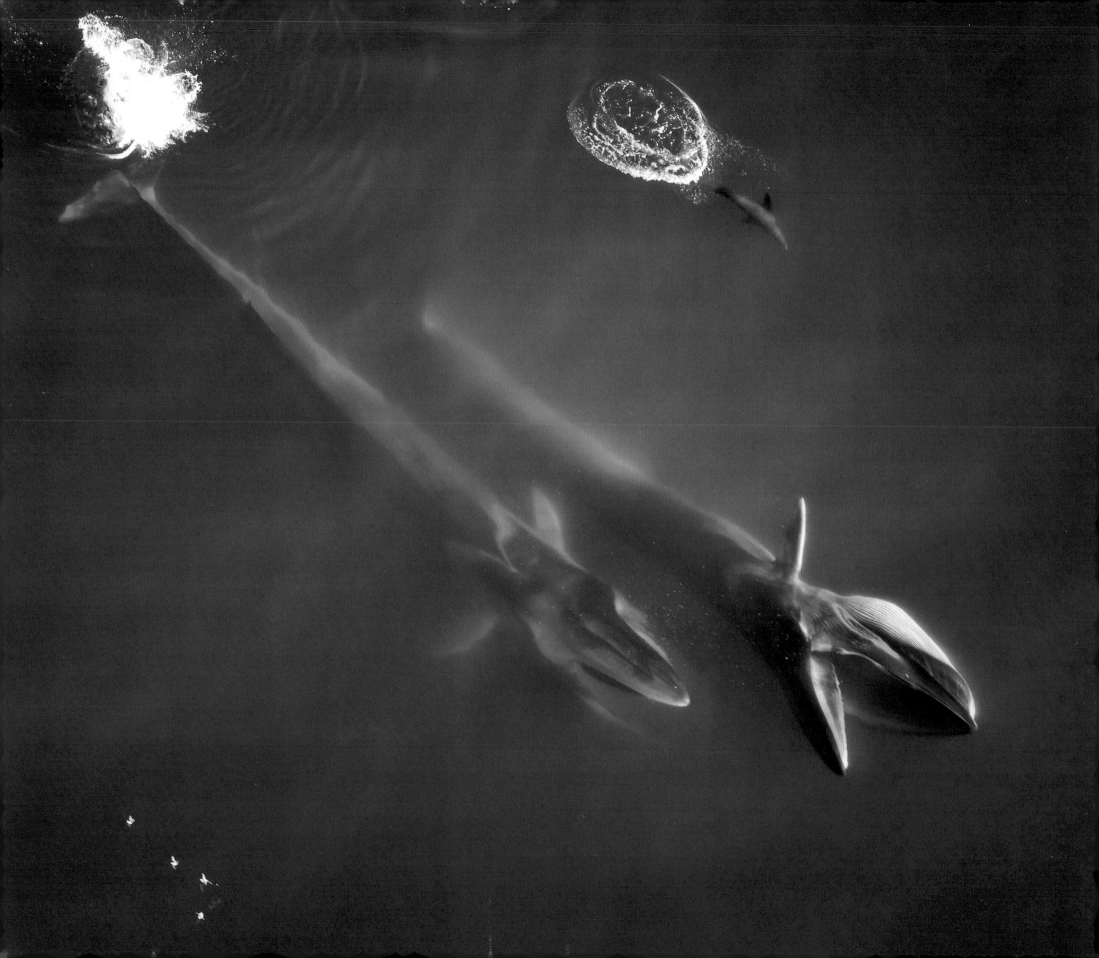

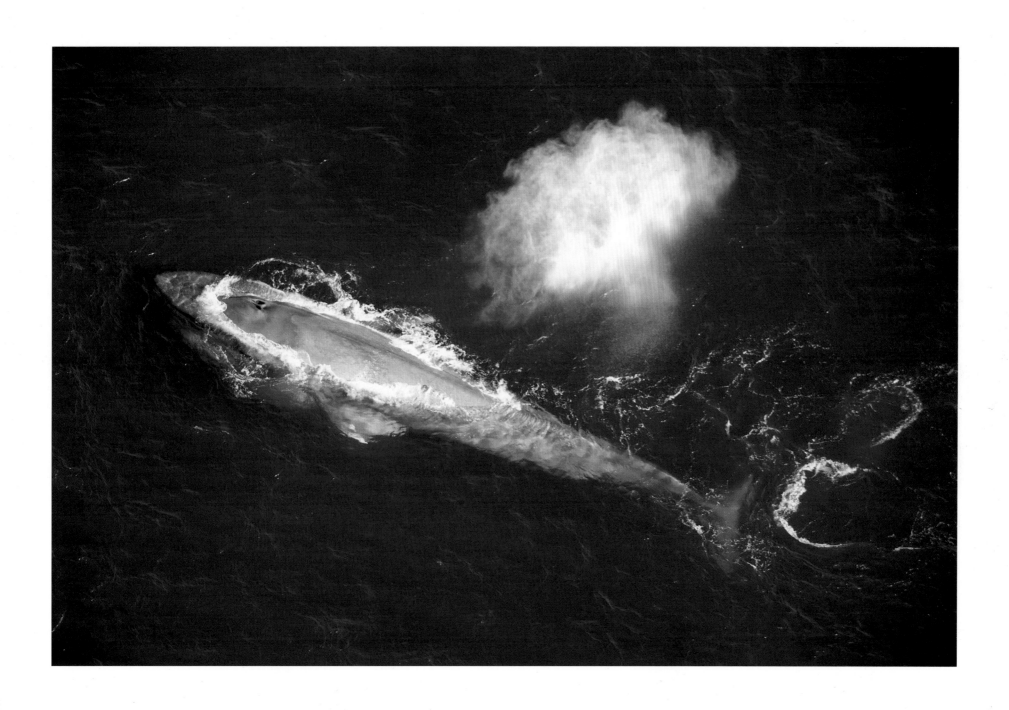

Facing page: Fin whales and a sea lion in the Gulf of California, Mexico.

Fin whales are the second-largest living animal, behind the blue whale.

Above: When giant blue whales, such as this one in the Gulf of California, Mexico, come to the surface

to breathe, they exhale approximately 1320 gallons of oxygen, creating a spout of up to 30 feet.

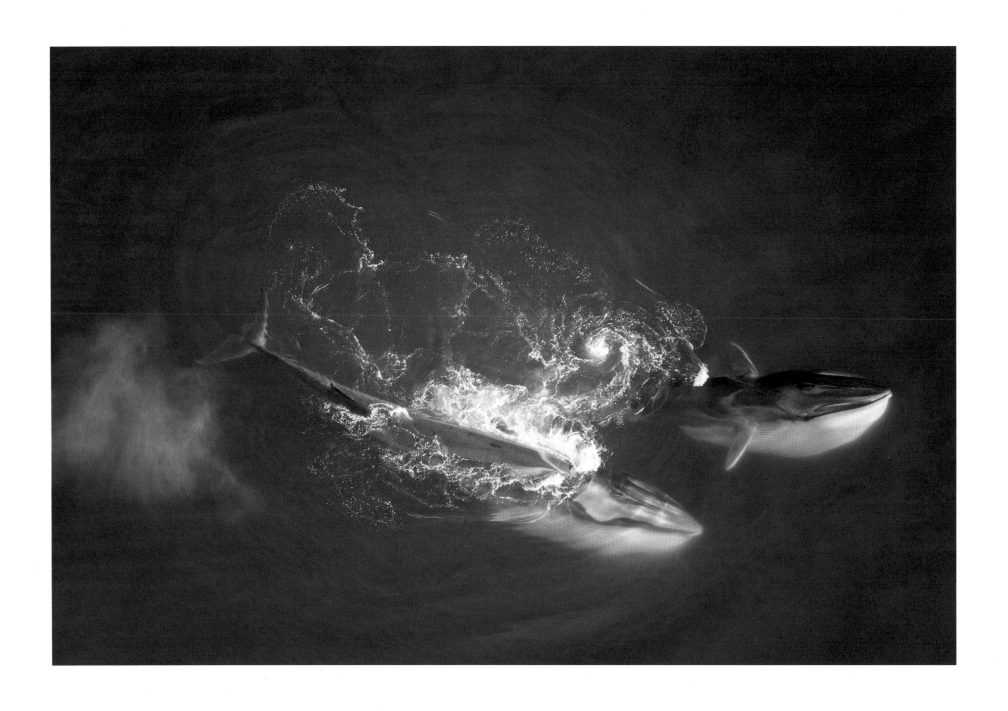

Fin whales feeding on krill in the Gulf of California, Mexico

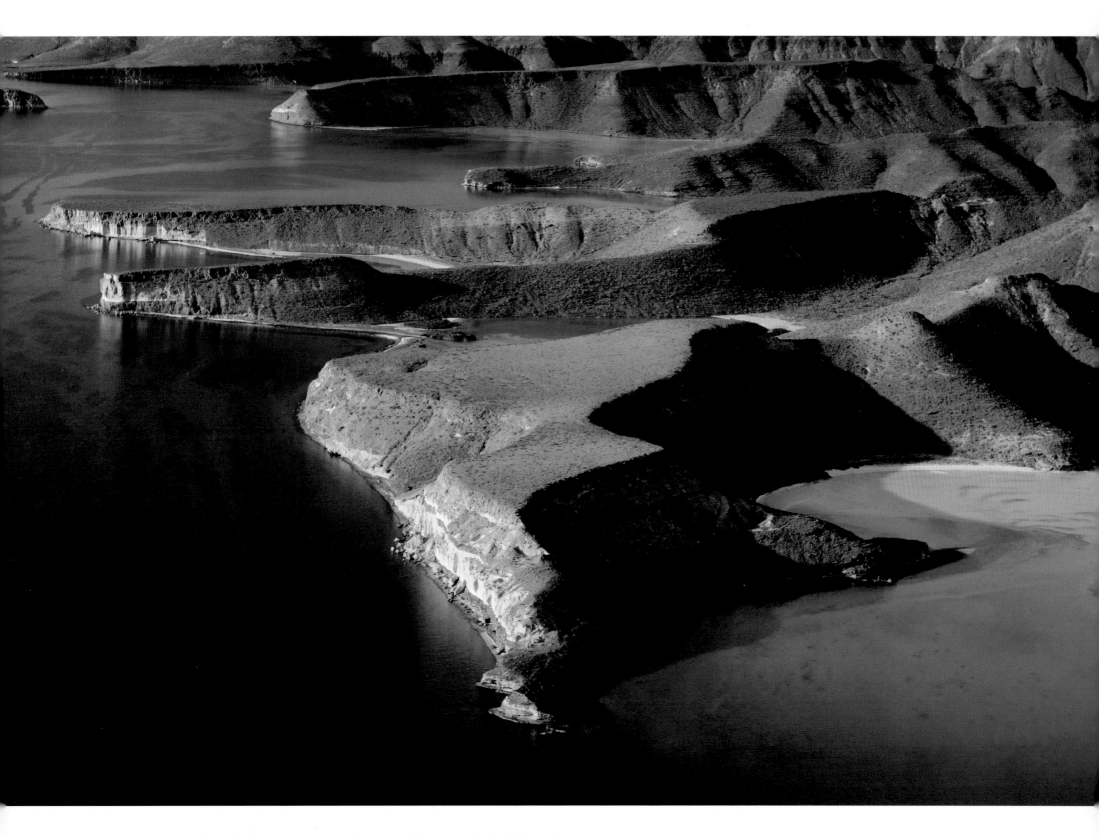

Isla Espíritu Santo is part of a network of protected islands in the Gulf of California, Mexico.

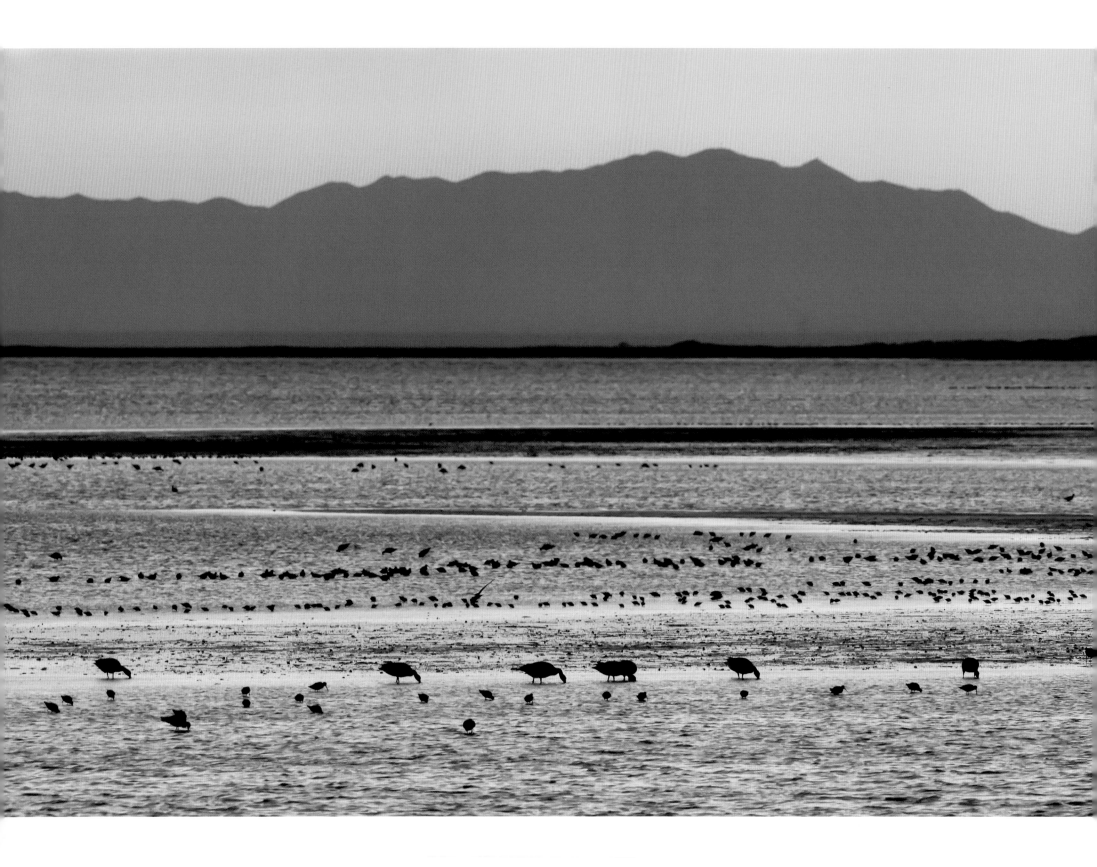

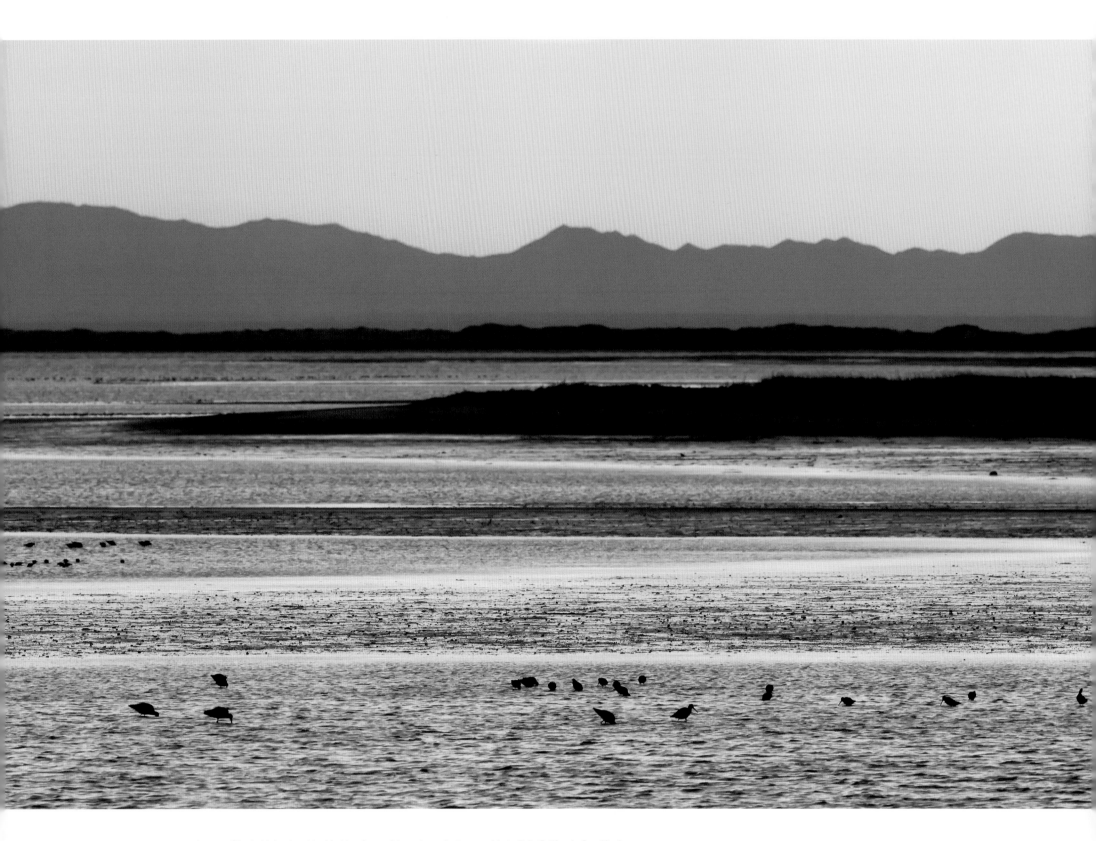

Laguna Ojo de Liebre is critical habitat for a wide variety of migratory birds, Baja California Sur, Mexico.

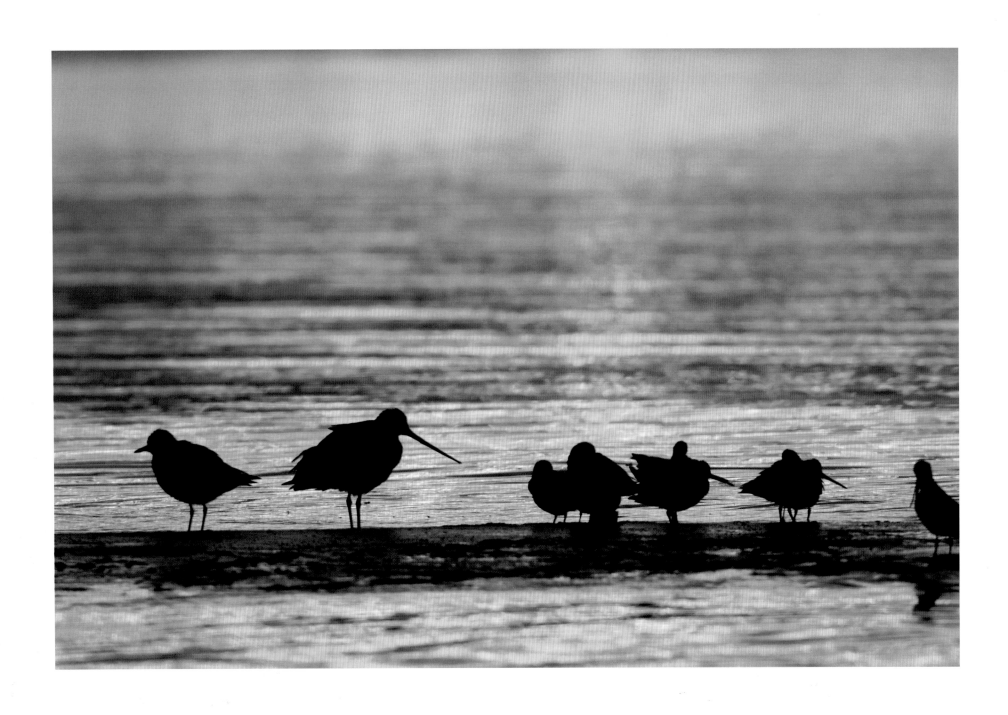

Migratory birds, Laguna Ojo de Liebre, Baja California Sur, Mexico

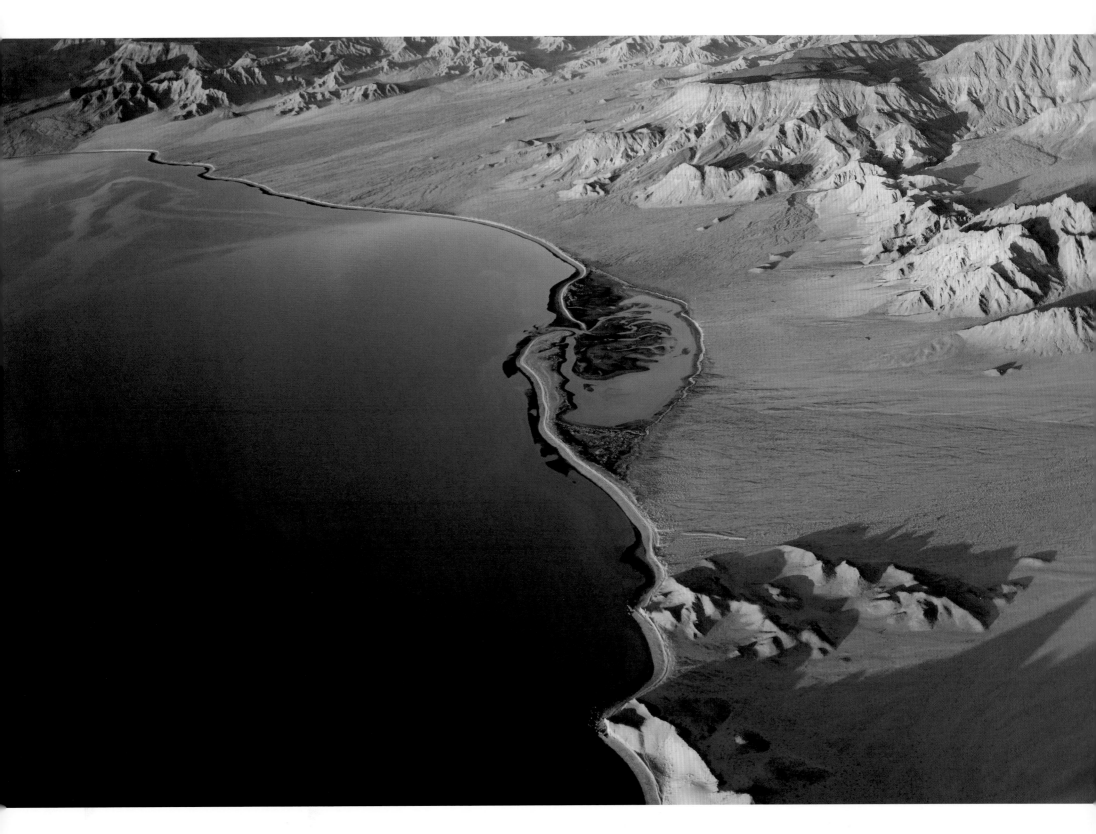

Isla Ángel de la Guarda, also called Archangel Island, is a large island in the Gulf of California, off the coast from Bahía de los Ángeles, Baja California, Mexico.

A coyote throws a shadow on the dried-out delta of the Colorado River, Baja California, Mexico.

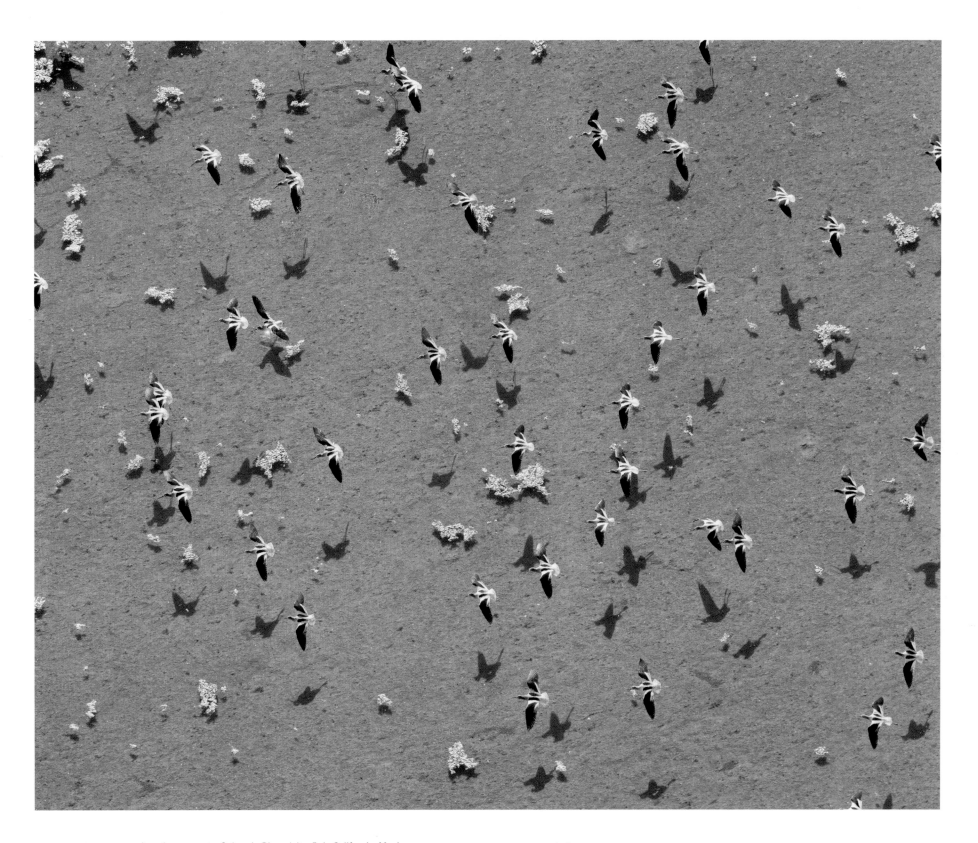

American avocets, Colorado River delta, Baja California, Mexico

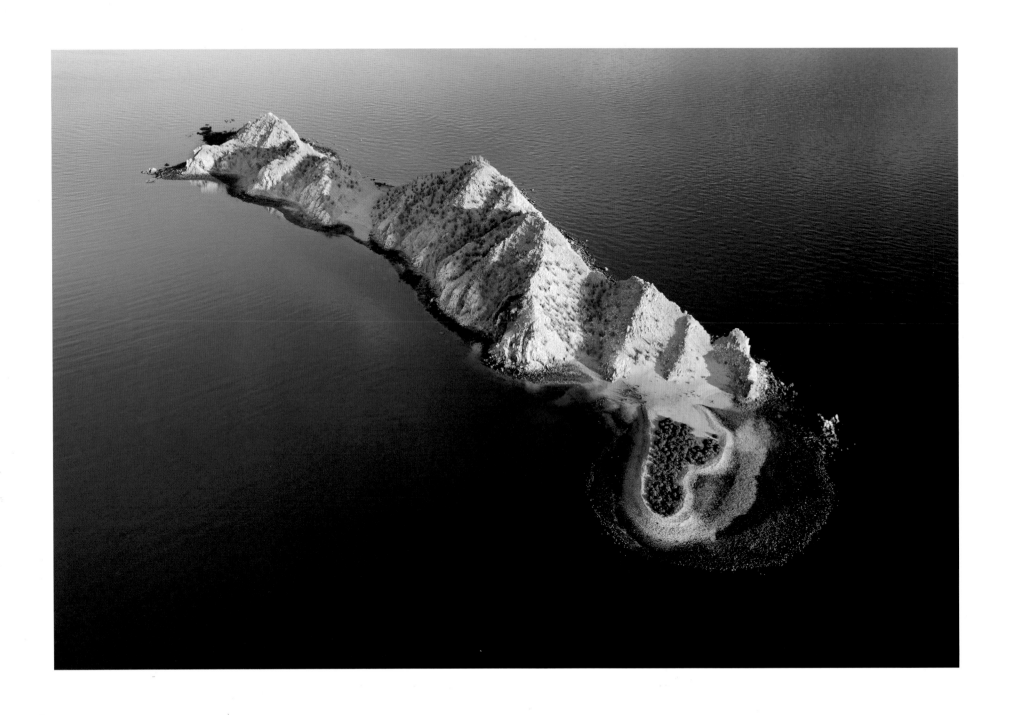

Small island in the Gulf of California, Mexico

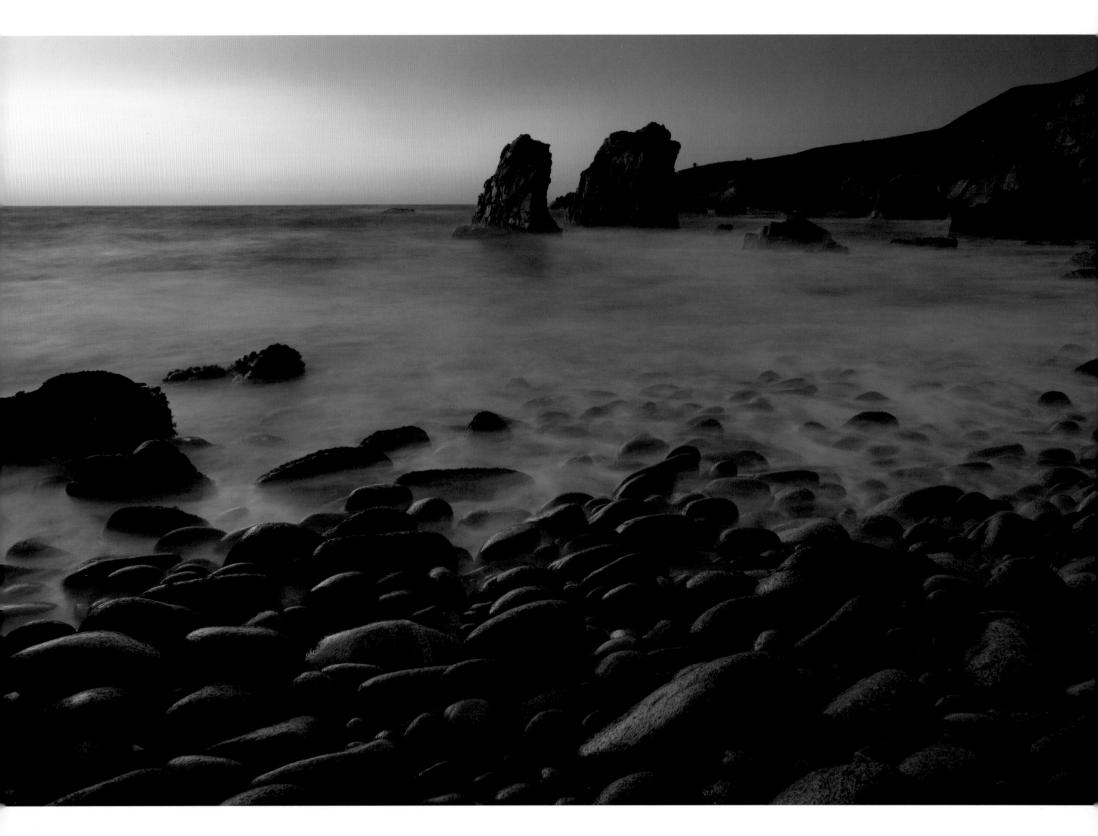

Sunset at Garrapata State Park on California's Big Sur coast

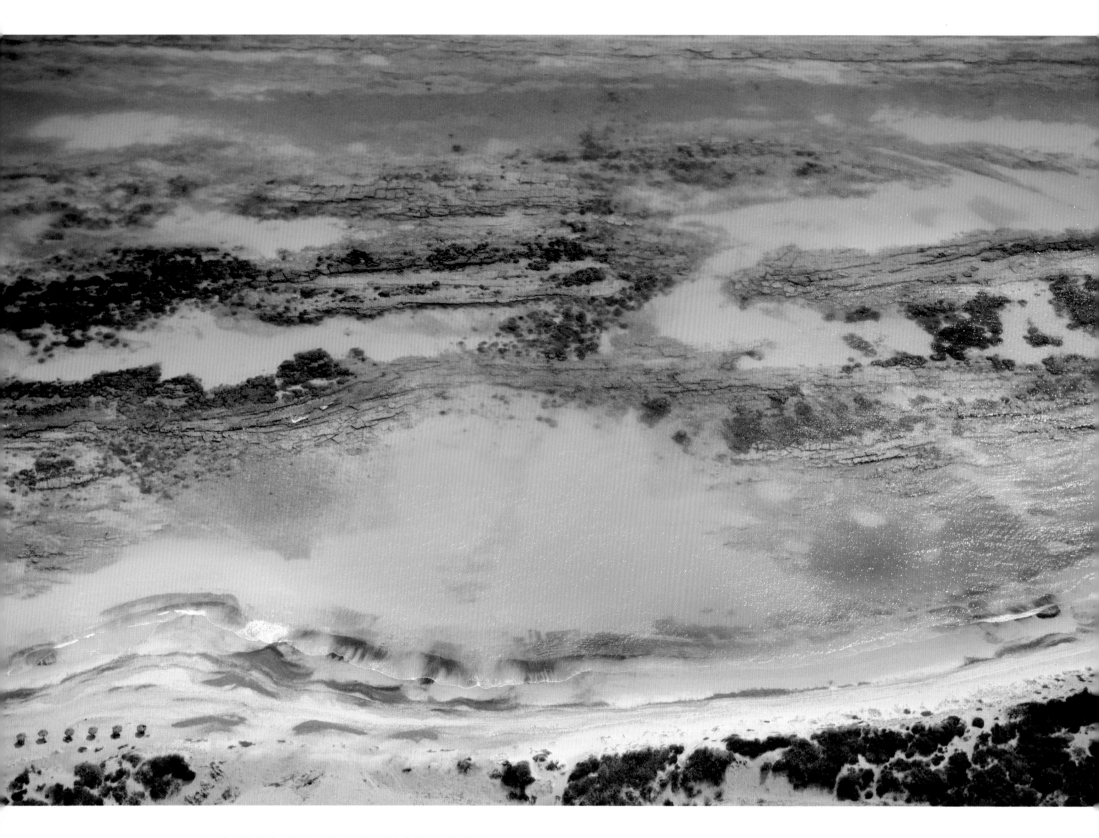

A reef in Cabo Pulmo National Marine Park, Baja California Sur, Mexico

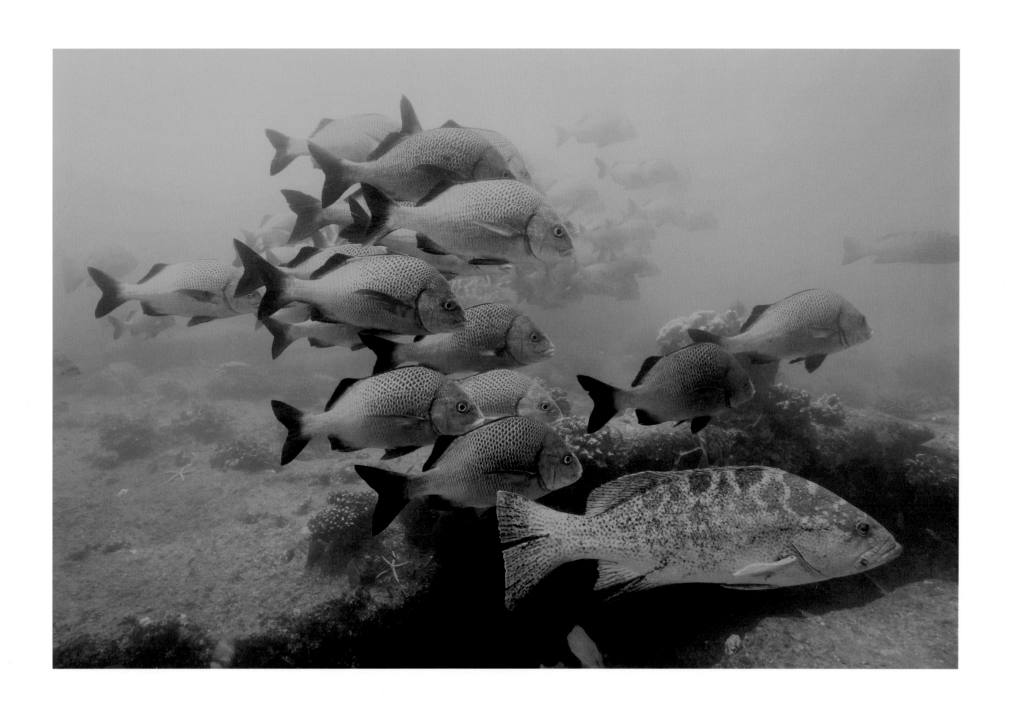

A school of grunts and groupers in Cabo Pulmo National Marine Park, Mexico

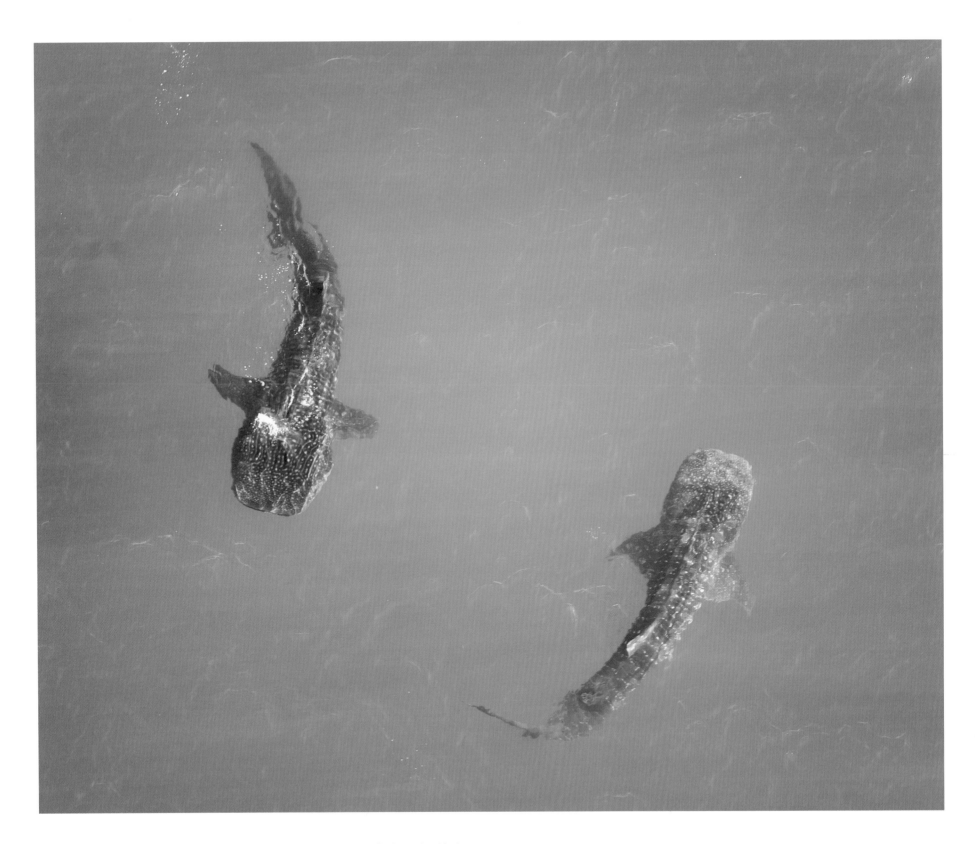

Whale sharks in the Gulf of California near La Paz, Baja California Sur, Mexico

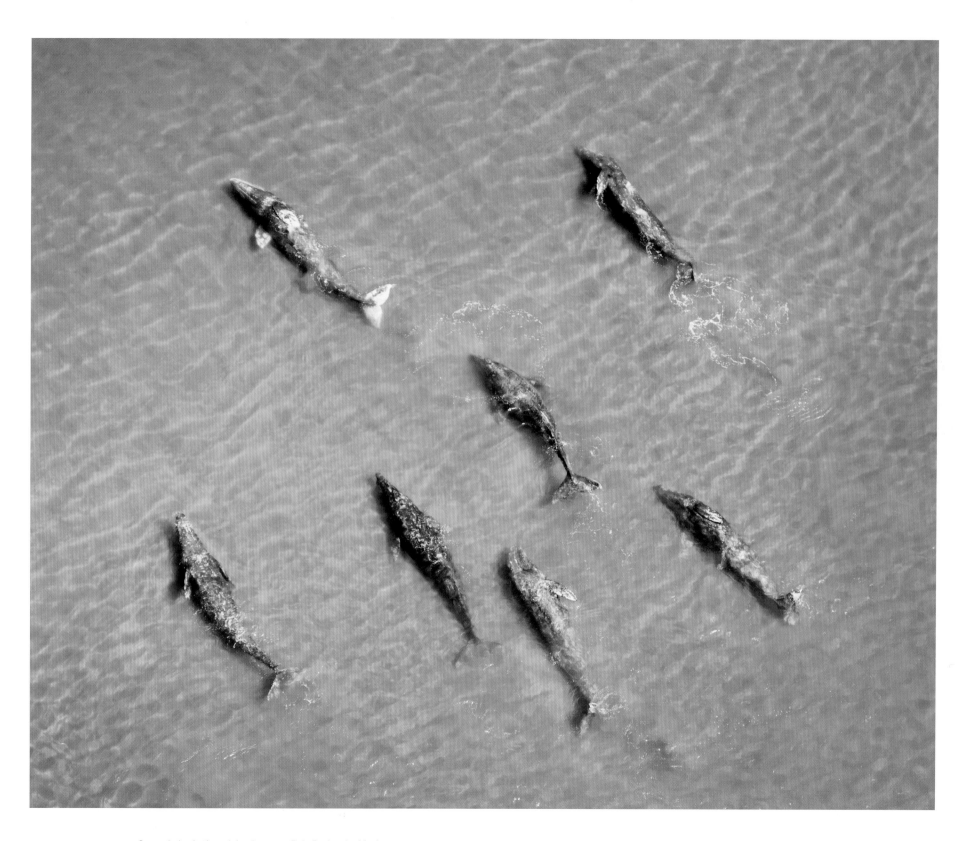

Gray whales in the calving lagoons, Baja Peninsula, Mexico

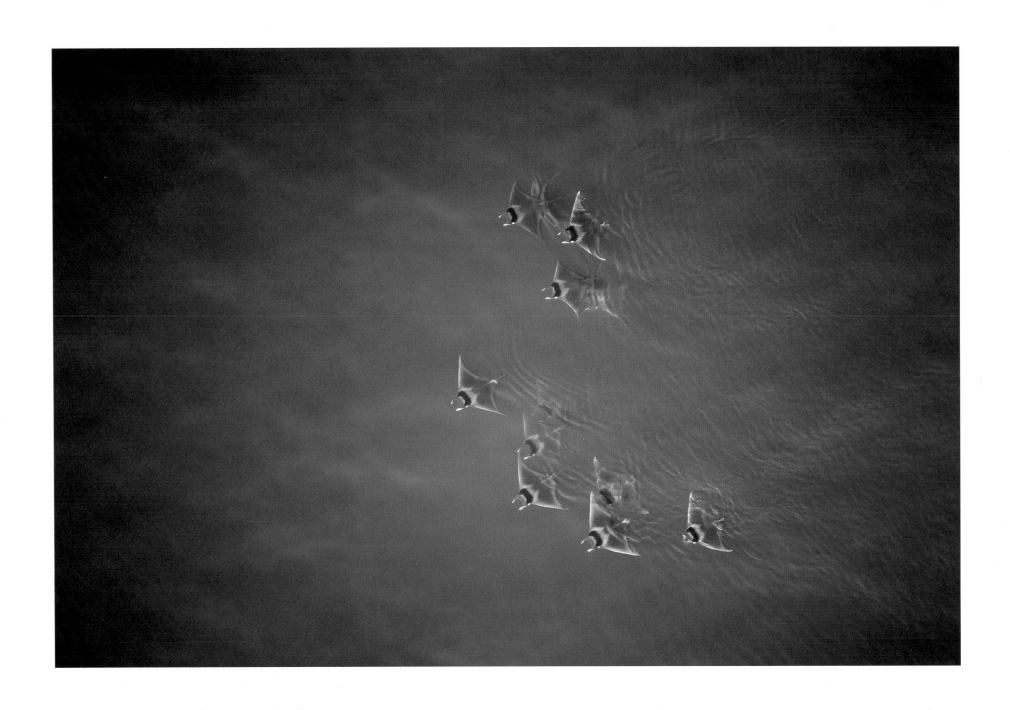

Munk's devil rays in the Gulf of California, Baja California Sur, Mexico

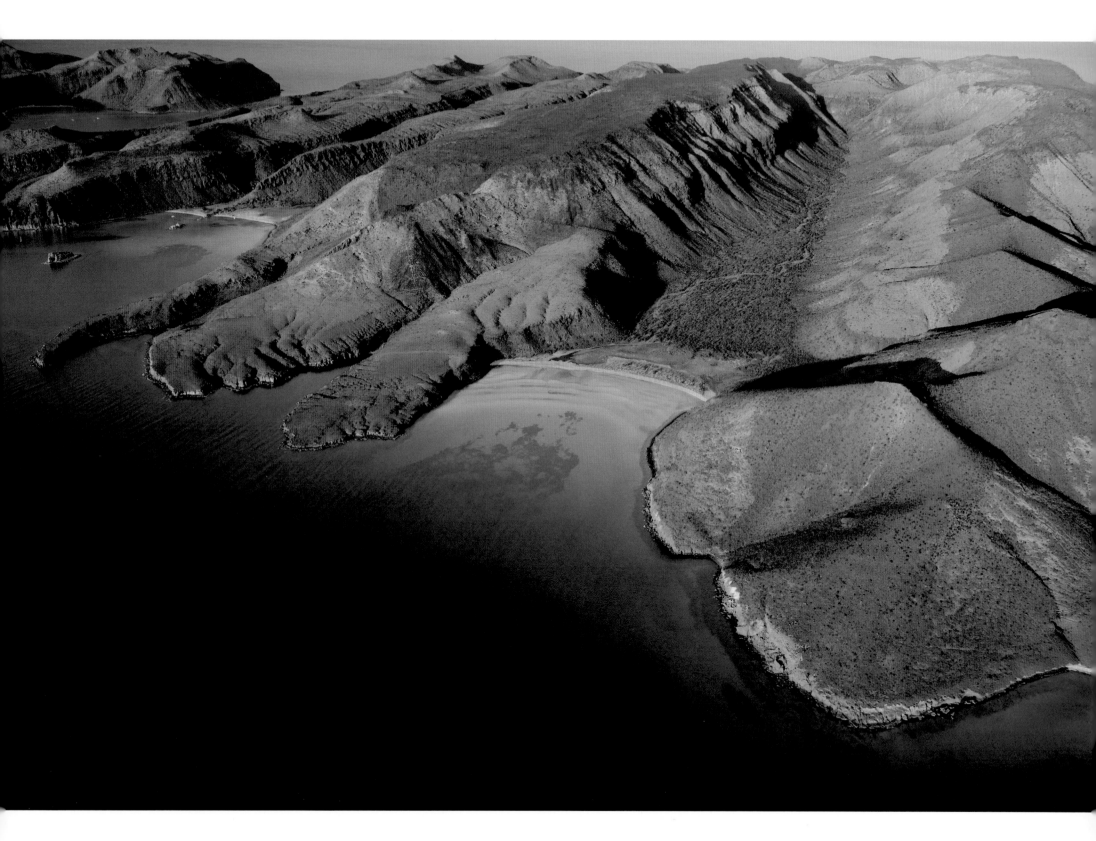

Isla Espíritu Santo in the Gulf of California, off the coast of Baja California Sur, Mexico

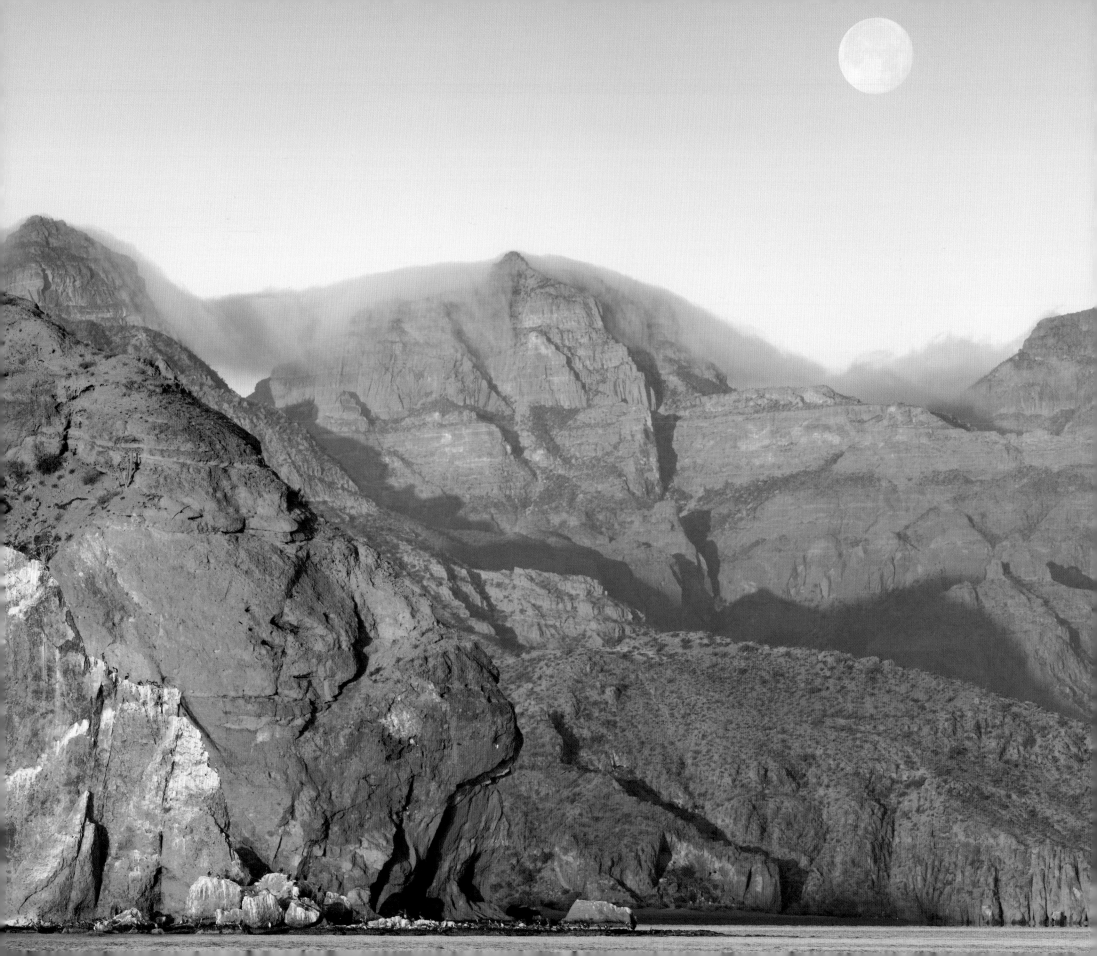

Facing page: Full moon over the Sierra de la Giganta as seen from the Gulf of California, Baja California Sur, Mexico

Above: A Sally Lightfoot crab along the rocky shore of Baja California Sur, Mexico

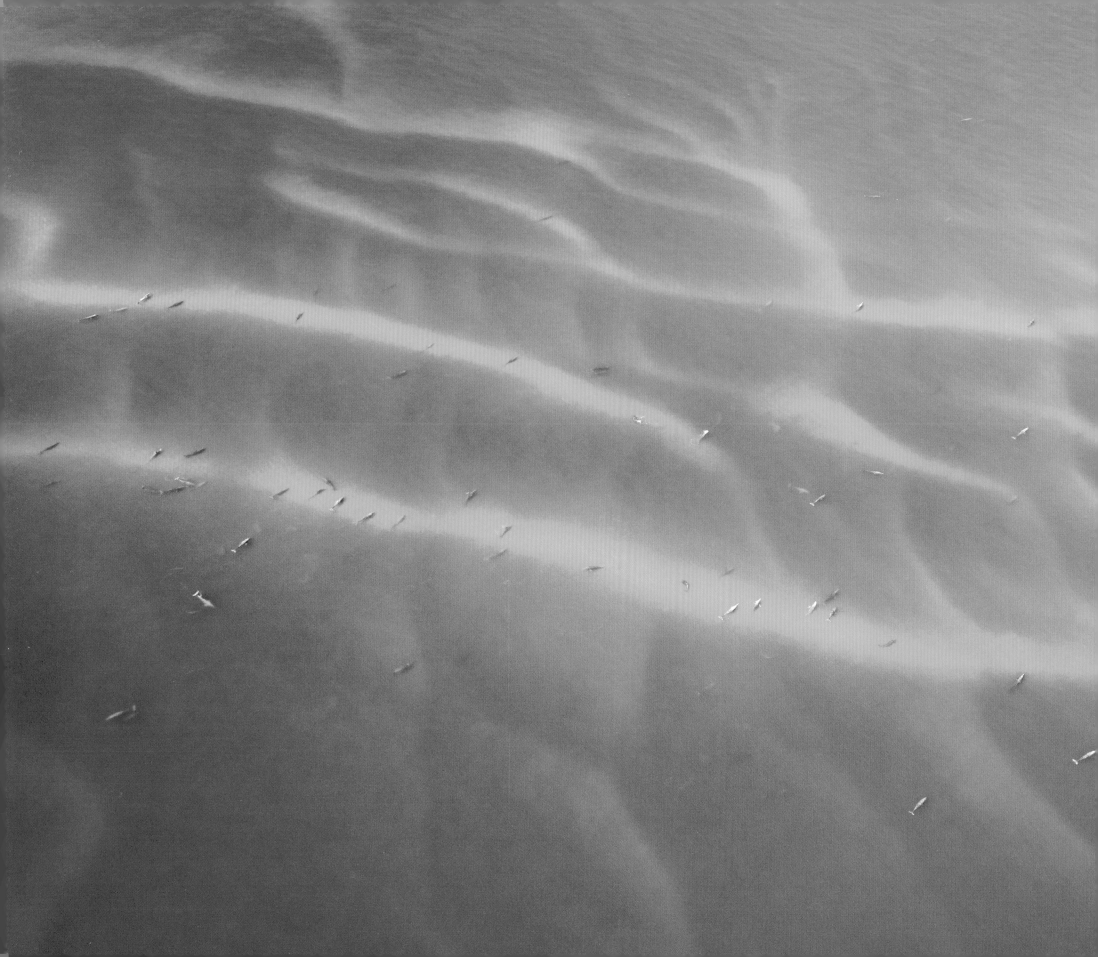

Facing page and above: Aerial perspective of gray whales during their winter congregation in the calving lagoons, Baja California Sur, Mexico

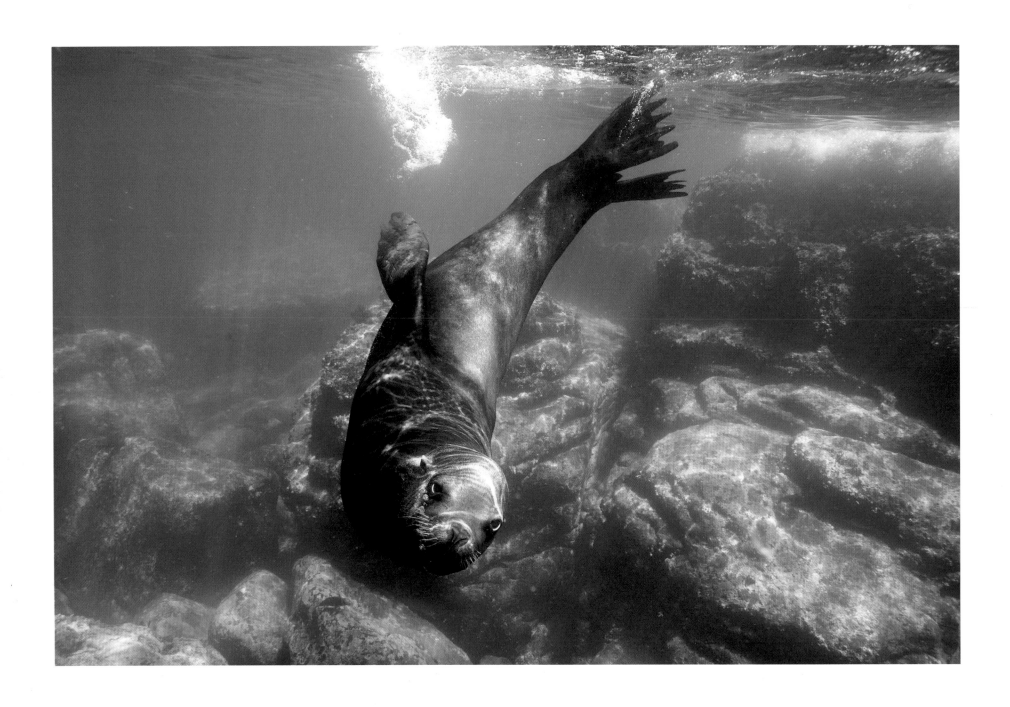

Above and facing page: Sea lions near Isla Espíritu Santo, Baja California Sur, Mexico

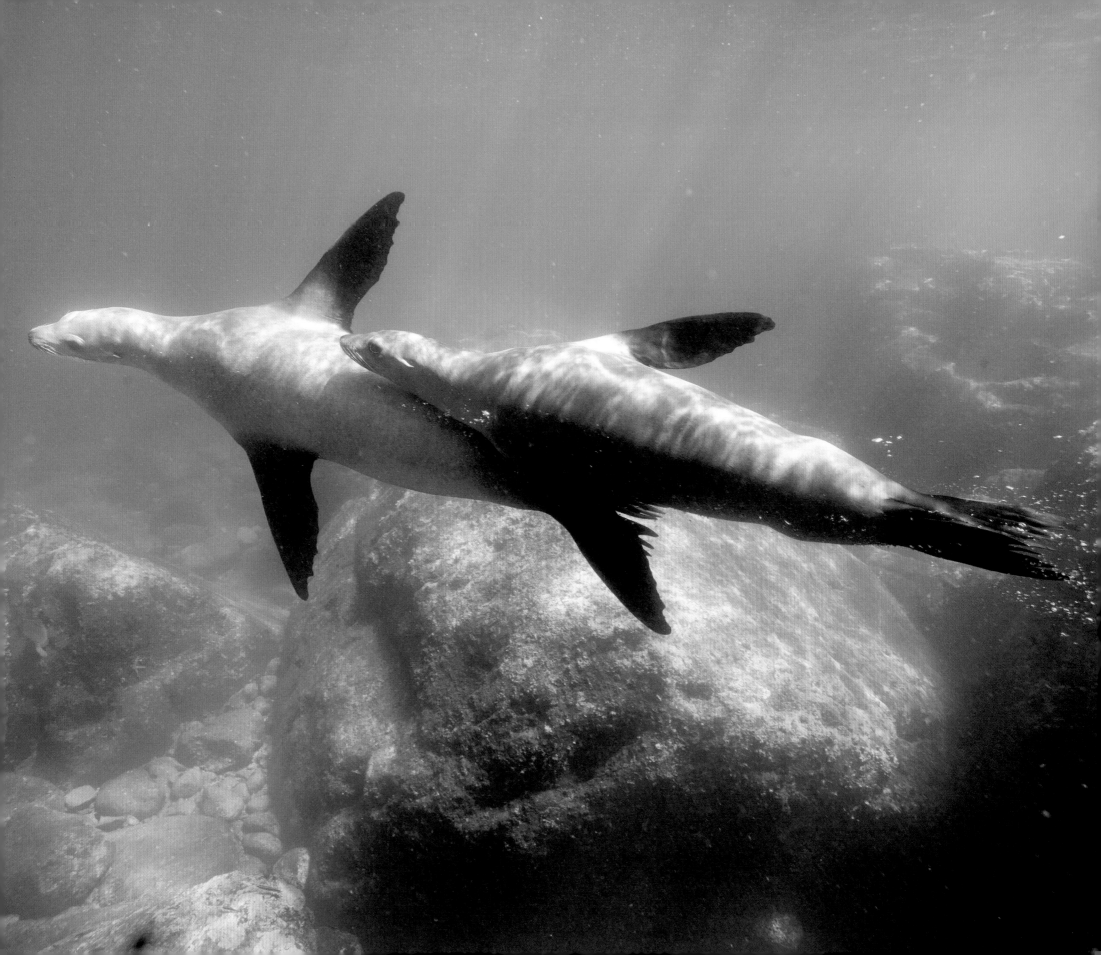

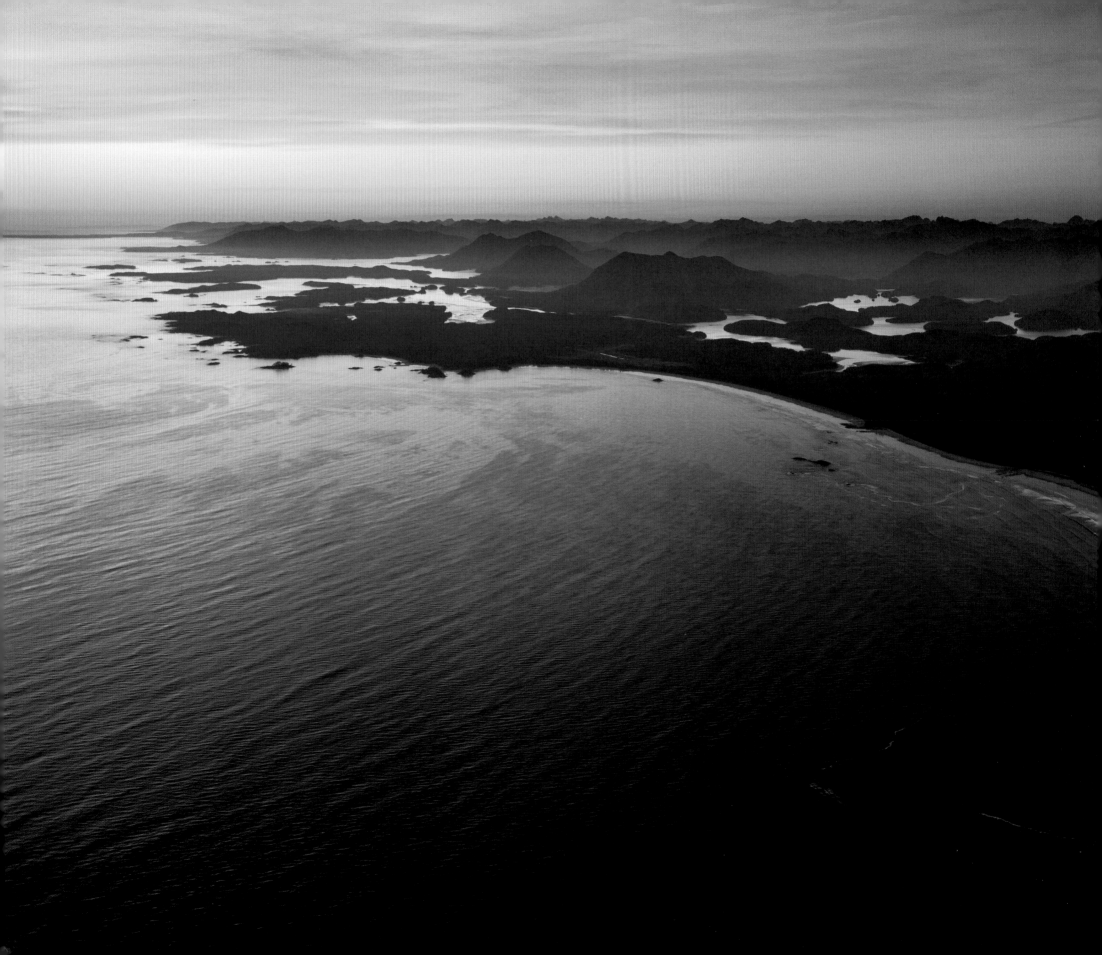

CENTRAL

NORTHERN CALIFORNIA TO
PRINCE WILLIAM SOUND, ALASKA

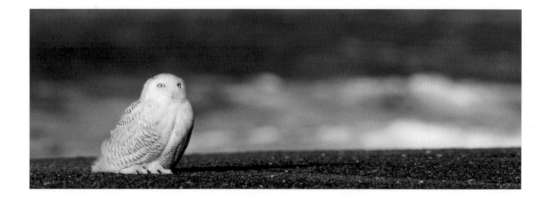

Imagine you are a gray whale, fur seal, or loggerhead turtle following the Baja-to-Beaufort annual migration trail—the conceptual journey we continue in this chapter, starting from Northern California. The underwater landscape will seem reassuringly familiar all the way to Alaska: billowing groves of bull kelp and feathery sea-grass beds, purple sea urchins and orange sea stars, muddy substrate loaded with tasty clams and amphipods.

Left: Sunset glows over Wickaninnish Bay and Long Beach, Pacific Rim National Park. In the background lies Clayoquot Sound, recognized as a UNESCO world heritage site, British Columbia, Canada.

NORTHERN CALIFORNIA TO PRINCE WILLIAM SOUND, ALASKA

But if you are a migrating brant or a carrion-stalking condor, the landscape below is not so constant. North of San Francisco Bay, the scrubby chaparral and sage and gentle hills covered with oaks and laurels give way to something more imposing: the world's greatest conifer forests, the terrestrial equivalent of the kelp offshore, watered by lavish winter rains and anytime fog. Like the kelp, the forests continue north up the Northwest Coast. Unlike the kelp, which grows and then decays like mushrooms, these mighty trees live hundreds, often thousands, of years, drawing and sinking more carbon from the atmosphere, acre for acre, than tropical rain forests.

As we travel north, the trees' names and species change: redwoods in Northern California overlap with Douglas firs, which in turn share the slopes with and yield the bog lands to western red cedar and western hemlock in Oregon, Washington, and British Columbia. These in turn give way to spruce, true fir, and Alaska yellow cedar farther north. But the basic idea—the race to grow tall and catch the precious sunlight—holds throughout.

This forested coast exhibits an extraordinary continuity of temperate climate and life-forms for almost 1400 miles (2250 kilometers), thanks to the two great equalizers: the California and Alaska currents, which form west of Vancouver Island, British Columbia, where the transoceanic North Pacific Drift splits in two. They push south and north, respectively, moderating the climate from the tip of Baja California Sur, Mexico, to just 500 miles (800 kilometers) below the Arctic Circle. The nutrient-rich waters along this continental shelf brim with zoological record holders: the largest octopuses, sea stars, swimming scallops, burrowing bivalves, and moon snails on Earth, to cite just a few examples (though Oregon's coast, beautiful as it is, just isn't as biologically or ecologically rich as California's or Washington's).

Critters grow to jumbo size in the forests as well. In Washington, the Olympic Peninsula's Roosevelt elk is the largest of its globe-spanning species, called red deer in

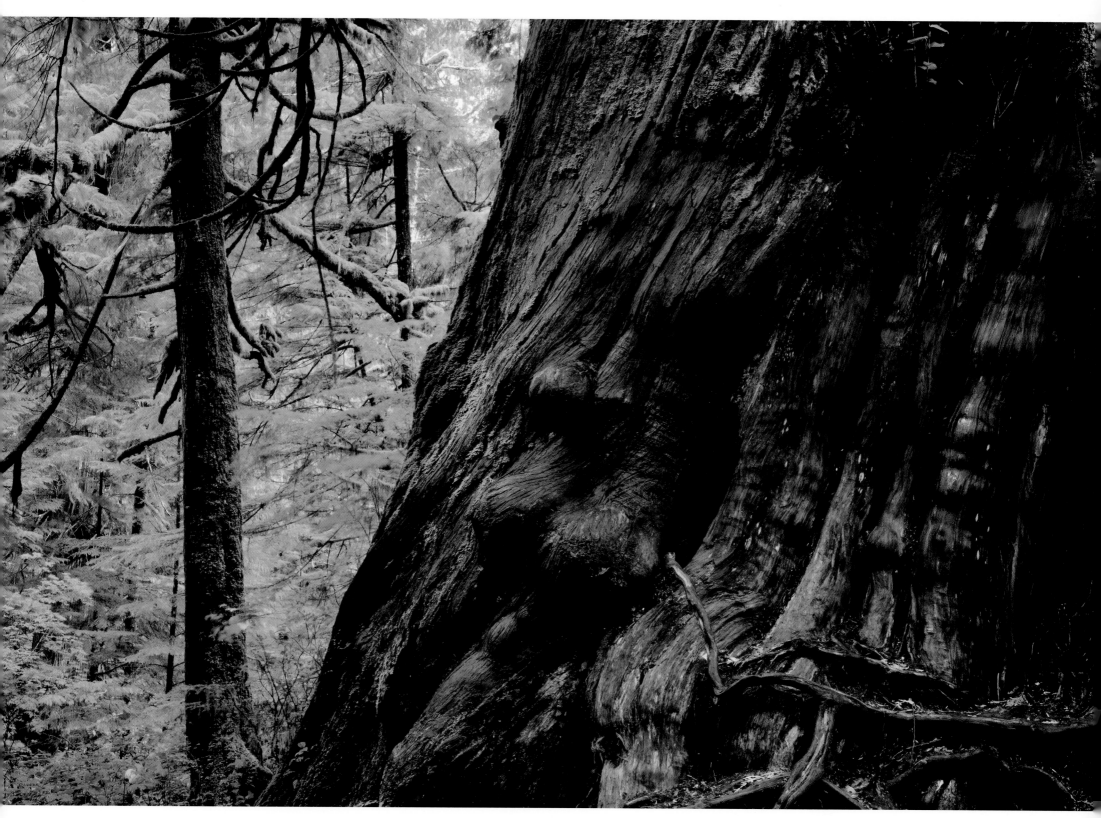

Last stand of old growth in Pacific Rim National Park, Vancouver Island, British Columbia, Canada

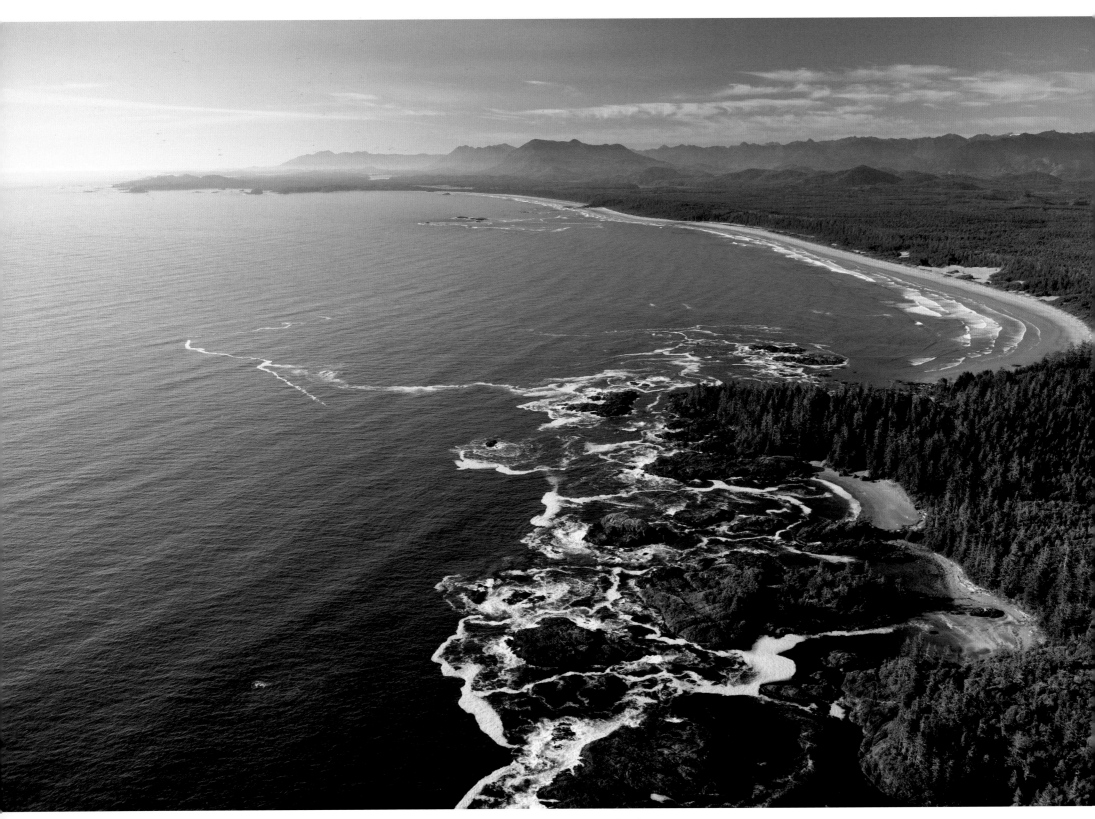

Wickaninnish Bay and Long Beach, Pacific Rim National Park, Vancouver Island, British Columbia, Canada

A rhododendron blooms in the redwood forest of Northern California.

Europe (think Robin Hood) and Asia. The Kodiak, Alaska, brown (grizzly) bears farther north are the largest of their global species, followed by the mainland grizzlies of the Great Bear Rainforest, which covers British Columbia's central and northern coast, from Queen Charlotte Strait to Prince Rupert) in lush, relatively unspoiled conifer canopy. The black bears of Haida Gwaii, also known as British Columbia's Queen Charlotte Islands, outgrow all their mainland cousins, fattening on salmon.

As with size, so with number. The West Coast has a profusion of species compared to the East Coast: five species of salmon, plus oceangoing rainbow (steelhead) and cutthroat trout, versus just one Atlantic salmon. Seven western hummingbirds versus one eastern. Atlantic marine biologists who come west marvel at the Pacific's coastal living riot: dozens of species here in a genus that has only a handful there.

The great forested central section of this coast—call it Cascadia, Ecotopia, the Pacific Northwest—is a land of big fish as well as big trees. Tim Egan, in *The Good Rain,* described the Northwest as "any place a salmon can get

to." That would include most of Alaska: the Yukon River and Kotzebue Sound, at the edge of the Arctic, are rich in kings and sockeyes, and some hardy chums and pinks make it all the way to the Beaufort Sea. Nevertheless, Egan's definition gets at something fundamental. Salmon are essential to the idea, myth, and (decreasingly, alas) experience of living in the Northwest.

I still recall the flash of wonder soon after I arrived in Washington State thirty-five years ago, when I saw for the first time the outsized, outlandishly red hunchbacked migrating spawning salmon thrashing their way up an Olympic Peninsula stream to bury their seed in the gravel and die. It was a rite of passage. I knew I'd arrived.

Most of the millions of tourists who pass through Seattle and the region's other increasingly sophisticated travel meccas never get near such spawning streams. But they still savor another rite: the obligatory grilled fillet of "fresh Northwest salmon," paying homage to this regional treasure. But salmon haven't just shaped the cuisine, culture, and economy of this region. They're unwitting geoengineers, creating and sustaining its forest

ecosystems. No other fish have raised anadromy (the journey from fresh to salt water and back again) to such a level as Pacific salmon.

Migration in the rain forest and coastal mountains is vertical. Elk, deer, and mountain goats range up and down the slopes with the seasons, following the pasture, evading pests and predators, gathering to rut. Salmon likewise must ascend, though only once. Theirs is a migration on the scale of Africa's Serengeti wildebeest or Alaska's North Slope caribou, but radiative rather than en masse. Instead of marching in one great wave or gathering in a single, seething breeding orgy, the salmon spread along the veins and capillaries of every river that human meddling has not blocked or otherwise wrecked. The fish form a biological conveyor belt, transferring energy and nutrients from sea to land. Everything from grizzly bears and eagles to blowflies feast on the salmon as they fight their way upstream or gasp and collapse after a last dash. Even wolves, not known to be fish eaters elsewhere, catch swimming salmon in the Great Bear Rainforest.

KATIE VOELKE

CONNECTING OREGON'S "ISLANDS OF CONSERVATION" BY BONNIE HENDERSON

© Randall Henderson

In the bigger scheme of things, the properties that North Coast Land Conservancy (NCLC) works to preserve on the Oregon Coast are mere drops in the bucket—a reach of stream here, a patch of dunes there, a former rain forest long since logged off and gone to weedy pasture. But therein lies the transformative power of these places: On this accessible coastline, where the economy revolves around tourism and the native landscape is fragmented by hotels, houses, and highways, scattered among these developments are national, state, and county parks—"islands of conservation," as NCLC executive director Katie Voelke characterized them. Connecting those large preserves by acquiring or otherwise conserving smaller tracts of land in between can make all the difference to returning fish, migrating birds,

and all the other animals, from otters to elk, trying to eke out their existence here—not to mention humans who need clean water and value beautiful scenery.

"Because we're local, we know about small but meaningful things you can do to connect the pieces in between," Voelke said. "We literally provide the connections. We're conserving land for its intrinsic value, allowing water to flow and wind to blow and soil to build," she explained. "It's not just about saving the endangered this or that." Given enough time and space, the land and its animal inhabitants can become resilient, she said—to natural or human-caused climate change, for instance. And that's what land trusts do, from the Nature Conservancy with its global reach to little regional conservancies such as Voelke's: they preserve land, in perpetuity.

Voelke grew up in California, where development pressures are even more acute than they are on the Oregon Coast. Her first career, as a field biologist, landed her in the middle of the northern Oregon Coast's Nehalem River, tagging chinook salmon as part of a spawning grounds survey. She began volunteering for the local land trust, hoping to learn more about the salmon life cycle and its role in coastal ecology and culture. Soon she was employed as a land

"Because we're local, we know about small but meaningful things you can do to connect the pieces in between. We literally provide the connections."

steward for NCLC and, three years later, as its executive director. Today she oversees a staff of six and more than a hundred volunteers, many of whom act as site stewards, providing ongoing monitoring of more than a dozen habitat reserves.

"A huge challenge of working in a coastal ecosystem is that the ocean is a significant part of that ecosystem, but there's a lot going on in the ocean that we don't know about and can't influence," Voelke said. The salmon migration is a constant, concrete reminder "that this is one ecosystem: that the land is not separate from the ocean," Voelke continued. "No matter how well we protect that stream, no matter how high-functioning it is, still the salmon have to be able to survive the ocean to be able to come back. And we need them to come back to keep the system working."

But it's not just about the salmon, Voelke said: "We can't know which critters we might be protecting this land for. But what we do know is that life on Earth needs this land."

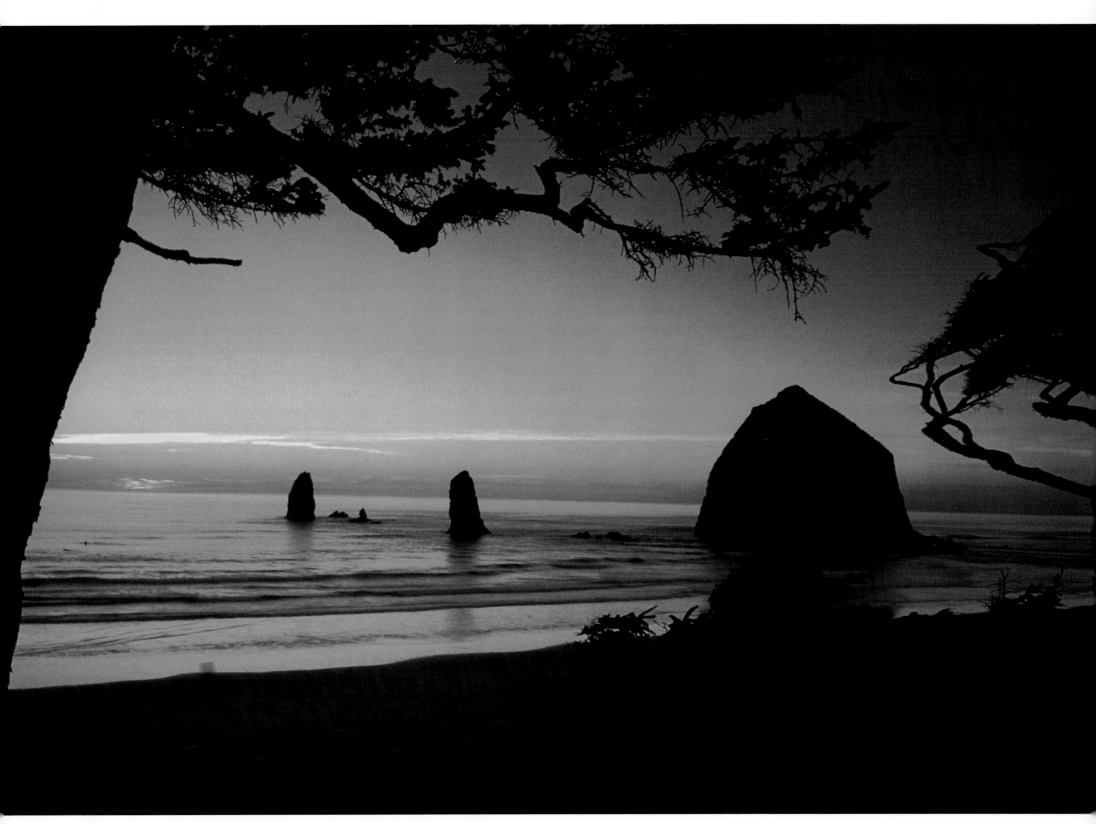

Iconic Haystack Rock is silhouetted against the sunset, Cannon Beach, Oregon.

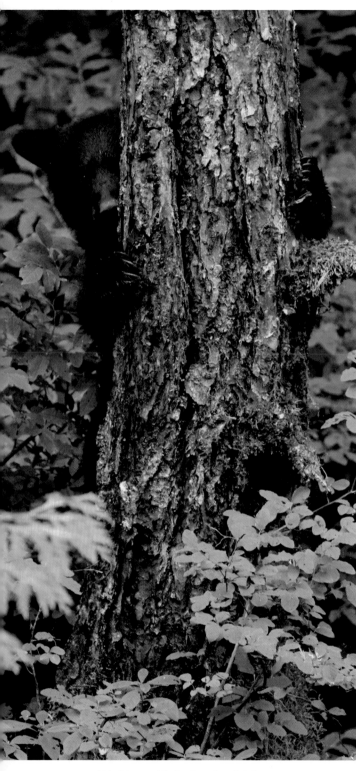

A black bear cub in the Great Bear Rainforest, British Columbia, Canada

The bears and wolves, plus mink, ravens, and river otters, spread the wealth across the forest as scraps, urine, feces, and finally their own carcasses. This sea-born, fish-borne manure fertilizes the trees. The trees in turn nurture and protect the salmon's habitat. Their roots impound spring floods that would otherwise wash out the spawning nests in the riverine gravel and anchor soil that would otherwise wash into the waterways as smothering sediment. Their boughs shade streams from fish-killing summer heat. Their fallen limbs and trunks provide the structure, the quiet pools and eddies, that small fry need to escape fast currents and predators.

At the southern end of the salmon's range, however, this cycle is unraveling. A 2000 study in the journal *Fisheries* estimated that at one time spawning salmon transported close to a quarter million tons of nitrogen and phosphorus up the rivers and streams of California, Oregon, Washington, and Idaho. By the late 1990s, the salmon and their bounty had declined by 94 percent.

At the same time, upstream development has delivered its own body blows: blocking the spawning runs with hydropower dams and fry-shredding turbines, cutting the protective trees for timber, crops, and pasture, and then covering the pastureland with impervious, flood- and pollutant-shedding pavement, roofs, and lawns.

Now an even more pervasive threat is being felt. Conservationists have long spoken of the four Hs of salmon loss: habitat, harvest, hydropower, and hatcheries (which can compete with wild runs and weaken their gene stock). Add to these a fifth H: heat. Biologists used to think salmon could thrive only in water temperatures in the low 50 degrees Fahrenheit (12 degrees Celsius) or below and could not survive anything higher than the mid-60s (18 degrees Celsius). They've since found more variation and adaptability in some runs, but nothing equipping the fish for the temperatures predicted as the climate and landscape change. And not just in sunbaked California and Oregon watersheds; even some Alaska streams are getting too hot in summer for salmon comfort.

The 854-mile-long (1374-kilometer-long) Fraser River, which spills out through the metropolis of Vancouver, British Columbia, is the ultimate salmon superhighway. With no dams to stop them, up to 50 million salmon—more than in any other river system anywhere, representing all five West Coast species—have returned each year to spawn. But the Fraser watershed is also home to two-thirds of British Columbia's 4.6 million people and, more worrisomely for now, an even larger number of homely bark chompers called mountain pine beetles.

This rice-grain-sized beetle is a native species, but it has behaved like an invader from hell since the climate warmed enough to let it winter over instead of dying off. Its larvae are ravaging inland British Columbia's conifer forests, together with their precious shady canopy and soil-anchoring roots. The effects run all the way up the food chain. Half-ton grizzly bears depend on the fat-rich seeds of the whitebark pine, a prime pine-beetle target. The withering forests, plus the same rising temperatures that coddle the beetles, are making even the dam-free Fraser less hospitable to salmon. In 2014 fisheries officials predicted a record return of sockeye there, but you have to look past the often-dramatic yearly fluctuations. Depending on species, the numbers of salmon returning to the Fraser have been declining for a decade in the case of pinks, two decades for sockeye, five for chinook. The effects extend beyond the Fraser watershed—beyond even the saltwater fishermen who depend on returning Fraser fish for their livelihoods.

As you move north up British Columbia's crenulated coastline the woes of the inland forests can seem far away. Will pine beetles make their way west over the Coast Mountains as summers get drier and hotter? So far they haven't, and ancient firs and cedars still droop lushly over uncountable foggy inlets.

This Great Bear Rainforest is the realm of an unusual bear indeed—the ghostly "spirit bear," a subspecies of

THE SAN JUAN ISLANDS AND THE SALISH SEA

The American San Juan Islands and the Canadian Gulf Islands are the crossroads of the Salish Sea, which encompasses the inland waters of Washington and British Columbia, from the southern tip of Puget Sound to the north end of the Strait of Georgia and west out the Strait of Juan de Fuca to the Pacific Ocean. Currents swirl from three directions around the islands, stirring a biological cauldron.

Perched between the hypermodern metropoli of Seattle, Washington, and Vancouver, British Columbia, and uneasily encircled by busy shipping routes, these island gems and the waters around them have, so far, led a charmed life. Everyone who lives on or visits them has indelible postcard memories. Supersized Steller sea lions roar and jostle for space on Race Rocks outside the Victoria, British Columbia, harbor. Nine bald eagles perch like soldiers on a San Juan Island fence waiting for a hay cutter to turn up tasty field mice. And, trumping every other sight, an orca that suddenly leapts and seems to fly, just 30 yards (27 meters) offshore, past the beach where I sat at the island's northwest end.

The eighty-odd orcas that scientists call "southern resident orcas" spend their winters who-knows-where in the Pacific Ocean but pass the warmer months very much in sight in the Salish Sea. Sometimes they thrill ferryboat riders from downtown Seattle. Usually they stay farther north, chasing the Fraser River–bound salmon whose calories they desperately need to gestate and nurse their young. They subsist exclusively on fish, particularly fat-rich chinook salmon, which sets them apart from the less-studied bands of transient orcas that stalk the coast like wolf packs, hunting marine mammals.

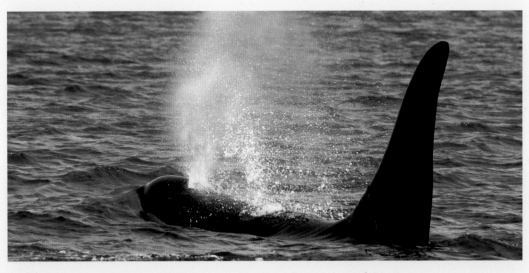

A member of a southern resident orca pod travels through the Salish Sea near Vancouver Island.

Scientists and whale watchers have long debated why the southern resident orcas' recovery, which began in the 1970s after marine shows stopped catching them, has faltered and reversed. New findings by ace conservation biologist Sam Wasser and his colleagues at the University of Washington may finally settle those debates. These metro-whales are starving, aborting the babies they can't feed, and releasing the PCBs and other toxins stored in the body fat they now must burn. Noise from whale-watching boats and other engines seems to sharpen their troubles by jamming the sonar they use to track fish. But the basic problem is lack of salmon. It's a stark example of the way land and sea are joined and of the importance of the migration corridors that tie them together—in this case a 1000-mile (1600-kilometer) salmon trail, from the open ocean to the Fraser watershed's upper reaches.

Local orca lovers and conservationists lobbied for years to have the waters around the San Juan Islands designated as a national marine sanctuary, on the model of California's Monterey Bay and Washington's Olympic Coast sanctuaries, or, when that failed, as a state marine reserve. But their efforts crashed against fishermen's and other islanders' fears of outside government meddling: "Don't let the feds in!" as one islander put it to me. Those fears, together with hopes that sanctuary status would be a magic bullet, may be overblown, since designation doesn't in itself prohibit fishing or any other activities. Sanctuaries, like national forests, are managed for "multiple use," and only a minority of the thirteen nationwide contain fully protected reserves. So the San Juans' defenders now look elsewhere for protection, while conservationists lobby to give the National Marine Sanctuaries Act more teeth.　　　　—E.S.

JULIA PARRISH

© BENJAMIN DRUMMOND

In late November 2013, residents of Saint Lawrence Island in the northern Bering Sea noticed a sudden surge of dead seabirds on the island's northern beaches. Three carcasses—a thick-billed murre, a northern fulmar, and a crested auklet—were found to have avian cholera, a deadly disease never before seen in Alaska and one that can spread quickly among birds in crowded conditions. It turns out that virtually the world's entire population of spectacled eiders spends the winter

huddled together in a *polynya*—an area of open water surrounded by sea ice—immediately south of the island. Had those sea ducks been infected? Should they be hazed, scattering them and potentially saving them from extinction, or could such hazing do more harm than good?

That's when authorities phoned biologist Julia Parrish, associate dean in the University of Washington's College of the Environment and founder of Coastal Observation and Seabird Survey Team (COASST), a citizen science program that trains volunteers to document the occurrence of dead birds on Pacific Northwest beaches.

"My part was to try and make a reasonable estimation of what size disaster we're seeing," Parrish recalled. "Is this just a few birds? Is this a lot? And this was all happening in real time: not 'we'll get a graduate student to work on this and get back to you in six months.' They needed an answer in two hours." Ultimately wildlife officials chose—correctly, in hindsight—to not haze the ducks. That incident, Parrish said, highlights what she loves about citizen science: "It pulls you into the real world."

Citizen science programs vary widely, but most use volunteers—typically adults or youth interested in learning more about the

natural world—to gather data or otherwise collaborate with professional scientists to further scientific research. COASST traces its beginnings to a 1991 oil spill off Cape Flattery, at the northwest corner of Washington State. Parrish was there doing field studies when a freighter collided with a fishing vessel. The spill she witnessed was locally devastating; some 4300 oiled, dead seabirds were collected on beaches from Vancouver Island, British Columbia, to northern Oregon. But, Parrish wondered, exactly how devastating was it? It isn't unusual to find seabirds dead of natural causes on the beach at certain times of year; how many more than normal died in this disaster? With no baseline data, there was no way to know.

So Parrish set out to establish that baseline. In 2000 she recruited and trained a dozen volunteers at Ocean Shores, Washington, to conduct monthly dead-bird counts, and she hired a team to scrutinize, confirm, and compile their reports. COASST has since grown to a cadre of nearly eight hundred hundred "COASSTers" scattered from Northern California to Kotzebue, Alaska, north of the Bering Strait. Collaboration with a sister program, the British Columbia Beached Bird Survey, fills the gap on the

"Most COASSTers monitor their beach because they love the beach: it's their place."

Canadian coastline. "Most COASSTers monitor their beach because they love the beach: it's their place," Parrish said.

Having witnessed both the enrichment COASST provides its volunteers and the value of the data they collect for conservation and natural resource management, Parrish is now working to apply the COASST model to documenting the incidence and potential harm of marine debris on Northwest beaches. That project has been made possible with a $2.7 million grant from the National Science Foundation—one of the largest ever awarded to a citizen science program.

"COASST is giving me all of these amazing life lessons: about people and why they are engaged and involved, and about science and how we should think about science education and science literacy," Parrish said. "Science is a team sport." She now lists citizen science ahead of seabird ecology as her primary research interest.

"COASST has affected me as much as I've affected COASST," Parrish said. "It's been a wild and wonderful ride."

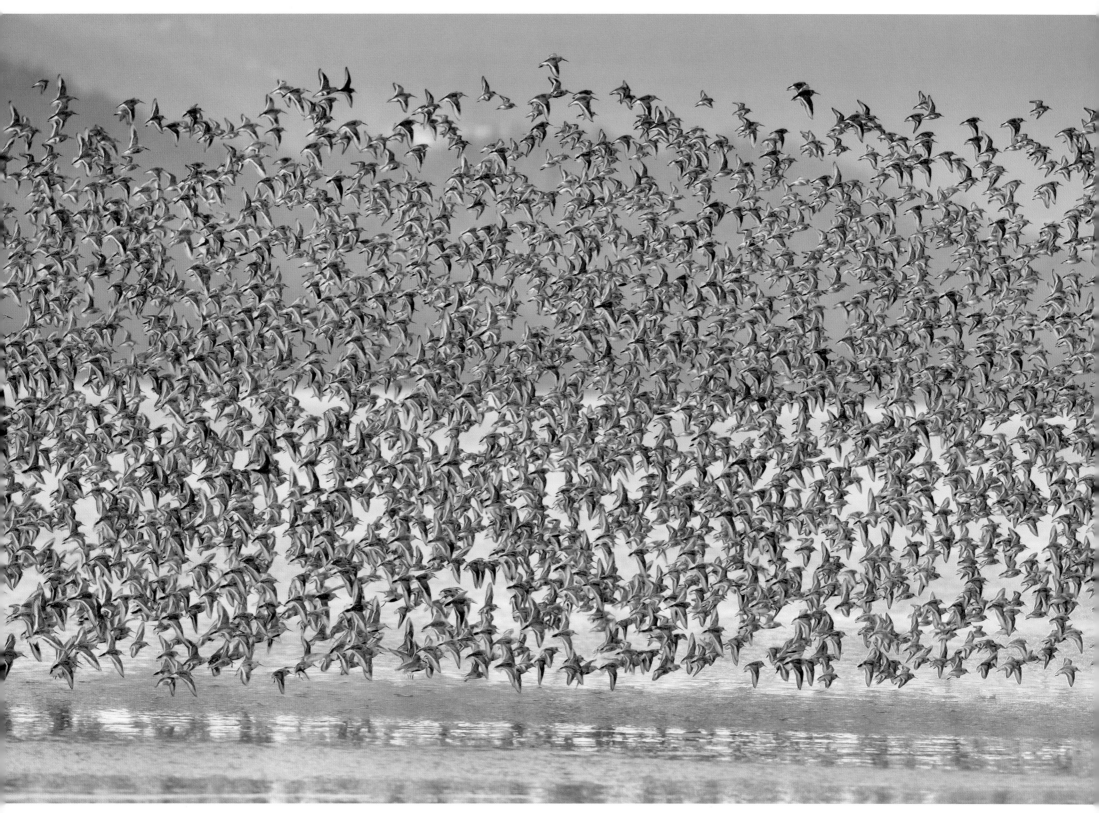

As summer approaches, millions of sandpipers and other migratory birds become restless and begin their migration north toward their Arctic breeding ground.

This Great Bear Rainforest is the realm of an unusual bear indeed—the ghostly "spirit bear," a subspecies of the common black bear that is unique to this coast.

the common black bear that is unique to this coast. Improbable as its creamy white coat may seem, it's actually adaptive. "Spirit bears" fare better than their dark brethren at catching salmon, which don't see them against the cloudy skies.

The trees are ancient but the forests aren't, though they seem eternal and unchanging. These forests, and the landforms they grow on, date back only about twelve thousand years, when the last ice-age glaciers retreated. They're hardly older than the first human artifacts found in the Americas and much younger than those found in Europe and Africa.

East of the coastal and inland forests, and of the Rocky Mountains that backstop them, lies a much older trove of sunk carbon, in the tar sands (or, as the petroleum industry prefers to call them, "oil sands") of Alberta, Canada. These sands hold an estimated 1.8 *trillion* barrels of tarry bitumen, of which about 9 percent is deemed "proven" (currently extractable), the third-largest reserves in the world after Saudi Arabia's and Venezuela's. The Albertan and Canadian governments want to ship this oil somewhere other than the United States, which, flush with its own hydrocarbons, pays only bargain prices. Short of running a pipeline all the way across Canada to an Atlantic port, that means sending it through British Columbia's forests and the waters beyond.

In 1969 and 1989, the Pacific Coast suffered what were then the biggest offshore oil spills in US history—California's Santa Barbara drilling-platform blowout and the grounding of the *Exxon Valdez* in Alaska's Prince William Sound, respectively—though both pale when compared with British Petroleum's 2010 *Deepwater*

Horizon disaster in the Gulf of Mexico offshore of Louisiana. Otherwise, the thousands of miles of coastline between California and Alaska have been remarkably free of major spills. What spilled in the next-most notorious incident, the 1999 grounding of the freighter *New Carissa* off Coos Bay, Oregon, was less than a thousandth of the oil that one of today's tankers can carry.

Such records are made to be broken. Two major pipeline operators are seeking to build their own hydrocarbon migration corridors through British Columbia's forests and mountains, in order to pump diluted bitumen (dilbit) from the tar sands to the tankers. Texas-based Kinder Morgan wants to build a second, larger pipeline paralleling the southern one it already operates from Alberta to Burrard Inlet in the busy heart of Vancouver. To the north, the Canadian firm Enbridge wants to punch an all-new "Northern Gateway" route through the Great Bear Rainforest and turn remote Kitimat into a major oil port. Conservationists and communities along the route look at the sorry record of ruptures, leaks, and other spills along pipelines in India, North Dakota, Michigan, Alaska's North Slope, and, most recently, Los Angeles. And they worry what damage the acidic, abrasive dilbit will do to pipeline walls. (Nothing untoward, Kinder Morgan contends.)

The First Nations bands along Enbridge's proposed route appear to have the strongest legal leverage for blocking Northern Gateway. If they persevere and succeed, their success will only reinforce the pressure to build Kinder Morgan's southern line. Anxious dwellers on the San Juan Islands and elsewhere along the already busy Lower Georgia, Haro, and Juan de Fuca straits will watch a new parade of jumbo tankers pass their beaches, wondering which might be the next *Exxon Valdez.*

Southeast Alaska, the "Alaska Panhandle," is a labyrinth of islands, fjords, peninsulas, and straits—life-giving margins, all of them, a cornucopia of marine life, not just for the fishermen of Ketchikan, Petersburg, and Sitka but for regions far to the

west. The prevailing currents sweep up larvae hatched here and carry them around the Gulf of Alaska to Kodiak Island and the Aleutians, seeding new life, another great conveyor at work.

British Columbia's Great Bear Rainforest continues north into Southeast Alaska, under the more prosaic name Tongass National Forest: 17 million acres (nearly 7 million hectares) of wetlands, icefields, tundra, and, mostly, dense old-growth red cedar, hemlock, and Sitka spruce forest, sheltering abundant wolves, grizzlies, black bears, and of course salmon, as well as the endangered marbled murrelet and distinctive Sitka black-tailed deer. For decades, the Tongass, the United States' largest national forest, has been a main battleground among timber companies, federal policy makers, and environmentalists. About a third of its area, including some but far from all of the Tongass's remaining old-growth forest, has been preserved as wilderness, and potential logging has been deferred but not necessarily foreclosed on much that remains.

British Columbia's Coast Mountains also lead north, into Southeast Alaska's even loftier Saint Elias Range, North America's second-highest peaks, which in turn lead to the Alaska Range and the highest peak of all, Denali (Mount McKinley). Washington's North Cascades, at the other end of this coastal super-range, are the youngest, steepest, most jagged peaks in the Lower 48. But they're well-worn foothills compared to these more northerly mountains.

Mountains, ice, and sea meet at Glacier Bay, at the north end of the Alaska Panhandle—though there is less ice than in past years. Once Glacier Bay was indeed a glacier, covered to its mouth in ice. But the ice started retreating in the eighteenth century, driven back by warmer temperatures, diminishing snowfall, and more summer rain—a process that has accelerated with the addition of smokestacks, tailpipes, and other human-created carbon emissions. Today Glacier Bay is an open fjord for some 60 miles (95 kilometers)—a fertile bonanza for the humpbacks, blue, fin, and gray whales

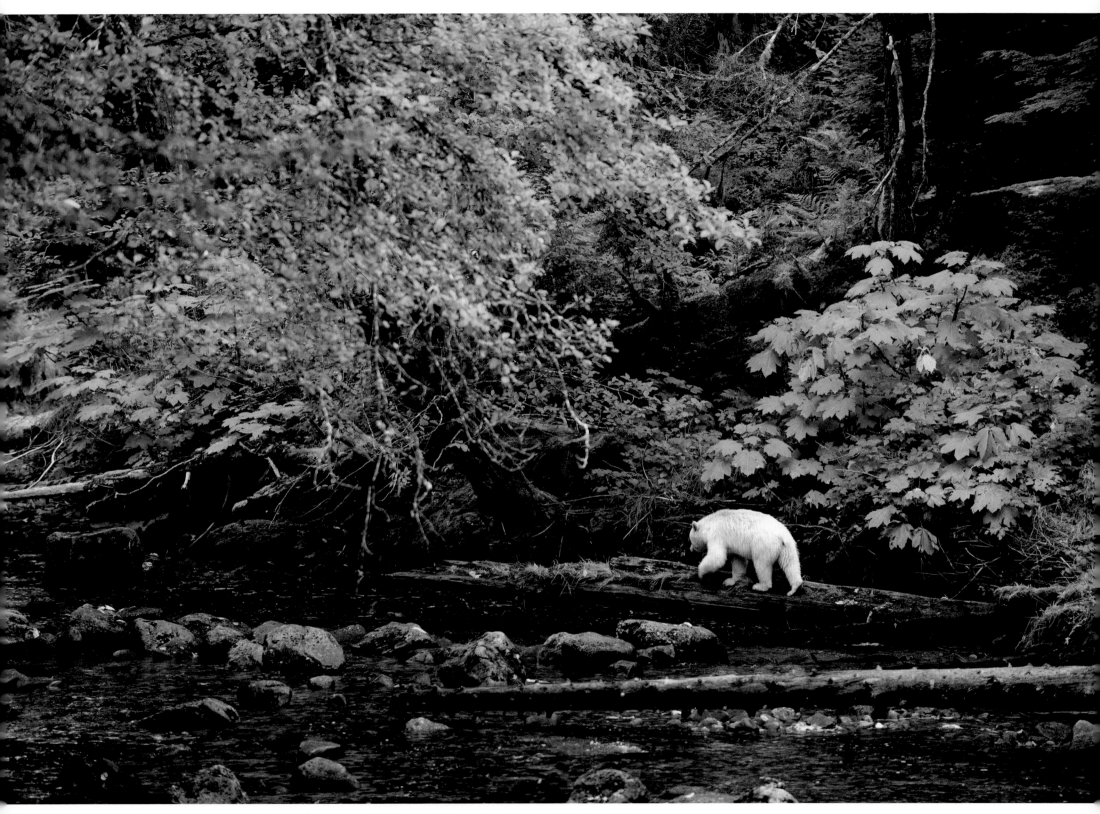

A spirit bear, also known as a Kermode or ghost bear, in the Great Bear Rainforest, British Columbia, Canada

Queen Charlotte Strait, which separates the north end of Vancouver Island from the British Columbia mainland, is a crossroads of currents and of the creatures that travel them. Blue, humpback, gray, and minke whales forage in its waters. The fog-shrouded Scott Islands, just west of the strait, host one of the world's largest colonies of Steller sea lions, which have far fared better here than the Aleutian Islands to the west. But it's the birds that make these five rocky isles extraordinary.

Together, these little islands compose British Columbia's most important seabird breeding ground. Two million seabirds arrive each year from as far away as Japan, Chile, and Australia, including endangered black-footed albatrosses and marbled murrelets, about 26,000 breeding pairs of tufted puffins, 40,000 pairs of rhinoceros auklets, and, on Triangle Island alone, 400,000 pairs of Cassin's auklets, more than half the world population. As they squawk and clatter in their multitudes, their islands, so silent in winter, become one of the noisier unplugged places on Earth.

The five islands themselves are protected as ecological reserves or provincial parkland, but the waters surrounding them are not. Conservationists have clamored for years for similar protection for these waters, to ensure the forage fish the birds need and to safeguard the birds against longline fishhooks and oil spills. In 2000 the Canadian Wildlife Service initiated the process for establishing Canada's first pilot marine national wildlife area around the Scott Islands. Now it's up to the government to complete the designation and fund protection for these vital waters.

Steller and California sea lions lounge on the rocks in the Broken Islands of Pacific Rim National Park, Vancouver Island, British Columbia, Canada.

STRAIT AND SOUND

GLASS-SPONGE REEFS

Just north of Queen Charlotte Strait, in Queen Charlotte Sound, lies another treasure. In the late 1980s, scientists unexpectedly discovered an entire "fossil ecosystem," previously thought to have gone extinct with the dinosaurs. This was a glass-sponge reef: 70-foot-tall (21-meter-tall), cream- and orange-colored spires of brittle immobile animals that look like whipped meringue, filtering water and sheltering fishes just as coral does. Glass sponges show up here and there around the globe, but nowhere else were they known to have formed reefs in the last 66 million years.

Since the late 1980s, divers and submersibles have cataloged sponge reefs across hundreds of square miles of Queen Charlotte Sound and in the Strait of Georgia, even offshore from teeming Vancouver. In 2005 they found yet more reefs 30 miles (48 kilometers) off Grays Harbor on Washington's southwest coast.

Queen Charlotte Sound's reefs lie in protected waters. But those in the strait are unprotected and, like corals, ordinary sponges and so many other structures in the depths of the oceans, are routinely smashed by trawlers raking the bottom for fish and shrimp. In the Indian Ocean, bottom trawling has driven the coelacanth onto the endangered list. Will it obliterate these ancient deepwater fairytale forests?

—E.S.

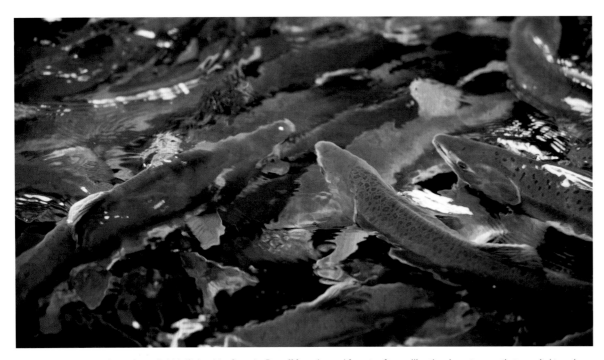

Salmon enter a spawning stream, British Columbia, Canada. Runoff from logged forests often sullies the clear streams that are vital to salmon.

that forage here and in Sitka Sound, Prince William Sound, and other sheltering, nutrient-rich bays and channels along Alaska's south-central coast.

The cavorting humpbacks are a special treat for the cruise-ship passengers who come to ogle whales and the icebergs that still calve off Glacier Bay's seven active tidewater glaciers. Unfortunately, the attraction is sometimes a fatal one—for the whales. In 2009 the jumbo cruise ship *Sapphire Princess* pulled into harbor in Vancouver, British Columbia, after an Alaska tour, with a dead fin whale—the largest animal on Earth after the blue whale—splayed, *Pietá*-like, across its scooped bow. The next year the same princess killed a humpback near Juneau, Alaska.

No one knows how many whales are killed by ships around the world. Those who monitor such strikes are sure of one thing, however: many more die than the hundreds that have been recorded. Often they go unnoticed, like the *Sapphire Princess*'s grisly trophy. Others may go unreported. Of those that do get noticed

and reported, fin whales are the most frequent victims, followed by humpbacks.

Humpback whales have rebounded since commercial whaling ended in the 1960s. The United States and Canada are considering delisting or demoting them from their endangered lists. Fin and blue whales have not recovered nearly so well, however (though the blues seem to be doing better in the eastern Pacific than elsewhere in the world), and ship strikes are a likely reason. This may reflect differences in their migration patterns: Migrating fins and blues tend to hug the continental shelf, where ship traffic is heaviest. Humpbacks undertake long cross-ocean migrations from the waters off Hawaii and the Philippines to Alaska, traveling where ships are fewer.

Establishing marine reserves where whales breed and feed is well and good, but the whales will still die when ships strike them as they migrate among reserves. And so will dolphins, seabirds, turtles, and seals that get caught in fishing nets or snagged on

longlines—brutally efficient commercial fishing lines that may stretch for miles and hold thousands of hooks.

Such conflicts arise not only when human activities collide with other animals' movements on the water but when human uses collide with each other. It's remarkable how easily conflicts can be resolved, though, once the will is mustered. For decades, crab fishermen and tug and barge operators along the coasts of Northern California, Oregon, and Washington caused each other no end of trouble and expense. The tugs' propellers snagged the crabbers' lines, forcing costly engine repairs, costly downtime, and considerable hazard. The crabbers lost millions of dollars in pots and more in fishing opportunities.

A marine extension program called Washington Sea Grant (which, let it be disclosed, I work for) has mediated a series of agreements between the two sides that rationalized the haphazard allocation of sea space. The tow operators traded old shipping lanes that were wider and farther offshore than they needed, plus unused spur lanes into inactive Oregon ports, for safer, more fuel-efficient lanes nearer shore. The crabbers gave up some fishing areas but gained more ground than they lost. More important, both parties escaped the danger and expense of tangled traps.

Such agreements are ad hoc examples of marine spatial planning, a process that's gaining new currency on American and other shores. Marine spatial planning is somewhat analogous to zoning on land: it entails inventorying and mapping various uses of ocean space (conservation being one "use," along with fishing, industry, recreation, and energy development) and then negotiating allocations to minimize conflicts.

The whales that migrate from the Baja Pennisula to the Beaufort Sea had no seat at the table when the crabbers and towboat operators worked out their plans. But they and other migrating animals can, and must, be considered if marine spatial planning is to live up to its name. As the tow-lane negotiations show, the accommodations required can be small and the payoff big. ∎

DAVID HARSILA

Third-generation fisherman David Harsila has been chasing salmon in Washington State's Puget Sound for forty years—a period corresponding with a steady decline in the number of wild salmon. It's a trend that started long before Harsila's time, with overfishing by early settlers, construction of dams that blocked salmon from returning to their spawning beds, near-extermination of beavers and resulting disappearance of the salmon-friendly wetlands they create, and degradation of the fish's habitat—"turning rivers into ditches," as Harsila put it. The road ahead remains rocky for restoration of wild salmon in Washington. But Harsila, cofounder of the Puget Sound Salmon Commission, also sees cause for optimism.

One big reason: better understanding of salmon's life cycle and habitat needs. Harsila said, "Many years ago the science wasn't quite there. And now what I see is some pretty solid science in regard to salmon." Take hatcheries, for example: once perceived as salmon's salvation, they're now considered detrimental to wild salmon runs. "The gene pool just shrinks," as Harsila put it, "and they don't do well." Research has also underlined the necessity of quality habitat: clean, complex rivers and creeks and off-channel wetlands where

"We did a lot of damage to rivers and streams by paving all the way to the bank. All of a sudden somebody said, 'Gosh, salmon need that habitat!'"

adult salmon can spawn and juvenile salmon can grow up before heading to the ocean. "We did a lot of damage to rivers and streams by paving all the way to the bank," Harsila said. "All of a sudden somebody said, 'Gosh, salmon need that habitat!' We had cleaned out all the debris in the rivers; now they're putting the debris back in: big, huge trees with roots, where the fish can hide, and trees that shade the water and keep it cool." Already there are some success stories in Puget Sound: the Green River, for instance, once devoid of salmon, now has 1 million or more pink salmon coming back every two years to spawn.

Most surprising of all—something Harsila said he never expected to witness in his lifetime—was the removal of two dams on the Olympic Peninsula's Elwha River beginning in 2011. "They said it would take many years for the accumulated silt to wash out of the river before salmon can spawn again," he said, "but it happened so fast, it was just shocking: so many fish going up above the dam site and spawning successfully."

© BONNIE HENDERSON

As a young fisherman, Harsila didn't think much about conservation—"Fish are fish, right?" he recalled thinking. "But when your fisheries fail, and then the fish runs fail, and the fisheries fail more, you either get out of the business or you start sitting down and thinking about what you can do." Things such as, in 1995, helping to organize the local fleet to create the Puget Sound Salmon Commission, which supports habitat restoration, educates consumers about sustainable fisheries, and helps local fishermen market their product directly to consumers.

"Around the world, fishermen began as fisheries resource extractors and found that these resources are finite and can be overexploited," Harsila said. "Today many fishermen are charged with being stewards of their fisheries. Fishermen have to bear the responsibility of becoming good resource managers." For Harsila, it all begins with the salmon themselves.

"We touch these fish a lot, and we see them up close, and I think we wind up just loving these fish and becoming passionate about them," he said. "You want to save them. You want to keep them going.

"From where I sit, I see that people who care about salmon keep on working to get it right until they die," he continued. "I'm probably one of those people."

IAN McALLISTER

© TIM McALLISTER

Ian McAllister came of age on Vancouver Island, British Columbia, in the late 1980s, when environmentalists were struggling to preserve the last remaining stands of old-growth forest on the island, the rest having long since been logged off. Then he made his first trip north, up the province's remote mainland coastline to what's become known as the Great Bear Rainforest: 25,000 square miles (40,000 square kilometers) of virgin forest, where grizzly bears and wolves roam among thousand-year-old cedars; where salmon run up clean, barrier-free streams; a place of uninhabited islands and islands populated by First Nations people with thriving cultures and living, indigenous languages. The Great Bear was among the largest intact tracts of temperate rain forest in the world when McAllister first visited in 1989, yet it was, as he put it, "very threatened, unknown, undocumented, and without any real conservation attention." Instantly he was hooked. Within a few years he had moved to a tiny island off the coast and begun working to conserve the Great Bear Rainforest. "I haven't really looked back since," he said.

As an author, filmmaker, and photographer, working in collaboration with scientists and his First Nations neighbors, McAllister has helped to publicize threats to the Great Bear and pique the concern of policy makers, most recently through Pacific Wild, a nonprofit conservation organization he and his wife, Karen McAllister, founded. Those efforts have paid off. Years of highly charged negotiations among loggers, Native people, conservationists, and government entities concluded in 2006 with an agreement that banned logging in one-third of the Great Bear and required that logging elsewhere in the forest be conducted in a sustainable manner. Since then, additional agreements have been crafted to create more habitat reserves and to further protect the forest's remaining old-growth groves.

Today there is a new threat, stemming from the worldwide demand for fossil fuel. Construction of shipping terminals for liquefied natural gas and crude oil have been proposed at Kitimat, a deepwater port at the end of the long fjord of Douglas Channel on the Inside Passage, off the Great Bear's northern coast. A pipeline would be laid across that virgin forest to the water's edge, where supertankers would fill up on black gold from the Alberta tar sands and head out to Asia-Pacific markets.

The risk of damage to the forest and the marine ecosystem from an oil spill is just one concern. To thrive, McAllister pointed out, the fish and marine mammals of the Inside Passage need another natural resource incompatible with industrial-scale shipping: silence.

"We have some of the least acoustically polluted waters on the planet," McAllister

We're 100 percent committed to this part of the world. Keeping this place whole and functioning is our life's pursuit."

said. He and his colleagues have been deploying underwater hydrophones to document and measure the ocean's ambient sound quality. "Increasingly, science is telling us that the reason acoustically sensitive species—which could include salmon, herring, and of course whales, porpoises, and dolphins—are here and are returning in historic numbers is probably because they can still communicate and forage and reproduce without having to scream over the din of shipping traffic," he continued. "That's why we're trying to develop science-based tools to propose acoustic refuges for marine mammals and other species."

The British Columbia coastline is a world treasure, McAllister said: "You can't find a single intact watershed over 5000 acres (2000 hectares) in size between Northern California and the Great Bear Rainforest. We're 100 percent committed to this part of the world. Keeping this place whole and functioning is our life's pursuit."

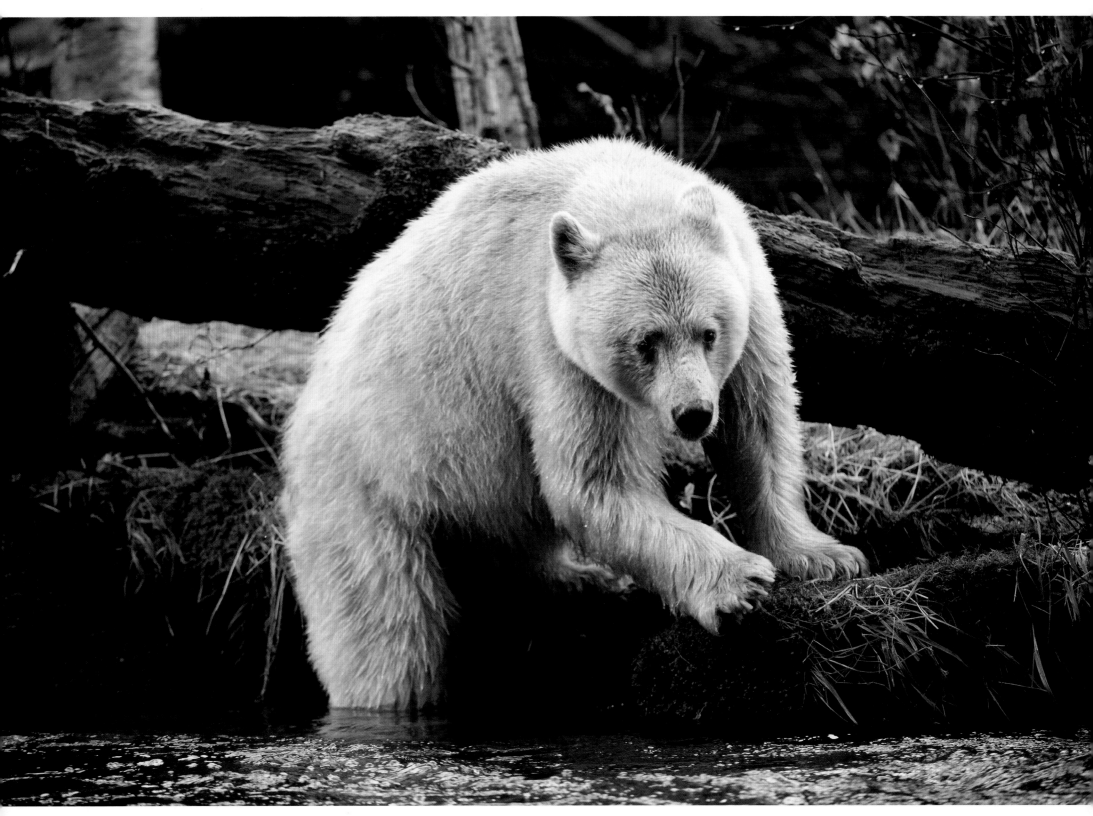

Spirit bears are actually black bears that have white fur due to a recessive gene, Great Bear Rainforest, British Columbia, Canada.

NOTES FROM THE PHOTOGRAPHER

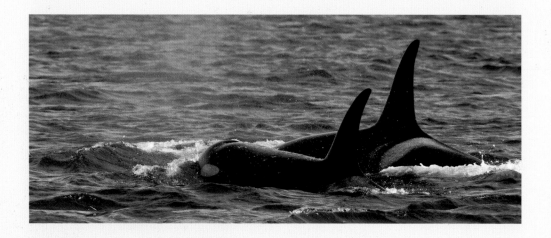

PACIFIC NORTHWEST OLD-GROWTH FORESTS:
ORCAS, SALMON, AND OWLS

I am on Bainbridge Island, on the Olympic Peninsula of Washington State. With my laptop in front of me, I am gathering my thoughts to write for the book you have in your hands. It is a warm, sunny day in May, and I see bald eagles delivering an air show outside. Again and again, my eyes wander across Puget Sound to Seattle and the Cascade Mountains beyond. This area has become a second home to me. It is a great base camp for my expeditions to the wilder parts of the continent,

Right: Sunset at Shi Shi Beach, Olympic National Park, Washington

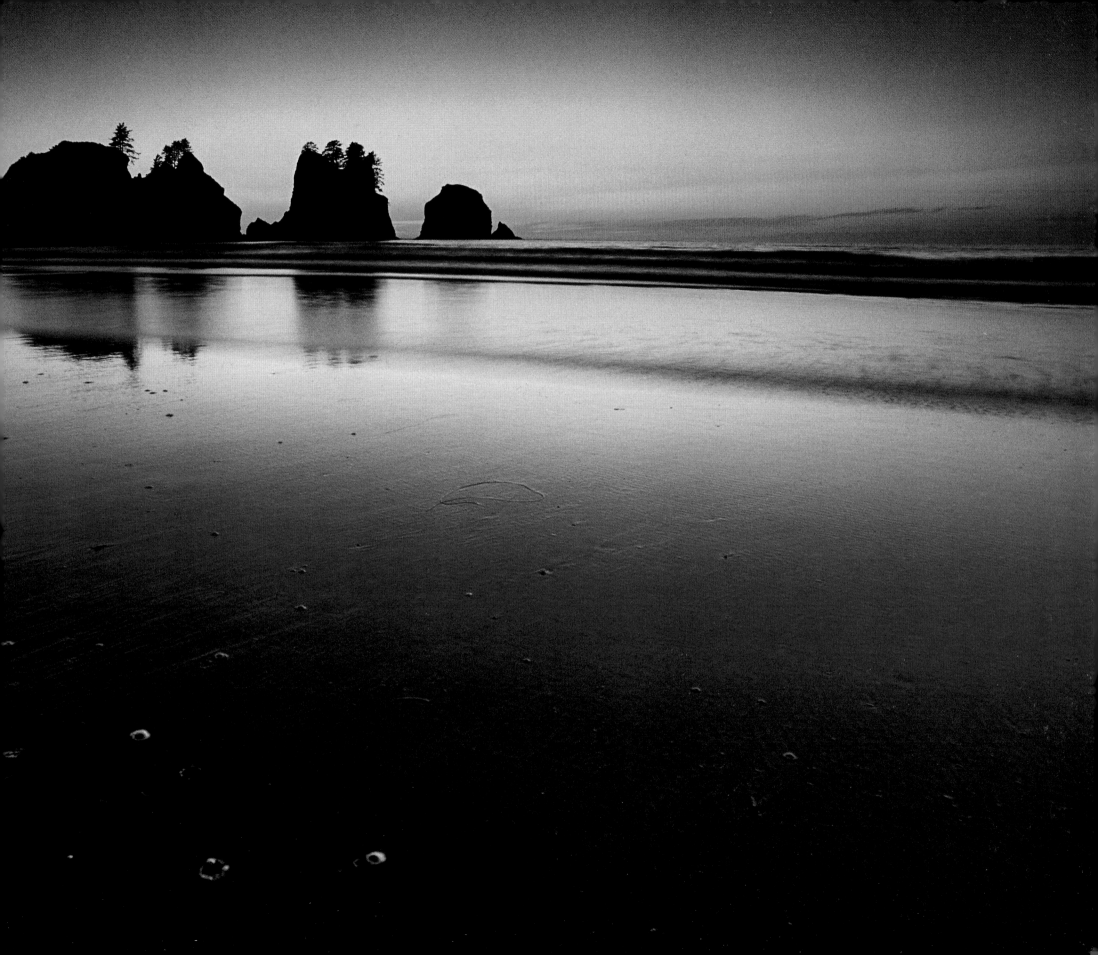

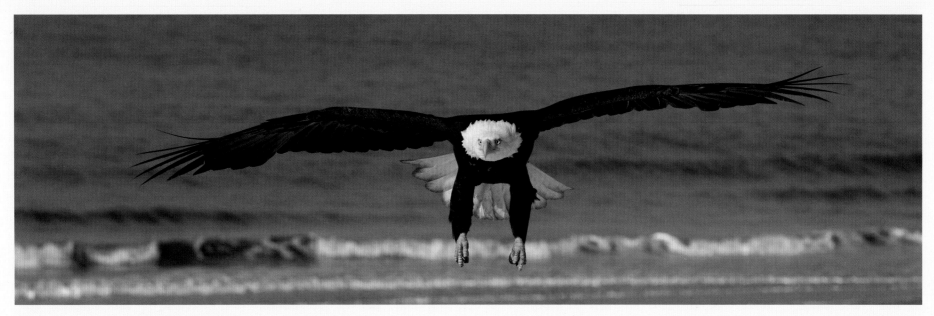

A bald eagle soars in for a landing on the beach.

and here I have found a community of nature enthusiasts, from which great friendships have grown over the years.

It was here in the Pacific Northwest that many years ago I made my first contact with a wild place on the northwest corner of Washington: Olympic National Park, a magnificent wilderness of towering Olympic Mountain peaks, thick rain forest, and remote Pacific Ocean beaches.

As an exchange student, I had come to America at the age of sixteen because I wanted to experience the wilderness we had lost in my home country of Germany. But I soon learned that all was not perfect in America, either. Its wild landscapes had become fragmented at an alarming speed.

After my year-long high-school exchange program, I traveled to Olympic National Park. I received my backcountry permit and started my first solo backpacking trip: to Shi Shi Beach on the Pacific edge of the park. I wanted to photograph those spectacular rock formations that defy the pounding ocean surf. In my pack, I had one of my Nikon cameras and a bag of 35mm film.

Following the firmer sand along the receding tide, I made my way north. At high tide, the waves crashed into the rocky walls reaching into the sea. So I left the beach, balanced on piled-up logs that winter storms had thrown far up the beach, and then climbed a steep little trail. Once on top of the cliff, I was rewarded with a great coastal view. More than once, the call of a peregrine falcon gave away a nesting site in the high cliffs.

The loud cries of the bald eagles in front of the house bring me back to the present. Two eagles are chasing each other across the sound, and my eyes follow them. I make out a disturbance in the water. I quickly go for my binoculars: it's a pod of orcas! Their characteristic tall dorsal fins rise out of the water, and they make explosive blows. It is the group of southern resident orcas that frequent this part of Puget Sound. They are a symbol of wild nature in the Pacific Northwest. Tragically, their numbers have experienced a steep decline.

In my quest to document the wild, I have kept moving west and north on the continent, to find ecosystems where humankind has not made a dramatic impact yet. But the animals we share the planet with do not have this option. If suitable habitat exists elsewhere, it is already taken by other individuals of their species, so they need to survive in their home range. For these orcas, this has become increasingly difficult. Habitat loss, resource depletion, PCB water pollution, and especially the dwindling numbers of chinook salmon—their preferred food—has made their long-term survival questionable.

Since 2005 they have been protected under the Endangered Species Act. While transient orca populations along the North Pacific coast have increased in recent years, those of the southern resident population have not. Most likely the reason is in the food supply. Since the Marine Mammal Protection Act of 1972, sea lion and seal numbers have grown and so have those of transient orcas, while chinook salmon have been in constant decline. The US government has considered reducing the chinook salmon fisheries quota to help the salmon and the orcas, but this is only a temporary solution.

I remember reading a statement by Oregon salmon fisherman Darus Peake, in the Portland *Oregonian* newsaper in September 2009, in which he calls such fishing bans politically easy but less effective than removing dams, cleaning up decades of pollution, and restricting logging and development along rivers. I am

in total agreement with him about the need to fight for a healthier ecosystem overall. But can this be achieved? Sometimes I feel the hopelessness of such a quest.

Recently, though, there have been signs that society is beginning to move in this direction. Olympic National Park began the largest dam removal project in history in 2011, restoring the entire Elwha River watershed to the Strait of Juan de Fuca. And in 2014, for the first time in more than a century, chinook salmon traveled to the spawning grounds of the upper river, above the former dams. Those salmon may soon be feeding the southern resident orcas once again.

I open up my digital archive to look at images of my first trip to Olympic National Park, nearly two decades ago. An image comes to my attention: a clear-cut hillside, the earth disturbed and littered with broken wood. Two large old-growth stumps fill the foreground, while a handful of trees line the horizon. I recall that on my way out to the Olympics, I had realized that areas I thought were ancient forest were in fact replanted clear-cuts with dense monoculture that allowed no

Roosevelt elk feeding among old-growth trees, Olympic National Park, Washington

Black bear, British Columbia, Canada

other life. When I looked at the data, I was shocked to learn that within less than a century, almost 90 percent of America's western old-growth forest had been cut down and most remaining fragments were isolated on steep mountainsides and in protected parklands.

In my work, I have learned that a healthy old-growth forest needs to be a vast, interconnected expanse of land with an extensive outer edge, not fragmented in many little separate pieces, which can affect the ecology of the forest. This situation became particularly evident with the recent decline of the numbers of the northern spotted owl, which is tied to the loss of its habitat: old-growth forest. While the northern spotted owl is protected now, it is still declining, in part because of the intrusion of more aggressive barred owls, which used to be absent from continuous old-growth forest but recently have been expanding into the northern spotted owl's territory.

In my search for those wild places, I continued my travel north to Vancouver Island in British Columbia,

Canada. I quickly realized that the situation for old-growth forest was not much better there. Wherever I looked, I saw huge clear-cuts and monoculture tree plantations. On my way to the remote, rugged west coast of the island, I experienced just a taste of what the forest here once looked like: Cathedral Grove, a piece of forest a little over a square mile (1.6 square kilometers) in size in MacMillan Provincial Park, left for tourists to get a photograph of themselves beside a huge tree.

When I arrived at Pacific Rim National Park, Barkley Sound, Clayoquot Sound, and the famous West Coast Trail, I experienced true relief. I am deeply thankful to those peaceful protesters in 1993 who fought for the protection of this magnificent temperate rain forest, which today is a UNESCO world heritage site. Without those protesters, I would not have seen those ancient giant cedars, western hemlocks, Sitka spruce, and other eight-hundred-year-old trees—nor would the creatures that depend on them be able to find sustenance here.

THE GREAT BEAR RAINFOREST

The wind grabs our little boat and tosses and turns it on the anchor line. Heavy rain is blown sideways by gale-force wind. The rattling of the boat, groaning of trees, and thunder of waves outside the inlet fill the air. The noise is deafening.

I stare out into the darkness, trying to make out the shore, but I can see nothing. Then suddenly the anchor alarm goes off. Because of the extreme wind, our anchor is dragging and we have gone over the perimeter I have set on the global positioning system device. The aggressive *peeps* drive my wife, Emil, out of our sleeping space, a tiny cave in the aft of our 27-foot (8.2-meter) trimaran sailboat. I can see concern in her eyes. We are spending the night in a small inlet on the outer coast of British Columbia, just opposite Haida Gwaii, the homeland of the Haida Indians on the Queen Charlotte Islands. The next village is several sailing hours away. We are surrounded by

roadless wilderness, and Emil is seven months pregnant.

I pull up the nautical chart on our laptop and start the outboard engine. We need to find a more secure anchorage. We move toward the far end of the inlet, which looks promising. There, we drop anchor and try to get more sleep.

We have come to the Great Bear Rainforest, a far-flung region on the Pacific edge of western Canada between Vancouver Island and Southeast Alaska. It is one of the last unspoiled wilderness areas in the world, one that few people see or experience. Set aside in 2006, this approximately 12,000 square miles (19,300 square kilometers) of the Coast Mountains encompasses not only the mainland but also the offshore islands, including those of Haida Gwaii. The reserve is so remote that, from the sea, it is accessible only by boat or seaplane; and from the interior British Columbia plateau, few roads penetrate to this wild coast. The trees of the thick forest include giant western red cedar and Sitka spruce, often more than a thousand years old and towering to 300 feet (more than 90 meters).

Hours later, the wind dies. I crawl up on deck and take a look around. The clouds are still rushing across the sky, but I can now see stars peeking through. Toward the east, a faint light on the horizon announces the approaching day.

Then I hear something—very subtle at first, then answered by an entire group: the deep, eerie howl of a pack of wolves.

By afternoon, we launch our dinghy and head to shore. The forest looms above sandy beaches separated by rocky ledges. Thick rafts of long seaweed ribbons float on the water's surface from the kelp holdfasts on the rocky bottom. As we make our way, we see a group of river otters cavorting onshore, and a kingfisher sounds its chattering alarm at our passing.

Things still feel right, here on this distant coast. In my many visits to the wild British Columbia coast over the years, I have witnessed the interconnectedness of the ecosystem that is so rich because of its close proximity to the sea. The many inlets and fjords form

Brown bears play-fighting along a salmon stream in Southeast Alaska

a complex environmental interface of land and sea, resulting in a lot of rain as the moist ocean air hits the high coastal mountain ranges.

In this undisturbed tract, nutrients get interchanged. Spawning herring feed the whales, sea lions, and many birds. When the migrating Pacific salmon make their annual return after traveling sometimes thousands of miles in the ocean, they swim inland up the many streams to spawn and die, later becoming food for bald eagles, minks, martens, cougars, grizzly bears, black bears, and the elusive Kermode bear, an indigenous subspecies of black bear with white fur referred to as the "spirit bear." And the animals in turn end up as fertilizer for the majestic old-growth conifers. In this ancient place, the magic web of life is still functioning.

On a small, calm beach, we push up the dinghy and head out to explore. A few feet from the boat, we see fresh wolf prints in the sand. The receding tide lets us know that the wolves must have left those tracks less than an hour ago. We look around. The forest has eyes and ears, and we feel it.

These are the mystical moments that have lured me back to this remote coast again and again. Here, I find creatures that have vanished from many other parts of the continent, and others, like the "spirit bear," that exist only here, in this stretch of forest. I still remember my first encounter with the white bear at a small salmon stream. Two black bears were moving up- and downstream, catching salmon in small pools. It had rained all night and mist rose from the stream. Then suddenly, far upstream, partly hidden by mist, I saw a white bear moving along a fallen log; then it disappeared. It was a brief moment, but the bear's presence radiated magic throughout the valley.

Hours later, after our hike, we are back onshore looking out at the sea, trying to spot blows of passing whales. As the sun goes down over the ocean, I sit behind Emil on the rocks. The water is peaceful now. I feel so happy exploring this coastal paradise. My arms are wrapped around Emil's belly and I suddenly feel a kick from the little one growing in her womb. I wonder what the world

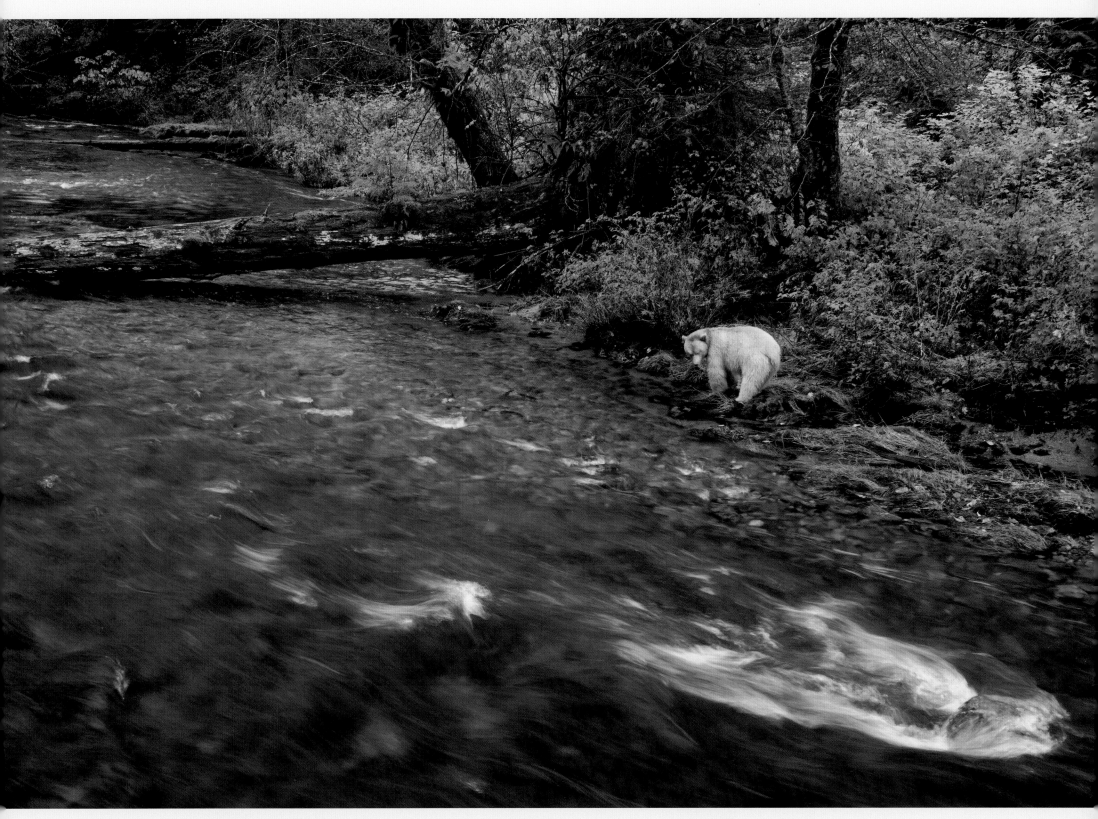

Facing page and above: Spirit bear, Great Bear Rainforest, British Columbia, Canada

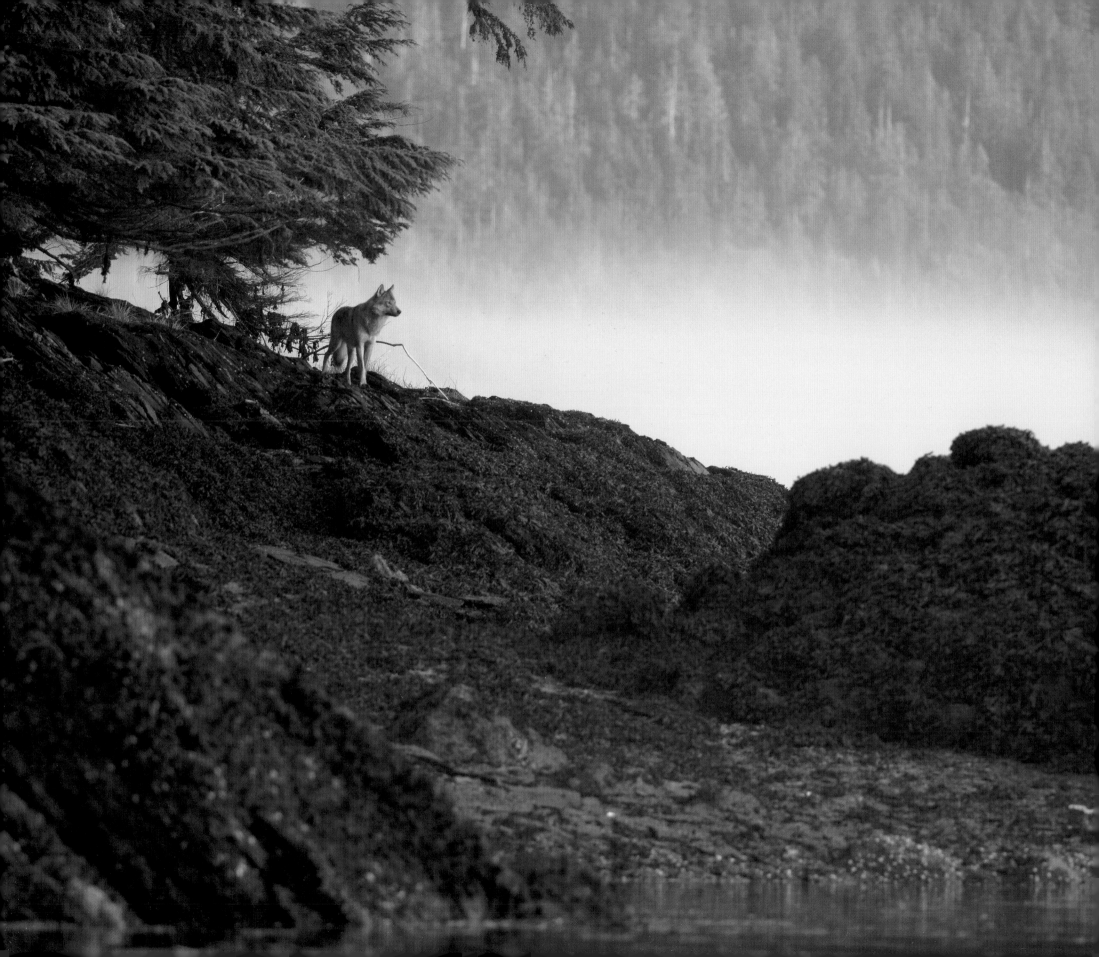

will look like when our child is my age? Will this coast still be so pristine and harbor so much life?

Just as the dark, heavy storm clouds have hovered over this place for days, there is danger brewing for this wilderness gem. Plans by energy giant Enbridge are on the table to send Alberta's tar sand oil through a pipeline to the coast and load it onto supertankers. The British Columbia coast and the Great Bear Rainforest have experienced environmental threats before, but the proposed Northern Gateway Pipeline project outdoes them all. More than half a million barrels of crude oil would arrive at the port of Kitimat every day, bringing 225 oil tankers to the narrow coastal channels of this place each year. It would not be a question of whether an oil spill would occur, but when.

This year autumn comes early to the North Pacific coast. The weather forecasts we have listened to daily this past month reported 60-knot winds and 40-foot (12-meter) seas. There is no place for a supertanker to hide on this coast. Reefs and shallows are everywhere, and Hecate Strait, the major passage before heading inland to Kitimat, is one of the most treacherous waterways on the continent. If a spill occurs, the oil would spread along the entire shore, entering the myriad inlets, and enormous tides would smear it up and down the shoreline. The *Exxon Valdez* oil spill in 1989 polluted the entire Prince William Sound in Alaska, and that ecosystem still has not recovered. The 2010 British Petroleum oil spill in the Gulf of Mexico has proven impossible to clean up; only a small percentage of spilled oil has been cleaned up.

I flinch at the thought of such a catastrophe happening here. I can imagine the news footage on beached whales, oil-drenched sea otters, and dying birds. A cold frisson zips down my spine. We cannot put this enchanting place at risk.

The year before, I was here on assignment to photograph the area for a *National Geographic* story, "Pipeline Through Paradise." We need to keep spreading the word to urge the Canadian government to shut this project down—forever. We owe it to future generations.

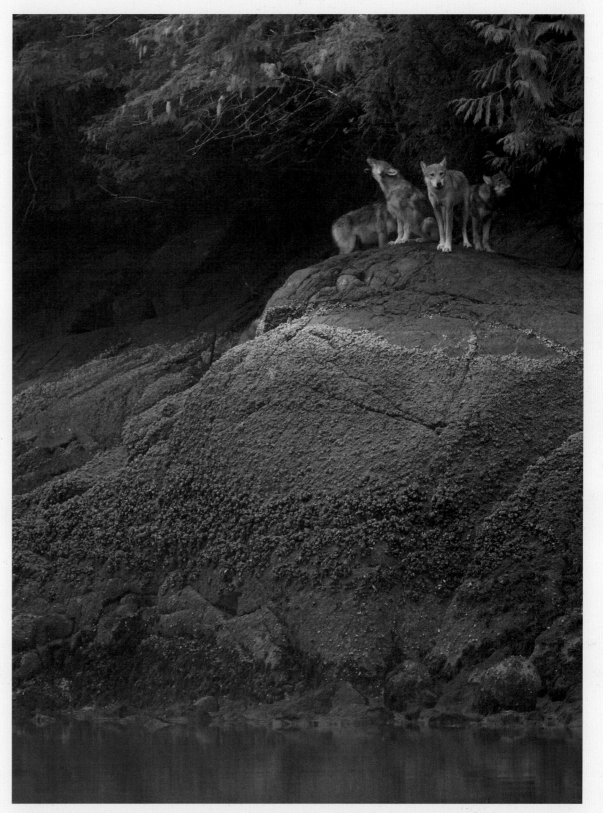

Facing page and above: Wolves on the northern coast of British Columbia, Canada

SOUTHEAST ALASKA BY WATER

Southeast Alaska is special. Roads are almost nonexistent, so the intricate waterways connecting mainland and islands are the primary travel routes. I have come to witness the rich ecosystem of this isolated place. We have just arrived in Juneau, and we have found a little 24-foot (7-meter) red sailboat that our budget can afford. Now we can get out into the wilderness for many weeks at a time with our supplies and camera gear. It will be our means of exploring this incredible place.

We have been alerted to the dangers of navigating the waters of Southeast Alaska. It is summer, but hurricane-force williwaw winds can suddenly sweep down from the mountains, knocking over boats; and massive tidal inflows into the narrow fjords can create standing waves and huge whirlpools. Anchoring is another challenge: the shore drops off fast, and the tides are huge.

Getting around in our little sailboat is slow. Our average water speed is about four to five knots. But we are not driven by a schedule, just by our desire to explore. We want to experience the beauty of the immense landscape. On our explorations, we crisscross most of the major channels of Southeast Alaska, passing

hanging blue-ice glaciers hovering over us on the cliffs. We make our way out through North Inian Passage into Cross Sound, and on good-weather days we get to the outer coast. From there, we have amazing views of the soaring, snowy peaks of the storied Fairweather Range.

In stunning Glacier Bay National Park, we spend days anchored in a little inlet, paddling our kayak along the shore and hiking up streams. Here, I have my first experience with coastal wolves. Wolves had always been one of the elusive species I so much desired to photograph. Scouting with binoculars from the sailboat, we discover a pack of wolves in one of the rare open shore areas. I am thrilled when I spot several pups

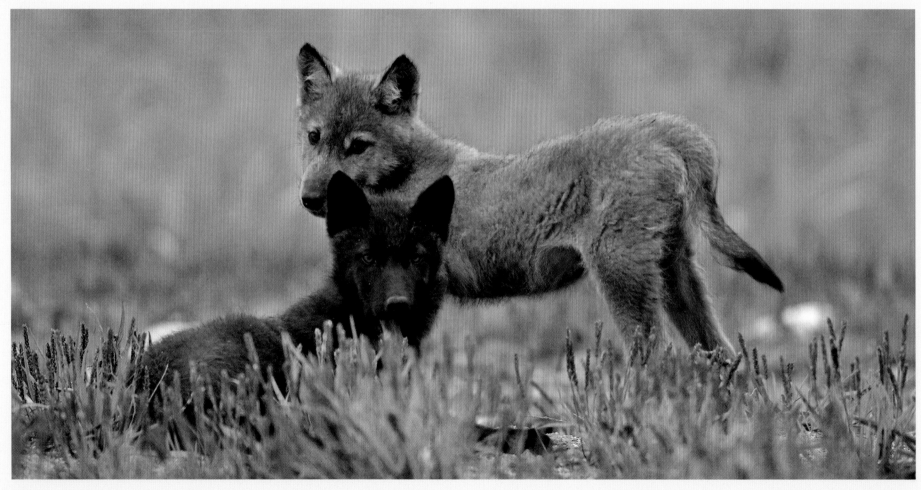

Wolf pups, Glacier Bay National Park, Alaska

playing while older wolves watch them. We stick around for days, and the wolves become used to our anchored boat and to us paddling up and down the shore.

One morning, I see an opportunity. Two of the wolf pups have fallen asleep on the beach. I grab my telephoto lens and we paddle slowly over toward the little pups. My thought is that with the rising tide, we may be able to drift in for a close-range photograph. Little by little the water rises, nudging the kayak closer, eventually getting us to the muddy beach. The pups are dozing in a patch of green grass, and even the bigger wolves do not appear alarmed.

We pin the kayak to the shore with our paddles. When the brown and black pups wake up and throw me a curious look, I am ready with my camera. *Click, click, click.* Their honey-colored eyes study me. They stretch, taking their time to rouse from their nap, then stroll away.

A week later, on an unusually calm day, we are drifting in Icy Strait in our sailboat. The water is completely still and the sun warms us. Suddenly we hear a series of blows in the distance. Several humpback whales have surfaced and their blows stand out against the dark backdrop of trees on the shore.

Southeast Alaska attracts large numbers of humpbacks every summer. In the 1960s, humpback numbers had declined dramatically, but since their protection in 1966 when a moratorium was placed on hunting them, their numbers have risen. Today the North Pacific population is estimated to be more than twenty thousand animals, with a feeding population of some five thousand individuals between British Columbia and Southeast Alaska. Even though gray whales are the migratory species people usually talk about on the West Coast, humpbacks also make a huge annual journey: a portion migrate in fall south to Mexico's warm waters to mate and give birth, while the rest travel west to Hawaii.

Five minutes later, we are startled when the whales break the surface near our boat. Deep trumpeting sounds echo through the air as they exhale. Spray shoots up

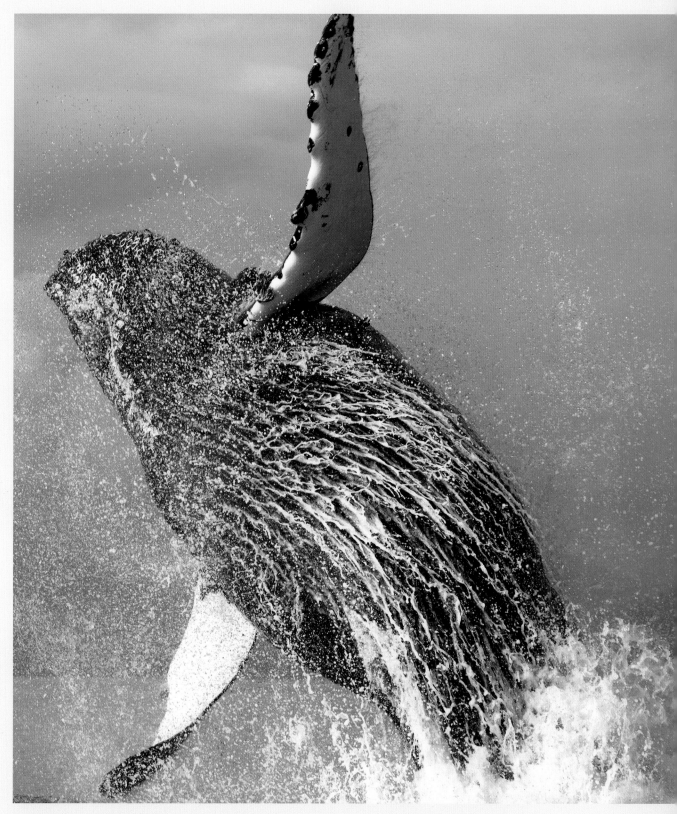

Breaching humpback whale, Southeast Alaska

121

15 feet (nearly 5 meters) and the light breeze carries it our way. The enormous cloud of fishy breath engulfs us. They turn sideways, twisting and throwing their flukes into the air as they dive again. Minutes of silence follow. Then suddenly a series of bubbles appears on the water's surface, directly next to our boat. Deep below, the whales are swimming in circles, slowly releasing air from their lungs. This is the way they collaborate to feed. The rising bubbles split into smaller bubbles, creating a "bubble net" in which herring will concentrate. Moments later, the whales' open mouths break the surface, gulping down silvery herring that fly through the air trying to escape. Our little boat rocks back and forth in the waves created by the whales. Then the group slowly travels on, diving directly underneath our boat, literally skimming inches by the keel. They rise to take another breath of air, and then arch their backs and dive, waving their majestic broad flukes.

Humpback whales are one of the most mesmerizing whale species to watch. When they play at the surface, the interaction becomes a compelling mix of flukes and long pectoral fins slapping the water. But what is truly exceptional is their breaching behavior. Picture this: a 45-foot (13-meter) whale some 100 feet (30 meters) below the surface picks up speed and shoots for the surface, catapulting its average 32 tons (29 metric tons) out of the water, and then falls back with an enormous splash.

To capture such an image, my big challenge is to anticipate where the whale is going to come up. On one of the days in Southeast Alaska, we encountered a particularly active humpback whale. It breached several times in a row, and I was eventually able to capture a unique image. The tip of its gigantic mouth split the surface of the water, and the whale kept on pushing toward the sky until almost its entire body had left the water. Then when it was falling back, it pulled up its enormous fluke and suspended its entire body above the water. I had never seen a full breach like that, and I was left gasping in awe. ■

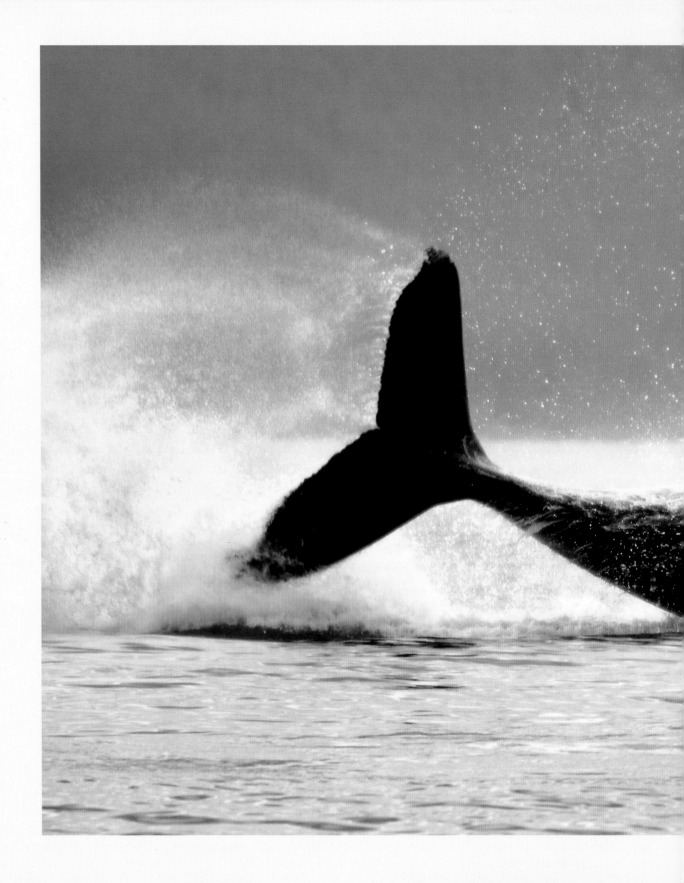

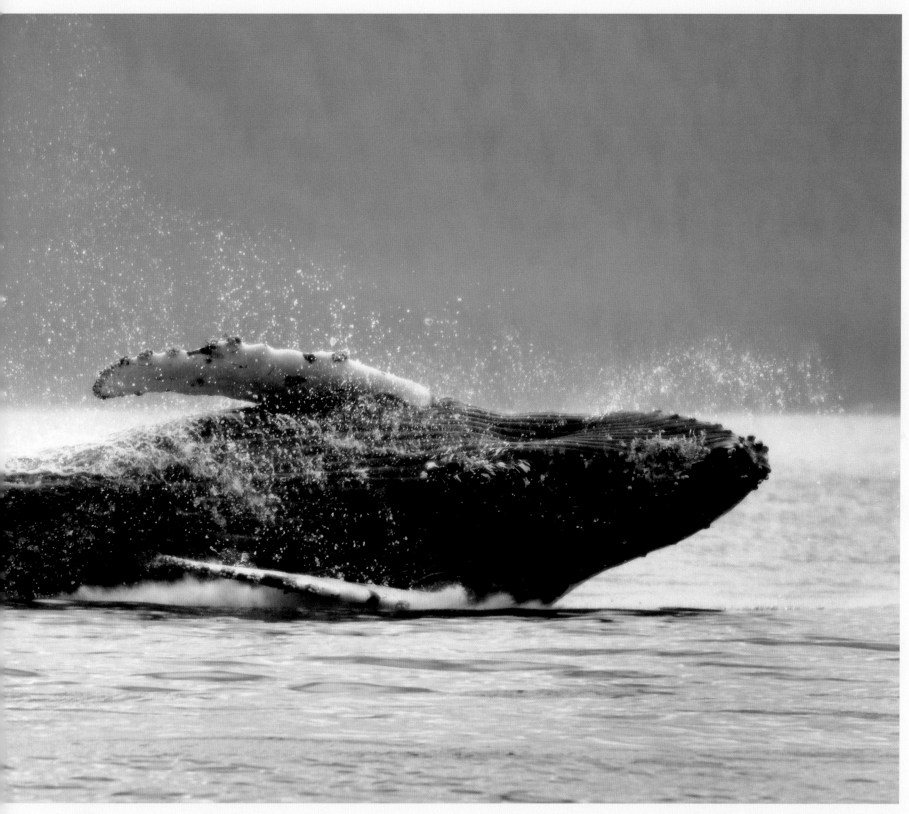

Despite the fact that it can weigh up to 40 tons (36 metric tons), a humpback whale can catapult its entire body out of the water, Icy Strait, Southeast Alaska.

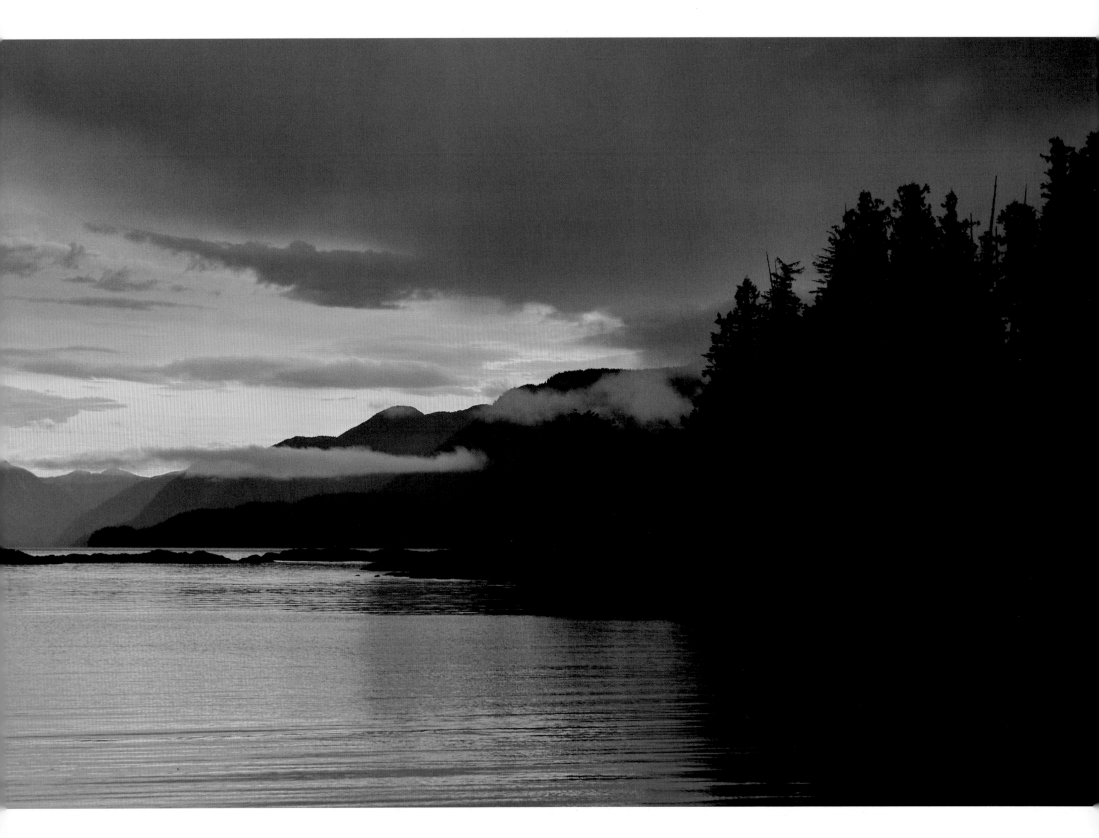

Sunrise at Rescue Bay with Mathieson Channel in the background, Great Bear Rain Forest, British Columbia, Canada

Facing page and above: Snowy owls have an irruptive migration cycle in the Pacific Norfthwest, migrating some years but not others, Olympic Peninsula, Washington.

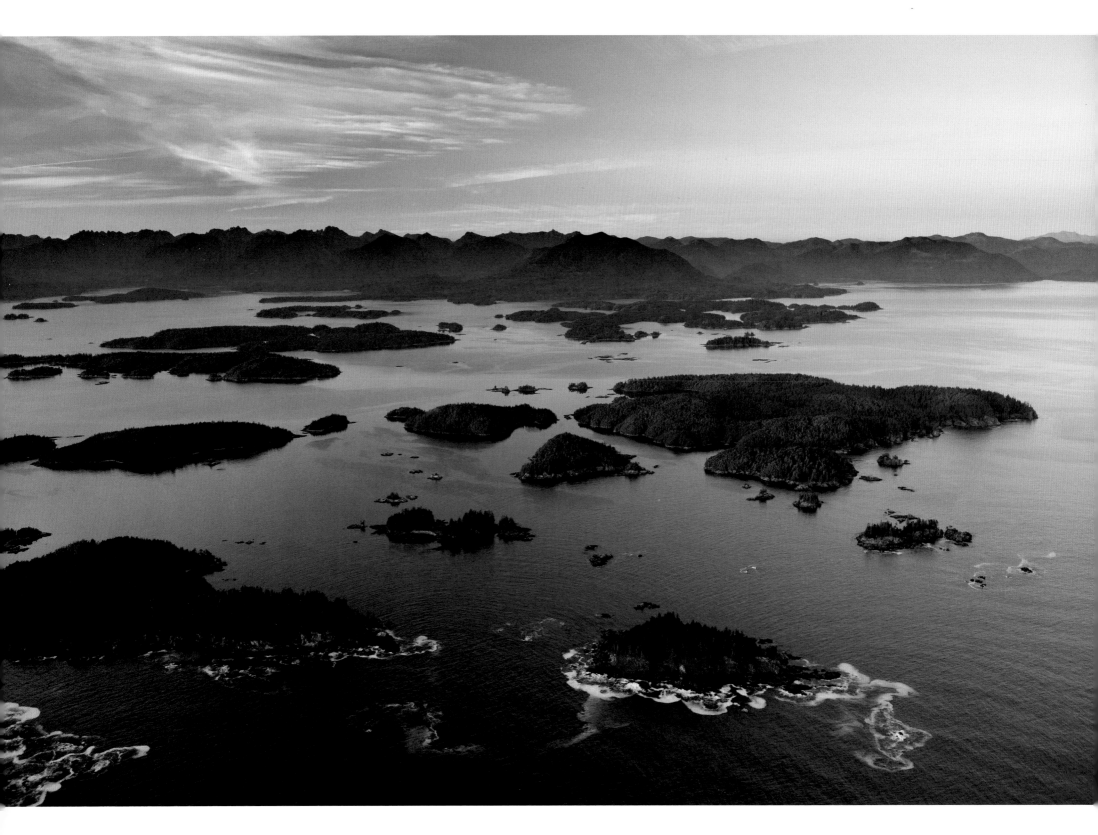

The Broken Islands, Pacific Rim National Park, Vancouver Island, British Columbia, Canada

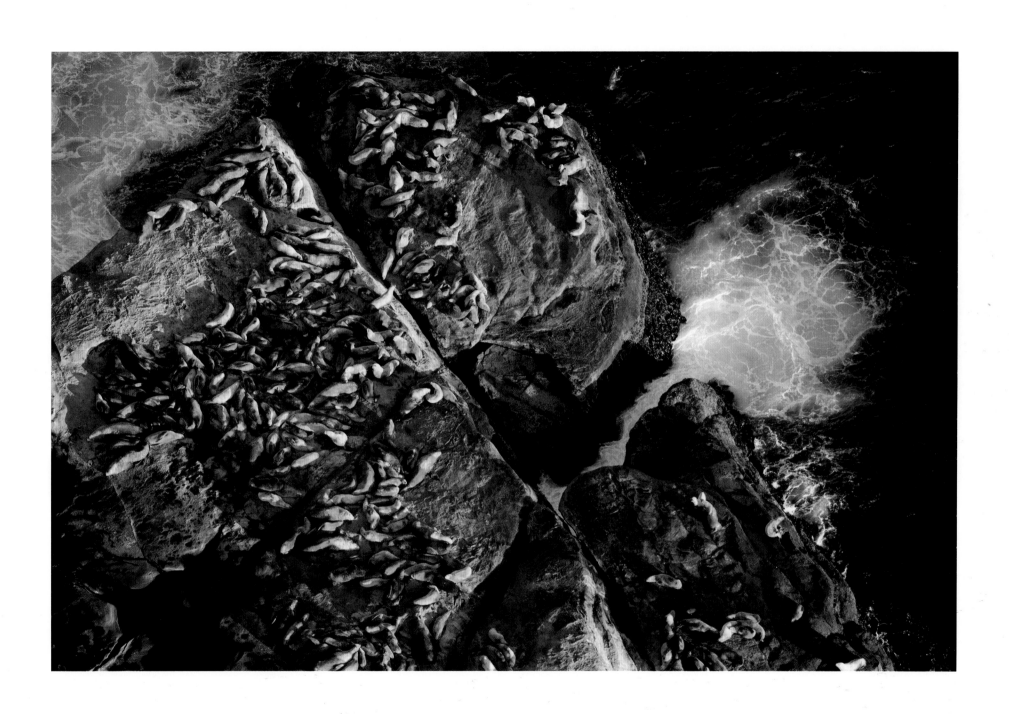

Sea lions on the west coast of Vancouver Island, British Columbia, Canada

A lonely beach on the northern coast of British Columbia, Canada

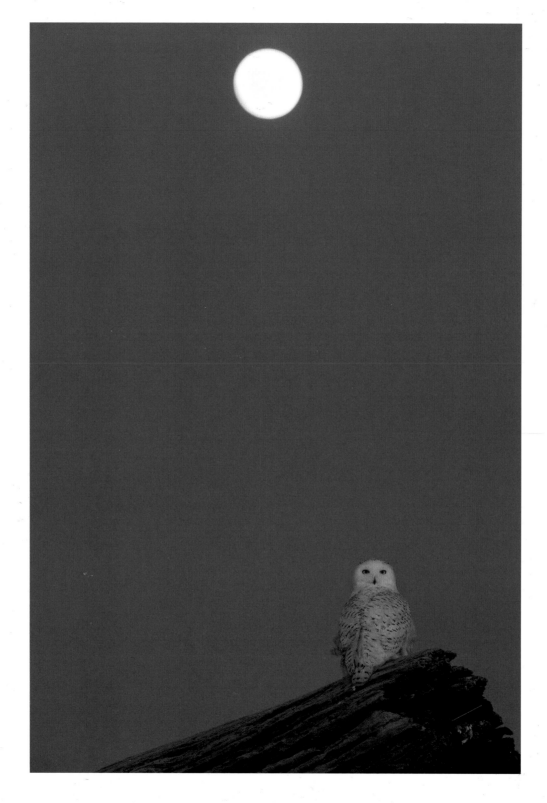

Above: Snowy owl winter migrant on a Pacific beach

Facing page: Stars fill the night sky over the northern British Columbia coast, Canada.

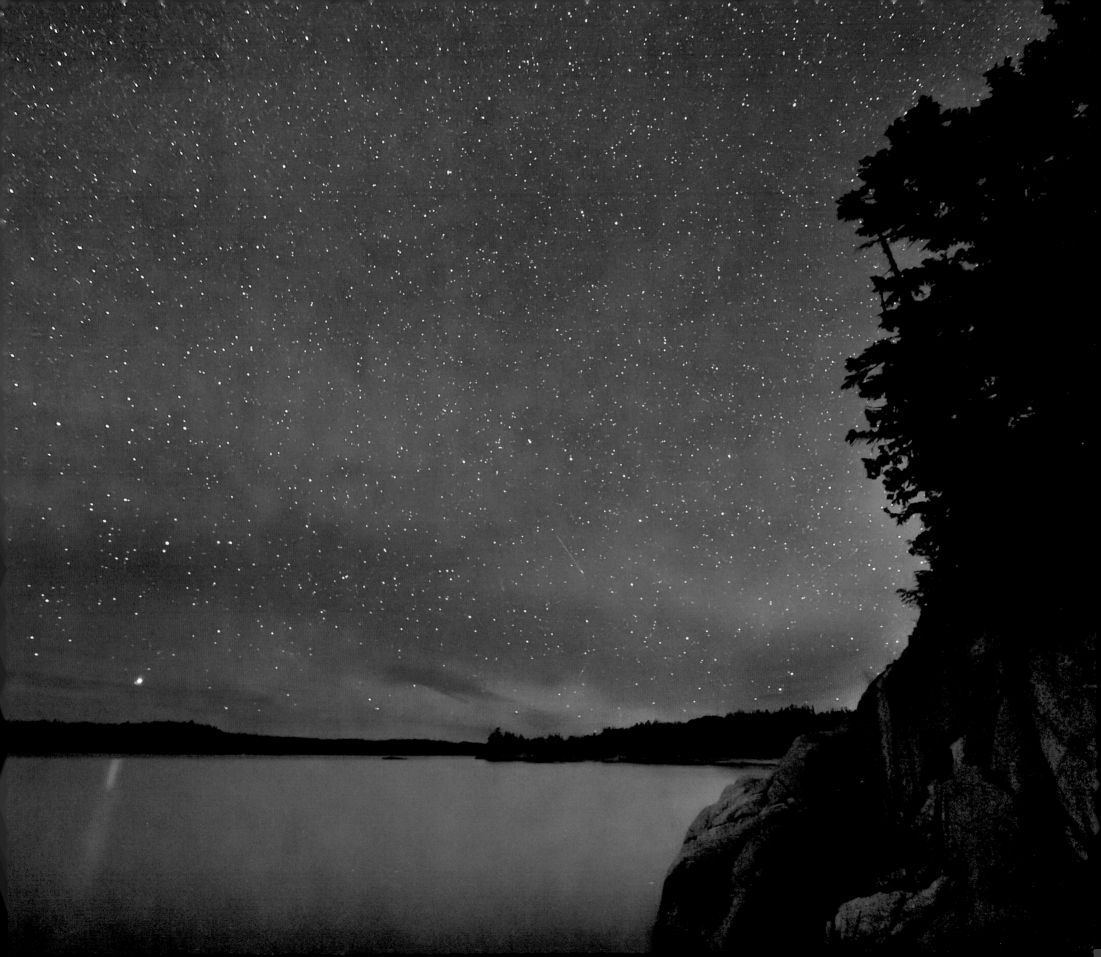

Old-growth forest on Princess Royal Island, British Columbia, Canada

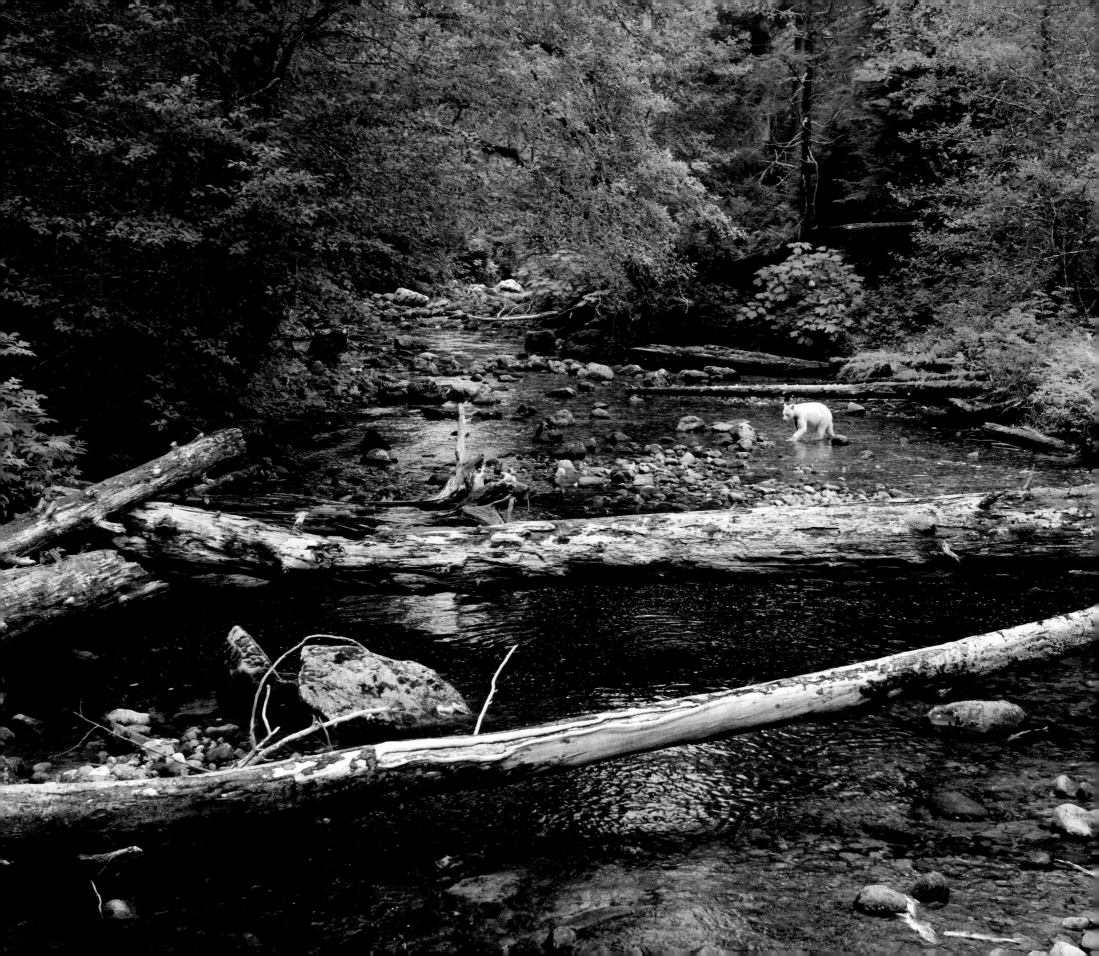

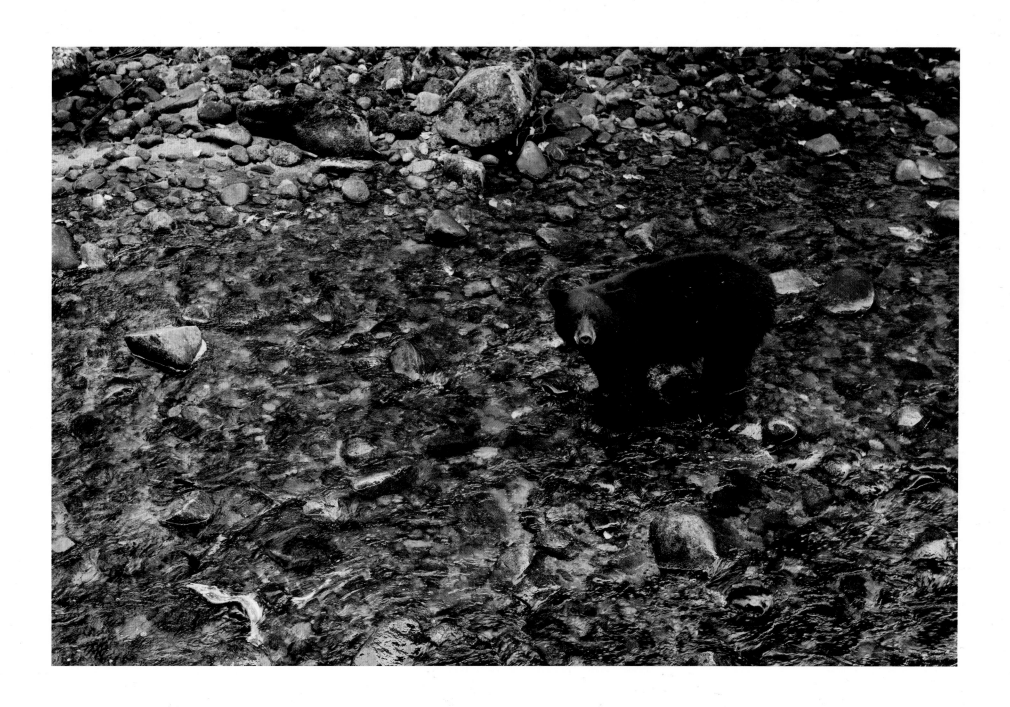

Facing page: Spirit bear moving along a salmon stream in the Great Bear Rainforest of British Columbia, Canada *Above: A black bear searches for salmon, Great Bear Rainforest, British Columbia, Canada.*

Rain clouds linger over the Khutze Inlet estuary, British Columbia, Canada.

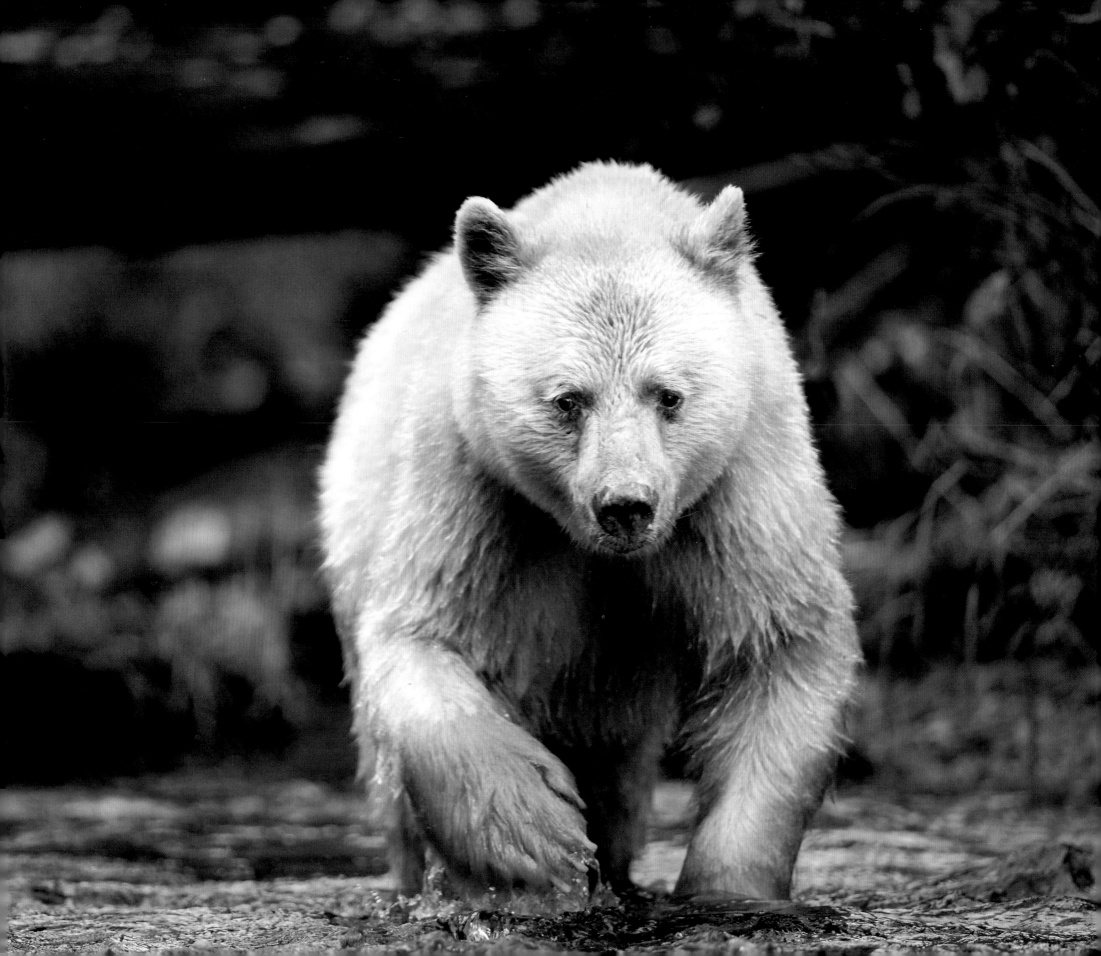

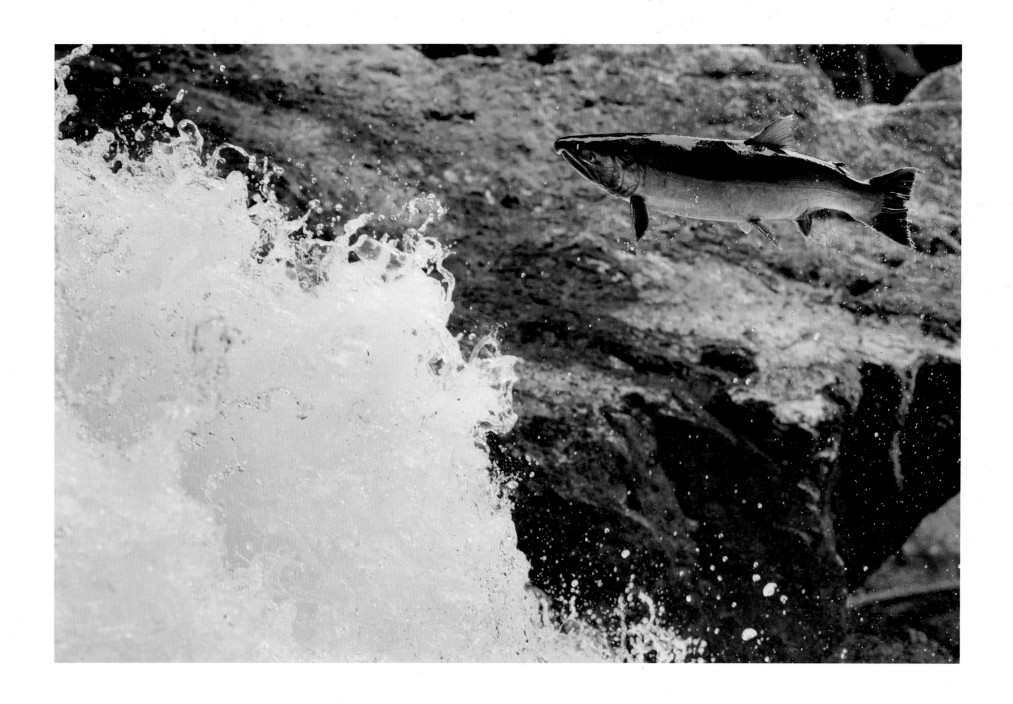

Facing page: Research has shown that Kermode bears such as this one are much more efficient than dark-coated bears at catching salmon because their coloring makes it harder for the fish to see them, Great Bear Rainforest, British Columbia, Canada.

Above: A coho salmon migrates up a stream on Princess Royal Island, British Columbia, Canada.

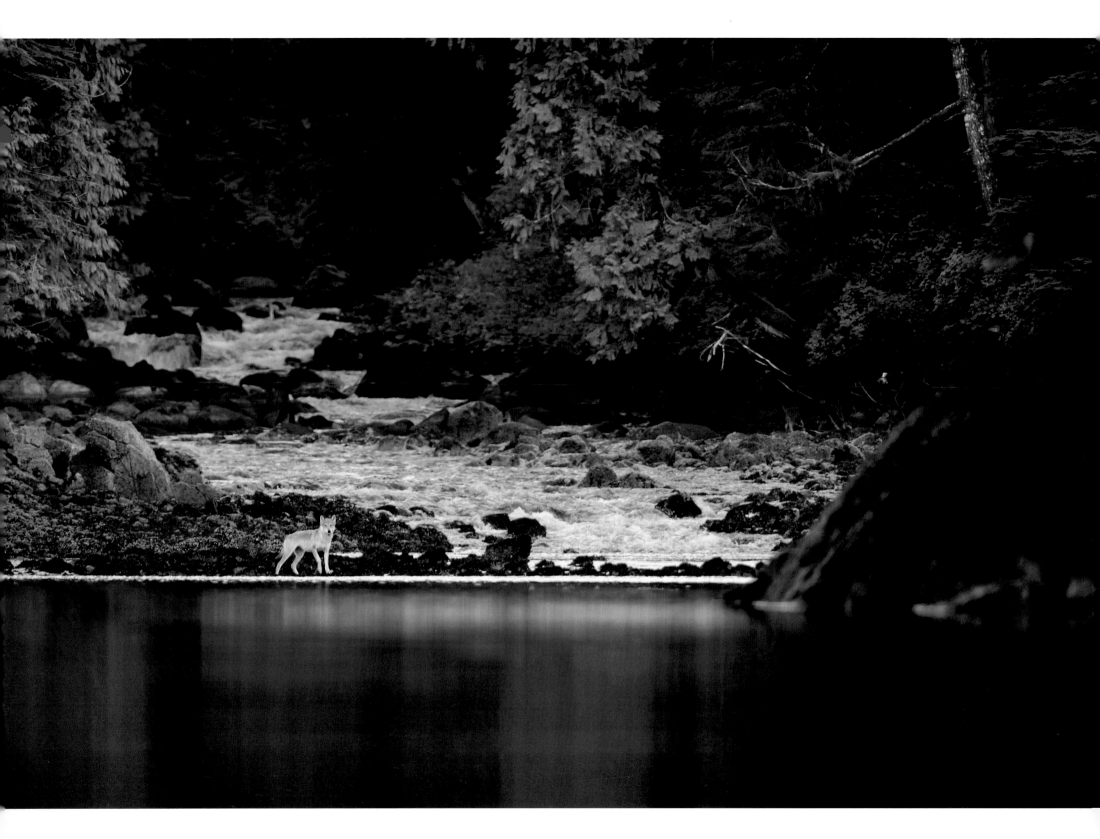

An alpha female coastal wolf checks the river for arriving salmon, Great Bear Rainforest, British Columbia, Canada.

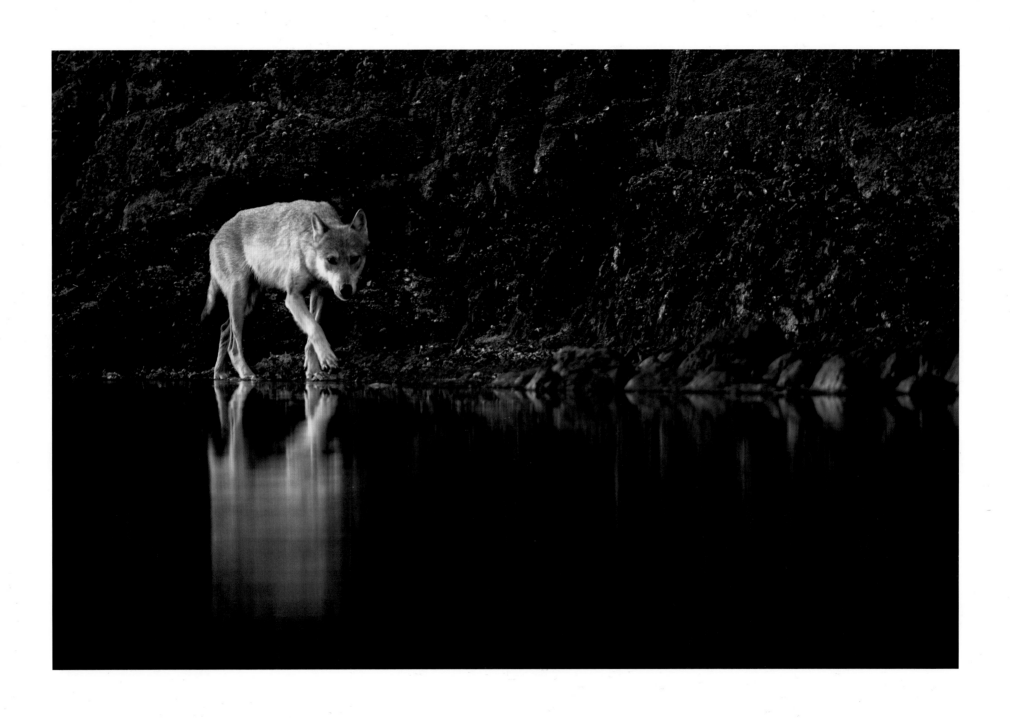

Wolf, Great Bear Rainforest, British Columbia, Canada

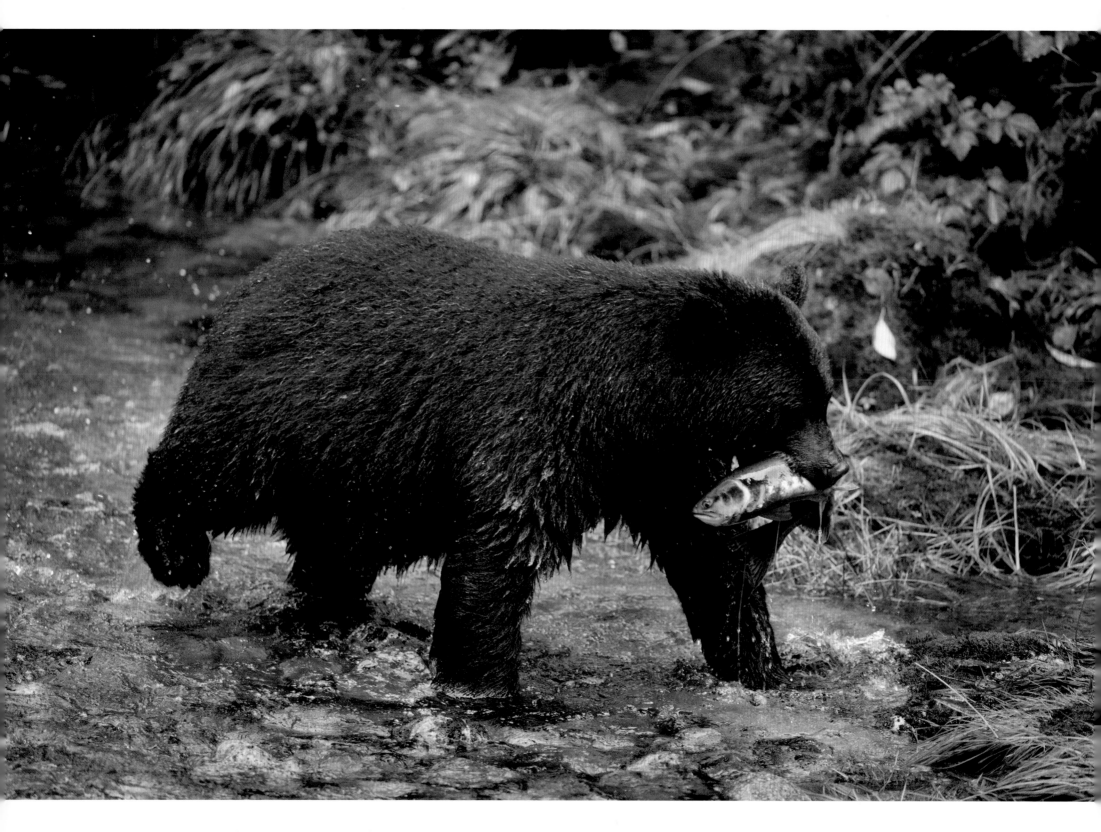

A black bear meets with success while fishing in the Great Bear Rainforest, British Columbia, Canada.

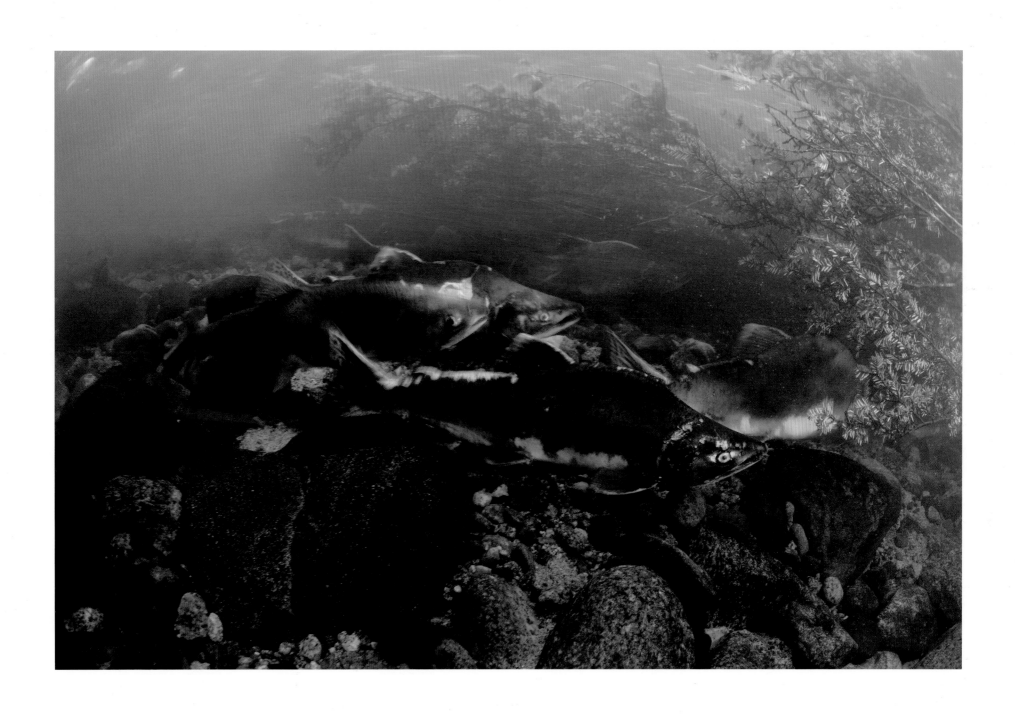

The Great Bear Rainforest has more than 2500 salmon runs, though they are facing increasing threats from human activity and climate change, Great Bear Rainforest, British Columbia, Canada.

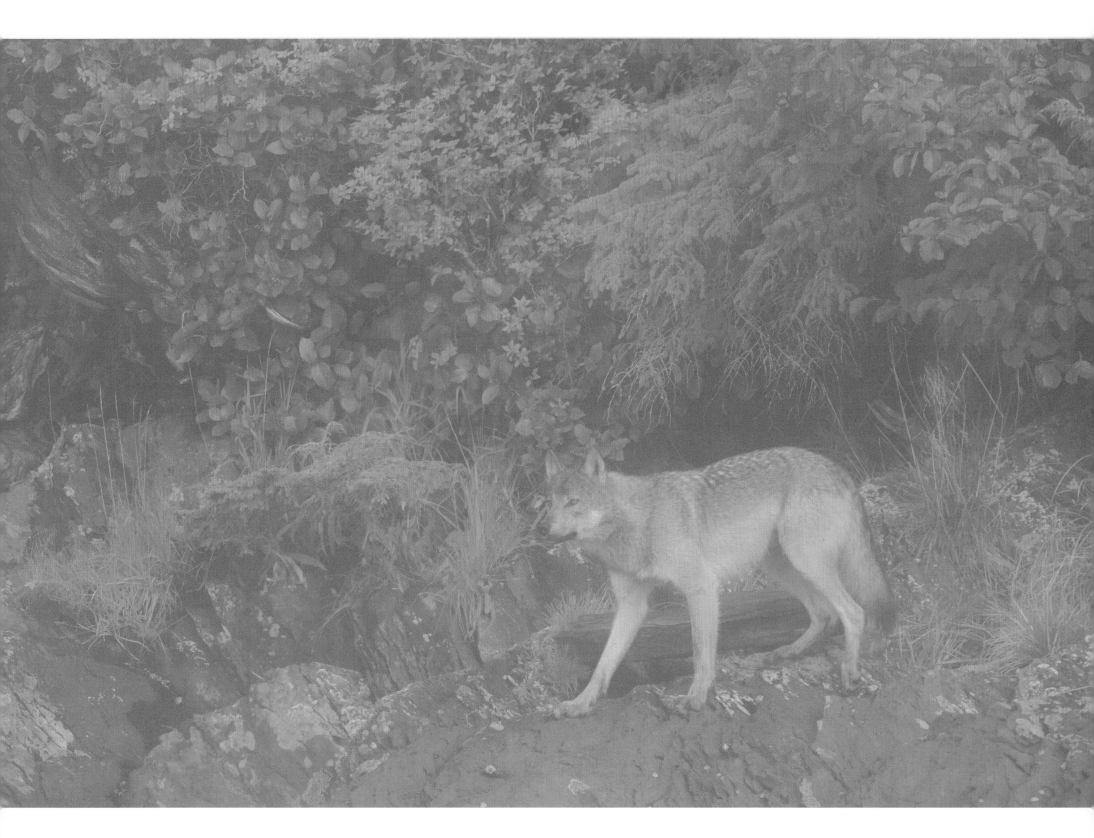

A wolf is barely visible through the mist on the northern coast of British Columbia, Canada.

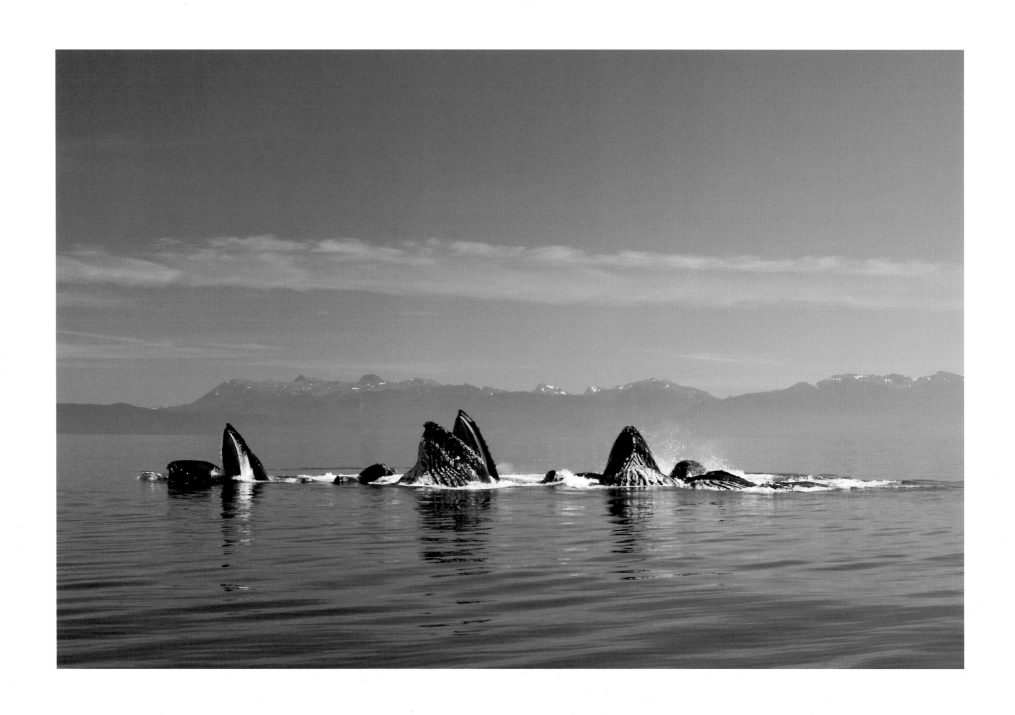

In a technique that is unique to the humpback whales of Southeast Alaska, these whales work together and use a "net" of bubbles to encircle schools of fish to eat, Chatham Strait, Southeast Alaska.

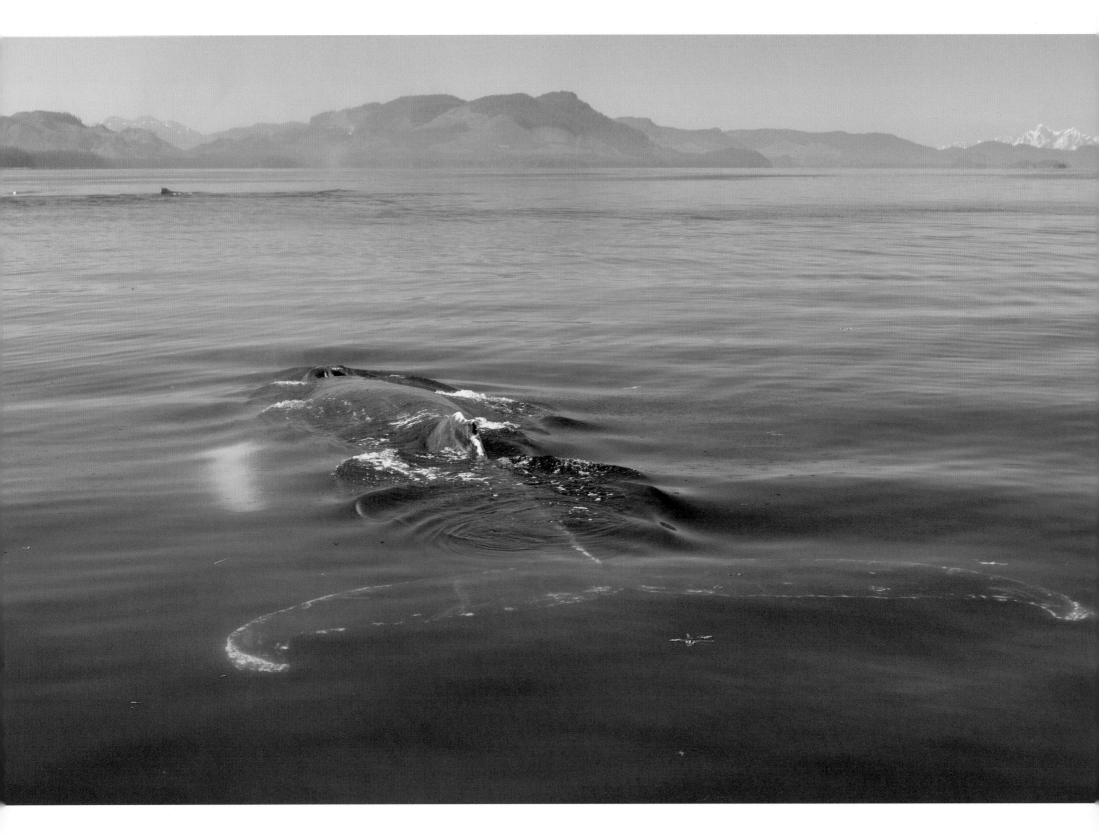

Humpback whale surfacing in Chatham Strait, Southeast Alaska

The density of glacier ice results in a distinctive deep blue color, Southeast Alaska.

A bald eagle lands on a large piece of glacier ice, Holkham Bay, Tongass National Forest, Southeast Alaska.

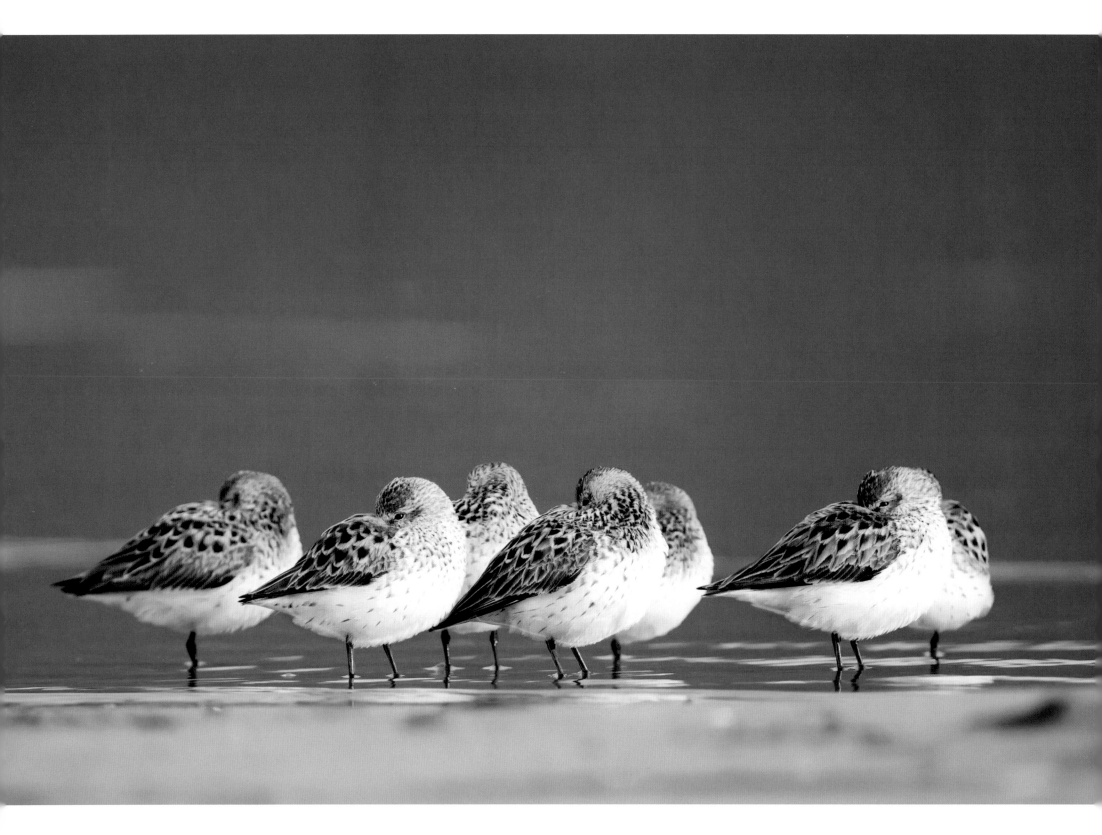

Western sandpipers rest to conserve energy between their strenuous migratory flights of hundreds, even thousands, of miles, Orca Inlet near Prince William Sound, Alaska.

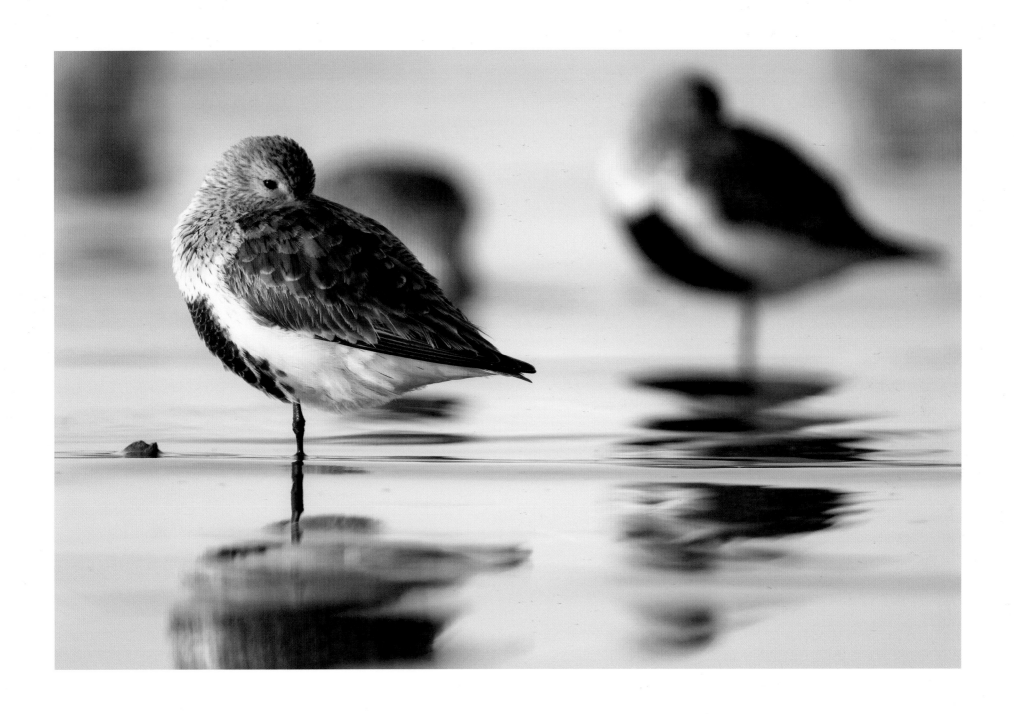

Dunlin sandpipers, Orca Inlet near Prince William Sound, Alaska

Sea otters rest on pieces of floating glacier ice that have calved from the Columbia Glacier, Columbia Bay, Alaska.

155

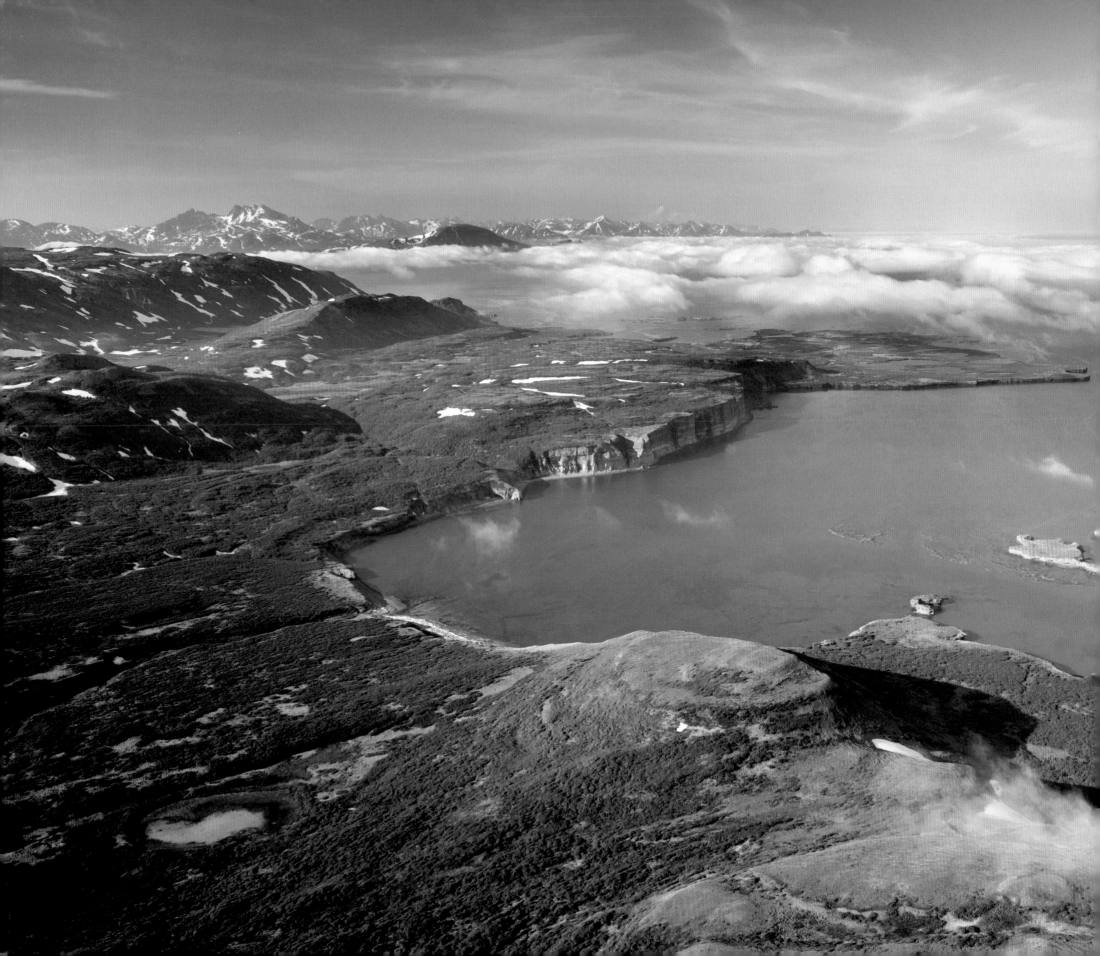

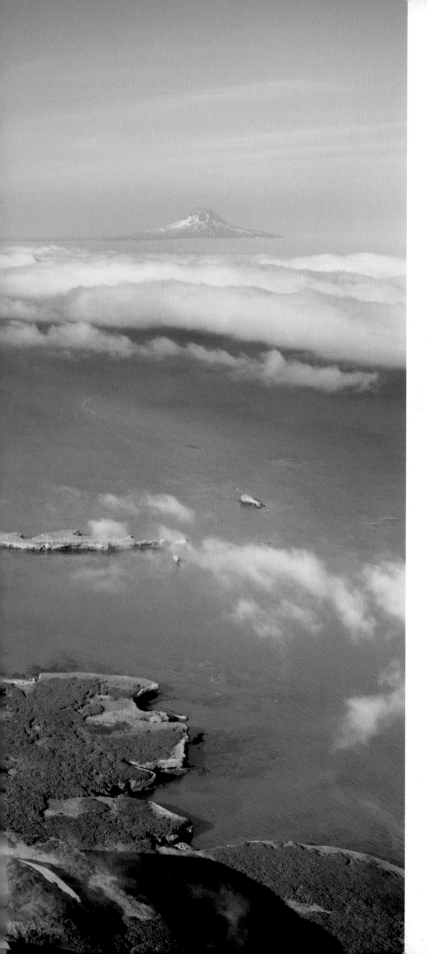

NORTH

PRINCE WILLIAM SOUND, ALASKA, TO THE ARCTIC'S BEAUFORT SEA

Down becomes up when the great equalizer of the north, the Alaska Current, separates from its southbound twin, the California Current, and sweeps north and west around the Gulf of Alaska, the Alaska Peninsula, and the Aleutian Islands, warming their waters. To the north along the Bering and Chukchi shores to the Beaufort Sea, inland along the fierce heights of the Alaska Range and the endless crumpled crenellations of the Brooks Range, lies the Alaska of

Left: The shoreline of Katmai National Park, Alaska

157

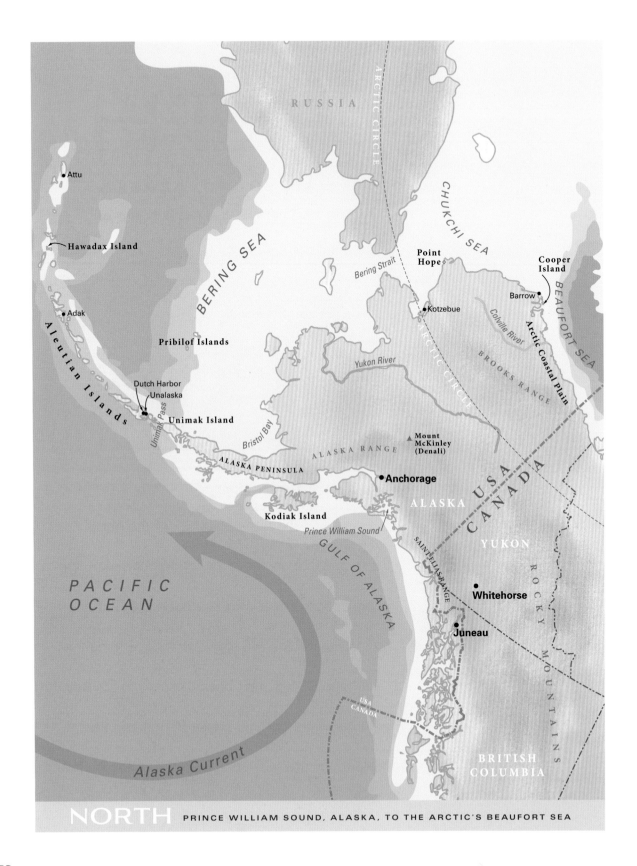

popular imagination and Jack London tales: permafrost and sea ice, shoe-sucking summer muskeg, white bears, owls, foxes, and whales. But to the west, along the 500-mile-long (800-kilometer-long) Alaska Peninsula and the 1200-mile (1900-kilometer) Aleutian Archipelago, a different climatic tale unfolds.

The Aleutians point like a saber, reaching almost to Siberia from the sword hand of the peninsula. They seem like the end of the world, but their weather is actually like the weather on the Washington, Oregon, and Northern California coasts, only more so—cloudier, foggier (pilots flying to the islands become expert at gauging what cloud cover is and isn't safe to land in), and windier.

"There's a woman behind every tree in the Aleutians," soldiers fighting there in World War II would joke—the joke being that there are no trees beyond ground-hugging stunted willows and the "Adak National Forest," a dwarf grove planted on Adak Island to remind servicemen stationed there of home. Corporal Dashiell Hammett, the oldest enlisted man on Adak when it was the front line against a Japanese invasion, reveled in the gray seas, stark volcanic landscape, and howling winds, but most servicemen loathed them. A sign at Adak's airport used to greet visitors with the English translation of the island's name: WELCOME TO ADAK, THE BIRTHPLACE OF THE WINDS. When I arrived in 2003, those winds had torn it apart.

But everything that makes the islands inhospitable to human mainlanders makes them a paradise for the wind-surfing, current-riding creatures of the air and sea. The western Aleutians, which extend to midway between the Alaska and Asia mainlands, are the ultimate marine and avian crossroads: Asian and American, arctic and temperate and even subtropical species all meet here, gliding up the Baja-to-Beaufort flyway to the east and its South China–to-Siberia counterpart to the west to forage in the rich northern seas. Tens of millions of seabirds, including the globe-spanning arctic tern, breed on the archipelago. Many others that breed on warmer islands to the south come to fatten up on Bowers Bank and the Bering Sea's other fertile shelves. Hundreds of

CRAIG MATKIN AND EVA SAULITIS

A LONG-TERM COMMITMENT TO ALASKA'S ORCAS

BY BONNIE HENDERSON

Between Unimak Island, just west of the Alaska Peninsula, and the rest of the Aleutian Island chain lies a 10-mile-wide (16-kilometer-wide) ocean passage. Nearly the entire population of migrating North Pacific gray whales bound for summer feeding grounds in the Bering Sea swim past Unimak Island, many of them funneling through Unimak Pass—and through a gauntlet of more than a hundred transient orcas that congregate there each spring to prey on gray whale calves. The young whales help sustain the orcas, explained whale biologist Craig Matkin, "and it's a super windfall for the bears." Those would be the Unimak Island grizzly bears, fresh out of hibernation, which (along with wolves, foxes, bald eagles, ravens, and other creatures of the land and sky) eagerly pounce upon the stray chunks of whale calf blubber that inevitably wind up on the beach.

And it is something of a windfall for Matkin, who has spent the past three decades studying the orcas of the northern Gulf of Alaska. "You need to find places where they congregate," he said. "[Unimak Pass] turned out to be, for transient orcas, the hot spot."

When Matkin first arrived in Alaska in the 1970s, it wasn't with the intent to study whales. But as a young fish biologist working and occasionally kayaking in Prince William Sound, he found himself enchanted by the orcas that frequently surfaced and glided alongside his boat, their tall black dorsal fins unmistakable and mysterious. Little research had been done on orcas to that point. So, after completing a master's degree in marine biology, he launched his own study in the early 1980s, initially supporting his work with commercial fishing and taking on, in 1987, Eva Saulitis as a field assistant. Then came the event that changed—and, in a sense, set the course for—both of their lives: the 1989 *Exxon Valdez* oil spill. Matkin led the effort to document the spill's impact on orcas, and he is still at it, in collaboration with Saulitis, who has since become his life partner and codirector of the North Gulf Oceanic Society, the nonprofit organization that supports their research.

Saulitis is a poet and essayist as well as a biologist. Her 2013 book, *Into Great*

Silence: A Memoir of Discovery and Loss among Vanishing Orcas, chronicles the impact of the oil spill on Prince William Sound and, in particular, on one family of orcas known as the Chugach transients: a distinct subspecies that is slowly going extinct as a direct result of that spill. Along the way, she noted that the interconnectivity of land and sea of the kind she and Matkin have observed at Unimak Pass cuts both ways. "The terrestrial world, just a dozen yards from the oiled shoreline, appeared pristine, though I knew it wasn't," she writes in *Into Great Silence*. "Eagles and river otters eating contaminated fish, defecating in the woods, could bring poison inland."

Her book is a moving elegy for the Chugach transients, whom Saulitis has

"When you're connected and present in a place every summer, you see the life force reasserting itself."

come to know personally, almost intimately. And it is a love song to a place whose essence, she said, remains intact, despite being ravaged by a devastating oil spill. Like a body that loses a limb, the sound endures, she acknowledged: "When you're connected and present in a place every summer, you see the life force reasserting itself."

"Prince William Sound has a particular kind of power," Saulitis said. "The more time I spend out there, the more strongly I feel that the place has an aspect of its spirit that is untouched by the oil spill. It is whole."

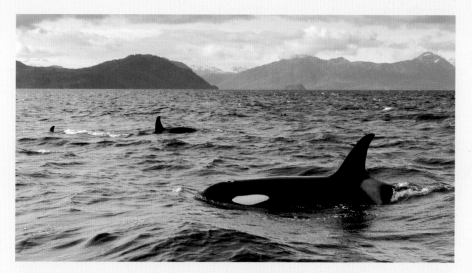

Orcas traveling the Knight Island Passage at the entrance of Prince William Sound, Alaska

THE ALEUTIAN ISLANDS

A HAVEN FOR SEABIRDS AND SEA OTTERS

Seabirds that breed on the Aleutians are afflicted by the nest-raiding predators humans have introduced, wittingly and unwittingly: cats, foxes, and especially rats. (Adak is also overpopulated with inbred caribou, released in the 1950s to give bored servicemen something to shoot.) But invasions can be reversed.

In 2012 Rat Island, so named by the Russians for an infestation bequeathed by a Japanese shipwreck, was renamed Hawadax, Aleut for "welcome"; federal authorities had finally succeeded in exterminating the rats. Eagles and other birds that ate the carcasses of poisoned rats suffered heavy collateral damage, but other species driven away by the rats promptly began nesting again there. Hawadax offers both a model and a cautionary example for sixteen other rodent-infested islands in the chain and untold others worldwide.

The travails of another Pacific icon shows how plundered species can return from the brink and then become vulnerable again. The Aleutians' sea otter population has crashed twice. The first time, in the eighteenth and nineteenth centuries, Russian overseers forced their Aleut vassals to scour the islands and the coast as far south as California for sea-otter furs. Fugitive otter colonies survived in the Aleutians and at Big Sur, California, eventually reseeding new colonies all along the Pacific Coast. By the 1980s, the Aleutian otter population may have reached as high as one hundred thousand.

Then it plummeted to less than one-tenth that. The likeliest culprit: predation by desperate orcas hunting their way down the nutritional ladder. How? After commercial whaling, which continued until the 1960s, nearly obliterated the great whales, the orcas turned to harbor seals, whose population crashed in the 1970s, then Steller sea lions, whose population crashed in the 1980s, and finally to the lean little otters.

Nevertheless, sea otters still cavort in Adak's Clam Lagoon, and harbor seals loll fearlessly. That's because orcas can't enter the lagoon's narrow channel, nor protected lagoons on other islands where otters also thrive—strong support for the hypothesis that orcas are to blame for their decline.

The otters' woes are a textbook case of how species losses and other disturbances can ripple through an ecosystem. Otters prey voraciously on sea urchins, which graze voraciously on kelp. In the otters' absence, kelp forests declined from California to Alaska. When otters returned, tribal urchin fishermen suffered but the kelp rebounded, along with the fish and crab species that shelter in it.

Whaling, ship strikes, oil spills . . . whatever threatens the great whales threatens much more as well.

—E.S.

Sea otters in Resurrection Bay, Kenai Peninsula, Alaska

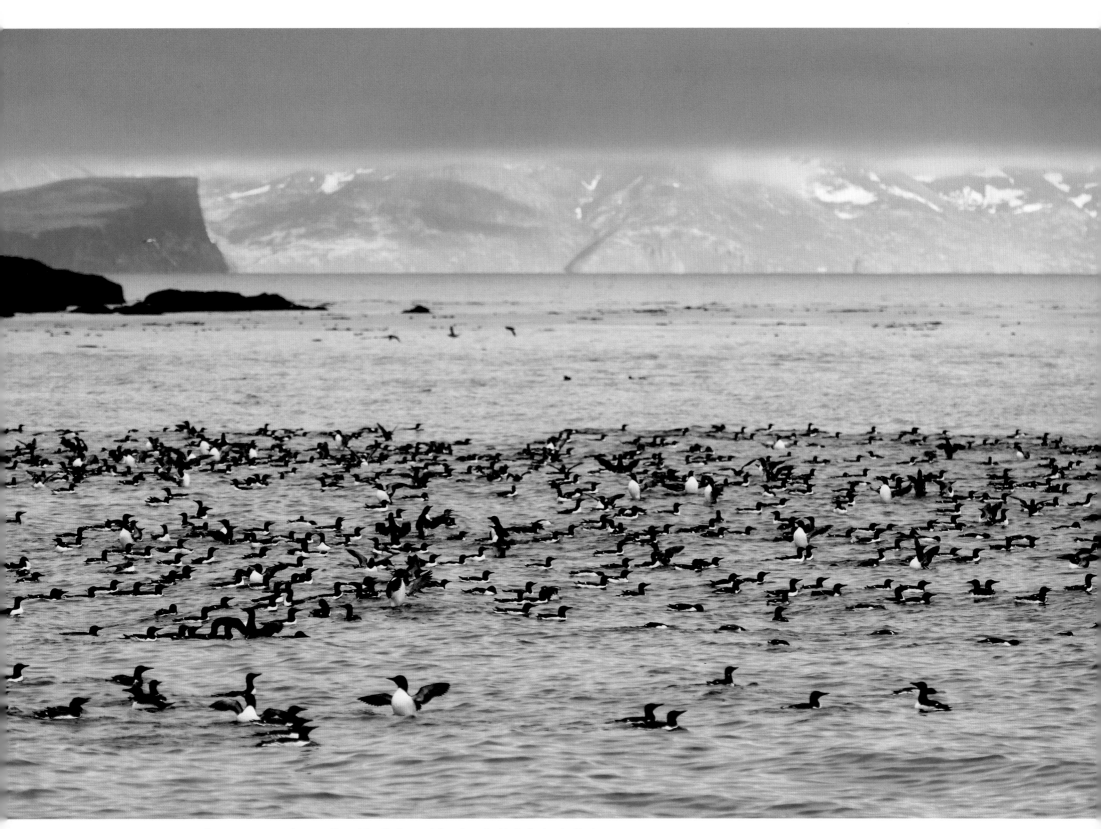

Common murres gather near Karpa Island in Stepovak Bay along the Alaska Peninsula, Alaska.

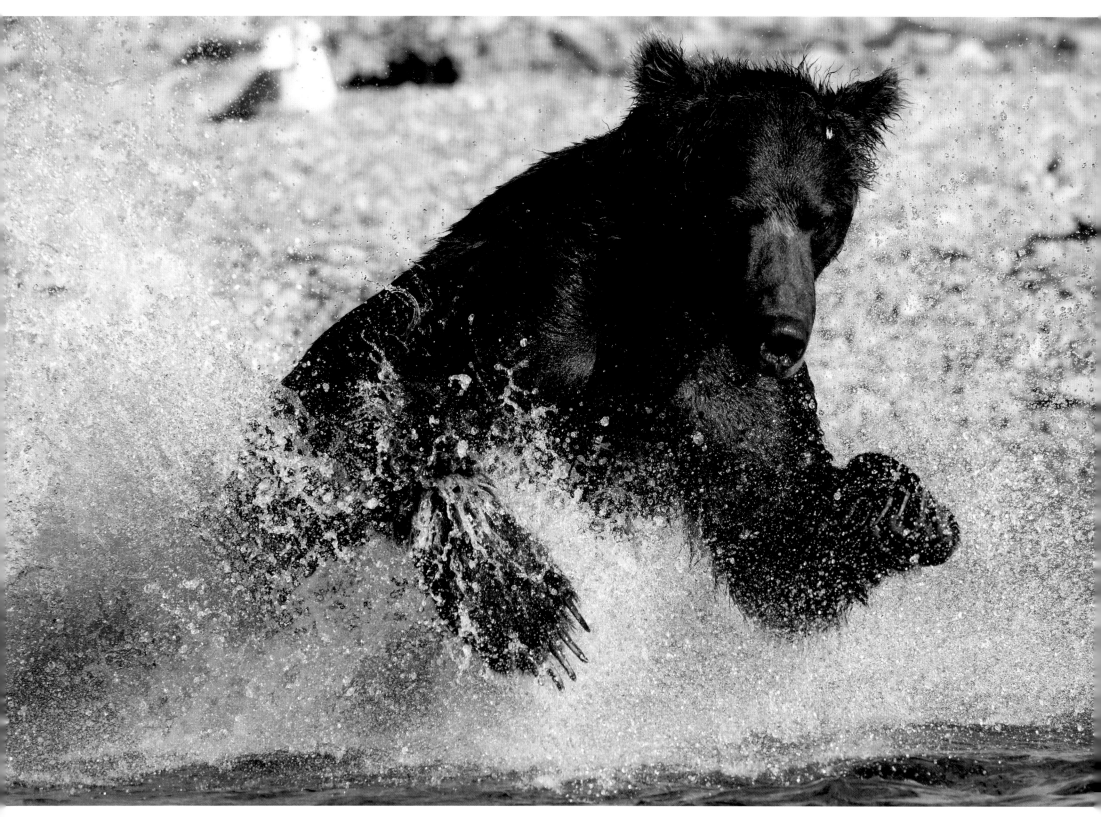

A brown bear charges into the water to catch salmon, Alaska Peninsula, Alaska.

ROBIN SAMUELSEN AND LINDSEY BLOOM

PRESERVING ALASKA'S SALMON CULTURE

BY BONNIE HENDERSON

© PEW CHARITABLE TRUSTS

Controversy over the massive Pebble Mine proposed for southwest Alaska has galvanized public opinion in Alaska since the turn of the millennium. The project would extract copper, gold, and molybdenum—minerals in high demand globally—from a site at the headwaters of the Kvichak and Nushagak rivers, two of the eight major rivers that feed Bristol Bay. Construction of the mine—including the world's largest earthen dam, to hold back billions of tons of waste—would provide some two thousand jobs and would employ about one thousand people throughout its expected thirty- to sixty-year life span.

Should that dam ever break or even leak, it could destroy one of the most productive wild salmon fisheries in the world: Bristol Bay sockeye salmon.

"Do we need more jobs? Yes," said Robin Samuelsen, a commercial fisherman in Dillingham, Alaska, who is a board member of the Bristol Bay Economic Development Council and the Bristol Bay Native Corporation. "But we don't need to destroy our habitat here in Bristol Bay for short-term income from a mine that's going to destroy our culture and our subsistence lifestyle."

A veteran activist on behalf of fish—and fishermen—Samuelsen, like his father and grandfather, has always practiced and preached sustainability in the salmon harvest. If that sometimes means "sitting on the beach"—idling in port until fisheries managers determine that the run is robust enough to set nets—so be it, he said: "If you're going to be a fisherman, you need to be involved in conservation. That's your business, and you need to take care of your business.

"I've been to Washington, DC, and I've been to Juneau more times than I care to remember," he continued, "but that's just the way it is. You need to protect the fisheries that you have. We have a commercial salmon fishery second to none. Why risk what we have?"

The Pebble Mine isn't the only threat to Alaska's fabled wild salmon runs—for example, on the Susitna River, a hydroelectric dam has been proposed at a point halfway between Anchorage and Fairbanks. With spawning grounds both above and below the proposed site, the dam couldn't help but impact salmon habitat and, ultimately, salmon runs. The state is also poised to grant permits for a coal mine on the Chuitna River west of Anchorage, a move that will destroy 11 miles (18 kilometers) of salmon spawning and rearing sites in exchange for a couple of hundred jobs. The coal that is extracted will most likely be shipped to Asia.

Lindsey Bloom of Juneau, Alaska, has been a commercial fisherman all her life, having starting out as a deckhand on her father's boat. Now she spends the off-season organizing support for salmon conservation, on issues such as the Susitna dam. "I have the growing sense that we are on the cusp of either repeating the mistakes already made in the Lower 48 or of charting a new course when it comes to salmon," Bloom said. She finds it ironic that Alaska is pursuing construction on the Susitna of what would be the nation's second-tallest dam at the same time that dams are being breached in Oregon and Washington to salvage dwindling salmon runs. "I believe the decisions made regarding salmon habitat in other states were made on the premise that dams, clear-cutting, urbanization, and salmon can all coexist," she continued, but throughout the world, that premise has proved false.

Alaska's salmon runs are doomed, Bloom said, if Alaskans don't choose a new course, one prioritizing salmon and their habitat: "It's clear that some decisions are going to be made in Alaska in the next few years that are absolute tipping points."

"Up here, salmon is common ground for everyone, regardless of your political beliefs or values," she stated. The concept of preserving ecosystems for their own sake does not necessarily resonate with every Alaskan. "But," Bloom concluded, "just about every Alaskan has salmon in the freezer."

© COREY ARNOLD/COREYFISHES.COM

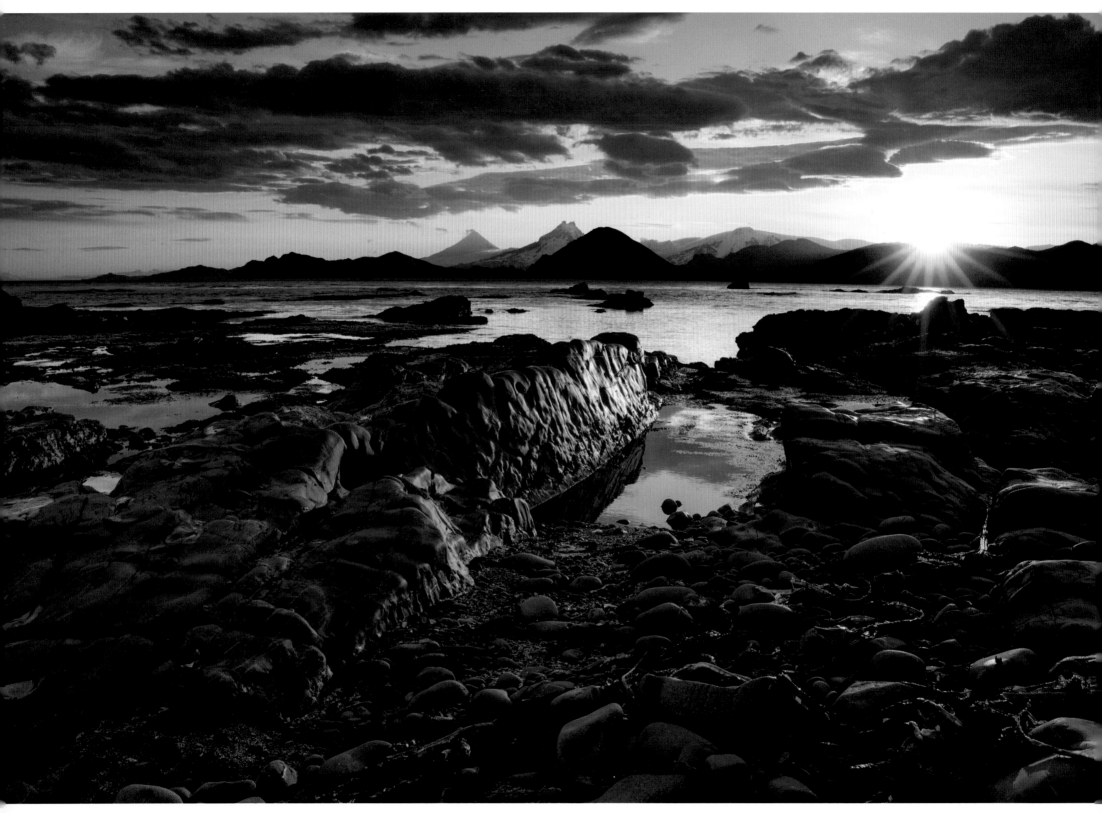

Sunset on the rugged shore of Unimak Island with the volcanoes Shishaldin and Isanotski in the background, Aleutian Islands, Alaska

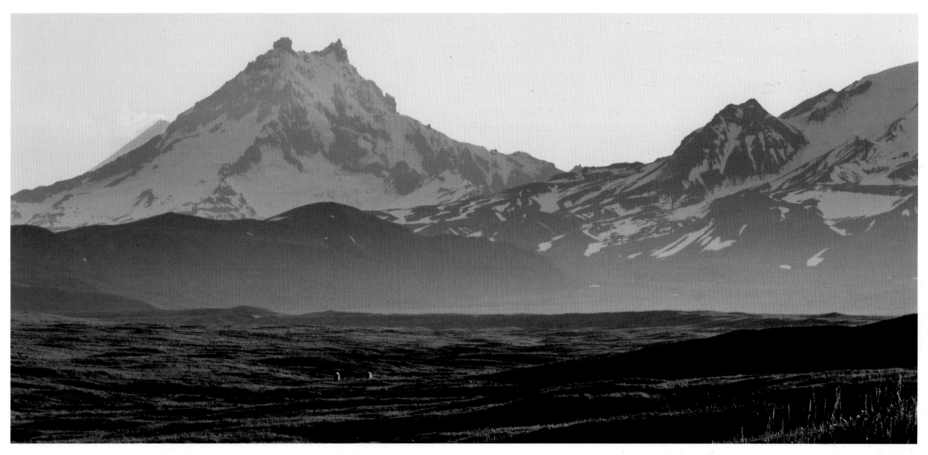

Two grizzly bears at sunset with the Isanotski volcano rising in the background, Aleutian Island, Alaska

feet down, a parallel underwater archipelago thrives: deepwater coral reefs, an ecosystem that was nearly unknown until recent decades, as diverse as tropical reefs. These organisms take centuries to grow but can be shattered in a minute by a bottom trawler.

Many of the Bering Sea's seabird populations have declined markedly, probably because of human overharvesting of the fish they depend on. One of the rarest is the turkey-sized short-tailed albatross, the largest albatross in the Northern Hemisphere, at once magnificent and cartoonish (with its big bubble-gum-pink bill). Millions of short-tailed albatrosses once roamed the North Pacific, before Japanese feather hunters all but wiped them out. Now only around two thousand remain, but that's up from just a few dozen in the 1950s.

Unimak Pass is a perilous place not least for the gray whales that must shepherd their new calves through it each spring to reach their Arctic feeding grounds. The narrow strait between the Alaska Peninsula and the Aleutian Islands that is the main eastern corridor—for migrating fish, seals, and whales alike—from the Pacific Ocean north into the Bering Sea is one of the key ambush sites, together with California's Monterey Bay and, lately, Santa Monica Bay, where transient orcas prowl for vulnerable gray whale calves.

The pass is risky for steel-hulled ships as well. In Washington's San Juan Islands and other spots along the shipping routes from British Columbia's current and proposed oil ports, residents worry mightily about what would happen if a tanker were to crash or ground along

their sheltered coasts. Fewer worry about what happens to the tankers and their sticky cargo after they pass Cape Flattery heading west into the Pacific Ocean and northwest along the Great Circle shortcut to Yokohama, Japan; Tianjin, China; and ports beyond. But the direst test may come at Unimak Pass.

In 2004 the Malaysian-registered bulk carrier *Selendang Ayu* ran aground nearby, spilling 1560 tons (1415 metric tons) of fuel—the second-largest spill, after the *Exxon Valdez,* in thirty-four years on the Pacific Coast. Six crew members died when a wave engulfed the helicopter rescuing them, and the fuel was soon lost in the roiling waves and tidal churn. But this all happened far from television cameras and, so, attracted much less media attention than the *New Carissa* did when it

THE PRIBILOF ISLANDS

FROM SEALS TO POLLOCK

Each spring, seabirds in their multitudes—puffins and cormorants, America's largest murre colony, cosmopolitan black-legged kittiwakes, and the Bering Sea's endemic red-legged kittiwakes—converge on the cliffs of Saint Paul, Saint George, and the three smaller Pribilof islands, about 300 miles (480 kilometers) west of the Alaskan mainland and north of the Aleutian archipelago. More remarkable yet are the northern fur seals that mob the beaches, especially Saint Paul's, to breed, up to three-quarters of a world population of about 1.1 million. Sixty years ago there were twice as many.

I happened onto the Pribilofs in 1983, a watershed year. For 195 years, the islands' Aleut residents had harvested the seals, first for Russian overseers, more recently under the gentler dictatorship of the US government. Now the government was winding down the seal hunt and spinning off the communities on Saint Paul

and Saint George islands from neocolonial guardianship.

Henceforth the Aleuts' destiny would lie in the billions of walleye pollock and other fish teeming in the surrounding waters of the Bering Sea. The government had funded new boats, a pier, and a processing plant on Saint Paul, but the change from clubbing and skinning seals to competing on the *Deadliest Catch* seas wasn't always easy.

The Bering Sea fish rush has proven perilous for the birds and seals as well: the likeliest causes for their diminished numbers are depleted fish stocks and starvation. Strategically placed reserves could help boost these stocks, protect the migration corridors of everything from whales to Bering snow crabs (which can traverse hundreds of miles in their lifetimes), and ensure the wealth endures. But for decades, Alaska has relied on fisheries management rather than buying that insurance policy.

—E.S.

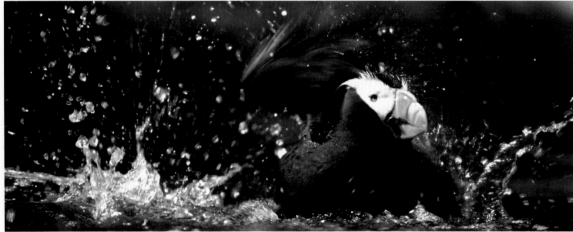

Tufted puffin cleaning its feathers, Alaska

grounded in easy view off Oregon. And the *Selendang Ayu*'s grounding happened far from any tugboats or other rescue facilities; the US government recognizes Unimak as an "international strait" with no notification or special pilotage required of transiting ships. Stationing a rescue tug at Unimak Pass would be no panacea, but it would offer some insurance against an *Exxon Valdez*–scale disaster or worse.

Tankers passing through Unimak Pass will mark just the start of the changes imperiling northern waters, as humankind's thirst for petroleum—and the climatic changes to which that thirst contributes—brings a new age of drilling and shipping to the northern reaches of the Baja-to-Beaufort corridor.

It doesn't take an actual spill for oil to kill at sea. Everyday leakage and bilge and ballast-water dumping provide a steady infusion that can coat feathers and fur just as fatally. University of Washington biologist Dee Boersma and her colleagues, who have studied Magellanic penguins at Punta Tombo in Argentina's Patagonia region for four decades, estimated that oil from illegal ballast dumping killed about 42,000 of the rapidly declining penguin population each year. They and others campaigned successfully to move the shipping lanes 15 miles (25 kilometers) farther offshore, beyond the penguins' foraging zone. Oil-fouled penguins stopped washing ashore.

Such accommodation will be essential in coming years as more and more ships transit vulnerable choke points such as Unimak Pass, the Dixon Entrance between Haida Gwaii and Southeast Alaska's Alexander Archipelago, and the Bering Strait at the northwest edge of Alaska. The shipping map is changing even more rapidly, and ominously, as the pack ice retreats from North America's northern edge, opening up the trans-Arctic Northwest Passage that explorers for centuries died trying to find.

Between Unimak Pass and the Bering Strait lies "America's fish basket," Bristol Bay and the rest of the Bering Sea. Newspapers commonly

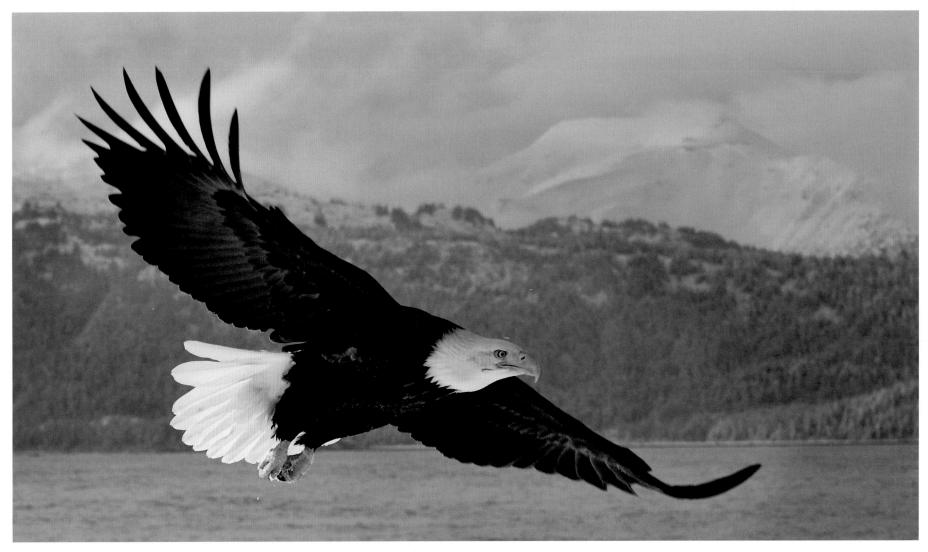

A bald eagle flies along Alaska's coast with the Kenai Mountains in the background.

cite the Bering Sea's "$1 billion fishery," but that figure includes only its largest component, the mild white pollock that is ubiquitous in fish 'n' chips, processed surimi, and other seafood staples. Add the cod, halibut, salmon, crab, and other species harvested from just the southeastern Bering Sea, including Bristol Bay, and that tally rises to more like $2 billion a year, $3 billion if processing is included. Factor in retail value and other multipliers, and Bristol Bay's sockeye salmon alone are worth $1.5 billion a year. Dutch Harbor, 60 miles

(97 kilometers) west of Unimak Pass, is the leading US fishing port by volume and the number-two port by value; six of the nation's top ten harbors by volume are in Alaska. The state's fisheries are widely touted as the best managed and most sustainable in the world—for the fish stocks themselves, if not for the whales, sea lions, and other animals that also depend on them.

But energy and mining companies smell gold and black gold in and around the Bering Sea. One proposed project has set off alarms worldwide: Northern Dynasty

Minerals' proposed Pebble Mine, an open pit that would produce great quantities of copper, gold, and molybdenum—and much greater quantities of rock tailings and discharge chemicals, to be stored behind earthen dams. All this in the middle of the Bristol Bay watershed.

In February 2014 the US Environmental Protection Agency issued a damning assessment, affirming what environmentalists, fishermen, and Native communities had contended all along: "The Pebble Mine would likely have significant and irreversible negative impacts on

"Melting rain in winter causes icing—the worst thing for caribou." It encases the lichens they eat. "They can't reach food. . . ."

the Bristol Bay watershed and its abundant salmon fisheries": for example, wiping out up to 94 miles (151 kilometers) of salmon-supporting streams and 5350 acres (2165 hectares) of wetlands, ponds, and lakes, which filter water before it reaches the streams and provide key habitat for fish, waterfowl, and migrating seabirds. This finding seemed to signal that the Obama administration would reject the project, but even that likely wouldn't end efforts to mine and dump at the heart of the nation's richest salmon fishery.

Meanwhile, 700 miles (1125 kilometers) north of Bristol Bay and 52 miles (84 kilometers) inland from the Chukchi Sea, another open pit, the Red Dog Mine, has dug lead, silver, and zinc—more zinc than any other mine in the world—out of the Brooks Range for twenty-five years. It has pumped its wastes straight into Red Dog Creek, seeded the landscape with heavy-metal dust, and generated billions of dollars for the Native regional corporation that owns it.

Alaska's economic development has swung between living resources—cod and salmon, sealskins and furs, timber, king crab and pollock—and mineral wealth, especially gold and oil. Now the balance seems to be tilting once again toward rocks rather than fish stocks. The Discovery Channel scored its first reality-TV hit with *The Deadliest Catch,* about storm-tossed crab fishermen on the Bering Sea. It's followed up with *Bering Sea Gold,* about dredging and sluicing. Oil companies are staking claims and jockeying to drill on the shelves of the Bering, Chukchi, and, now that retreating sea ice makes it possible if not safe, Beaufort seas.

At a community meeting in Barrow, on the Beaufort Sea at Alaska's northern tip, I heard Inupiat residents

and government wildlife biologists share stories of global warming's impacts writ small. Geoff Carroll, the Alaska Fish and Game Department's resident biologist for the vast North Slope, explained how the Western Arctic caribou herd had shrunk by half since 2005 and a third of the herd's females were dying each year.

"Is this due to oil development?" one older woman wearing a traditional hand-sewn *ataraaq* asked, scowling. This was no idle question. The herd provides both sustenance and identity to a culture still rooted in subsistence hunting. And though more than 200 miles (320 kilometers) insulate Barrow from the oil depot at Prudhoe Bay, residents worry that the helicopters roaring overhead will disturb the animals.

"Very little," Carroll replied. "We believe global warming is a big cause. Melting rain in winter causes icing—the worst thing for caribou." It encases the lichens they eat. "They can't reach food," he continued, "or they spend lots of energy getting it." Either way, they starve to death.

Carroll told me caribou weren't the only local ungulates that were suffering. In summer, moose make their way north along the Colville River to the Beaufort coast. "They're doing very poorly," Carroll explained, even though they don't depend on icebound lichen. The reason: ticks and other parasites that weren't previously known this far north. "Caribou and moose across Canada are dying from them," another researcher interjected.

Again and again in the far north, the conversation turns to the warming climate. Truckers driving from Fairbanks, Alaska, to Barrow got stranded when the ice road turned mushy and collapsed. Each year the black guillemots return earlier to nest on nearby Cooper Island. This year, biologist George Dikovy (see his profile in this book) can't ride a snowmobile out to resume his long-term study of the guillemots: the shoreline sea ice that used to last reliably into June can now break up in May or earlier. In late April I went skijoring with a borrowed husky harnessed to my waist, savoring the solitude of having nothing below but the Arctic Ocean

sea ice and nothing between me and Murmansk, Russia, but the abstract North Pole. The next day a southwest wind rose up and blew the ice I'd been on out to sea.

For millennia, the sea ice has protected the waters of the Beaufort and other Arctic seas from the fierce winds that sweep across the top of the world. Now, as the ice retreats, those winds whip up storms and waves here on a scale never before seen in human memory.

This is, from a commercial point of view, a good news–bad news joke: The newly opened Northwest Passage will provide a shorter, faster shipping route between Europe and East Asia. But the new superstorms will batter, and sometimes sink, those ships.

From an ecological view, this is a very scary prospect. These waters lie much farther from emergency response infrastructure than those of Prince William Sound, where the effort to contain the *Exxon Valdez* oil spill failed miserably. Imagine not cormorants but polar bears gasping and dying under a slick of oil. Should offshore drilling ensue in the Arctic, these waters and shores will continue to change, even in the unlikely event that an oil spill never occurs. The Arctic is global warming's front line, heating faster than any other part of the planet and generating feedback loops that will only accelerate the warming. The ever-earlier melting of snow and sea ice reduces surface albedo (reflectivity), causing the sea and land to absorb more heat, melting the ice and snow faster . . . and so on. The thawing permafrost releases carbon dioxide and methane (a greenhouse gas about twenty times more potent), causing more warming and thawing . . . and so on.

Organisms and ecosystems that have thrived in the unusually stable climate that human civilization has enjoyed for the last ten thousand years will struggle to adapt to radical new regimes. Some will follow the temperature gradients northward, perhaps with devastating consequences for those already there. Orcas are expanding into the Arctic as the ice (which their tall dorsal fins collide with) recedes. Inuit hunters, the vanguard observers, report that orcas are targeting

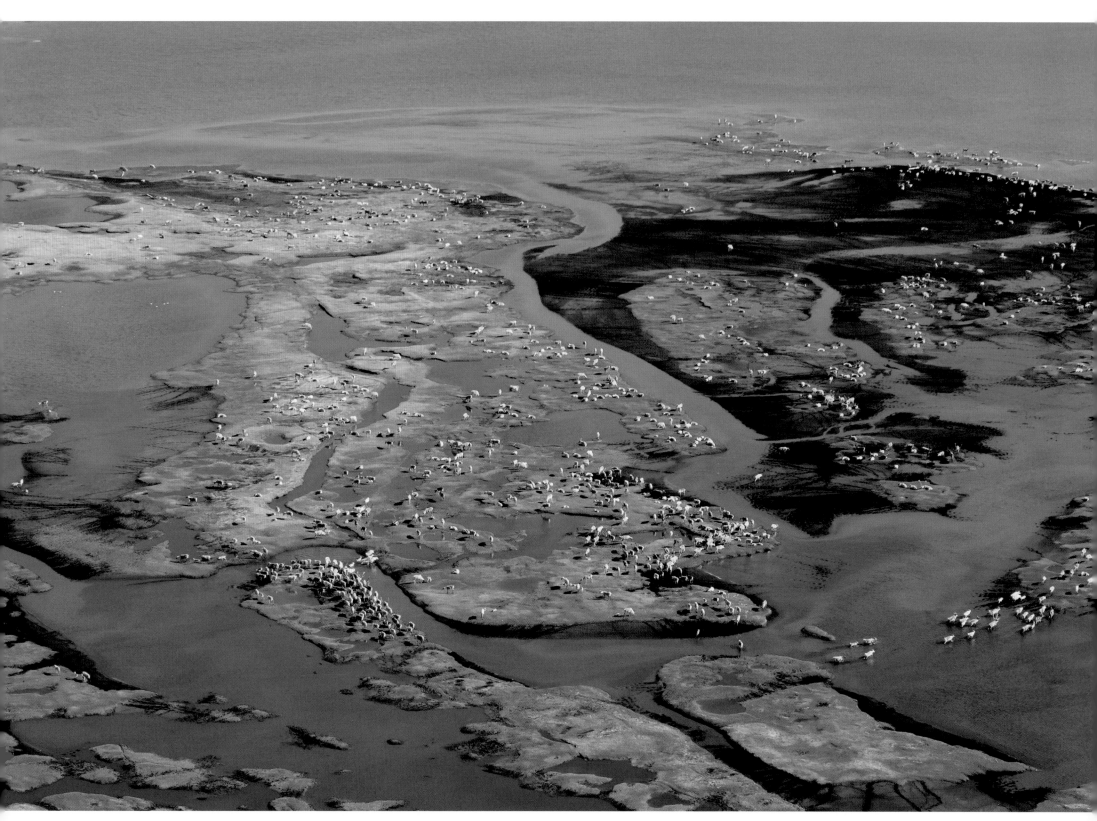

Members of the Central Arctic caribou herd congregate at the edge of the Arctic Ocean, seeking relief from increasing summer temperatures, Alaskan Arctic.

GEORGE DIVOKY

ON THE FRONTIER OF CLIMATE CHANGE ON COOPER ISLAND

BY ERIC SCIGLIANO

© ROSE+SJÖLANDER

It's early May, and George Divoky has no idea how he'll get to Cooper Island—a 3-mile (4.8-kilometer) spit of sand and gravel off Alaska's North Slope—in June. All his fallbacks have fallen by the wayside: Bush pilots no longer fly out of Barrow, the northernmost settlement in the United States, 25 miles (40 kilometers) west of Cooper. The helicopter pilot who used to take him in a pinch isn't flying. Boats can't get through until July. And the Inupiat pal who usually drives him out says there's

no way the softening ice will support a snowmobile this year.

"This is all due to warming," Divoky explained. For nearly all his forty summers on Cooper Island, he could rely on the sea ice. That's changed; nature has delivered another riposte to the climate "skeptics" who brush off whatever he and other on-the-ice observers report.

"I can't take too much pleasure in saying 'I told you so,'" he sighed. Being right complicates his work; he'll just have to come back in June and wrangle a way to the island. There's no doubt he'll get over this obstacle as he has every other, through a combination of charm, tenacity, and ingenuity. Such are the hazards of doing research on a shoestring at the top of the world.

Divoky came to the Arctic to study birds, not climate. He arrived in 1970, a rookie ornithologist sent by the Smithsonian Institution to assess seabirds offshore from the newly discovered Prudhoe Bay oil field. On Cooper Island he made his own discovery: a colony of black guillemots, natty pigeon-sized auks that supposedly never nested this far north. The rocky crevices they require are absent here, but they'd found a substitute: crates and other debris dumped by the US Navy.

Intrigued, Divoky returned in 1975 to study these outliers. He's returned every summer since, with and without funding, recording every detail of breeding, diet, nesting success, survival. It's an extraordinary chronicle, one of very few comprehensive long-term studies of seabird populations and the first in the Arctic.

Along the way, he noticed something surprising. Guillemots, which nest as soon as the snow melts off their cavities, were arriving earlier each year. Cooper Island and the high Arctic were warming, fast. Other, more immediately threatening signs confirmed this. In 2002 hungry polar bears, which couldn't be bothered with tiny birds or wayward ornithologists when they had the pack ice they need to hunt seals, began raiding the nests. In 2009 they wiped out all but one nestling. Divoky set up tough plastic cargo cases for the guillemots and a hut and electric fence for himself.

Suddenly his study was about more than birds: it was a unique decades-long record from the frontier of climate change. It's brought him peer acclaim and improbable fame. "Your data are more robust than the models'," Craig George, the North Slope Borough's senior wildlife biologist, told him when I visited Barrow

When he was at a Seabird Group meeting at Oxford, another researcher declared, "With all the new technologies, it's a great time to be a seabird biologist." Divoky replied, "Yes, but it's a lousy time to be a seabird."

with Divoky in May. The *New York Times Magazine* featured Divoky on its cover. England's National Theatre staged a play based on his work. When he was at a Seabird Group meeting at Oxford, another researcher declared, "With all the new technologies, it's a great time to be a seabird biologist." Divoky replied, "Yes, but it's a lousy time to be a seabird."

Rather than resting on such laurels, Divoky pushes on. He's now monitoring the guillemots' shift along the food web as their cold-loving preferred prey, arctic cod, decline and they turn to a spiny, less-sustaining fish, the sculpin. He doesn't know whether the evidence he or any other scientist uncovers can change humankind's carbon-spewing ways: "People are informed now, and they don't change." But he keeps building the record, just in case.

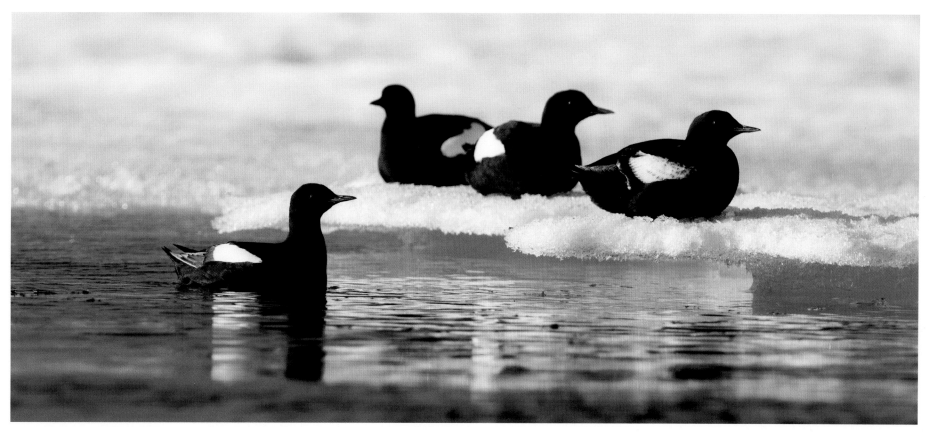

Black guillemots in the Arctic, Alaska

narwhals, belugas, and bowheads, which can't dive deep enough or swim fast enough to escape them. Polar bears driven to land for lack of ice meet grizzlies venturing farther north, producing so-called "grolar" or "pozzly" hybrids.

Much bigger changes are happening out of sight. In the short term, warming may bring more ice algae, strands of diatoms that grow like reverse kelp under sea ice and nourish krill and other critters that are critical to the Arctic food web; the algae grow faster and thicker as the ice thins and more sunlight penetrates. But as the ice retreats, so do the algae—and the entire food web that depends upon them.

Ocean acidification may disproportionately affect the Arctic; cooler waters can hold more carbon dioxide than warm water can. But it's already wreaked havoc on shellfish hatcheries in Oregon and Washington, which produce oyster seed for growers up and down the Pacific Coast, from Mexico to Canada. And carbon-induced climate change threatens to subvert even the mighty oceanic processes that have made that coast's waters such a wellspring of life, for humans and other animals. As the ocean's surface warms, its waters become more stratified, impeding the upwellings that have served up the nutrient bonanza that feeds everything from phytoplankton to great whales and high-flying arctic terns.

Eventually this warming could disrupt the mighty currents that have shaped the climate along the coasts from Baja California to the Beaufort Sea. Without the moderating influence of the Alaska Current, for example, Southeast Alaska might experience the temperature extremes of permafrozen northern Labrador. At the same time, fast-falling rain will replace slow-melting snowpack in the Cascades and other mountain ranges along the coast. This will alter the annual stream-flow regimens upon which salmon and other aquatic species—from dragonflies to red-legged frogs—depend on to lay eggs that will hatch and produce young that will carry on their life cycles. Spring floods will wash out some salmon redds; strangled water flow will leave other runs high and dry.

Marine protected areas and other reserves and migration corridors cannot solve these challenges; only unprecedented changes in human behavior on a global scale can. And even then, the effects of carbon already emitted into the atmosphere will echo for centuries. But reserves and wildlife corridors like the B2B can function as a sort of immune system, helping embattled species and ecological communities muster the strength they need to weather the storms we have created. ▪

NOTES FROM THE PHOTOGRAPHER

UNIMAK PASS: GATEWAY TO THE BERING SEA

It is the middle of May in Homer, Alaska, yet the Kenai Mountains across Kachemak Bay are still covered with deep snow. We are loading the sailboat *Jonathan II* for a two-month expedition to explore the Alaska Peninsula and the Aleutian Islands. The team includes three friends from my Arctic work—Audun Tholfsen, Chris Scanon, and Mark van der Weg, captain of the boat—as well as my brother, Salomon. All adventurous guys, they know how to survive in the outdoors. Mark has just completed sailing the Northwest Passage, and Audun walked

Right: Bald eagles at the shore of Kachemak Bay with the Kenai Mountains in the background, Alaska

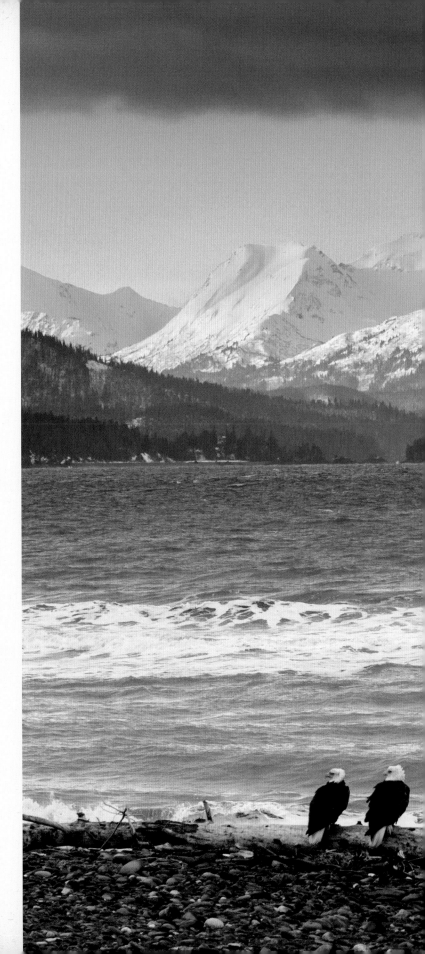

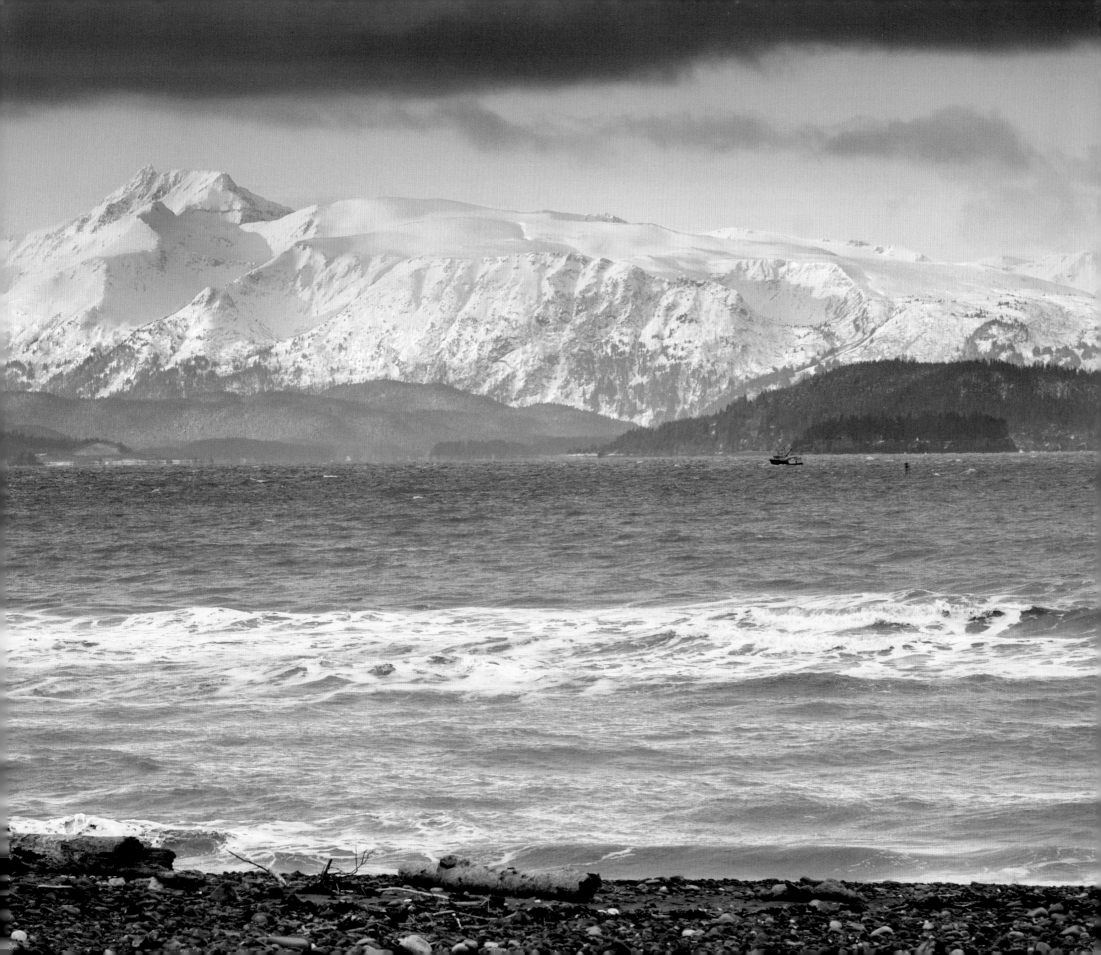

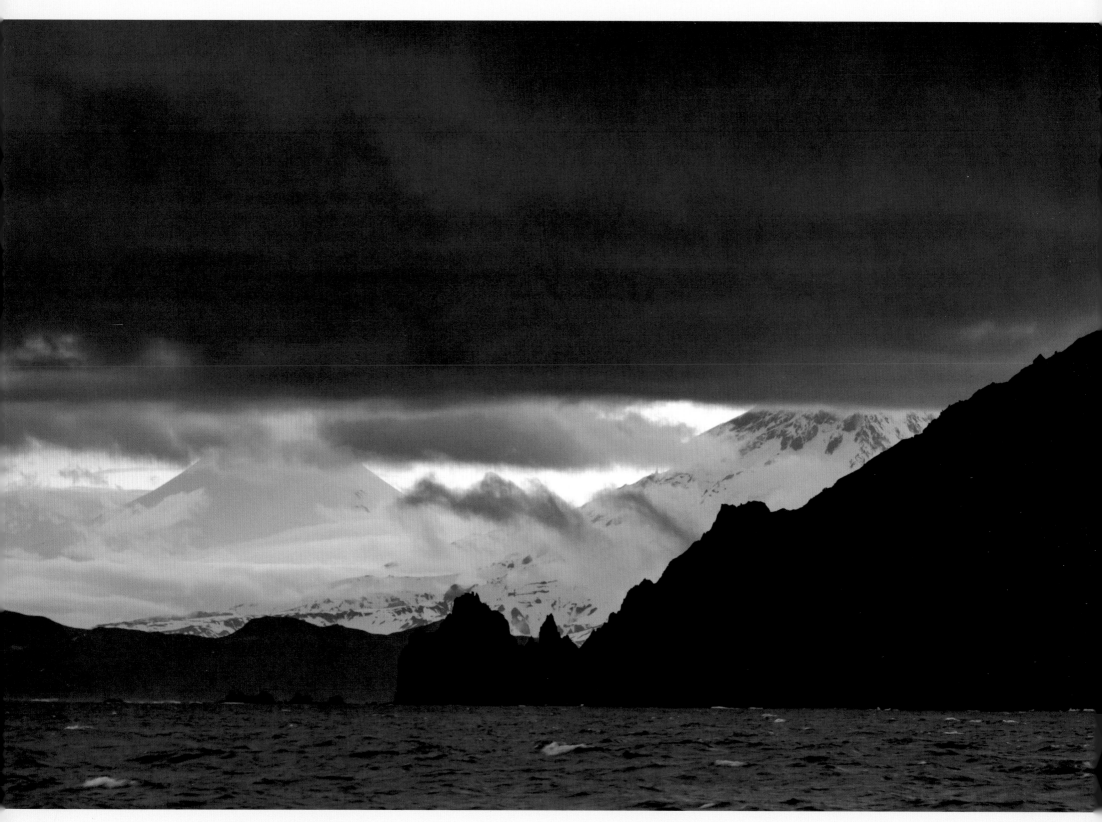

Unimak Island, Aleutian Islands, Alaska

and paddled from the North Pole to the Svalbard Islands of Norway's Arctic.

This winter has held its grip on the land for a particularly long time, but along the shore, we see unmistakable signs of spring. Hundreds of thousands of little wading shorebirds, mostly dunlins and western sandpipers, have stopped over on their annual migration north. They fill the mudflats of the bay, feeding on insects and small sea creatures. The rising tide pushes the birds inland, making the flock denser and denser until the shoreline becomes covered with their feathered bodies. Suddenly, they lift collectively into the air and fly north, across the water, pulled by a sense of urgency to reach their annual nesting grounds on the Arctic coast of Alaska.

I also feel a certain restlessness to get on our way. Many sailing days through dangerous water are ahead of us. One of my goals is to explore Unimak Island, the biggest island in the Aleutian chain—and the westernmost home of Alaska brown bears, a large subspecies of the mainland grizzly bears. These coastal bears feed on spawning salmon, and they grow huge.

Located about 700 miles (1125 kilometers) southwest of Anchorage, Unimak is a remote wilderness. Just beyond the island lies Unimak Pass, the first navigable opening between the stretched-out Alaska Peninsula and the Aleutians into the Bering Sea. For millennia, tens of thousands of whales have passed through this bottleneck every year. Now, in this modern age, with a melting Arctic Ocean, an ever-larger number of huge tankers, cargo ships, and ocean liners competes for space in the narrow pass.

On the evening of our seventh day in the Gulf of Alaska, the shore of Unimak Island is visible in the distance. A rugged coastline looms above us to the north. The rusty steel skeleton of a shipwreck washed up on shore reminds us of the storms that batter this coast. A cold, stiff breeze is blowing, and thick, dark clouds race over the land and sea. Approaching Unimak, we can just see the base of

an enormous mountain, its top covered in clouds. It is Mount Shishaldin, one of the most active volcanoes in the world, its peak rising to 9373 feet (2857 meters). Watching closely for shallows, we sail into a small, protected bay to anchor for the night.

The next morning we are up on deck at first light, searching the coastline for signs of life. The landscape this far west has changed completely. It is barren: there is no sign of trees or bushes. Even though we are not that far north, I find as if we've been transported to the Arctic. Here in the Aleutians, the harsh arctic climate dips south below the Arctic Circle, producing the same arctic tundra vegetation as up north. There is a unique beauty to this rough landscape. The snow has just retreated in the lower elevations. Bald eagles nest on the rocky cliffs, which in this treeless landscape is the only safe spot for them.

I watch a little red fox as it hurries along the shore, sticking its nose into the seaweed here and there. Then the fox suddenly freezes. All its attention is focused on the edge of a large boulder. Readjusting my binoculars, I see a large brown bear suddenly come out from behind the rock. Swinging his heavy body right and left, the boar slowly walks down the beach. He has a keen interest in the piles of seaweed on the beach, digging at them with his huge paws, his thick tongue licking through the slimy salad. He is finding hordes of little pea-sized beach hoppers, small protein-rich crustaceans, a perfect diet for the bear after a long hibernation. The bears are not the only ones after this snack. The little fox is going from pile to pile, licking up the hoppers like candy.

Later, as we sail along the shore of the island, we see more and more bears. Many of them are also harvesting the beach hoppers. It becomes clear how closely the wildlife on the island is tied to the sea, supported by what the ocean brings ashore. And up the

Two bald eagles are silhouetted against the setting sun, Kachemak Bay, Alaska.

coast, bears cling like mountain goats to steep, grassy slopes, eagerly feeding on the nutritious greens. On one slope half the size of a football field, I count seven bears.

Our focus shifts. In the distance we see the spray of whales. There are about a dozen individuals, with at least one calf in the group. The gray whale calves, born in winter in the calving lagoons of Baja California, have journeyed north at their mothers' sides. In Baja's shallow bays, they had been safe from the great white sharks lurking in open water. For more than two months and 4000 miles (6400 kilometers), they have swum tirelessly until they reach this crucial point in their migration: the entrance to the Bering Sea, through narrow Unimak Pass. This may be the most dangerous part of their journey. Here, supreme hunters await that are more dangerous than a great white shark because they hunt in packs: orcas, the wolves of the sea. As I see the group of gray whales swim on, I wish them luck. I wonder if the whale that let me scratch its nose in Baja might be in this group.

Several days later, we explore Unimak Island, following one of the many well-worn bear trails through the grass. A light change in wind now pushes a plume of rotten air in our direction: it is the smell of a dead whale. We walk down to the shore, and there we see a young gray whale washed up on the beach. Orcas have attacked its face, but the rest of the body is pretty much intact. The whale will offer a buffet for the bears and other animals and birds in the coming weeks.

I want to photograph what will happen when bears find the whale, so we set up a blind out of logs and washed-up branches, filling in the gaps with dry grass. As I sit in the blind, I think of the fate of the dead whale calf. It is a sad sight, but at the same time, it is part of the cycle of life. The whales that have come all the way from Baja California are feeding the bears on Unimak Island, just when they have emerged from hibernation and desperately need nutritious food. All in nature is interconnected.

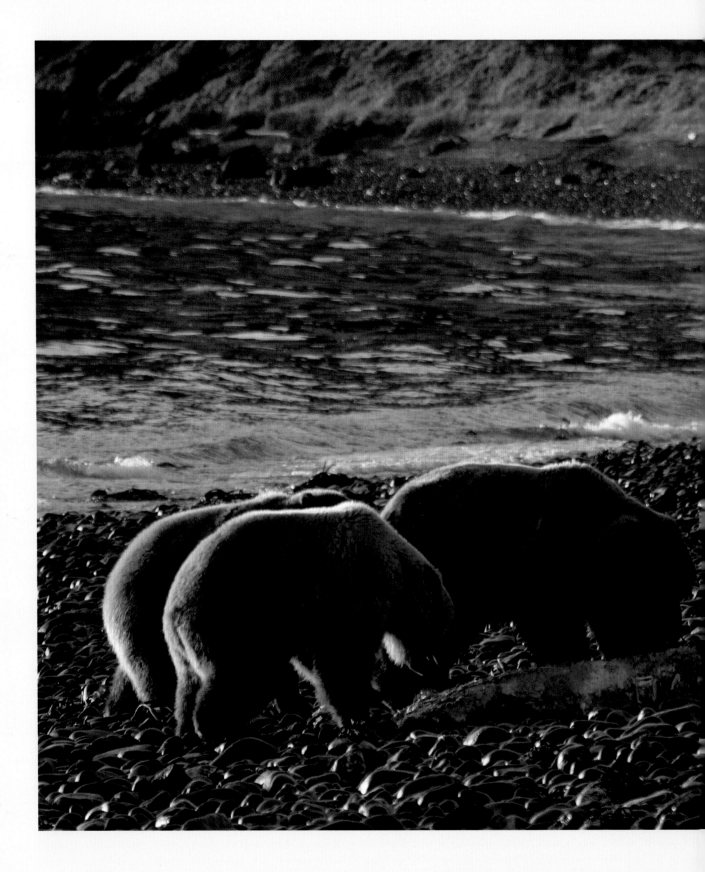

Brown bears feed on a whale carcass on Unimak Island, Aleutian Islands, Alaska.

WESTERN ALASKA FROM THE AIR

The fog slowly lifts over the river as the brilliant orange orb of the sun climbs above the horizon. The screeching of gulls and the splashing of water fills the air. Several huge brown (grizzly) bears rush into the stream, trying to catch fish. They are after the sockeye salmon that have traveled upriver from Bristol Bay in huge numbers. In some areas, the spawning salmon are so thick the river looks deep red.

As I watch from atop a high riverbank, I count more than thirty-five bears along the river. The bears

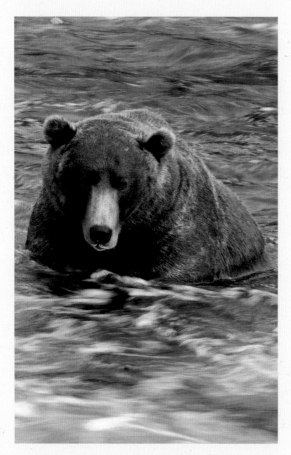

A grizzly bear waits patiently for an opportunity to catch a sockeye salmon, Katmai National Park, Alaska.

are charged up with excitement about the fish. They are driven to seize this moment of plenty so they can fatten up before their winter hibernation.

Bristol Bay, in southwest Alaska, is the richest salmon fishery in the world, with runs of kings, chums, silvers, and sockeyes arriving seasonally to complete their cycle of life. Up to 40 million sockeye salmon return to this watershed each year.

A threat looms over this amazing place: the proposed construction of the largest open-pit gold mine in North America. The effort would require massive dams to hold back the toxic waste, called tailings, a by-product of the mining operation. The project is planned on such a scale that it threatens the entire Bristol Bay watershed.

I want to get a clearer picture of the area. Together with my friend Ken, a bush pilot, I plan to document the landscape of western Alaska from the air. I want to explore the proposed mine site and also look at the coastline farther north. Ken, an expert aviator, intimately knows the capabilities of his Super Cub. With me in the single backseat, stuffed in with camera gear and camping equipment, we take off. Capable of lifting off in 200 feet (60 meters) and landing on strips as short as 400 feet (120 meters), this ultimate bush plane can take us to just about any spot in this wild country.

We glide over rivers filled with salmon, again and again seeing groups of bears and the stream beds colored red with sockeye salmon. Soon, in front of us Lake Iliamna opens up. Alaska's largest lake, its deep blue color changes to shades of turquoise along the shore. Its waters drain into Bristol Bay.

As we get closer to the proposed mine site, we try to find the Pebble Mine exploratory camp. It is not easy to locate in this enormous open region of streams, lakes, rolling hills, and mountains. It is unimaginable to me that anyone would consider changing this spectacular, remote landscape into a gravel pit large enough to see from the moon. As we glide over the lake's north shore, Ken points out little specks in the distance: the exploratory camp.

I think about the recent headlines of the Mount Polley Mine disaster in British Columbia, which is threatening the 2 million–strong Fraser River salmon run and polluting pristine Quesnel Lake. The mine's tailing pond dam broke and released years' worth of accumulated toxic mining waste. The US Environmental Protection Agency has identified the hard-rock mining industry as the nation's largest producer of toxic waste. In the case of the proposed Pebble Mine in Alaska, the tailing dam would be much larger than the one at Mount Polley Mine, and it is located in a seismic area, posing a disastrous threat to a renewable resource that feeds everything from eagles to wolves and bears, not to mention countless numbers of people worldwide.

Gliding for hours over unspoiled landscapes fills my heart with joy. My eyes constantly scan the terrain for wildlife and compelling photographic imagery. At the end of the day, Ken simply sets down the plane on a riverbank to spend the night, I in my bivy sack, Ken in the plane.

We slowly make our way farther north on our aerial expedition, eventually passing Nome and Kotzebue in northwest Alaska. Halfway between Kotzebue and Point Hope, we fly over the existing Red Dog Mine. For years, this zinc-lead mine has been polluting the streams and surrounding tundra. Discharge of toxic waste far above the permit limits continues unchecked. The local Native community of Kivalina has sued the company for violating the Clean Water Act, but the contamination is still going on.

The Arctic landscape generally is wilderness with little human development because of the harsh climatic conditions. The wildlands are still endless enough to support several enormous caribou herds. Just north of the De Long Mountains in northwest Alaska, we encounter the biggest of Alaska's caribou herds: the Western Arctic caribou herd, which fluctuates between 250,000 and 500,000 animals.

When I see the caribou appear below us and into the distance, spanning an entire river valley—miles of caribou in all directions—I am reminded of when bison filled the Great Plains by the millions. After the influx of Europeans

Grants Lagoon on the western shore of Iliamna Lake, Alaska

two hundred years ago, such sights quickly disappeared. Only here in the Arctic do we still see hundreds of thousands of caribou going about their annual migration as they have done for millennia. I feel a responsibility to fight for conserving the last of the wild.

With the changes in our planet's climate becoming ever more evident, the Arctic is altering at a rapid rate. The temperature has risen twice as fast in the Arctic as in any other region. As we fly along the northern Alaska coast at the beginning of July, there is no ocean ice as far as I can see, whereas in years past, large sections of drift ice would have covered the ocean. This change sparks additional interest in resources because of easier accessibility to the sea's depths. The oil reserves around Prudhoe Bay are almost exhausted, so the oil industry is looking for where to go next. Drilling in the Arctic Ocean is on the table.

I think of the thousands of seals I saw on the ocean ice when I was here in May. In the case of an oil spill, what would happen to them and to the millions of seabirds? Today there is no known method to clean up an oil spill in icy waters. It would be an absolute catastrophe. Whales, seals, and seabirds would die, leaving polar bears without food.

With the Arctic Ocean ice melted, the coast is exposed to larger waves and is eroding fast. Brown plumes of eroded dirt color the sea along the coast. Climate change is already drastically affecting the Arctic landscape and its inhabitants. The climate change issue is so big and in a way so hard to grasp that I sometimes get overwhelmed and feel hopeless. Yet I know the natural world finds an easier balance if we leave it alone. Again and again, industries want us to believe that their practices will have little or no impact on the environment, yet we learn daily of new oil spills, mining disasters, and contamination sources. When massive disasters strike, the responsible companies either go bankrupt and leave the cleanup for the taxpayer or find refuge in decades-long lawsuits, as we have experienced in Alaska's Prince William Sound after the 1989 *Exxon Valdez* oil spill.

As we pass Kasegaluk Lagoon north of the Bering Strait, I see well over a thousand beluga whales along the coastline. Their white bodies shine brightly at the sea's surface as they patrol for fish. Just a few miles inland, we find another exploratory mining camp. One of the largest coal deposits on the planet lies in this area of Alaska, just below the surface. Might this be the next environmental battle in the future?

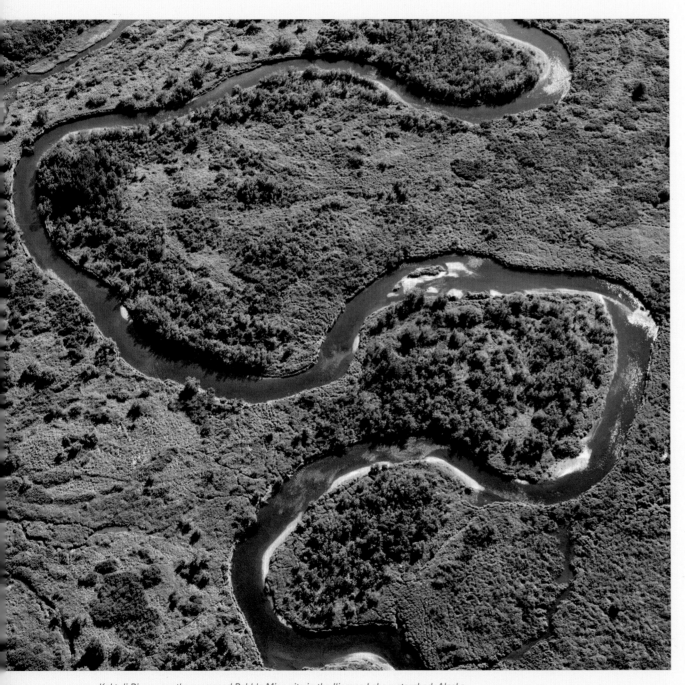

Kaktuli River near the proposed Pebble Mine site in the Iliamna Lake watershed, Alaska

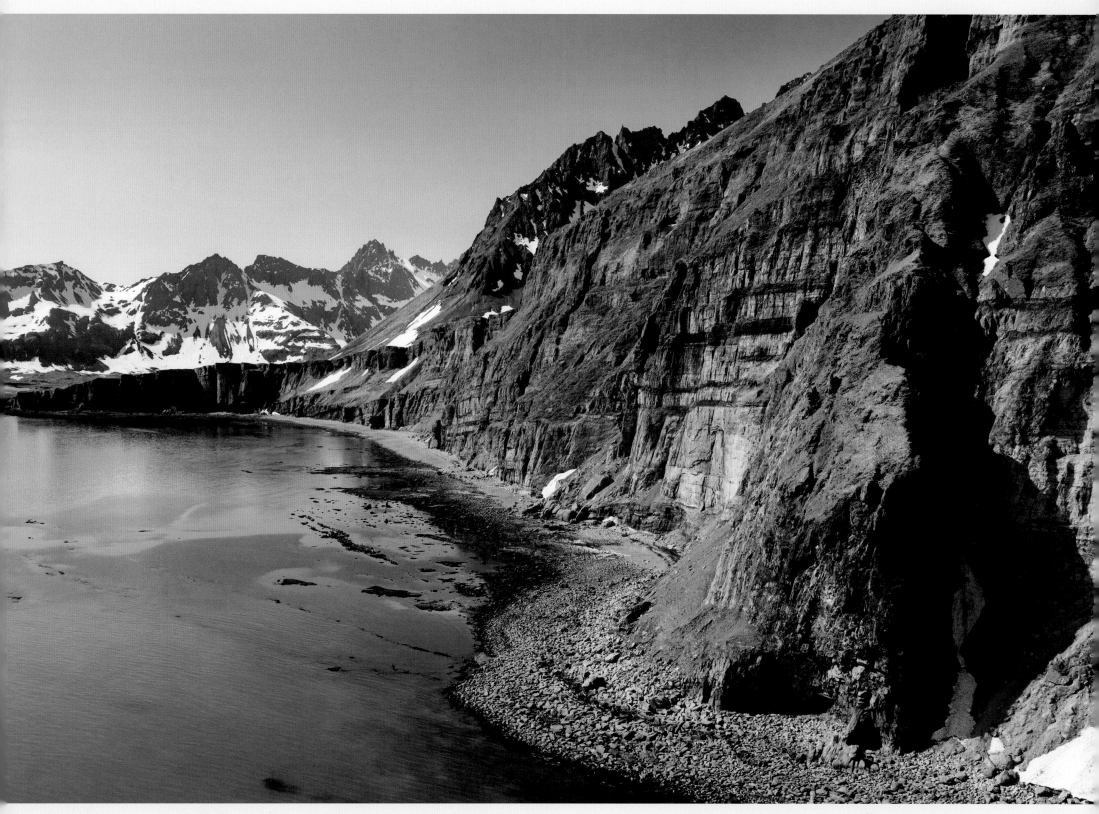

Rugged shoreline along Katmai National Park, Alaska

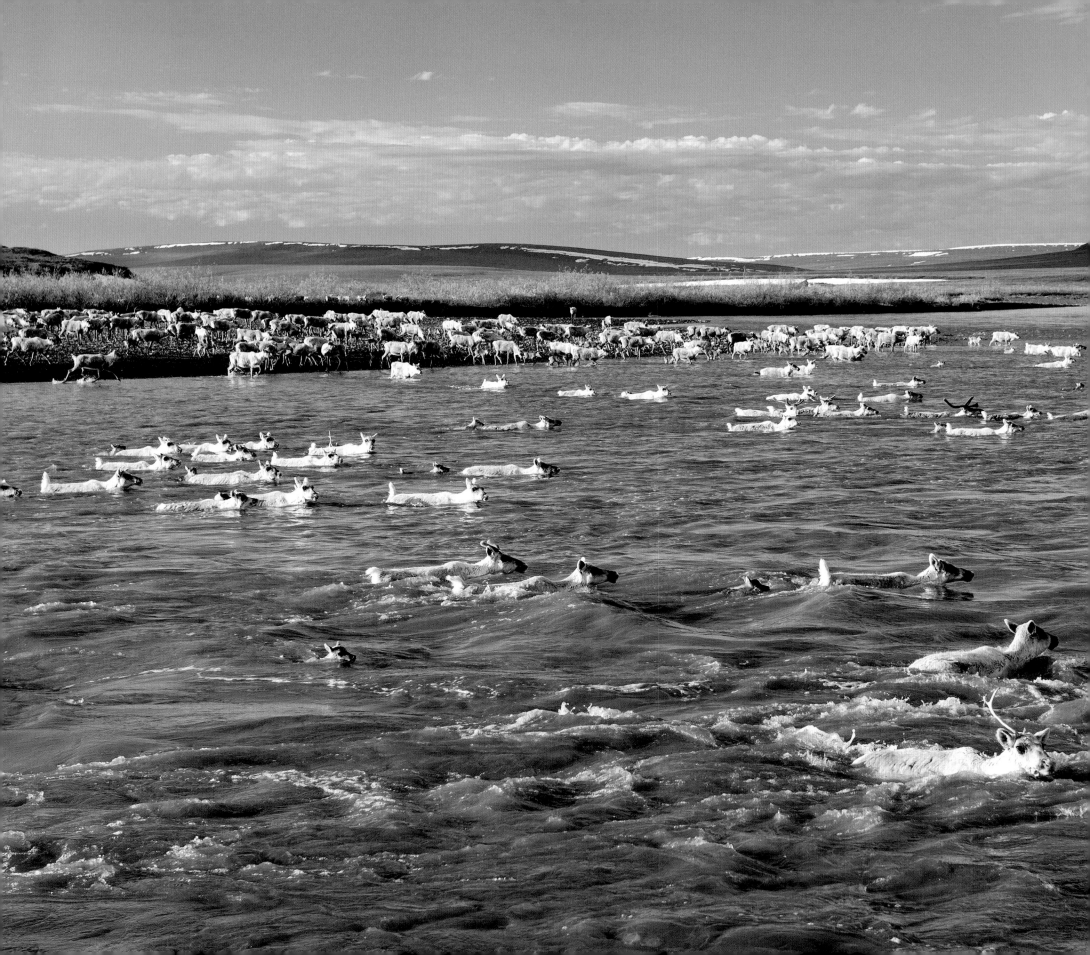

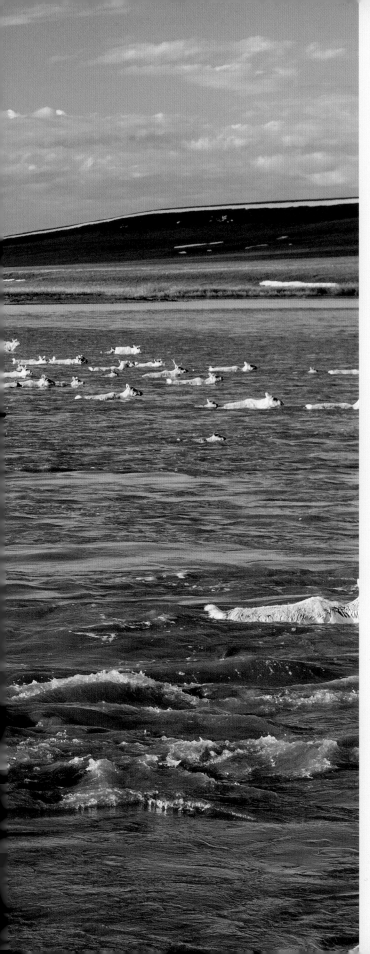

LOOKING FOR CARIBOU

I sit on a mountaintop in one of the largest interconnected wilderness areas on the North American continent. Together, Canada's Vuntut and Ivvavik national parks and Alaska's adjacent Arctic National Wildlife Refuge comprise an area of more than 35,000 square miles (56,000 square kilometers), comparable to the size of the state of Indiana. The region is free of roads and powerlines and has only small settlements of Native people. The Canadian government has put a moratorium on industrial development.

I have traveled to this remote place hoping to find the Porcupine caribou herd. Named after their calving grounds along the Porcupine River, the herd of about 160,000 animals uses this enormous landscape as their home range, as it has for thousands of years. They migrate northwest in spring over 1500 miles (2400 kilometers) every year, from the boreal forests of the Yukon Territory and Alaska to the coastal plain of the Arctic Refuge. Their migration is driven by the availability there of nutritious food and their need to reach snow-free calving grounds.

Our group, which includes my wife, my brother, me, and some friends, has been dropped off by a DeHavilland Twin Otter, and we have just begun our journey. We are rafting the Firth River in the Yukon Territory with the hope of intercepting the migrating caribou herd. We will float to the north, arriving at the Beaufort Sea, where the river pours into the Arctic Ocean.

My heart is filled with joy as I look around at the untouched landscape. I feel as if I am experiencing the world as it was many thousands of years ago: unaltered, raw, and wild. And, in fact, the Firth River drainage is more unchanged than the land just a few hundred miles to the west. This region is called a refugium, meaning it escaped being glaciated in the last ice age, so the ancient landscape, creatures, and forms of vegetation have survived intact.

I glass the surrounding hills for signs of caribou. It is late June, and the herd is somewhere out there on their trek west. It should be easy to spot so many animals, but the area is vast, and caribou can easily blend into the tundra.

The Firth River takes us through breathtaking sights. We float by the nests of falcons and rough-legged hawks. As we set up our camp, a grizzly bear wanders by and checks us out.

Not only is the landscape thrilling, but the ride on the river is too. The 150-mile (240-kilometer) stretch of the river is littered with class III and IV rapids. Again and again, we pull to shore and step out to scout the whitewater ahead.

Each day, I hike up hills and viewpoints, but there are no caribou to be seen.

As we come out of the mountains and the river peacefully flows along, we search for a geological landmark in the coastal plain: Engigstciak Rock. It is a very special place, sticking up from the coastal plain like a lonely peak. From the top, we will have a far-reaching view in any direction. I can imagine the hunters from long ago resting here in search of prey. And indeed, many artifacts have been found at this geological site: ancient flint items mixed with bones of extinct animals.

I am still hunting for caribou with my camera, and I don't see a single one from this high point. But caribou tracks litter the landscape. Thousands of them must have just passed by. We have seen tufts of caribou hair hanging from willows along the river where they crossed. With my binoculars, I can make out grizzly bears that have been trailing the migrating herd, hoping for lost calves or injured animals.

The next day, we make our way to the coast through the increasingly shallow, braided river's maze of channels. Again and again, the rafts hang up on the river bottom and we have to get out and drag them along.

Close to midnight, we arrive at Nunalak Spit. The sun, hovering above the Arctic Ocean, gives us a warm welcome. A light breeze has blown in some drift ice, offering a dreamlike scene.

Caribou cross the Utukok River during their westward migration, Western Arctic, Alaska.

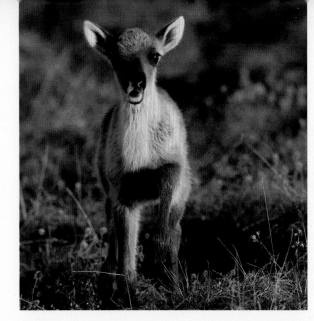

A caribou calf calls its mother. Tens of thousands of calves migrate with the herd immediately after they are born, Utukok Uplands, Western Arctic, Alaska.

Countless birds nest on the Barrier Islands including plovers, long-tailed ducks, and arctic terns in large colonies. Arctic terns, such elegant fliers, have traveled all the way from the Antarctic Ocean on their 20,000-mile (32,000-kilometer) annual migration north to breed and raise their young. Under a never-setting sun, arctic terns dart into the water in their hunt for capelin, sand eels, and small crustaceans. In only twenty-five days, the young will fledge and soon after embark on their epic journey to the Antarctic for the first time.

I am disappointed not to have seen the big caribou herd on this expedition, but at the same time I am thrilled to be in this landscape. After all, the unpredictability makes the adventure. And it means I will need to come back.

I have returned again and again to the Arctic, looking for caribou. This year, I have spent close to four months in the Arctic National Wildlife Refuge. Finally, at the bank of the Katakturuk River I have found them: thousands of individuals of the Porcupine herd surround me. For hours, I have tried my best to capture their migration on film.

I pause to just observe. I ask Jake, my friend and pilot, to clock sixty seconds. He looks at his watch and says, "Go!" and I frantically count the caribou streaming over the ridge. One, two, three . . . ten; one, two, three . . . ten. I have just counted more than one hundred caribou when the minute is done. I begin to grasp the numbers. This part of the herd has been moving by me for hours at this rate: every ten minutes, a thousand individuals—six thousand an hour—making it many tens of thousands that night.

With every day, the mosquitoes grow in number. The caribou herd moves to the coast, to escape them. They head to the delta of the Canning River. The last remnants of winter's ocean ice linger near shore. The Canning River marks the boundary of the Arctic National Wildlife Refuge. Farther west lies Prudhoe Bay, with the oil field's sprawling web of roads, drilling pads, pump stations, and pipelines.

On one of the sand spits that join the Barrier Islands, I am filming some of the migrating phalaropes and golden plovers. I see one of the industrial oil sites hovering like a mirage over the water. I think, *It looks as if they have already gotten their way about drilling in the Arctic Ocean.*

Suddenly a large male polar bear appears on the beach. Head down, he follows the shoreline, sniffing. Then he turns and climbs the steep, eroding bank until he reaches the thick, carpetlike tundra vegetation and lies down to rest. For polar bears, summer is a time of little food. Their main protein source is seals, for which they hunt on the sea ice. Now the bears are mainly dependent on washed-up carrion, such as marine mammals or the remains of a bowhead whale from an Inupiat hunt. In awe, I observe the powerful polar bear. He must have swum a very long distance, because now, with global warming, the sea ice is so far from land. He will now be landlocked until the return of winter when the ocean freezes over once again. ■

Members of the Central Arctic caribou herd congregate at the edge of the Arctic Ocean where the cold breeze gives them relief from mosquitoes, Canning River Delta, Alaskan Arctic.

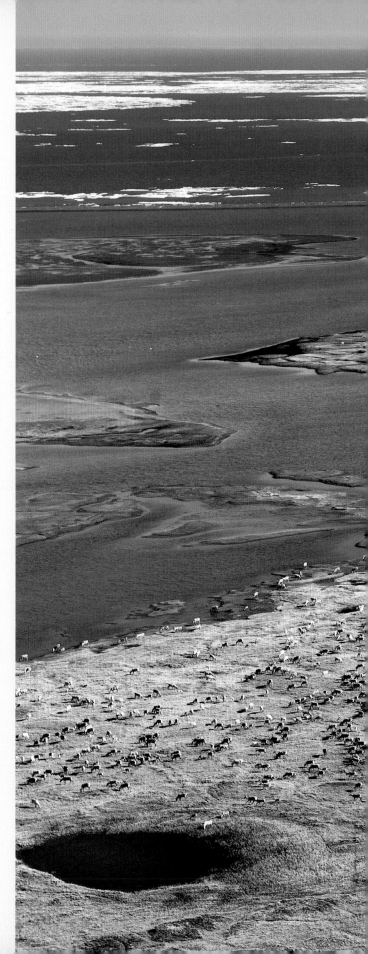

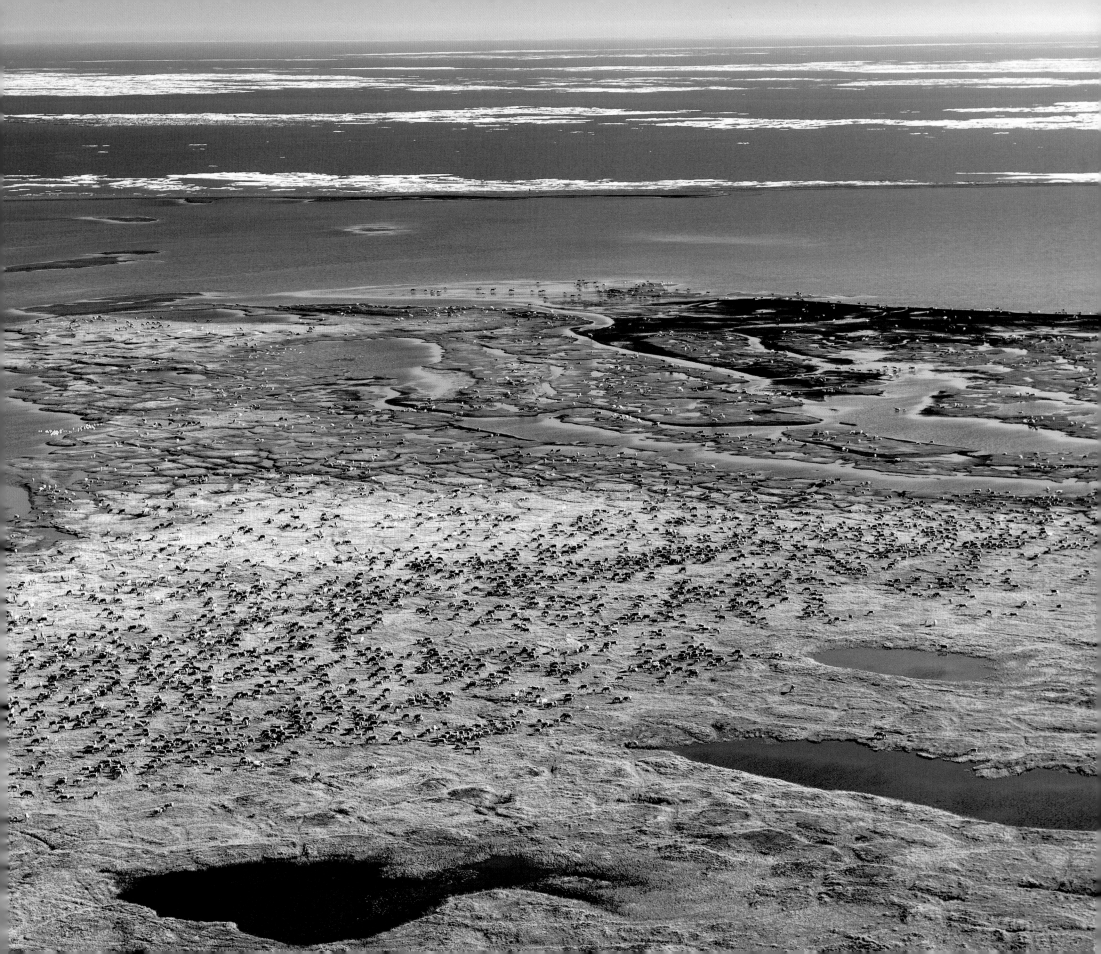

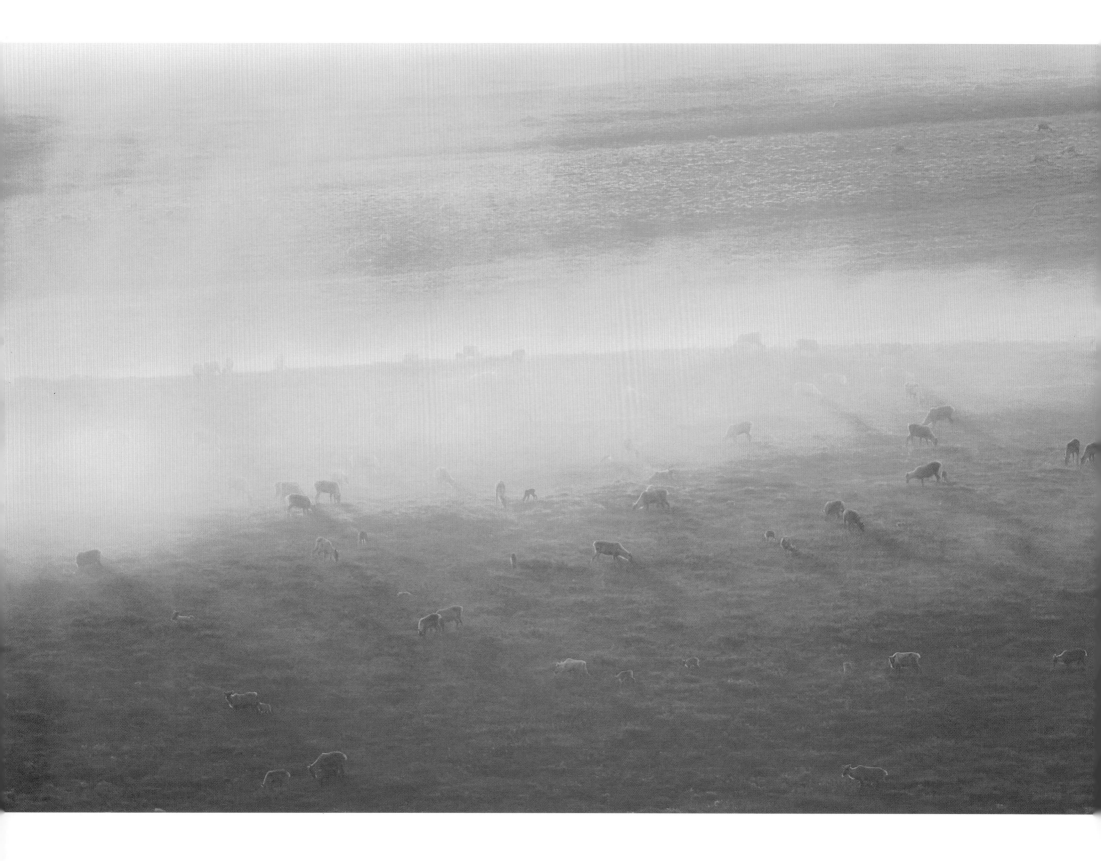

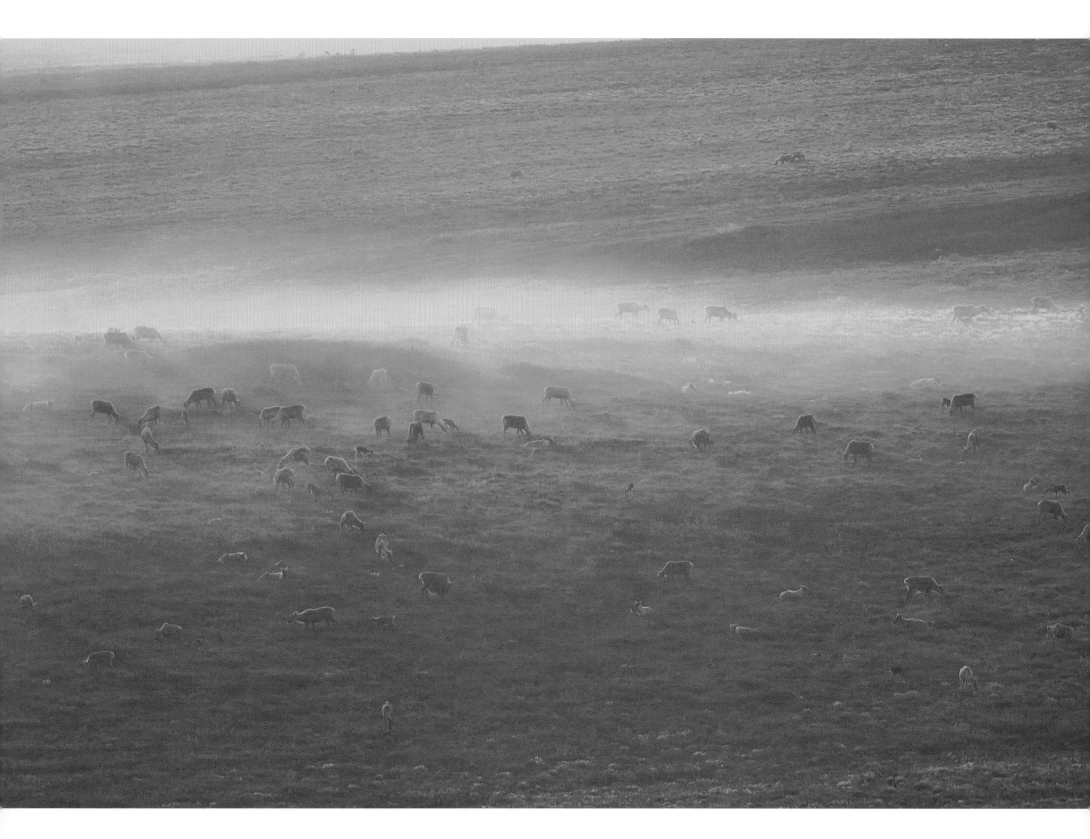

Caribou migration near the Utukok River, Western Arctic, Alaska

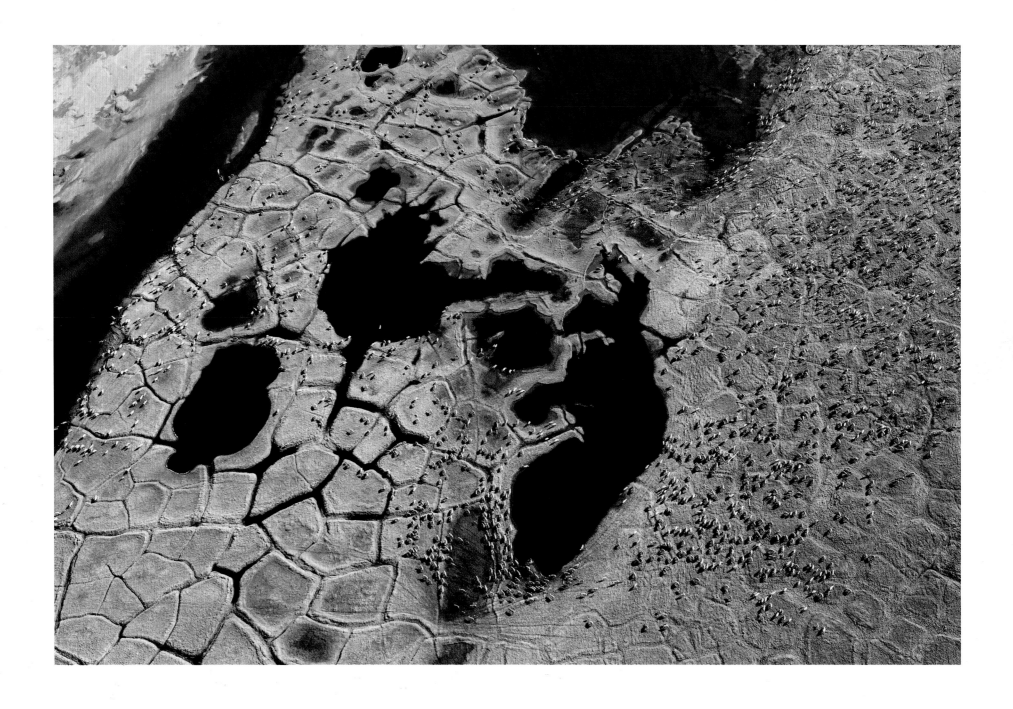

Above: Caribou migrate across the Arctic tundra where the cycle of thawing and freezing has created "tundra polygons," Arctic National Wildlife Refuge, Alaska.

Facing page: Caribou on the coastal plain of the Arctic National Wildlife Refuge, Alaska

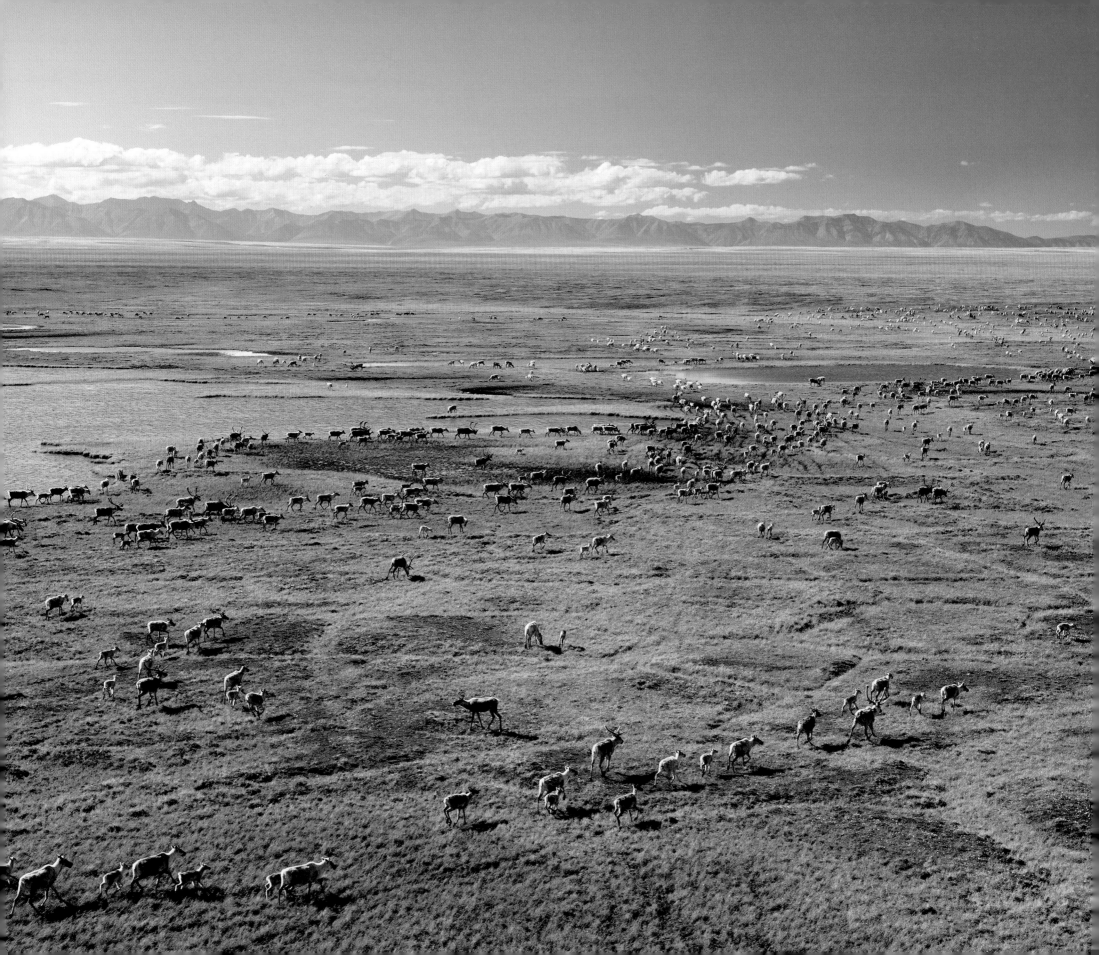

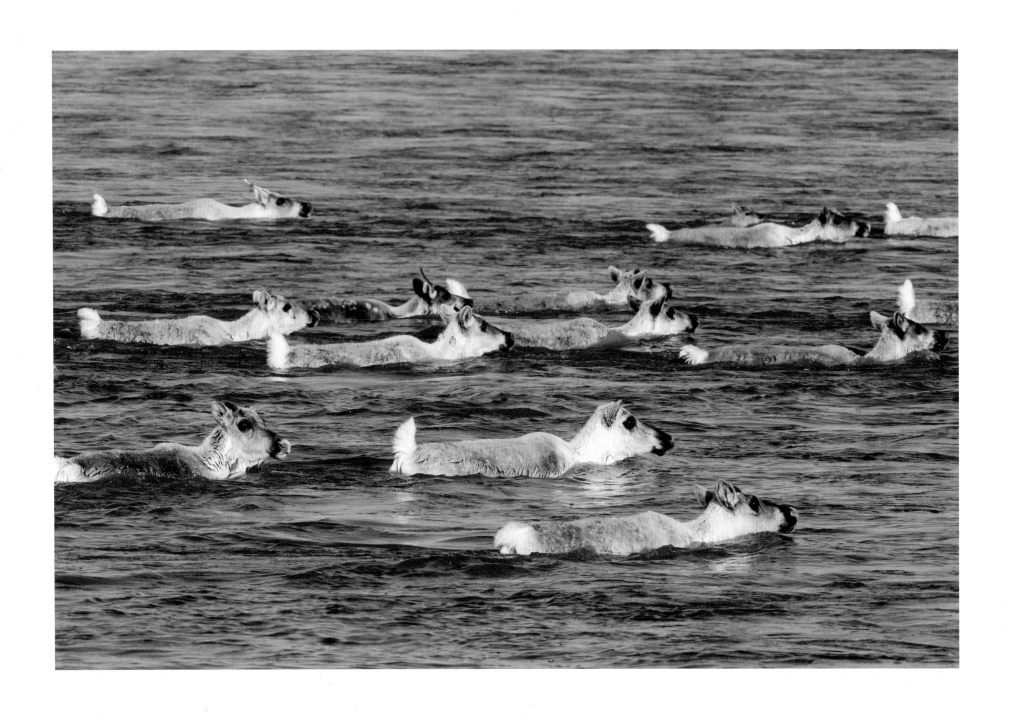

Caribou crossing the Utukok River, Western Arctic, Alaska

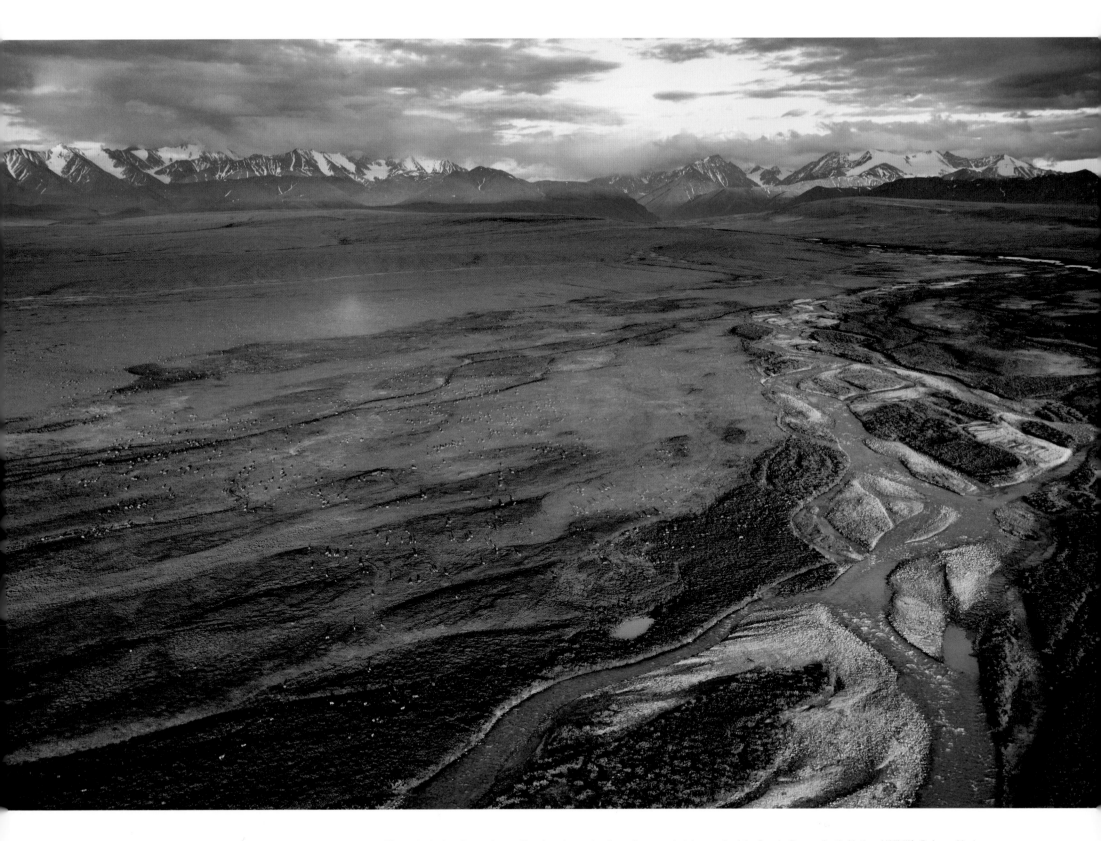

Toward the end of June, as mosquitoes proliferate in the interior tundra, caribou form larger herds on the coastal plains north of the Brooks Range, Arctic National Wildlife Refuge, Alaska.

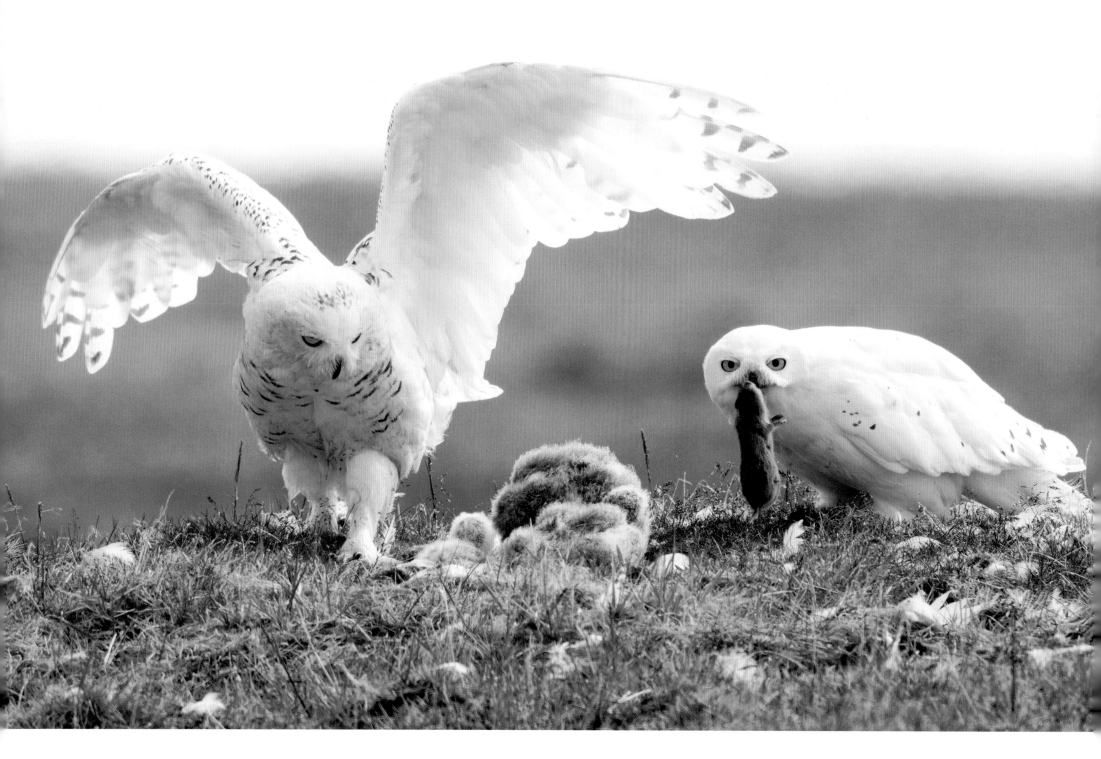

A male snowy owl returns to the nest to provide a lemming for the chicks, northern Alaska.

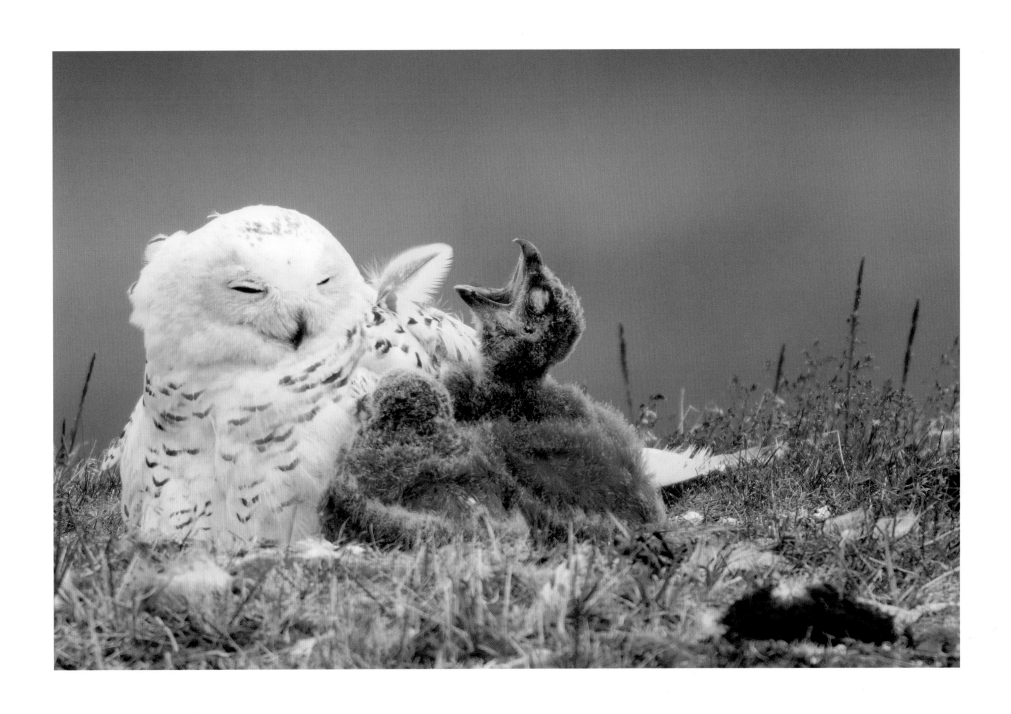

Snowy owl and owlets on the Arctic tundra of northern Alaska

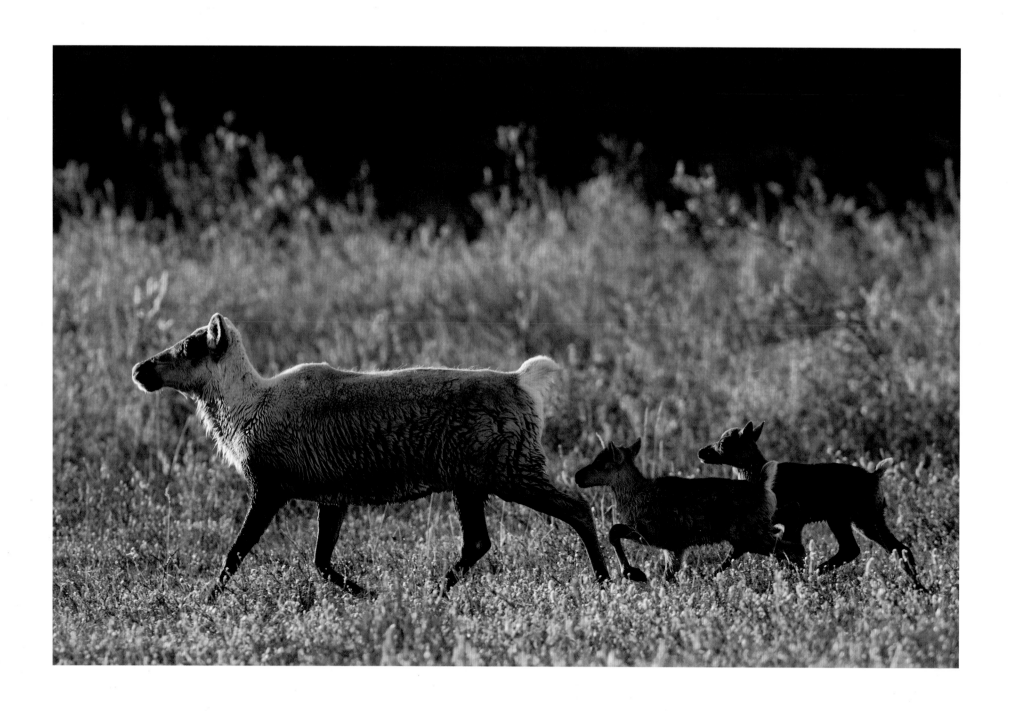

Mothers and calves travel continuously during their migration to the coastal plains, National Petroleum Reserve, Alaska.

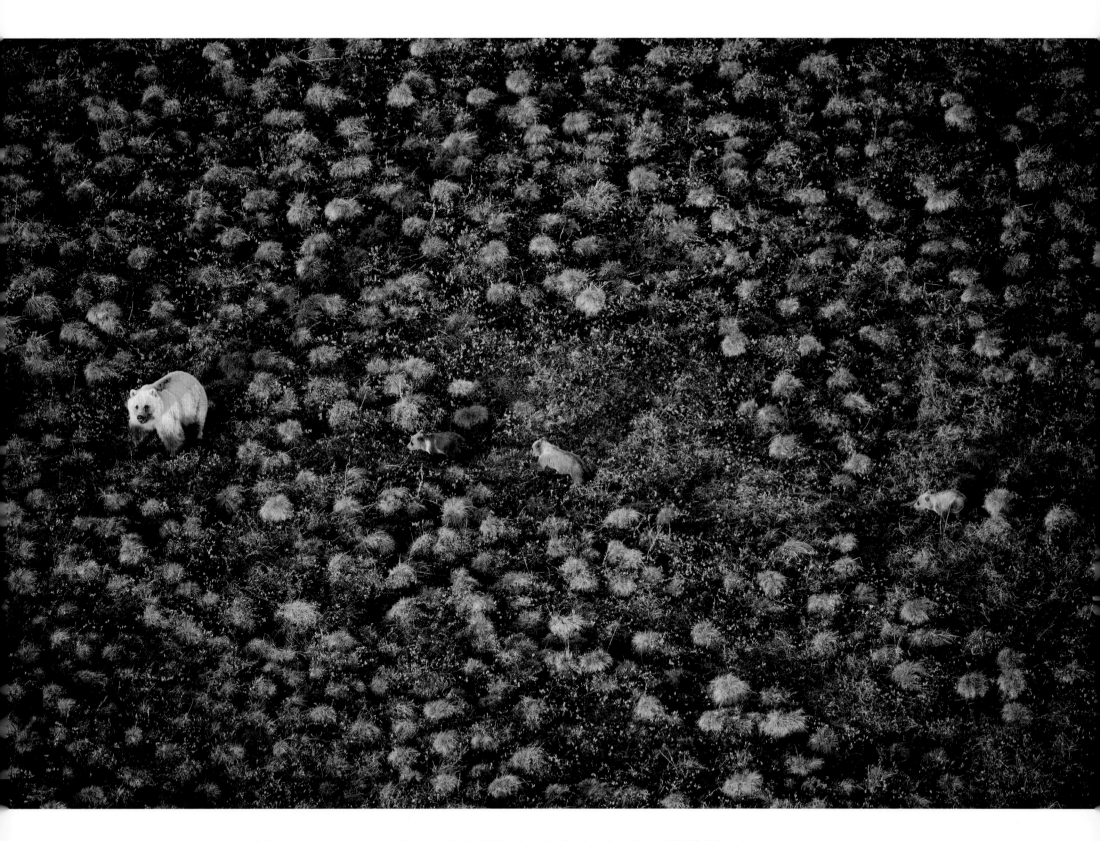

A mother grizzly and cubs, on the hunt for a sick or injured animal, follow the tracks of caribou, Arctic National Wildlife Refuge, Alaska.

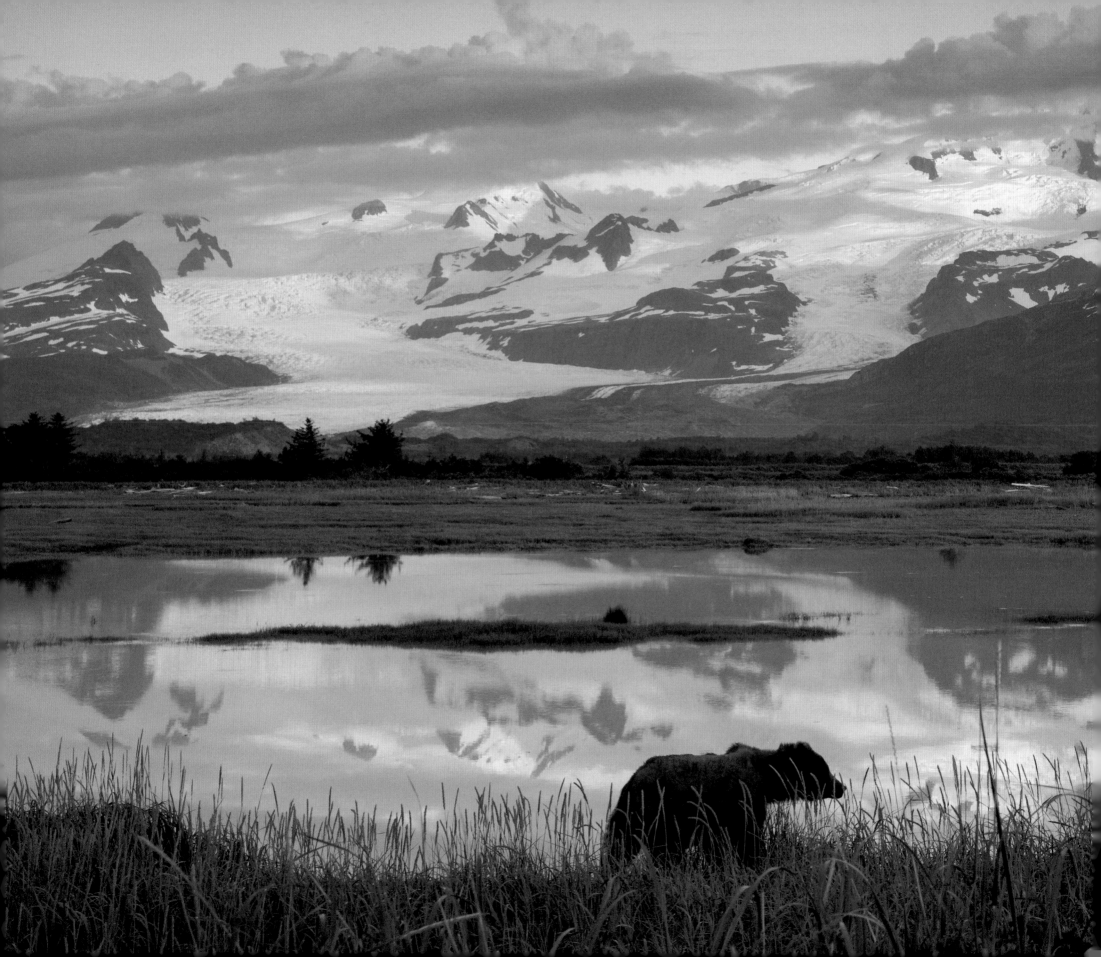

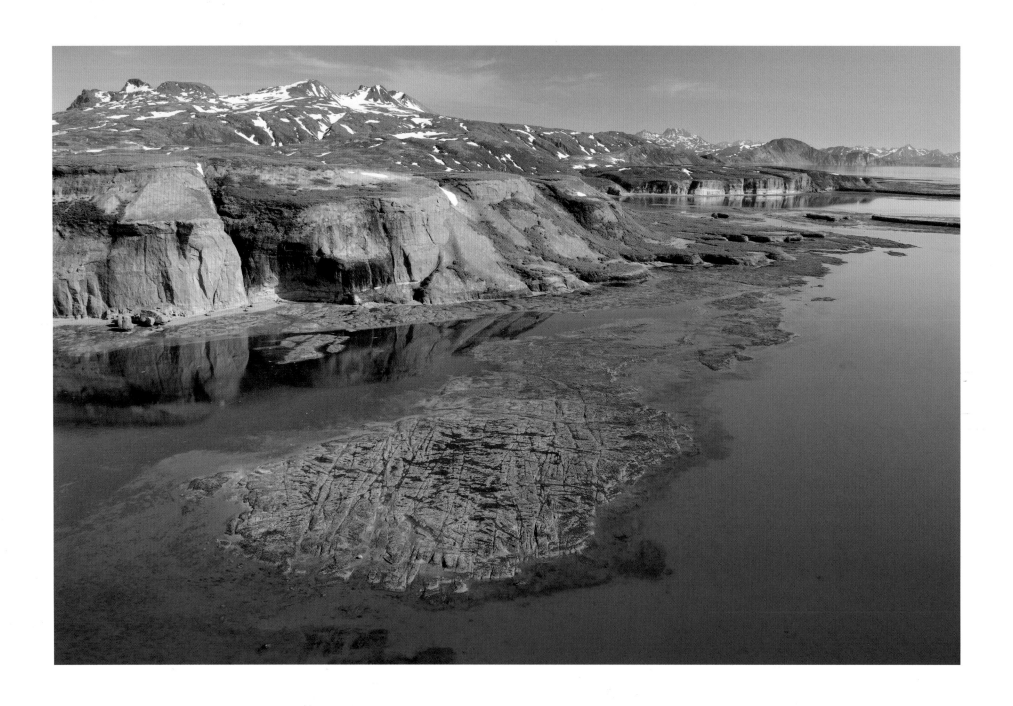

Overleaf: A coastal brown bear travels the edge of Hallo Bay, Katmai National Park, Alaska.

Above: The coastline of McNeil Cove with Chenik Mountain in the background, Alaska

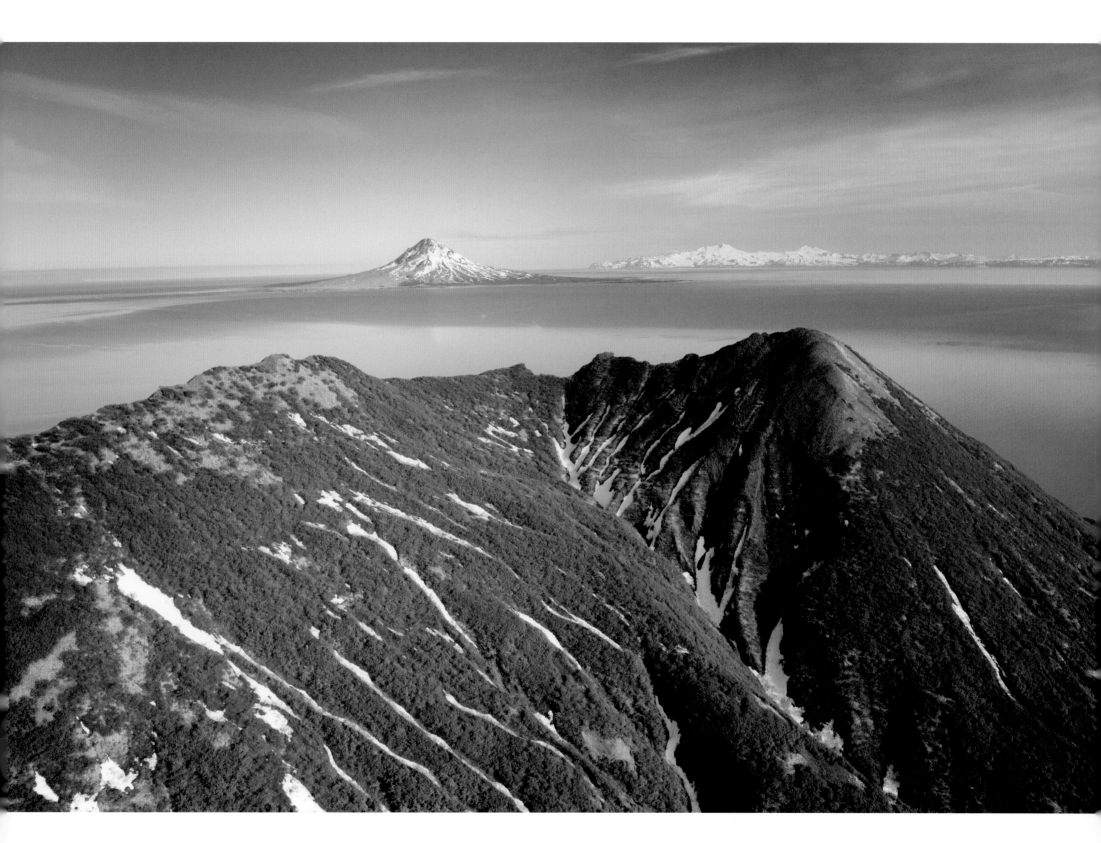

View of Mount Augustine from the north shore of Cook Inlet near Ursus Cove, Alaska

Newhalen River, which runs into Iliamna Lake, Alaska

Northwestern shore of Iliamna Lake, Alaska

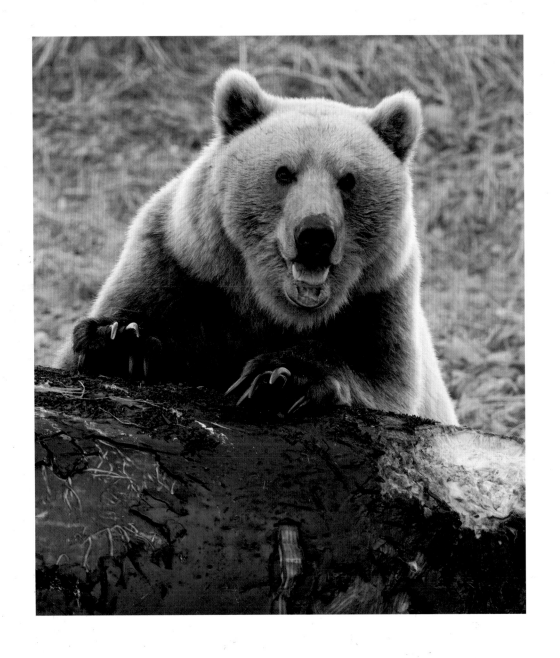

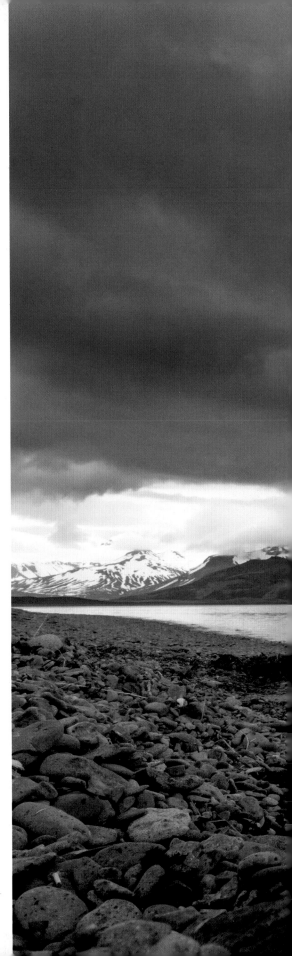

Above: A brown bear tries to break through the tough, rubber-like skin of a gray whale carcass that has washed ashore at Unimak Island, Aleutian Islands, Alaska.

Right: A brown bear returns to the gray whale carcass on Unimak Island, Aleutian Islands, Alaska.

Facing page and above: Brown bears search the river for arriving salmon on the Alaska Peninsula, Alaska.

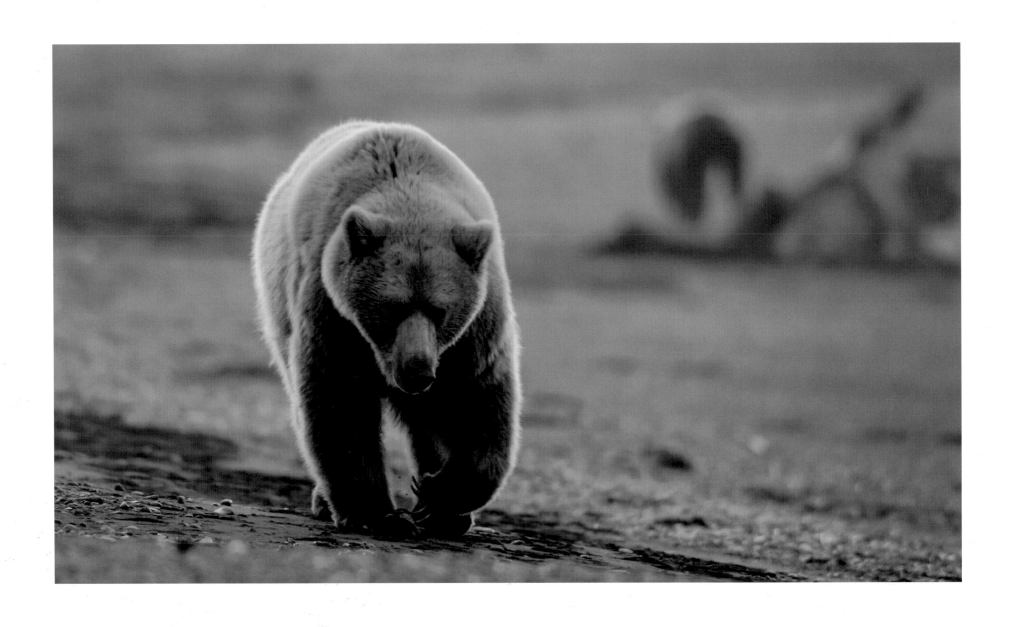

A grizzly bear patrols the shore in search of food, Unimak Pass, Aleutian Islands, Alaska.

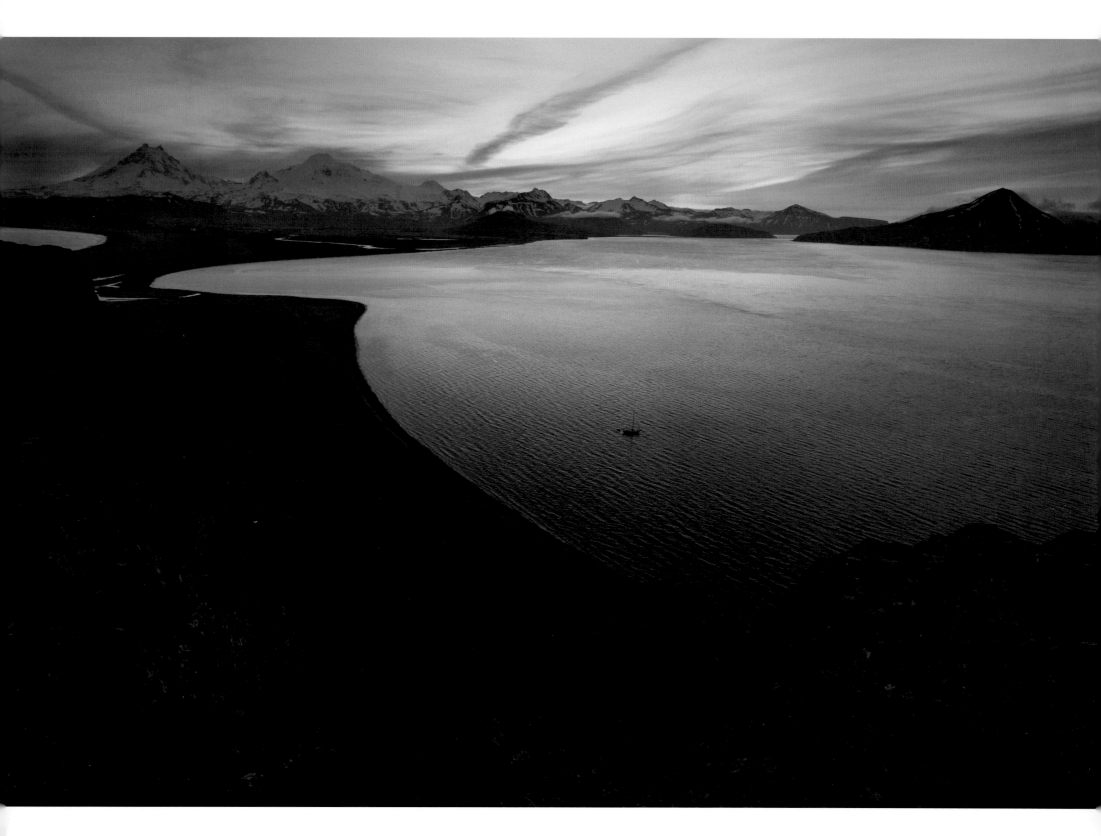

Night falls over Unimak Island, Aleutian Islands, Alaska.

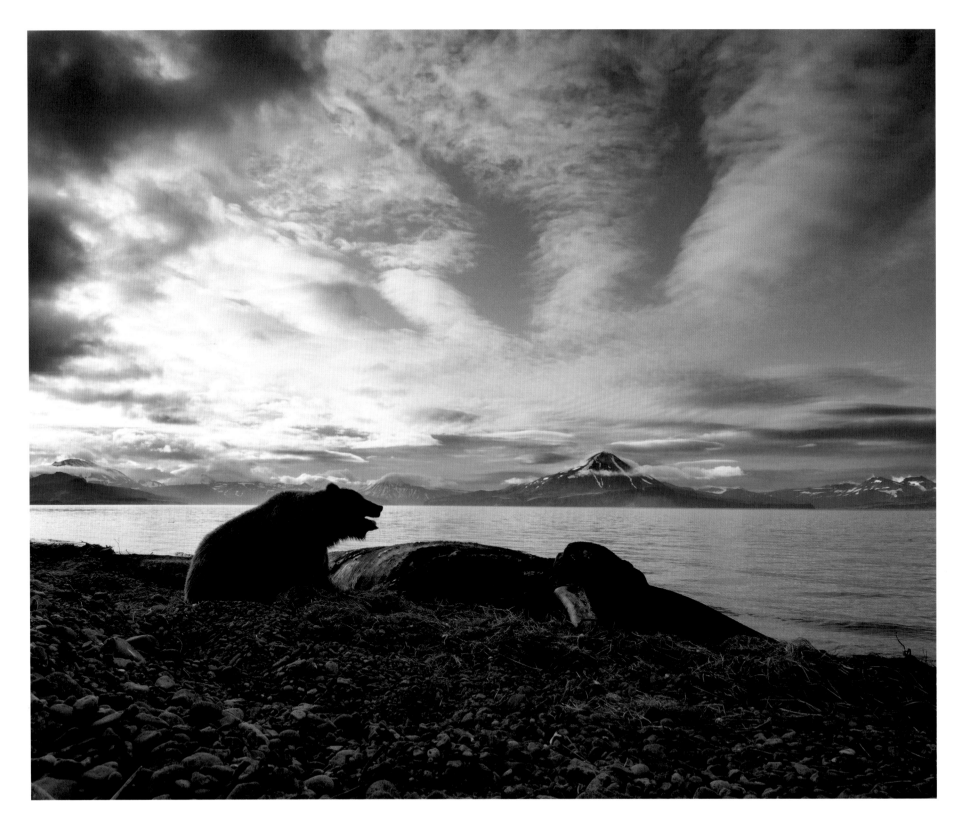

A brown bear feeds on a whale carcass along the shore of Unimak Island, Aleutian Islands, Alaska.

Sunset over Otter Cove on Unimak Island, Aleutian Islands, Alaska

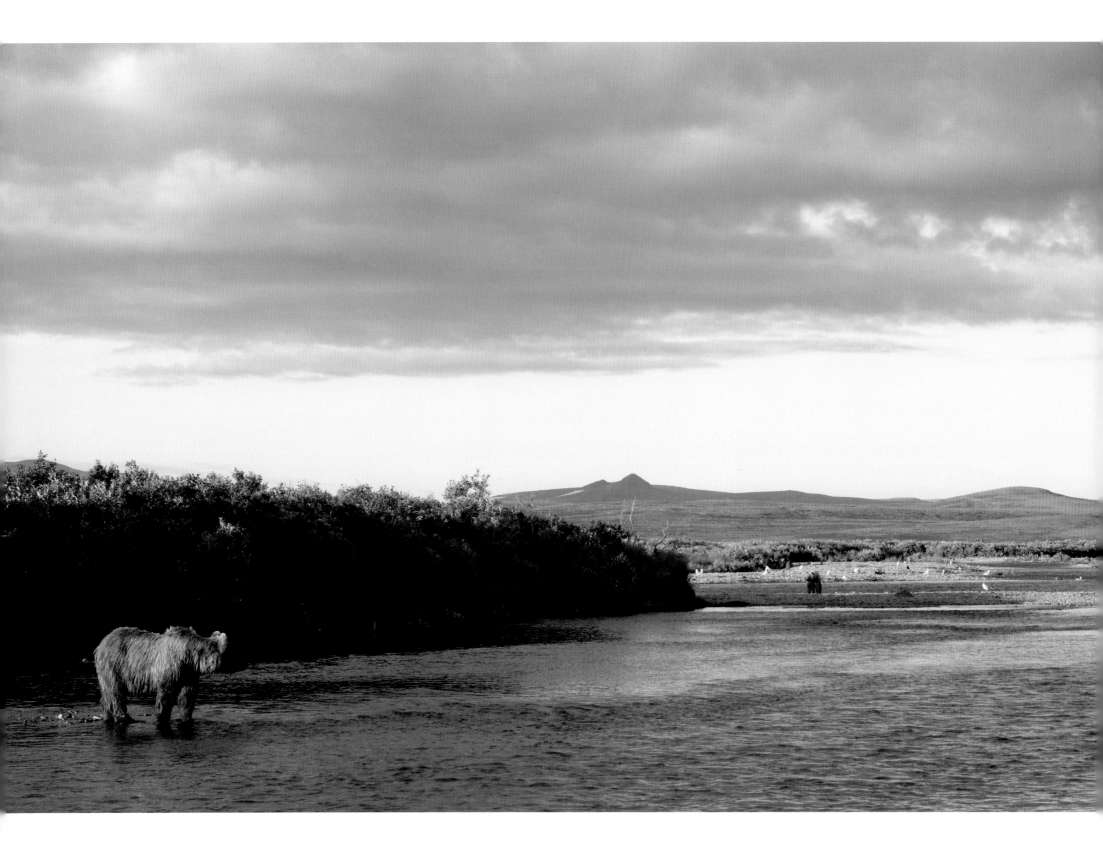

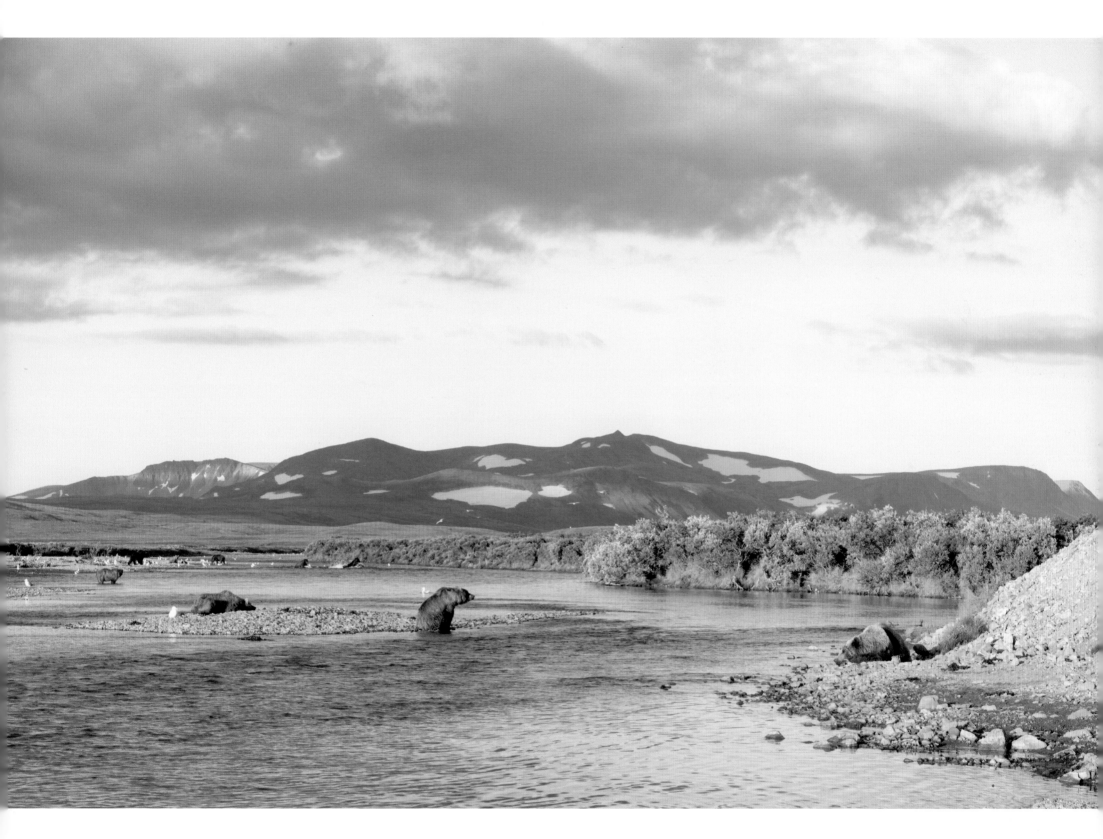

The Bristol Bay watershed is home to the largest sockeye salmon run and the highest density of brown bears in North America.

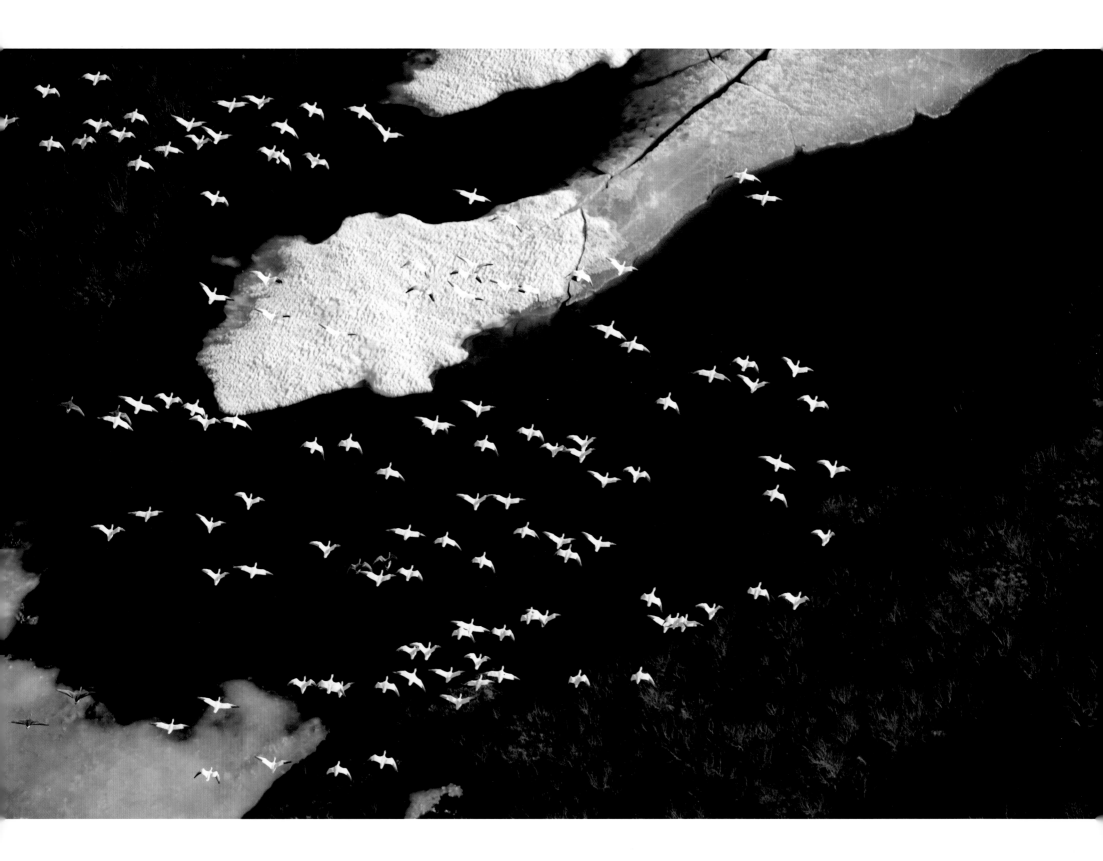

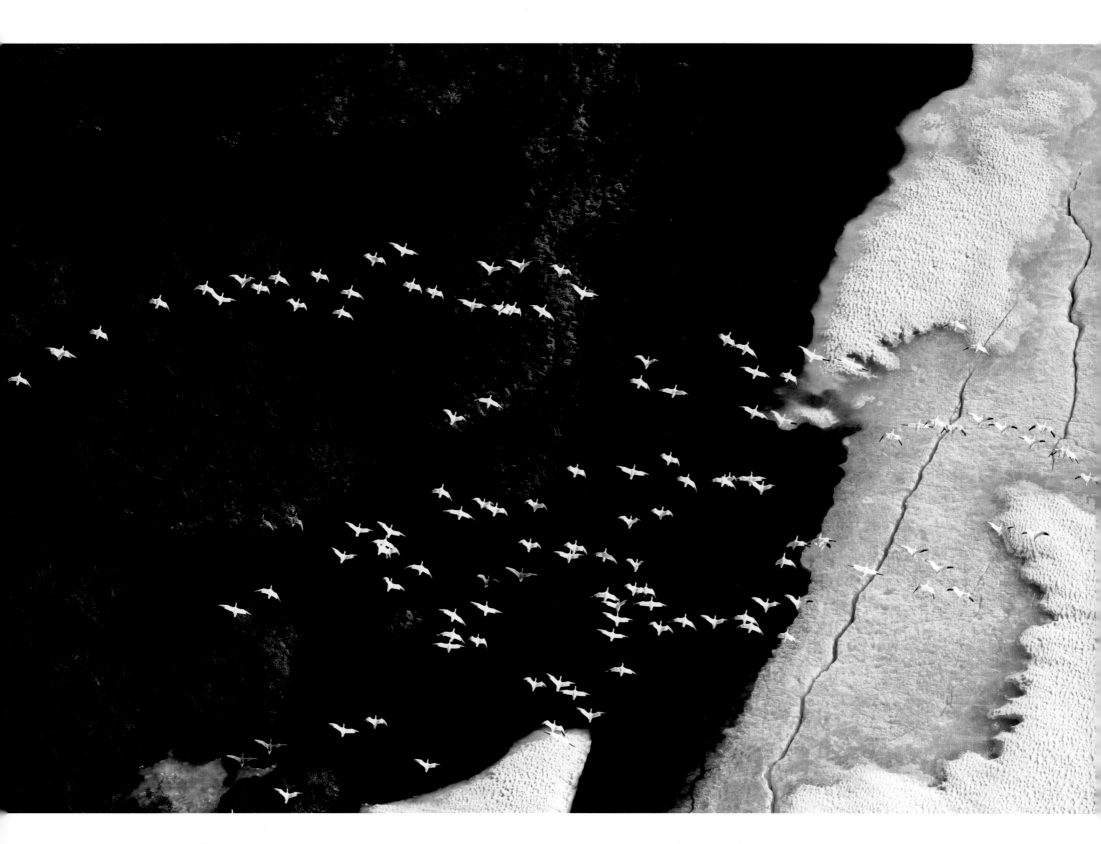

Facing page and above: As the snow just begins to melt away, snow geese return to nest in the high Arctic of northwestern Alaska.

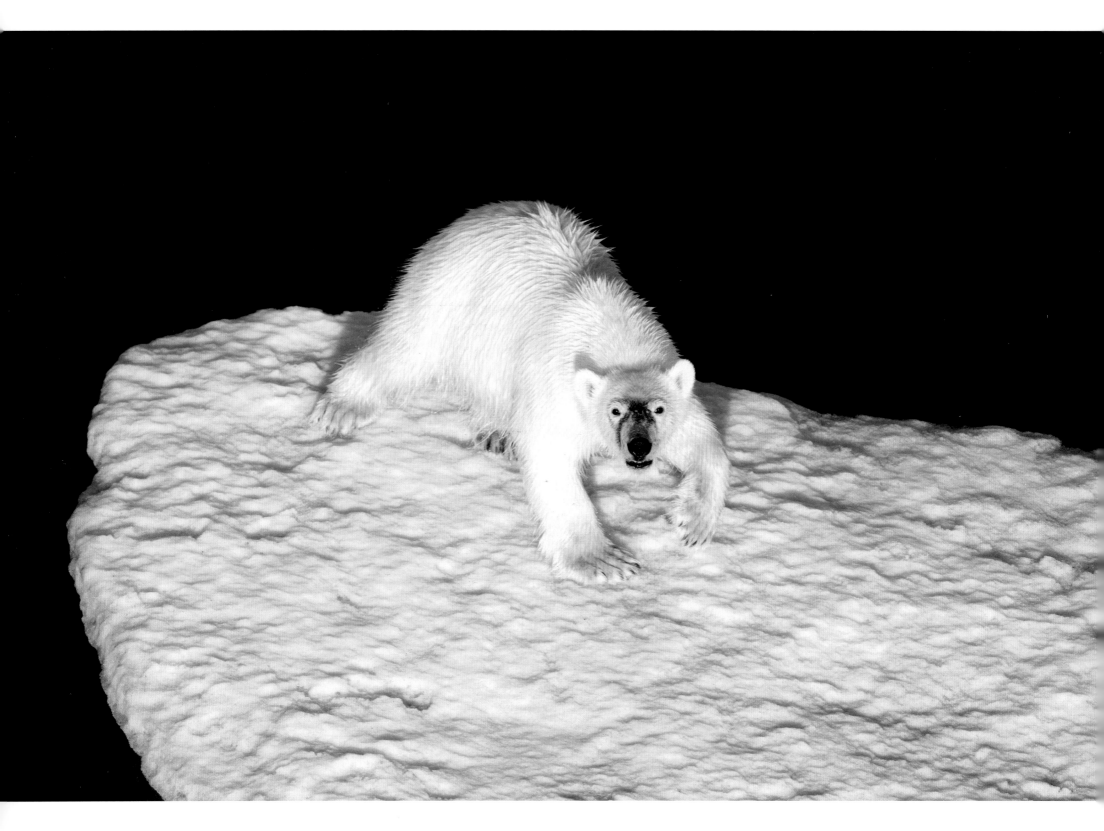

Polar bear on an ice floe in the Beaufort Sea, Alaska

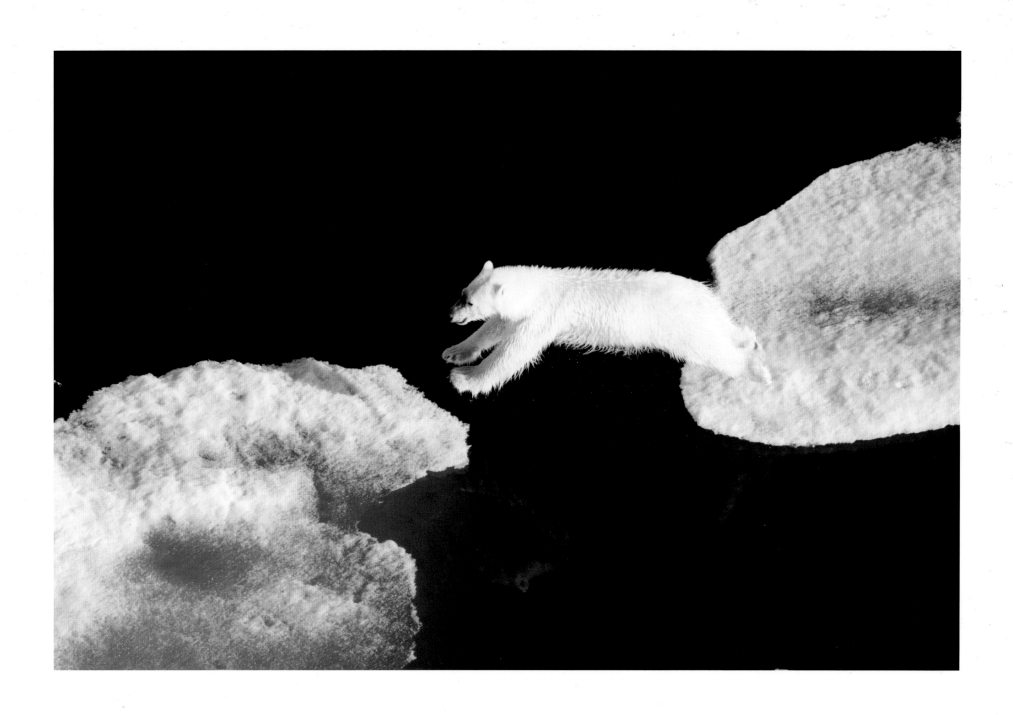

As the sea ice retreats, polar bears follow the ice's edge to hunt for food, jumping from ice sheet to ice sheet when they can.

Once the ice is completely gone, bears often need to swim enormous distances to land, Beaufort Sea, Alaska.

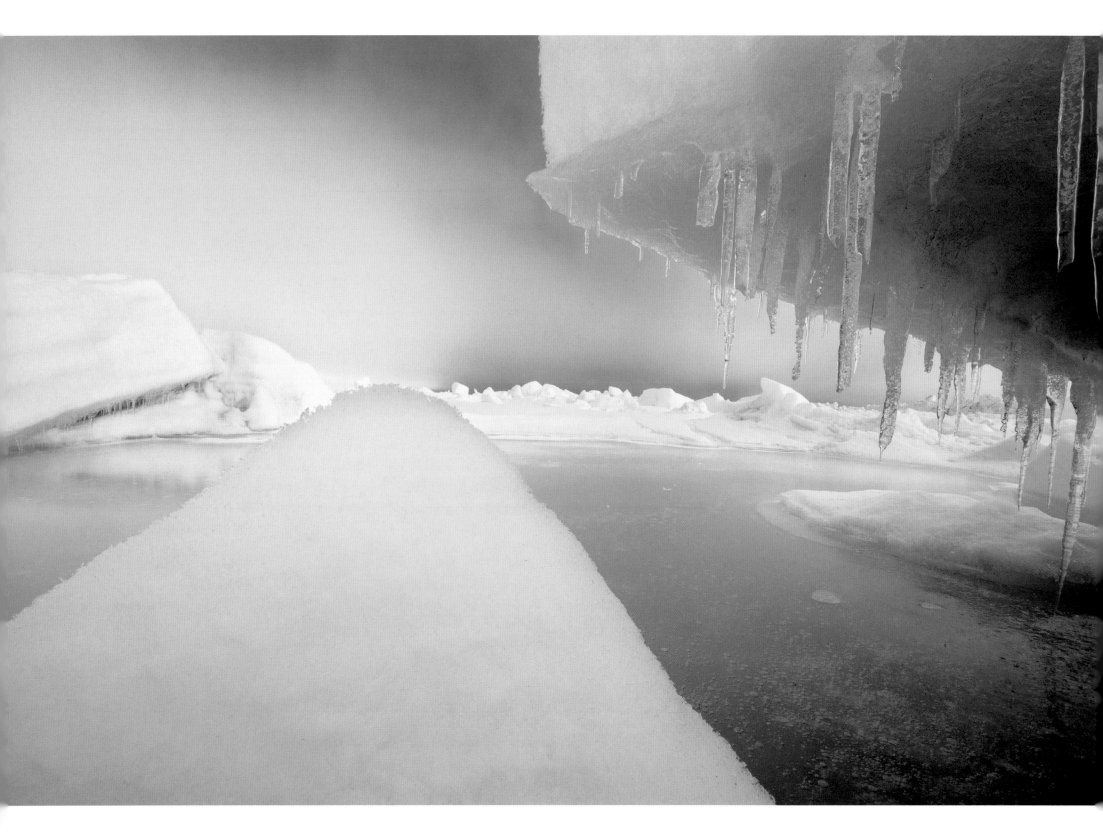

The forces of the wind and currents break up sheets of ice and later crush them together, forming ever-changing landscapes that vanish with the arrival of summer, Chukchi Sea, Alaska.

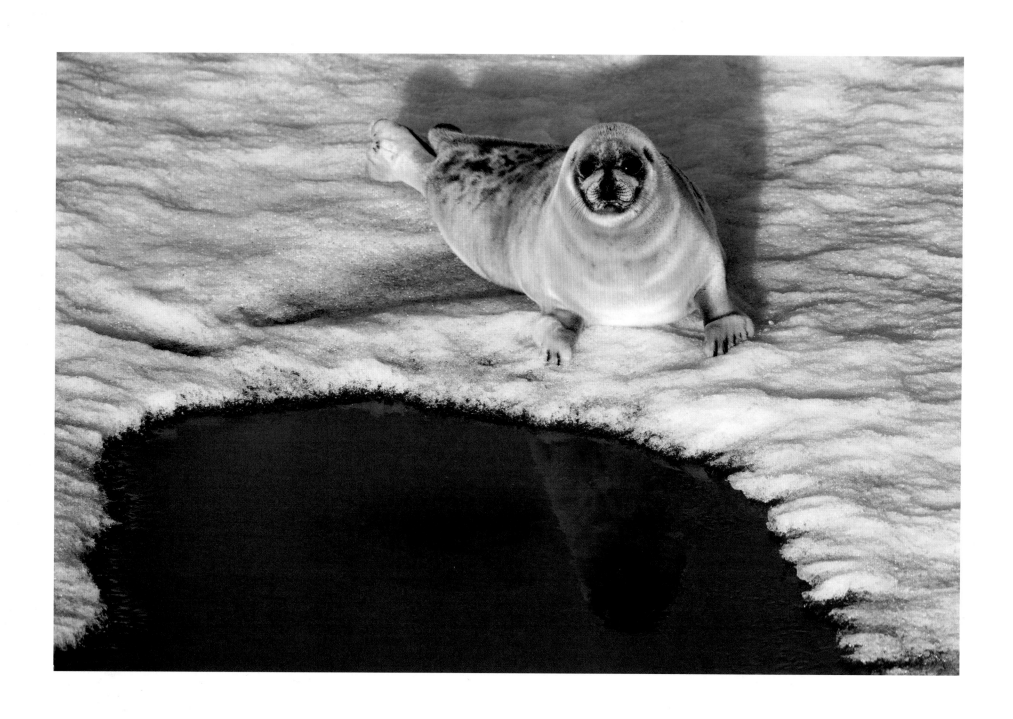

Ringed seal resting near a breathing hole in the Beaufort Sea, Alaska

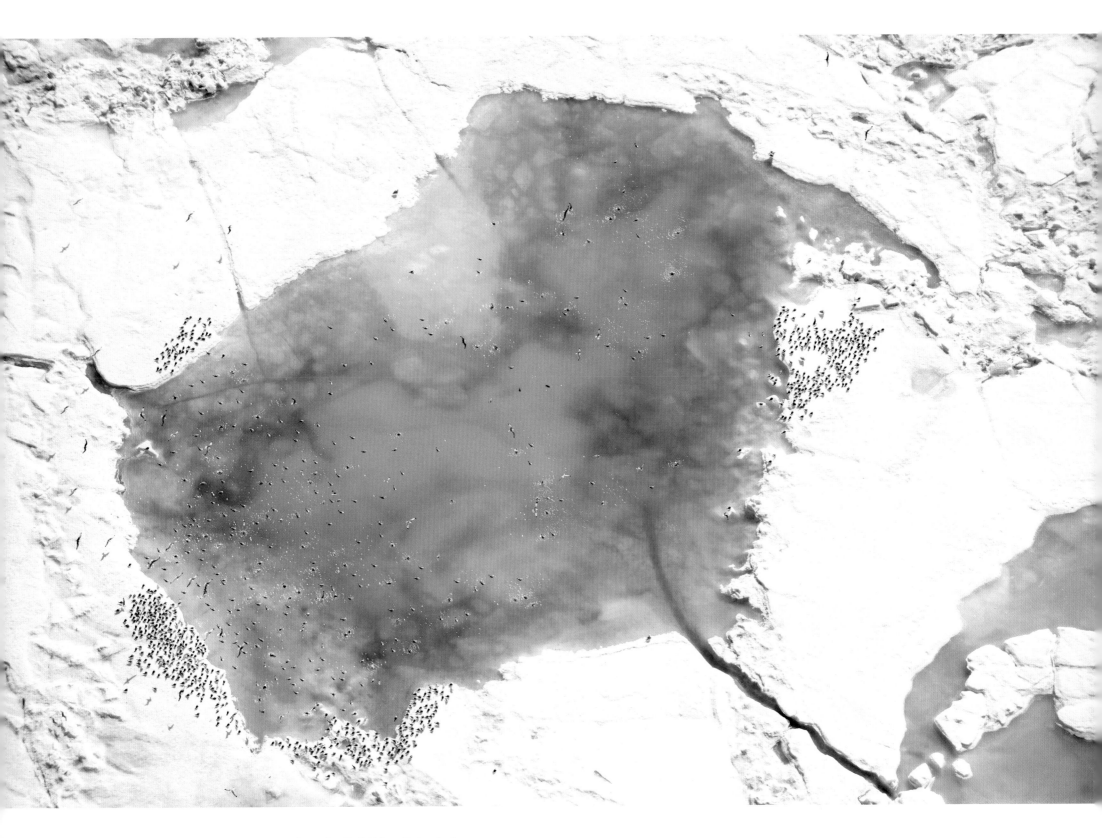

Kittiwakes resting on the sea ice, Chukchi Sea, Alaskan Arctic

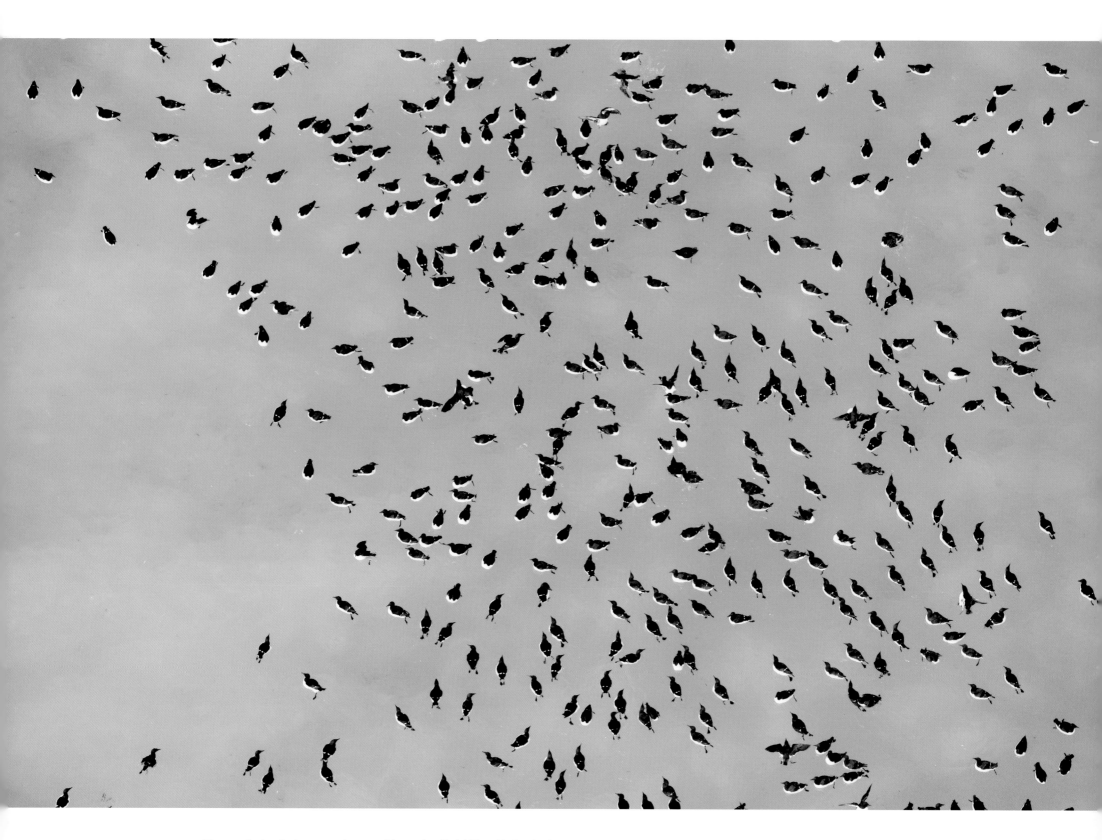

Murres swim in a freshwater pool on top of the sea ice, Chukchi Sea, Alaskan Arctic.

Above: As the Arctic sun gathers strength, large freshwater pools form and create wonderfully colored patterns on the sea ice, Beaufort Sea, Alaska.

Facing page: By the end of June, large leads are created by currents and wind in the sea ice of the Beaufort Sea, Alaska.

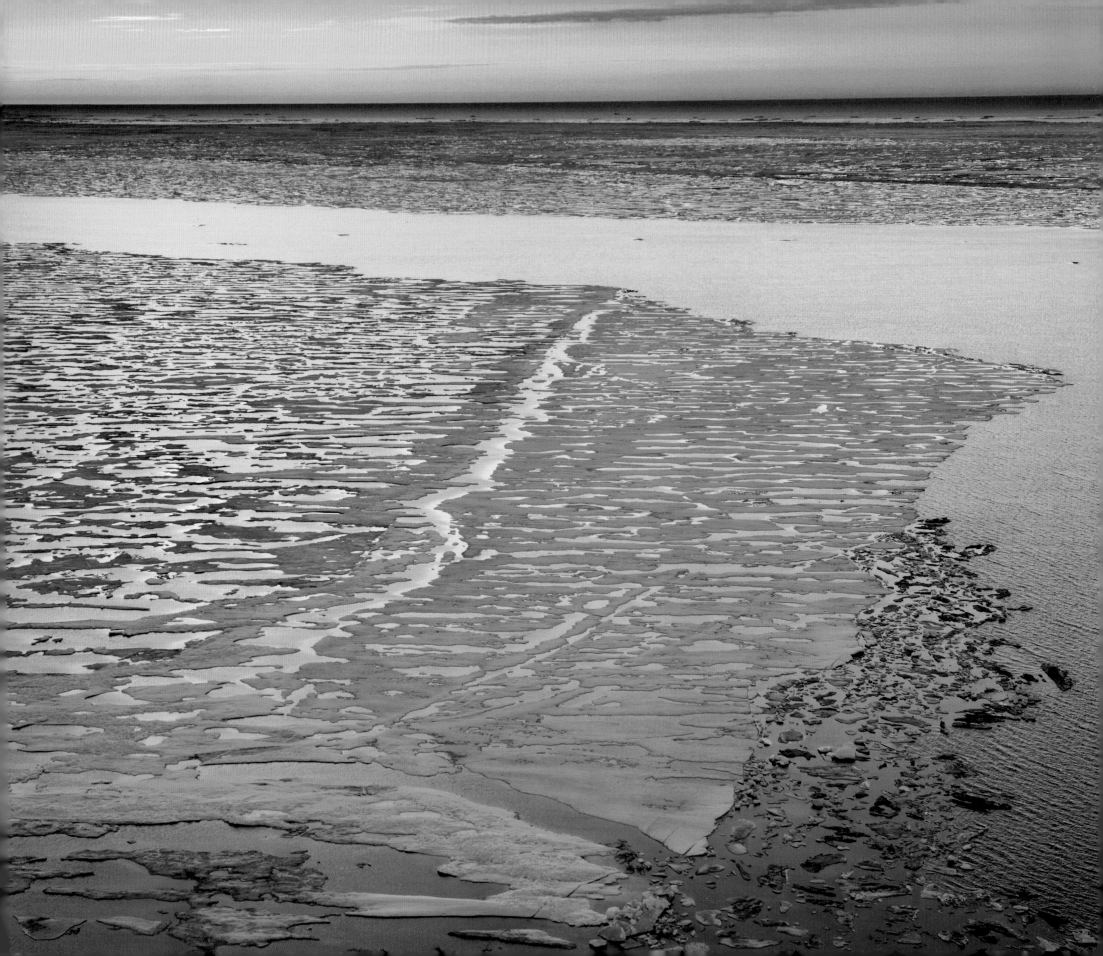

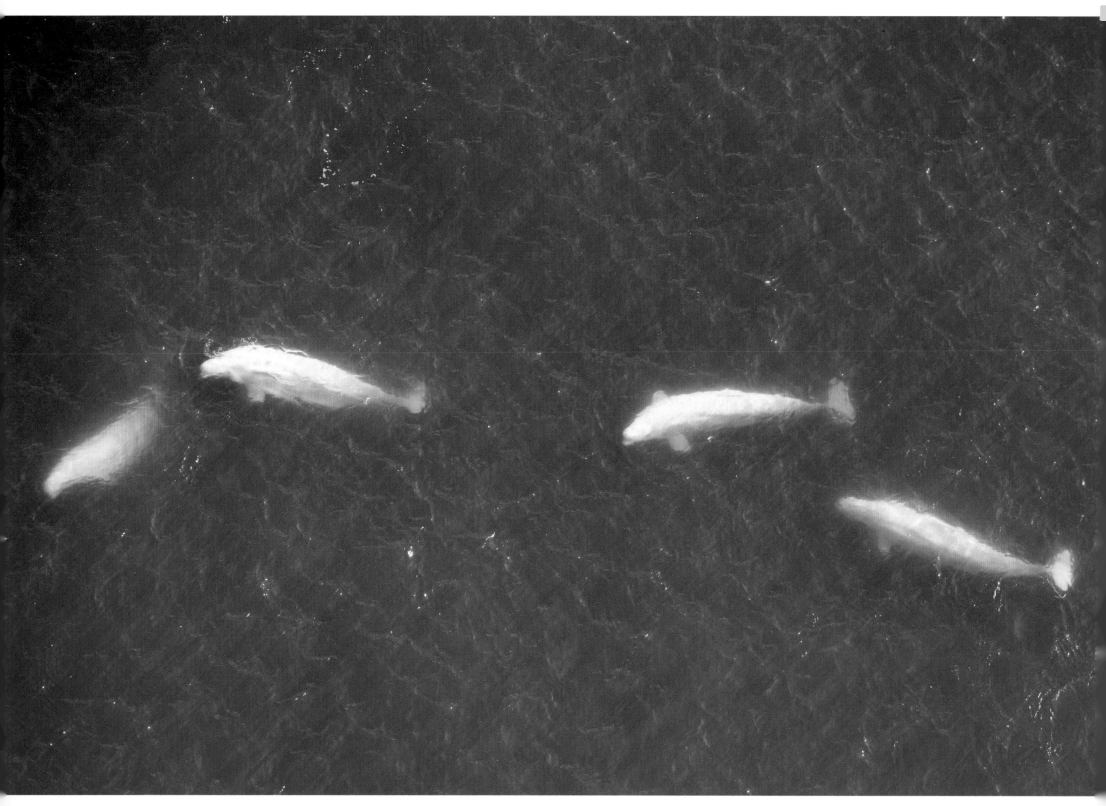

Beluga whales are quite social, and groups of more than a thousand have been counted south of the Kasegaluk Lagoon in early summer, Chukchi Sea, Alaska.

CAUSE FOR HOPE

PHILIPPE COUSTEAU

My grandfather, Jacques Cousteau, once called the area around the Baja Peninsula "the aquarium of the Pacific," so rich were its waters. I have spent a great deal of time around Baja California and have also had the fortune of traveling along the western Pacific Coast all the way north to Alaska.

However, the most impactful experience I had was with the gray whales in Baja California. To me they embody the changing attitude of humanity toward not only these magnificent creatures but toward nature as a whole. As Bruce Barcott writes in his introduction, human perception of gray whales has changed dramatically in 150 years. In the early days, gray whales were called "devil fish" because of their tendency to fight back against humans who were hunting them, flipping the small whaling skiffs that hounded them for decades during the heyday of whaling. Now, gray whales are referred to as the friendly whales because of their habit of gently approaching whale-watching boats to interact and play with their occupants.

I, too, have encountered the gray whales of Laguna San Ignacio. I once spent the better part of an hour scratching the belly of a 40-foot-long (12-meter-long) male that appeared to react to it with what I can only assume was delight, as he stayed with our boat, repeatedly rolling over onto his back.

Thinking back upon that day, I continue to be awestruck, not simply by the experience but by the context in which it happened. Traveling 6000 miles (9600 kilometers) from the scorching desert to the

The world is waking up, slowly but surely, to the need to explore and understand the interconnectivity of our planet.

freezing Arctic is nothing short of miraculous, yet gray whales do it every year—round-trip. And while gray whales are often the poster child for the corridor from Baja California to the Beaufort Sea, countless creatures rely on this remarkable interconnected system for survival. I have witnessed the cacophony of an elephant seal rookery along the California coast, and I have dived among the swaying kelp of Puget Sound. Once, on an early summer morning, with mist rising off the water, I sat in silent awe as a mother bear and her cub slowly walked along the shore of a remote island in Southeast Alaska.

All of these memories are precious and a perpetual reminder of why I dedicate my life to the conservation of our planet and the search for knowledge—because, unfortunately, our knowledge (particularly of the oceans) remains feeble at best. Indeed, the cost of one space shuttle launch is equivalent to all the money spent by the US federal government in one year on ocean research. While the allure of space—and the presence of water on Mars—is undeniable, do our planet's oceans not deserve at least as much passion? Indeed, the countless wonders that exist in our oceans are not only fascinating but vital to our very existence.

My grandfather once wrote, "For most of history, man has had to fight nature to survive; in this century he is beginning to realize that, in order to survive, he must protect it." Those words are truer today than when he first wrote them, for humanity faces a litany of threats that have grown exponentially since my grandfather's day, from climate change and ocean acidification to the freshwater-shortage crisis. These challenges will be evident to anyone reading this book, and though at times they may seem overwhelming, I believe that there is endless cause for hope.

The world is waking up, slowly but surely, to the need to explore and understand the interconnectivity of our planet. As we unravel her mysteries one layer at a time, the urgency of conserving an ecosystem—not just its individual parts—becomes more and more obvious. The question we must each ask ourselves is whether we will have the courage to fight for the places in the world that are so unique and so majestic that they transcend the very notion of ownership by any individual, group, or nation. Places that connect to one another, creating a vast tapestry of life so incredible and so grand that we must take action.

The corridor from Baja California to the Beaufort Sea is just one of those places. In a world that seems to be inundated by bad news, it should give us all comfort that there is still hope, that it is not too late, that we can protect these vital places and leave a legacy to our children of which we can be proud. ■

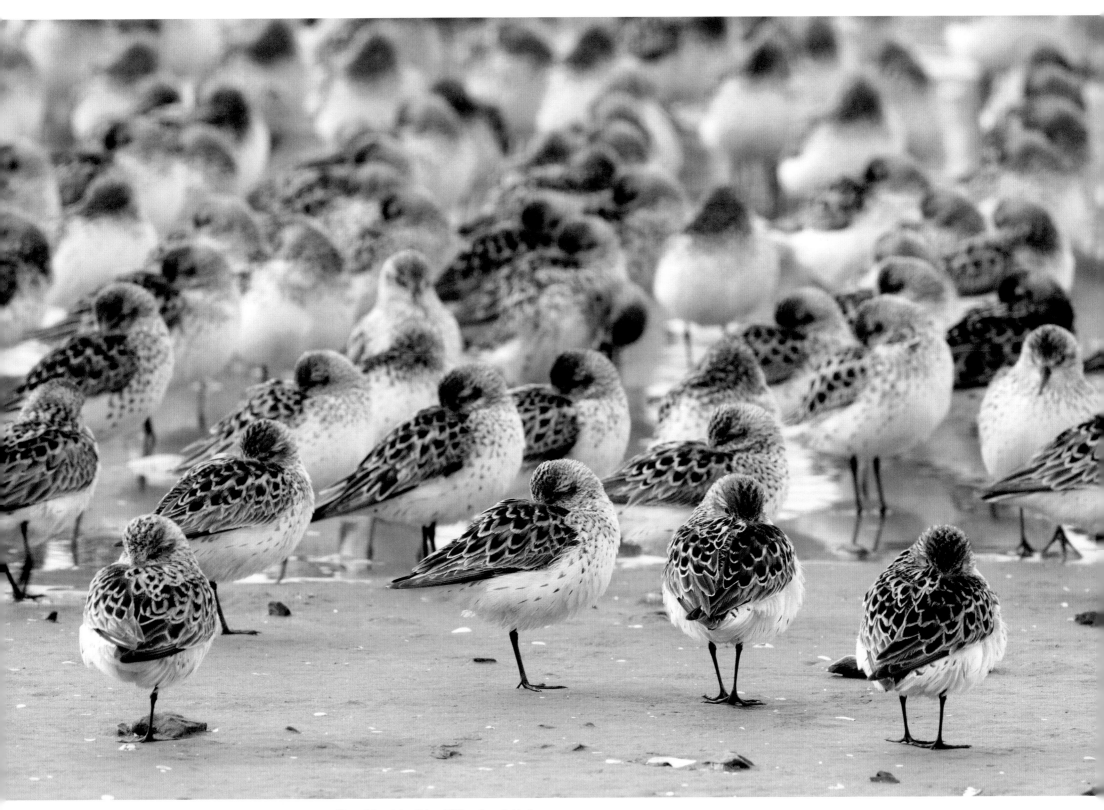

Western sandpipers on the mudflats of Orca Inlet, Prince William Sound, Alaska

CITIZEN SCIENCE TAKES OFF

JON HOEKSTRA

Life from Baja California in Mexico to the Beaufort Sea in Alaska is always on the move. Gray whales, humpback whales, orcas, and other cetaceans journey along the coasts. Geese, ducks, and swans wing their way south for the winter. Swifts and swallows swirl overhead as they return each spring. Salmon struggle upstream to spawn. Monarch butterflies mingle at winter roosts. Sea turtles return to nesting beaches.

Of all these creatures in motion, three species—gray whales, sockeye salmon, and dunlin sandpipers—epitomize the myriad animal migrations that crisscross the Baja-to-Beaufort region in the sea, in rivers on the land, and through the air. Their stories reveal how easy it is to disrupt these movements and how difficult it can be to restart them. These stories also demonstrate the power of people working together in Mexico, the United States, and Canada to conserve what makes the B2B so special.

Every winter, gray whales gather in warm, protected lagoons along the Pacific Coast of Baja California to give birth to their calves, thrilling tourists who visit the calving lagoons to experience close encounters with these gentle giants. Adults can reach 50 feet (15 meters) long and weigh more than 30 tons (27 metric tons). Just two to three months after birth, newborn calves follow their mothers on an extraordinary journey. They swim as much as 6000 miles (9600 kilometers) north along the Pacific coastline to the cold, productive waters of the Bering, Chukchi, and Beaufort seas west and north of Alaska

Gray whales, salmon, dunlins, and other migratory species need freedom to roam. When their migrations are interrupted, species are unable to complete their life cycle, leading to population declines.

to feast on a summer bounty of plankton. As summer wanes, the whales head back south along the coast, returning again to warm Baja California waters. Their annual journey, one of the longest migrations of any mammal species, is emblematic of the Baja-to-Beaufort region.

Meanwhile, millions of sockeye salmon converge in summer and fall on cascading coastal rivers from Point Hope in northwestern Alaska to the Columbia River in Washington and Oregon after roaming the North Pacific basin. Following cues imprinted at birth, the salmon swim upstream, sometimes hundreds of miles, to spawn in the very same place where they were born. As they approach their spawning streams, the silver fish turn bright red. Females scour nests (called redds) out of the river-bottom gravel, and males jockey for chances to fertilize the eggs. Their offspring renew the life cycle as they journey back downstream to the Pacific Ocean until it is their time to make their own return trip upriver. Such salmon runs are spectacles of nature that support important fisheries. Grizzly bears, black bears, bald

eagles, and other species feast on the salmon, too, making salmon a vital link between the food webs of the forests and the sea.

Each spring, dunlin sandpipers congregate by the thousands in shape-shifting flocks for their northward migration. These eight-inch-long (20-centimeter-long) brownish-gray shorebirds with a drooping bill are distinguished in breeding plumage by a large black patch on their belly. From their wintertime habitats in Baja California and California, flocks of dunlins hopscotch up the Pacific Coast, stopping in estuaries, mudflats, and wetlands to refuel on worms, insects, crustaceans, and other small prey until they reach their nesting grounds in the Arctic tundra. There, they raise their young in the perpetual daylight of the short Arctic summer before flying south once more in the fall.

Gray whales, salmon, dunlins, and other migratory species need freedom to roam. When their migrations are interrupted, species are unable to complete their life cycle, leading to population declines. Even if their travel corridors are restored, it can take generations for species to repopulate. For species that learn their ancient migration routes from their parents, interrupting a migration could mean losing the generational knowledge needed to bring the species back.

Consider how the inherent challenge of long migratory journeys for a small bird like the dunlin is made more difficult by the loss of essential stopover habitats. When marshes and wetlands are drained, or if estuaries are diked, the birds lose valuable refueling stations. They

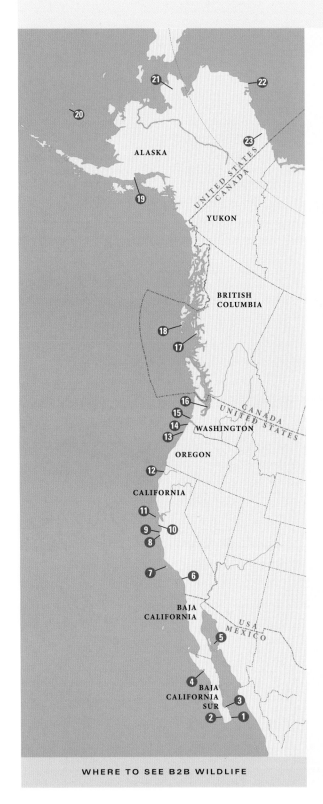

WHERE TO SEE B2B WILDLIFE

THE BAJA CALIFORNIA TO BEAUFORT SEA corridor offers myriad opportunities to witness life on the move along the Pacific coastline. You could venture on your own migration across the region, or visit a wildlife viewing location where B2B species come to you during different seasons. Below are some of the best places to see B2B wildlife. Some are easy to reach near populated areas; others are more exotic and remote. Because wildlife moves on its schedule, not ours, be sure to check with a local wildlife agency or conservation group to learn what species are likely to be seen during a particular time of year.

S (spring), SU (summer), F (fall), W (winter), Y (year-round)

1. CABO PULMO NATIONAL MARINE PARK, MEXICO: Located at the southern tip of Baja California, the coral reefs of Cabo Pulmo are home to hundreds of fish species and other marine biodiversity. **W**

2. TODOS SANTOS, MEXICO: During nesting season, olive ridley sea turtles come ashore here in massive groups called *arribadas* to lay their eggs in the sandy beaches off the Pacific Ocean. **SU, F**

3. ISLA ESPÍRITU SANTO, MEXICO: This popular location in the Gulf of California for sea kayaking boasts beautiful beaches and abundant marine life where one might even snorkel with sea lions. **W**

4. LAGUNA SAN IGNACIO, MEXICO: Gray whales give birth to their calves in these warm, sheltered Pacific Coast waters that are protected as a UNESCO world heritage site. **W, S**

5. GULF OF CALIFORNIA, MEXICO: Dubbed "the aquarium of the Pacific" by Jacques Cousteau, the Gulf of California hosts one-third of all marine mammal species, including the critically endangered *vaquita*, along with hundreds of fish species, from massive whale sharks to leaping manta rays. **W, S**

6. SAN JUAN CAPISTRANO, CALIFORNIA: The annual return of the swallows to the ruins of the Great Stone Church of San Juan Capistrano marks St. Joseph's Day and is one of nature's rites of spring. **S**

7. CHANNEL ISLANDS, CALIFORNIA: Endemic island foxes and nesting seabirds can be found on the islands, while the food-rich waters around them attract gray whales, superpods of dolphins, and even giant blue whales. **Y**

8. BIG SUR, CALIFORNIA: This rugged coastline is a prime vantage point from which to see southern sea otters feeding amid the fronds of underwater kelp forests and perhaps to spot a rare California condor. **Y**

9. PACIFIC GROVE, CALIFORNIA: An unassuming grove of trees in this coastal California town is a magnet for migrating monarch butterflies that congregate here before continuing south. **W**

10. AÑO NUEVO STATE PARK, CALIFORNIA: During mating season, bull elephant seals weighing up to 4500 pounds (2000 kilograms) battle for control of the beach where females will give birth to their pups. **W**

11. FARALLON ISLANDS, CALIFORNIA: Just 28 miles (45 kilometers) from San Francisco, this rugged archipelago is home to rare ashy storm petrels and other nesting seabirds and is also a popular viewing location for humpback whales and great white sharks. **SU, F**

12. REDWOOD NATIONAL AND STATE PARKS, CALIFORNIA: Roosevelt elk wander among the world's tallest trees, bathed by fog rolling in off of the Pacific Ocean. **Y**

13. DEPOE BAY, OREGON: Home to the Oregon Whale Watching Center, Depoe Bay is one of dozens of coastal vantage points from which to watch for migrating gray whales and other coastal wildlife. **S, SU**

14. CANNON BEACH, OREGON: This popular beach town is famous for Haystack Rock, where puffins and other seabirds nest just offshore. **S, SU**

15. **GRAYS HARBOR, WASHINGTON:** Hundreds of thousands of sandpipers and other shorebirds visit this food-rich estuary on their migration to and from Arctic breeding grounds. **S, F**

16. **SAN JUAN ISLANDS, WASHINGTON:** In this scenic archipelago near the US-Canada border, orcas feed on salmon returning to the Fraser River and Puget Sound. **SU, F**

17. **GREAT BEAR RAINFOREST, BRITISH COLUMBIA:** The largest temperate rain forest in the world features giant trees and spirit bears, a rare, almost white version of the black bear. **S, SU, F**

18. **HAIDA GWAII, BRITISH COLUMBIA:** Also known as the Queen Charlotte Islands, Haida Gwaii boasts rich intertidal zones from which you can observe marine mammals and humpback whales in nearby waters. **SU**

19. **KATMAI NATIONAL PARK, ALASKA:** This park is famous for opportunities to view brown bears catching salmon that leap over falls in the river. **SU, F**

20. **PRIBILOF ISLANDS, ALASKA:** The "Galapagos of the North," this is where more than 3 million seabirds nest on rocky cliffs over the Bering Sea. **SU**

21. **SEWARD PENINSULA, ALASKA:** Ten thousand years ago the Seward Peninsula was part of the Bering land bridge that connected Siberia and Alaska. Today, it is a place where you can find moose and musk oxen on land and jaegers, gulls, and marine mammals offshore. **SU**

22. **BARROW, ALASKA:** This northernmost US town is a great base from which to look for nesting eiders, snowy owls, gulls, belugas, and bowhead whales. **SU**

23. **ARCTIC NATIONAL WILDLIFE REFUGE, ALASKA:** Migrating caribou are icons of this remote tundra wilderness that is also home to bowhead whales, polar and grizzly bears, wolves, waterfowl, and more. **SU**

are forced to fly farther on less fuel between stops. That increases the chances that they won't survive the arduous journeys north and south.

Even gray whales, whose migratory pathways appear continuous in the ocean, can encounter obstacles. When food is scarce in coastal waters, as might happen as a result of a pollution-induced dead zone, whales struggle to find enough food to fuel their long journey and may become emaciated or even die before they reach their summer seas. Modern tanker and container ships move so fast through coastal shipping lanes that whales can't always get out of their way. More than half of such collisions are fatal for the whale.

Salmon face a multitude of challenges as they move through different phases of their life cycle. Returning adults must first run a gauntlet of fishing nets in the ocean and at many river mouths. Those that travel up larger rivers must often contend with dams that can block passage to their spawning streams. Eggs and fry are susceptible to smothering by sediment washing into streams because of deforestation in the surrounding watershed. As young fish move downstream toward the sea, they may encounter water pollution resulting from urbanization and industrial activities. And they must then compete with hatchery fish for limited resources. Each of these factors takes its toll on salmon populations. Many salmon runs in the Lower 48 have been reduced to only 10 percent of their historic abundance.

Despite considerable efforts to reengineer dams and reform fisheries and hatcheries, many populations of salmon in Washington, Oregon, and California remain at risk of extinction and will require ongoing human assistance if they are to persist. For example, in order to ensure safe downstream passage for young salmon in the Columbia and Snake river system, they are sometimes transported past dams on barges so that they avoid passing through turbines or over spillways. Such assisted migration might be necessary in extreme cases, such as for endangered salmon, but it is an expensive substitute for maintaining high-quality, connected

habitat that can support continued natural migrations.

To sustain migrations across the Baja-to-Beaufort region, wildlife needs people in Mexico, the United States, and Canada to protect essential habitats and coordinate management across state and national boundaries to ensure the right places are ready to support animals on their annual journeys. For gray whales, that means protecting their calving waters along Baja California and the productive ocean habitats where they spend the summer in Alaska—and safe passages in between. Salmon need us to preserve and restore rivers and streams to ensure clean, clear water for spawning and also to set sustainable fishing quotas. Dunlins need us to protect wetlands, marshes, and estuaries all along the Pacific coastline that they depend on in winter and during their seasonal flights to and from the Arctic tundra where they breed.

From Baja California to the Beaufort Sea, people are working together in their communities and across the region to protect vital habitats for migratory species. When an industrial company proposed in the late 1980s to build a saltworks in Mexico's Laguna San Ignacio, local grassroots activists mounted a campaign to protect this important calving lagoon for gray whales. With help from whale enthusiasts from the United States and beyond, the campaigners were successful in pressuring the development to be abandoned. In 1993 Laguna San Ignacio was officially protected as an internationally recognized UNESCO world heritage site.

In Port Susan Bay, part of Puget Sound in Washington State, the Nature Conservancy protects more than 4000 acres (1600 hectares) of estuary habitat that is an important stopover site for dunlins and other migrating shorebirds and waterfowl, as well as nursery habitat for young salmon. Leaders of nearby communities and government agencies in Washington State also recently teamed up with the Nature Conservancy to reconfigure an old dike along Port Susan Bay so that the Stillaguamish River could flow more naturally into the estuary. The result is an improvement in estuary

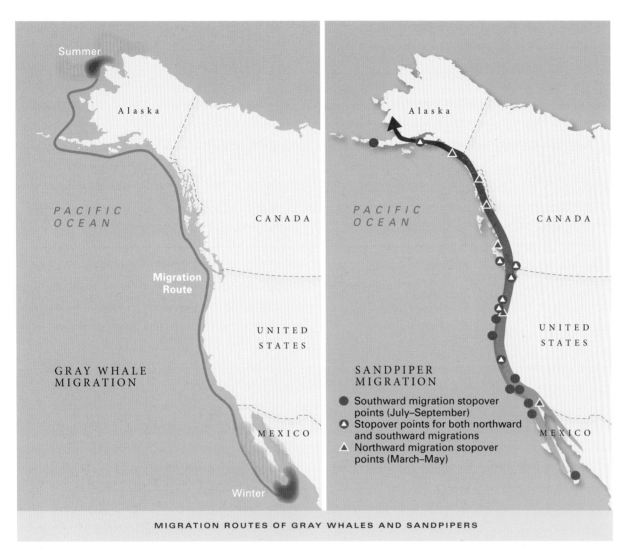

Summer

Alaska

PACIFIC
OCEAN

CANADA

**Migration
Route**

UNITED
STATES

GRAY WHALE
MIGRATION

MEXICO

Winter

Alaska

PACIFIC
OCEAN

CANADA

UNITED
STATES

SANDPIPER
MIGRATION

● Southward migration stopover
 points (July–September)
◓ Stopover points for both northward
 and southward migrations
△ Northward migration stopover
 points (March–May)

MEXICO

MIGRATION ROUTES OF GRAY WHALES AND SANDPIPERS

health that will benefit migrating birds and salmon and improve flood protection for neighboring farms and communities.

Bristol Bay in southwest Alaska supports the world's largest sockeye salmon fishery. More than 35 million fish return each year to spawn in the lakes and streams that flow into the bay, supporting ten thousand jobs and generating more than $1.5 billion in economic value. A proposed gold mine could put this vibrant fishery at risk if toxic wastewater were to leach into the ecosystem.

In response, a coalition of local communities, fishermen, and conservation groups, including the World Wildlife Fund (for which I work), has come together to protect the salmon and the many social and economic benefits they provide to Alaskans.

Because migratory species pay no heed to state or national boundaries, successful conservation across the B2B region also depends on effective transboundary coordination regarding conservation policies and protections. Whaling nearly drove gray whales extinct in the 1800s.

An international whaling ban established in 1946 and maintained today by the International Whaling Commission, as well as protection under the US Endangered Species Act in 1970, has allowed the gray whale population in the corridor to rebound. They are once again close to historic abundance, and so they were removed from the United States' endangered species list in 1994—a notable conservation success story. The Migratory Bird Treaty Act of 1918 protects dunlins and more than 150 other migratory bird species by making it illegal to hunt, capture, or kill them. The treaty has been agreed on by the United States, Canada, Mexico, Russia, and Japan. Efforts to conserve and sustain salmon are aided by the 1985 Pacific Salmon Treaty under which the United States and Canada jointly set fishery limits based on scientific assessment of salmon abundance. The treaty also provides funding to support habitat enhancement and restoration.

To be successful, conservation efforts need citizen support and participation. There are many specific ways in which we can help in our communities and more broadly across the B2B region. We can become "citizen scientists" by participating in research and monitoring initiatives to help increase understanding about the corridor, the species that migrate across the region, and what they need to survive. Volunteering time or giving money helps to protect and restore natural habitats used by migratory wildlife. We can vote for public policies that promote sustainable use of natural resources and maintenance of healthy forests, rivers, and coasts that both wildlife and people depend on. All of us can speak up on behalf of wildlife and natural habitats near us and across the Baja-to-Beaufort region. And these activities give reasons to get outside to observe the natural world around us and to learn about when different species can be found near our communities during their seasonal migrations. With some patience and persistence, everyone can witness life on the move from Baja California to the Beaufort Sea. ∎

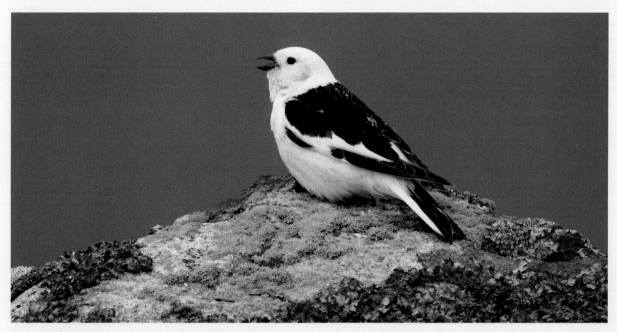

Snow bunting claiming its territory, Aleutian Islands, Alaska

You don't need a PhD to become a "citizen scientist." If you are curious and willing to learn, a number of hands-on initiatives offer opportunities to educate yourself about life on the move in the Baja-to-Beaufort region while contributing to improved scientific understanding that aids conservation efforts.

HELP HATCHLINGS: Groups like Tortugueros Las Playitas in Baja California Sur, Mexico, depend on volunteers to aid in the conservation of olive ridley and threatened leatherback sea turtles. Volunteers help scientists patrol beaches, relocate nests, and care for hatchlings until they are ready for release into the sea. Learn more at www.todostortugueros.org/.

TRACK WHALES: The American Cetacean Society and other local groups organize volunteers to count gray whales from various coastal viewing locations during their migration. These observations provide important data about the abundance of whales, the number of calves making their first journey north, and timing of migration along each stretch of the Pacific Coast. Learn more at http://acsonline.org/.

COUNT BIRDS: For more than a hundred years, the United States' National Audubon Society has organized volunteers to conduct Christmas Bird Counts, which were originally intended as an alternative to sport hunting. The data compiled annually is now revealing important insights into how bird populations are changing in abundance and distribution as a result of development, land clearing, and climate change. The Great Backyard Bird Count is now adding data about bird occurrences during late winter. Learn more at http://gbbc .birdcount.org, or contact your local Audubon chapter.

TALLY SPECIES: The first BioBlitz was organized in 1996 by the US National Park Service at the Kenilworth Aquatic Gardens in Washington, DC. The goal was to count every species found during a twenty-four-hour period. Since then, groups of scientists, naturalists, and volunteers have organized their own BioBlitzes in parks, preserves, and other natural areas all around the world. The 2014 BioBlitz in Golden Gate National Park near San Francisco tallied more than 2300 species, including 80 species that had never been documented in the park before. BioBlitz events are a great way to gain awareness of the incredible diversity of plants, animals, and even fungus and micro-organisms in natural areas near you. Check with a local park or preserve to see if they are planning a BioBlitz, or learn how to organize your own at http://nerdsfornature.org/bioblitz/.

MONITOR COASTS: Volunteers with the Coastal Observation and Seabird Survey Team (COASST) serve as coastal monitors for their communities in California, Oregon, Washington, and Alaska. After completing some basic training in bird identification and data collection, these citizen scientists monitor local shorelines for beached birds. Their observations establish baselines used by researchers and natural resource managers to detect and mitigate impacts from oil spills and other marine accidents. Learn more at http://depts.washington.edu/coasst/.

RESTORE STREAMS: Members of the Pacific Streamkeepers Federation in British Columbia are applying science to maintain healthy streams for local salmon and other wildlife. They use standard techniques to monitor water quality, aquatic insects and crustaceans, and fish populations and help implement streamside restoration as a way to mitigate impacts from urbanization, logging, and agriculture. Learn more at www.pskf.ca/.

—J.H.

RICK RIDGEWAY

JEFFREY PARRISH

The concept of large-landscape connectivity is at the heart of the Freedom to Roam movement—an effort that began on land and is now expanding to include the world's oceans. This idea, and the science behind it, has grown exponentially over the past two decades, thanks in large part to the efforts of Braided River's partners in the Baja-to-Beaufort campaign, the Patagonia clothing company and the World Wildlife Fund. Together with Florian Schulz, they have worked not only to build awareness but to act on a local level around the world to protect large landscapes connected by vital corridors.

In this conversation with Rick Ridgeway, vice president of environmental affairs at Patagonia, and Jeffrey Parrish, senior director for conservation resources at the World Wildlife Fund, they share the history of their organizations' roles in Freedom to Roam and what it means to the future of conservation in general and the Baja-to-Beaufort corridor in particular.

What inspired Patagonia to engage with the idea of wildlife corridors? And how did you do it?

RICK: In 1991 Patagonia launched a year-long campaign to advocate for what wildlife biologists call large-landscape connectivity, a strategy that had been conceived by conservation biologists including Michael Soulé. Back then Soulé and his colleagues were about the only people who knew what a wildlife corridor was. As climbers and backcountry skiers and surfers ourselves, we had seen with our own eyes the wildlands that support wildlife being fragmented by human development. When the biologists explained how connecting those fragments with wildlife corridors was the best chance for the survival of many species, we understood, and we wanted our customers to understand, too. So for a full year we ran essays in our catalogs and had signage in our stores explaining the threat of habitat fragmentation and the hope of habitat connection.

We succeeded in raising awareness, but by the early 2000s we could see that wildlife habitat was not only continuing to be fragmented because of development, but it was also beginning to shift because of climate change. The corridor concept had taken root among conservation scientists during this time: for example, the

Yellowstone to Yukon Conservation Initiative was working on the largest intact corridor in North America, and Karsten Heuer wrote eloquently about the Y2Y corridor in his book *Walking the Big Wild*, published in 2004. Yet public commitment and policy makers—much less corporations—were unaware or ambivalent. We felt we could help raise awareness even more. So in 2007 we decided to reprise the wildlife corridor campaign because habitat connectivity and large-landscape conservation remained one of the best strategies for reversing the increasing rate of extinction of species.

We realized that we needed to "brand" the idea. In a brainstorming meeting with several colleagues, we had fifty names on the chalkboard but none resonated. As we brainstormed, we also spread on the table a dozen books on the topic. I was staring at the books, trying to come up with more names, when my eyes rested on a book by Florian Schulz: *Yellowstone to Yukon: Freedom to Roam*, which was published by Braided River in 2007 when they and Florian created the Freedom to Roam concept. "That's it!" I thought. "The perfect name. Freedom to Roam." The name was perfect, but we also liked connecting to Florian's long-term vision of creating national wildlife corridors in the same visionary manner as the American government had created national parks at the start of the twentieth century.

JEFFREY: Florian got it long before we did: we have to be a voice for nature; we have to tell the stories and what wildlife needs to survive in a world that is increasingly more crowded and warming year on year. We realized that connectivity was to this century what the creation of national parks was in the last. But it would happen only if people cared.

How did the Freedom to Roam campaign evolve beyond one of your usual awareness campaigns?

RICK: For the next two years we used our communication channels—the catalogs, the website, the stores—to build awareness around the need for wildlife corridors and large-landscape connectivity. Up to this point, most of our environmental campaigns had lasted only one year, but we considered this campaign critically

important. So at the end of the campaign we did something we'd never done before: we used the campaign to launch a diverse coalition to continue the awareness effort.

We brought in other companies, including utilities such as Southern California Edison and retailers such as WalMart. We brought in nongovernmental organizations such as Defenders of Wildlife, the Teddy Roosevelt Conservation Partnership, and the World Wildlife Fund. And we reached out to local, state, and national governments. This led to an invitation to present Freedom to Roam to the 2008 annual meeting of the Western Governors Association, a meeting that included fourteen governors from western states, four premiers from Canada's border provinces, nearly a hundred CEOs from some of the country's largest corporations, and hundreds of their support staff. My presentation at this meeting gave us the chance to align all the governments of the entire western United States around the most promising commitment they could make to wildlife protection: the commitment to the connectivity that gives that wildlife the freedom to roam.

How did World Wildlife Fund come to take the reins of Freedom to Roam?

RICK: Patagonia is of course in the business of making clothes, so as the momentum behind Freedom to Roam grew, it became a challenge to keep up with it. Ultimately, in 2010 we transferred the initiative to the World Wildlife Fund. They had been part of the Freedom to Roam coalition from the start, and as the most iconic "brand" in wildlife conservation, they were a good home for the Freedom to Roam effort— itself an initiative designed to brand the idea of large-landscape conservation and connectivity. Today the Freedom to Roam concept remains at the core of their efforts to protect large landscapes and seascapes around the world.

JEFFREY: When Rick and I embarked on growing this movement to ensure lands and waters were connected for wildlife to survive in a warmer and more crowded world, we always intended to work with and through other institutions—be they government agencies, companies, or other nonprofits. We were never ones to approach an environmental challenge in a traditional way,

such as forming another long-term nonprofit for a specific cause. Instead, we thought, What if we could inject this imperative of connectivity into other institutions and make it happen on the ground around the world through the world's largest environmental organization?

On a snowy walk in Denver, Colorado, one day as we pondered the future of the idea of Freedom to Roam, we realized that the World Wildlife Fund was in fact a perfect vehicle. WWF is the largest and most effective organization working on international biodiversity conservation. It had itself gone from working in protected areas primarily back in the '60s and '70s to working at ecoregional and large land- and seascape scales. WWF embraced this way of working with cores and corridors at large scales around the world—whether it was Africa's Congo Basin or the southeast Pacific's Coral Triangle, Namibia or North America's northern Great Plains. Finally, at a global level, WWF's panda logo is well known and has a powerful identity and voice among the public, the private sector, and governments alike.

Synergy and a shared view on such an alignment followed quickly, with WWF's senior leadership recognizing the value of Freedom to Roam and of our approach to mainstream large-landscape conservation in society. Freedom to Roam was never meant to be a separate entity—it is a movement, one that found a home in WWF.

How is Freedom to Roam evolving now that it is with WWF?

JEFFREY: First, the Freedom to Roam concept now has a global call for action. Large-landscape conservation is the only way wildlife and wildlands will survive into the next century, whether we are talking about pronghorn in Wyoming or tigers in Nepal. While under Patagonia's purview, Freedom to Roam was focused primarily in the United States, on North American wildlife. Yet connectivity needs to be a global priority, and no other organization works at that scale like World Wildlife Fund. The WWF is engaged in more than a hundred nations around the world and with a global level of influence that is unsurpassed.

Second, WWF as a place-based organization gave Freedom to Roam a tremendous opportunity to see the vision of connectivity become a reality *on the ground* in real places, with real people, and

through real strategies to protect and connect core areas. Previously, Freedom to Roam developed and marketed the stories about places to promote connectivity but was not wed to a specific geography. World Wildlife Fund allowed Freedom to Roam not only to have deep and enduring stories about why connectivity matters but also to see those strategies take hold in real landscapes around the world and see them through to fruition—in places like the northern Great Plains, the Arctic, southern Africa, and Nepal.

So if we have the science for connectivity issues, why are stories still important?

JEFFREY: WWF and the larger conservation community continue to make discoveries about wildlife movement and migrations and to pioneer scientific studies, planning, and priorities that indicate clearly what needs to be done to make sure that animals can adapt to climate change and that habitat fragmentation can stop. Yet, even with the scientific knowledge in the world, if public desire and political will to connect these lands and waters are not there, we will ultimately never succeed—at least not at the scale that matters. Stories are what make these issues—which sometimes are far away—very real to people and policy makers. That's what Freedom to Roam brings to the conservation movement and what Florian Schulz brings to the world.

And it's why the partnership between WWF and Florian and Braided River around this book is so important and so powerful. WWF's science, global influence, brand recognition, and global reach, linked with Braided River's commitment to advocacy through books and exhibits, coupled with the powerful storytelling and heart-stopping imagery that Florian brings—as embodied here in *The Wild Edge* bring hope to the world that wildlife will have the freedom to roam for many centuries to come.

Why does this particular project— Baja to Beaufort—matter?

JEFFREY: In *The Wild Edge,* Florian captures the value of and the risks to the interconnected coastal and marine seascape of the northern Pacific and puts into your hands and into the front of readers' minds the importance of these places.

For WWF, this project captures two regions of extraordinary priority. The Gulf of California (Mexico's Sea of Cortés) is a marine hot spot central to the survival of species such as the gray and humpback whales. And to the north, the last frontier on this planet—the Arctic Ocean—is at its eleventh hour, a pivotal moment that will decide its future and indeed the future of our climate and of many species that call the place home for at least part of their lives. WWF is determined to protect, connect, and set the new rules for a rapidly melting and opening Arctic Ocean.

This is not hyperbole. Today the polar ice cap is 40 percent smaller than it was just thirty years ago. This massive melt is opening not only new shipping routes but also access to 13 percent of the world's undiscovered oil and 30 percent of the world's natural gas. Offshore energy development companies have leased more than 120 million acres (48 million hectares) of the Beaufort and Chukchi seas—about the size of California and

Maine combined. In 2013 trans-Arctic shipping traffic doubled. This "Cold Rush" is like North America's Wild West of the late 1800s.

RICK: We must ask ourselves: Will we run roughshod over this frontier like we did in the Lower 48? Will we exploit and deplete the Arctic for quick return now and leave the impact on the climate—and the decimation of indigenous cultures and of charismatic species such as whales and polar bears—to be mourned by our children?

JEFFREY: WWF believes there is a smarter way and that we can and we must learn from the patterns of past frontiers. With this book—these images and powerful storytelling that bolster the irrefutable science—we can ensure that a suite of Arctic jewels remain untarnished in the crown of the planet. Then, with these places protected and connected, the pulse of wildlife in the B2B corridor will have the freedom to roam. ■

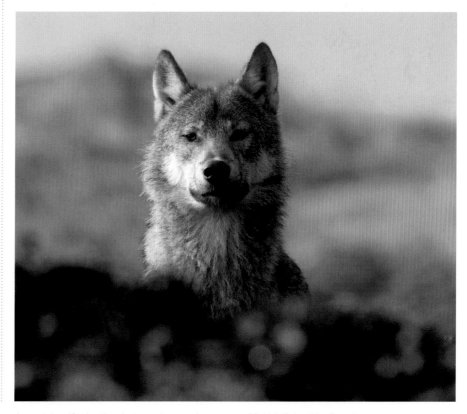

A coastal wolf spies the photographer, northern coast of British Columbia, Canada.

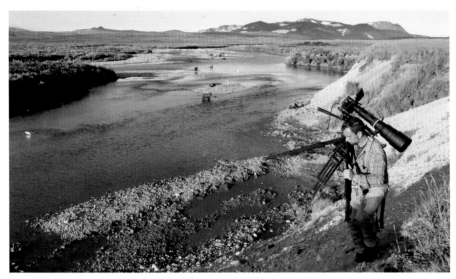

Photographing brown bears in the Bristol Bay watershed, Alaska

This book covers a vast geographic area. How much time did it take you to complete this project?

Florian: It is an immense area indeed. If you start at the Colorado River delta and follow the outline of the Pacific coast in a very rough fashion, it encompasses more than 8500 miles (13,675 kilometers). In order to cover the different locations from the Baja Peninsula to the Beaufort Sea, I undertook countless expeditions over the past ten years. Some expeditions lasted as long as two months, and often one expedition followed the next. It was important to me to invest the time to get a true feeling for the different ecosystems and to capture images with depth.

I have focused my work around the concept of Freedom to Roam for well over a decade now, and so this project was like undertaking a migration of my own. I enjoyed the idea of following the gray whale as well as the countless migratory birds from Baja California to the Beaufort Sea. At the same time, I wanted to highlight the remaining wild places along the western seaboard—those places that still are home to bears and wolves. What makes this area so special is how the sea and the land are interconnected. In this zone, the ecosystems are especially rich, providing a variety of food that sustains an incredible array of wildlife.

What kind of camera equipment did you need out there?

Florian: My passion for documenting entire ecosystems means that I have to live with the consequences of a huge amount of equipment. I work with the line of professional Nikon camera bodies and a broad selection of lenses, from the 16mm fish-eye to the Nikon 600 mm F/4 supertelephoto lens. In addition, I use Nauticam

underwater housings for my underwater photography. Since it is impossible to carry everything on my back, I need to find ways to either create base camps or get the equipment into the field with boats or bush planes. Then I repack the specific gear I need for the shoot of the day into smaller manageable packs.

What was the most challenging image in the book to capture?

Florian: It's hard for me to pin down one specific shot. Some images were difficult because of the patience I needed to capture them; others required me to refine certain skills, such as my long-lens aerial work. Working from small aircraft, which often have wing struts, a propeller, or tires reducing my field of vision, I needed to become good at keeping a watchful eye on the corners of the frame while creating a powerful composition. An additional challenge was simply keeping my food down in the many tight turns while looking through the viewfinder. Sometimes the difficulty was due to the remoteness of a location or dangers such as aggressive bears or an intense storm while I was on the boat.

What were some of your most memorable experiences with wildlife during this project?

Florian: I love thinking back to finding the caribou. I am utterly fascinated with the large herds that migrate across the vast, open landscape. It is the essence of Freedom to Roam for me. The areas they migrate to in the far north are the last truly wild places that have no boundaries for animals. Several times I was right in the middle of the large migration, surrounded by caribou. I loved those encounters.

Finding wolves along the coast was another highlight. In most places it is very difficult to observe, much less photograph, wolves in the wild and being able to do so filled me with joy— especially when I observed the young at the beach.

Then, of course, there are my encounters with whales. I will never forget being watched by a full-grown gray whale. As his eye studied me, it felt as if we engaged in a silent dialogue. And once, as I was adrift in a tiny boat, a large group of humpback whales appeared, seemingly out of nowhere, and surrounded the boat. Their bodies were twice as

*Top to bottom: Florian and Emil filming the annual caribou migration in the Arctic National Wildlife Refuge, Alaska; Florian waits for blue whales to surface, Baja California, Mexico; Enduring constant rain, Florian searched tirelessly for the elusive coastal wolf, Great Bear Rainforest, British Columbia, Canada; Aerial photography along the Alaskan coast
Left, top to bottom: Filming spirit bears along the coast of the Great Bear Rainforest, Canada; Night falls over the sailboat* Jonathan II *during the Aleutian expedition, Alaska.*

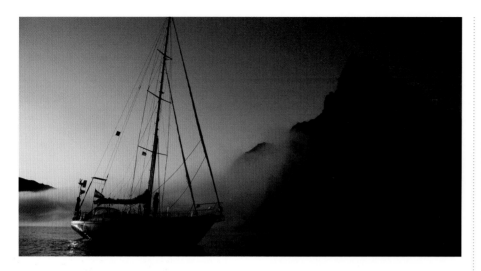

© SALOMON SCHULZ

long as our little vessel, yet they simply explored around us for a while and then disappeared again. It gave me a feeling of reverence.

Shooting in the Arctic, you've witnessed firsthand the changes that climate change has brought about in this region, and the impact is striking. Is it possible to maintain a hopeful outlook?

Florian: Yes and no. We are facing enormous challenges and often I have doubts, but I do not want to give up. The changes I've seen in the Arctic have been dramatic. Temperatures have risen there at a faster rate than any other place. In general, the sea ice is much thinner and now vast areas of the ocean become ice-free much earlier in the year. Along different parts of the coastline, I have seen the permafrost washing into the sea as if it were icing melting off a cake. Unfortunately, it is not only the Arctic that is affected; we are all seeing the effects of climate change across the globe—from extended droughts to large wildfires to the acidification of the oceans.

Yet I do remain hopeful, and this drives my work. My wife and I have a three-year-old son. He will grow up in this different world, and it is a beautiful world. Along the western seaboard, there are incredible wild places left. It is our obligation to protect them for future generations. The idea of keeping large wilderness areas interconnected is also our best bet against a changing climate. Through their size and connectedness, such ecosystems are much

Top to bottom: Traveling by sailboat enabled Florian to capture the unique features of the Aleutians Islands, Alaska; Florian photographs a group of humpback whales circling the boat, Southeast Alaska ; Nanuk and Emil splash through the mud flats at low tide, Hallo Bay, Katmai National Park, Alaska.
Top right: Florian and Emil sailing the outer coast of Southeast Alaska with the "little red boat"

© SALOMON SCHULZ

more resilient and are more able to cope with a changing climate.

What is the main thing you hope to impart to your audience about the B2B corridor?

Florian: I want to convey that we need to think about nature in a different way and on a different scale. All our natural world is interconnected, and the B2B corridor is a wonderful showcase for that. I want to instill a sense of pride in readers of the natural wonders that can be found along North America's west coast and also a sense of urgency to protect what is left of the natural world. It is not enough to reduce nature to a number of national and state parks; we must also

think about how to keep them connected, and this includes the oceans. We want to take the idea behind Freedom to Roam—that of protected wildlife corridors—and apply the same model to the sea with an extended network of marine protected areas. I think this is something that hasn't occurred to many people, even people who care deeply about the environment, so I hope my work, and the work of others who are engaged in this effort, gets people thinking about protecting the B2B.

Below: Florian Schulz expands the Freedom to Roam message beyond the book to support grassroots conservation efforts through multimedia events, museum exhibits, and film.

© EMIL HERRERA-SCHULZ

BRUCE BARCOTT, a former Guggenheim Fellow in nonfiction, is a contributing editor at *On Earth* and *Outside* magazines and the author of *The Last Flight of the Scarlet Macaw* and *The Measure of a Mountain*. His articles on science, the environment, and public policy appear in the *New York Times Magazine*, *Rolling Stone, National Geographic*, the *Atlantic Monthly*, and other publications. His work has been widely anthologized, nominated for the National Magazine Award, awarded the Society of Environmental Journalists' highest honor, and taught in college classrooms nationwide. His latest book, *Weed the People: A Journey into America's Legalized Future*, examines the changing legal, cultural, and social landscape in Washington, Colorado, and across the country as marijuana legalization takes hold in an ever-growing number of states. He lives near Seattle with his wife, memoirist Claire Dederer, and their two children.

© VOYACY PRODUCTIONS

PHILIPPE COUSTEAU is a prominent leader in the environmental movement whose life mission is to empower people to recognize their ability to change the world. He has hosted television series for the British Broadcasting Corporation, Animal Planet, and Discovery Channel. He is currently the host of the television series *Awesome Planet* and a special correspondent for CNN International. He has cowritten many books, including *Going Blue* and *Make a Splash,* both of which have won multiple awards. He is the founder of EarthEcho International, an environmental, education organization that is equipping youth with the knowledge to understand environmental challenges, the critical-thinking skills to solve them, and the motivation to do so. He and his wife, fellow adventurer Ashlan Gorse Cousteau, reside in Los Angeles, California.

© OCTAVIO ABURTO/ILCP

EXEQUIEL EZCURRA is a Mexican ecologist with a doctorate from the University of North Wales. In the 1970s he developed the first environmental impact assessment studies in Mexico, where his innovative approach and original methodologies set the foundations for novel legislation on environmental impact mitigation. He has published more than two hundred research papers, essays, books, and book chapters and developed the scientific script of the film *Ocean Oasis*, winner of the Jackson Hole and the BBC Wildscreen awards. He was honored with the 1994 Conservation Biology Award and the 2006 Pew Fellowship in Marine Conservation, among many other awards. He chaired the Scientific Committee of the CITES Convention and was president of Mexico's National Institute of Ecology. Currently, he is the director of the University of California Institute for Mexico and the United States (UC MEXUS) and professor of ecology at University of California–Riverside.

© CHARLES ZENNACHÉ

Journalist **BONNIE HENDERSON** has had a long career in newspapers, magazines, and public relations for nonprofit organizations. Currently she is a freelance writer and editor focused on exploring the intersection of the natural world and the human experience close to home. She is the author of four books: *The Next Tsunami: Living on a Restless Coast, Strand: An Odyssey of Pacific Ocean Debris*, and two hiking guidebooks, including *Day Hiking Oregon Coast*. She divides her time between the Oregon Coast and her home in Eugene, Oregon.

© JENNIFER STEELE

JON HOEKSTRA is chief scientist and vice president for science for the World Wildlife Fund in the United States. As leader of WWF's Science and Innovation team, he helps WWF apply cutting-edge science to the challenge of saving nature in a rapidly changing world. He is the lead author of *The Atlas of Global Conservation* and a frequent speaker on technology and the future of conservation. He has published numerous scientific articles on diverse issues including endangered species biology, conservation planning, climate change adaptation, global habitat loss and protected areas, and conservation return-on-investment. He earned bachelor's and master's degrees from Stanford University and a doctorate from the University of Washington, where he maintains a faculty appointment. He lives in the B2B region and enjoys watching wildlife on the move whenever he can.

© FLORENCE OMORO SMITH

ERIC SCIGLIANO has written on Pacific Northwest marine and environmental issues for more than twenty years. He is a science writer at the University of Washington's Washington Sea Grant and a past staff writer and editor at various Seattle newspapers and magazines. His books include *Puget Sound: Sea Between the Mountains; Love, War, and Circuses: The Age-Old Relationship between Elephants and Humans; Michelangelo's Mountain: The Quest for Perfection in the Marble Quarries of Carrara*; and, with Curtis E. Ebbesmeyer, *Flotsametrics and the Floating World: How One Man's Obsession with Runaway Sneakers and Rubber Ducks Revolutionized Ocean Science.* His articles have appeared in *Harper's, Discover, New Scientist*, the *New York Times,* and many other publications. His reporting on salmon and the Aleutian and Pribilof islands has received Livingston, Kennedy, and American Association for the Advancement of Science honors. Many of his recent articles can be found at Crosscut.com.

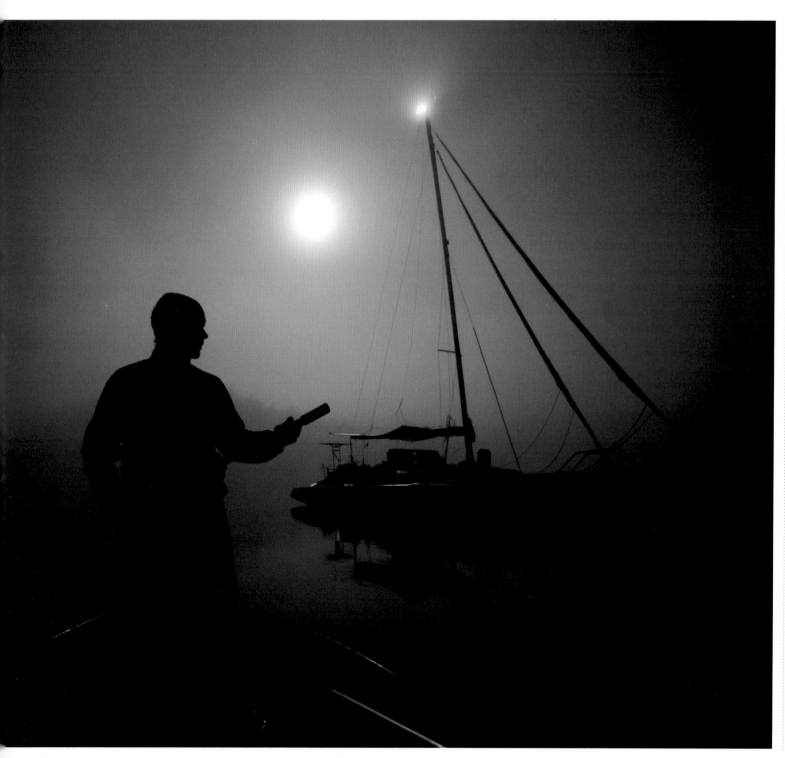

Anchored on the outer coast of British Columbia, Canada

Florian Schulz is an internationally acclaimed nature photographer dedicated to capturing inspiring images of the natural world. A native of Germany, Schulz spends many months at a time in the wild, working on long-term photography projects that portray entire ecosystems. His major focus has been the Freedom to Roam campaign, through which Schulz hopes to promote a new conservation vision of wildlife corridors. His photographs have appeared in international publications, such as *National Geographic*, *BBC Wildlife*, and *GEO*, among many others. Two of his books have won the Independent Publisher Book Awards as outstanding publications: *Yellowstone to Yukon: Freedom to Roam* and *To The Arctic*, the companion book to the MacGillivray Freeman/ Warner Brothers IMAX film of the same name. Schulz is also a sought-after speaker, delivering memorable and inspiring presentations about his adventures in the wild and his conservation objective. In recent years he has applied his creative vision to film projects. Schulz has received numerous awards, including Environmental Photographer of the Year, Conservation Photographer of the Year, and the Ansel Adams Award. Schulz lives with his wife, Emil, and son, Nanuk, in southern Germany.

For more information, please visit www.VisionsoftheWild.com.

ACKNOWLEDGMENTS

This book, *The Wild Edge,* that you hold in your hands is part of my ongoing Freedom to Roam project. Ever since I first began exploring wild places across North America I have been inspired by the landscape and the animals that call it home. My fascination with the continent's remaining wilderness led to my interest in landscape-scale conservation. My work on the Freedom to Roam project now has been going on for well over a decade and would not have been possible without the support of my family, a large group of friends, fellow conservationists, and supporters. I am deeply indebted to the many people who have provided the support and assistance necessary to make this book a reality.

First of all I would like to thank my wife, Emil Herrera-Schulz, for her tremendous and unconditional support throughout the development of this project. She has been on the front lines in the most challenging situations and always has been understanding and supportive of the needs of the project. I can never thank you enough for your loving guidance and artistic eye that have brought this book project to life.

My deepest gratitude goes as well to the late Margot MacDougall who passionately supported the Freedom to Roam project ever since our paths crossed years back. Because we shared a love for wide-open spaces, the American West, and its wildlife, she immediately understood the concept. I fondly remember our time together brainstorming and plotting. Even though she is no longer with us, Margot's supportive words and encouragement will always stay with me. I am excited to continue the mission to help protect wilderness and wildlife with Allen Preger. Allen, Lisa, Julie: Thank you for the tremendous support. I am so pleased that our families have connected through Margot's vision.

I want to give my most sincere thanks to Tom and Sonya Campion. Through your dedication the wild has found a voice, which flows through the many channels you tirelessly continue to build. We share the stubbornness to move conservation forward, each in our fields of strength. I am honored to lend my visual voice in our joint efforts. From the bottom of my heart I thank you for believing in our work.

My sincere appreciation also goes to Martha Kongsgaard, Ann and Ron Holz, and Renate Schreieck, who have been consistently supportive and caring throughout my career and the development of this book.

It has been a continuous joy crafting partnerships with leading conservation organizations where my voice and visual narrative can support their conservation missions. In recent years World Wildlife Fund (WWF) and I have collaborated to push the issue of wildlife movements and corridors into the public eye and to give attention to those areas that are far removed from the public's awareness, such as the high Arctic. I want to especially thank Carter Roberts, Jeffrey Parrish, Matt Wagner, Margaret Williams, Julie Sauder Miller, David Aplin, Alanna Ulen, Gayle Brown, and Kim Collini.

I also want to thank Earthjustice, especially Ray Wan and Trip Van Noppen, for joining forces to push Arctic conservation forward. Achieving conservation and drawing public attention to crucial environmental issues is a collaborative effort and for that I would like to thank Cindy Shogan (Alaska Wilderness League), Dan Ritzman (Sierra Club), and Stan Senner (Audubon).

I am especially grateful to Helen Cherullo, publisher of Mountaineers Books and executive director of Braided River, who has devoted her heart and soul to crafting book projects with a conservation vision. Your guidance has been invaluable for me. Thank you, Helen, for believing in our projects and for being such a wonderful partner for the past twelve years. Another special thanks goes to the Braided River team and their efforts to keep this project on track and make it happen: editors Janet Kimball, Ellen Wheat, and Deb Easter, as well as the rest of the team including Lace Thornberg and Margaret Sullivan. Many thanks to Lance Morgan (Marine Conservation Institute) for his scientific expertise. A special thanks goes to Betty Watson for her tireless dedication to making this a very special, beautiful book.

My thanks also go to the many writers who have given this book such a strong and unique voice: Bruce Barcott, Eric Scigliano, Philippe Cousteau, Exequiel Ezcurra, Bonnie Henderson, and Jon Hoekstra.

It is my goal to capture our natural world in the most splendid form. I want to thank the Nikon Professional Team in Germany, particularly Yasuo Baba, Viktoria Deines, and Michael Ramroth, who have provided the best possible service and stood by my side with advice and support. I also want to thank the team at Patagonia, especially Cameron Ridgeway for providing us with quality outdoor gear for the range of environments I have worked in.

Many expeditions were necessary to capture the entire B2B corridor. I would like to give a very special thanks to Marven Robinson from Hartley Bay who helped us during our explorations of the Great Bear Rainforest. Thanks goes also to the team at Ocean's Light Adventures, especially Jenn Broom for facilitating access to remote areas of the British Columbia coast and the Great Bear Rainforest. We had a lovely and memorable journey.

Our expedition to the Aleutians would not have been possible without Captain Mark van de Weg's remarkable guidance and his sailboat *Jonathan II*. I would like to thank my brother and filmmaker, Salomon Schulz, for his dedication on this and other trips. Without you this would have not been such a successful endeavor. Also special thanks go to Florian Such and Audun B. Tholfsen for their incredible support and companionship during this memorable journey. This was not only a job for them; they were passionate about helping me and my brother visually capture this incredible area and its wildlife. Thanks also to Chris Scanion and to helicopter pilot and Cineflex operator Daniel Zatz who provided invaluable footage of us in the sailboat.

Aerial photography was crucial in my efforts to capture the grandness of the B2B region. I especially want to thank my good friend Ken MacDonald for your impeccable care and professionalism when flying in remote areas of Alaska. Another very special thanks goes to Sandy Lanham who undertook long hours of flying with me over thousands of miles across the Baja California Desert and the Gulf of California.

A special thank you to Alexandra Garcia (ILCP), Shari Saint Plummer (Mission Blue), Steve Freiligh (Nature's Best), Dan Lemont and Natalie Fobes (Blue Earth Alliance), Chase Jarvis, Rick Ridgeway (Patagonia), Jolene Hanson (G2 Gallery), Mark Lukes (Fine Printing), Lauren Wendell (PDN), Frank Heiler (Senckenberg Research Institute Frankfurt), Martin Bethke (Ravensburger Verlag), Kate Lopez Ley and Christine Nienstedt (Cowan Miller & Lederman), Joel Connelly, and Angela Demma and Julie Decker (Anchorage Museum).

We are deeply indebted to our many friends who have offered us unconditional friendship while welcoming us into their homes and making us feel like part of their families. We thank Theresa Mackey, James Daniels, Joline Esparza, Ken Mills, Kelly Walters and Natalie Eleftheriadis, Pam and Carl Battreall, Scott and Stephanie Dickerson, the Poindexters, Adam Weintraub, Xioamara Romero, Jaime Rojo and Fátima Andrade, and Darren and Rhea deStefano. Special thanks to Hillary, Emily, and Thomas MacDonald for taking care of my family while I was out in the bush with Ken; to Susan Aikens for providing a great Arctic base camp; to Dona and Curt Perrin for helping us while we were preparing the "little red boat" in Juneau and for giving us invaluable sailing advice about navigating the dangerous waters of Southeast Alaska. Curt, also special thanks to you for helping Emil tow the sailboat to Baja California. Thanks to Lynn Schooler for keeping an eye on our sailboat in Juneau for so many years and to Pete Carrs for his marvelous advice as we set sail on the trimaran *Trust Me*. Your consistent support and encouragement during the process of this project was essential for Emil and me; we are sincerely grateful to you all.

And last but not least Emil and I would like to thank our family in Germany—my parents Achim and Gerdi Schulz and my siblings, Jonathan, Immanuel, Sarah and Salomon—for their loving support and for believing in our work.

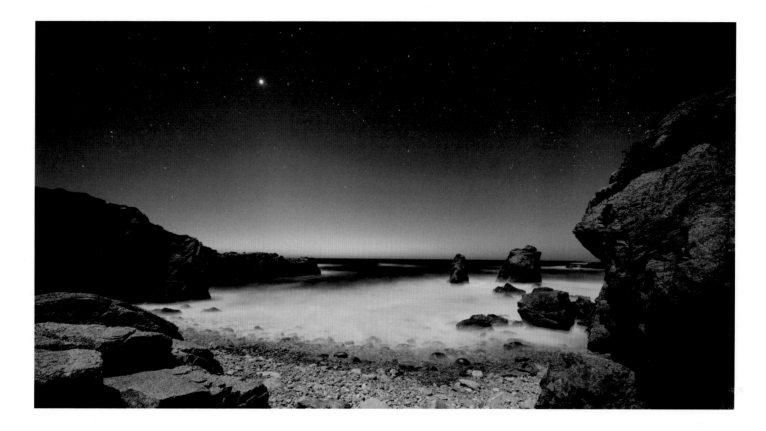

The Wild Edge *project was made possible*
through the friendship and generosity of:

Margot MacDougall

Campion Foundation

JiJi Foundation
Wilburforce Foundation
Ann and Ron Holz
The Engelstein Family and Classic Accessories
Kongsgaard-Goldman Foundation
The Mountaineers Foundation
George L. Shields Foundation
Furthermore: a program of the J.M. Kaplan Fund

BRAIDED RIVER

BRAIDED RIVER®, the conservation imprint of Mountaineers Books, combines photography and writing to bring a fresh perspective to key environmental issues facing western North America's wildest places. Our books reach beyond the printed page as we take these distinctive voices and vision to a wider audience through lectures, exhibits, and multimedia events. Our goal is to build public support for wilderness preservation campaigns and inspire public action. This work is made possible through the book sales and contributions made to Braided River, a 501(c)(3) nonprofit organization. Please visit BraidedRiver.org for more information on events, exhibits, speakers, and how to contribute to this work.

Braided River books may be purchased for corporate, educational, or other promotional sales. For special discounts and information, contact our sales department at 800.553.4453 or mbooks@mountaineersbooks.org.

THE MOUNTAINEERS, founded in 1906, is a nonprofit outdoor activity and conservation organization, whose mission is "to explore, study, preserve, and enjoy the natural beauty of the outdoors. . . ." MOUNTAINEERS BOOKS supports this mission by publishing travel and natural history guides, instructional texts, and works on conservation and history.

Send or call for our catalog of more than 600 outdoor titles:

Mountaineers Books
1001 SW Klickitat Way, Suite 201
Seattle, WA 98134
800.553.4453
www.mountaineersbooks.org

Manufactured in China on FSC®-certified paper, using soy-based ink.

MIX
Paper from responsible sources
FSC® C008047

Publisher: Helen Cherullo
Acquisitions and Developmental Editor: Deb Easter
Project Manager and Developmental Editor: Janet Kimball
Developmental Editor: Ellen Wheat
Content and Copy Editor: Kris Fulsaas
Cover and Book Designer: Elizabeth M. Watson, Watson Graphics
Development and Communications: Lace Thornberg, Director; Jill Eikenhorst, Associate
Cartographer: Ani Rucki, BeesKneesStudioSeattle
Scientific Advisor: Lance Morgan, PhD, President, Marine Conservation Institute

Map sources:
Marine Ecoregions and Priority Conservation Areas map and caption, page 22: Lance Morgan, Sara Maxwell, Fan Tsao, Tara A. C. Wilkinson, Peter Etnoyer, "Marine Priority Conservation Areas: Baja California to the Bering Sea." Commission for Environmental Cooperation of North America and Marine Conservation Biology Institute (February 2005)
Migration Routes of Sandpipers, page 228: Robert W. Butler, Francisco S. Delgado, Horacio de la Cueva, Victor Pulido, and Brett K. Sandercock, "Migration Routes of the Western Sandpiper." *The Wilson Bulletin* 108, no. 4 (December 1996)

For more information, visit:
www.thewildedge.org

Front cover: *Gray whale mother and calf along the Baja Peninsula, Mexico*
Back cover: Top: *Munk's devil rays, Gulf of California, Baja California Sur, Mexico*; Middle: *Humpback whale, Icy Strait, Southeast Alaska*; Bottom: *Brown bears, Alaska Peninsula, Alaska*
Front flap: *Spirit bear, Great Bear Rainforest, British Columbia, Canada*
Page 1: *The eye of a gray whale in the calving lagoons along the Baja Peninsula, Mexico*
Title page: *Migratory birds in the Laguna Ojo de Liebre, Baja California Sur, Mexico*
Page 4: *The sun rises over Isla Angel de la Guarda with Isla Smith in the foreground, Gulf of California, Mexico*
Page 6: *Gray whales in the calving lagoons, Baja Peninsula, Mexico*
Page 240: *Ringed seal, Chukchi Sea, Alaska*

Furthermore: a program of the J.M. Kaplan Fund

The Wild Edge benefited from the support of many generous funders, including Furthermore: a program of the J. M. Kaplan Fund.

Library of Congress Cataloging-in-Publication Data

The wild edge : freedom to roam the Pacific Coast : a photographic journey / [photography and compilation] by Florian Schulz ; introduction by Bruce Barcott ; epilogue by Philippe Cousteau.
 pages cm
 Includes index.
 ISBN 978-0-89886-773-2 (hardcover)
 1. Natural history–Pacific Coast (North America)—Pictorial works. 2. Pacific Coast (North America)—Pictorial works. 3. Pacific Coast (North America)—Description and travel. 4. Nature photography—Pacific Coast (North America) 5. Wilderness areas—Pacific Coast (North America) I. Schulz, Florian, 1975- photographer Photographs. Selections.

QH104.5.P32W55 2015
508.7—dc23

2015009571

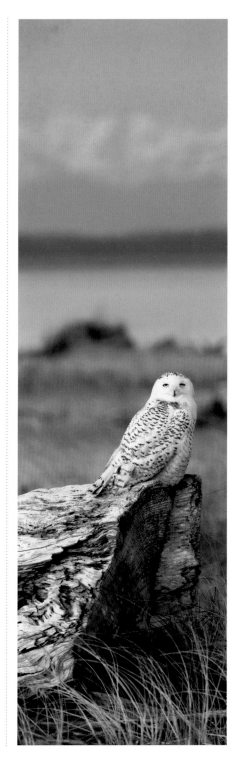

Snowy owl wintering on the west coast in Washington State with the Olympic Mountains visible in the background